BASQUIAT

BASQUIAT

A QUICK KILLING IN ART

PHOEBE HOBAN

VIKING

VIKING
Published by the Penguin Group
Penguin Putnam Inc., 375 Hudson Street, New York, New York 10014, U.S.A.
Penguin Books Ltd, 27 Wrights Lane, London W8 5TZ, England
Penguin Books Australia Ltd, Ringwood, Victoria, Australia
Penguin Books Canada Ltd, 10 Alcorn Avenue, Toronto, Ontario, Canada M4V 3B2
Penguin Books (N.Z.) Ltd, 182–190 Wairau Road, Auckland 10, New Zealand
Penguin India, 210 Chiranjiv Tower, 43 Nehru Place, New Delhi, India, 11009

Penguin Books Ltd, Registered Offices:
Harmondsworth, Middlesex, England

First published in 1998 by Viking Penguin,
a member of Penguin Putnam Inc.

10 9 8 7 6 5 4 3 2 1

Author's Note: This is an unauthorized biography that has not been endorsed by either Gerard Basquiat or the estate of Jean-Michel Basquiat.

Grateful acknowledgment is made for permission to reprint excerpts from the following copyrighted works:
 "Genius Child," "Mellow," and "Harlem (2)" from *Collected Poems* by Langston Hughes. Copyright © 1994 by the Estate of Langston Hughes. Reprinted by permission of Alfred A. Knopf, Inc.
 The Andy Warhol Diaries, edited by Pat Hackett. All rights reserved. Reprinted by permission of Warner Books, Inc., New York, New York.

Photograph credits:
p. 1 of insert: William Coupon; p. 2 (above, left and right): Cynthia Bogen Shechter; p. 2 (below left): Marina D.; p. 2 (below right): Mary-Ann Monforton; p. 3 (above): Edo © LLC 1995; p. 3 (below) Lee Jaffe; pp. 4 (above) and 7 (above right): Stephen Torton; p. 4 (center): Gianfranco Gorgoni; pp. 4 (below) and 7 (below right): photographed by Tseng Kwong-chi, 1987. © Copyright Muna Tseng Dance Projects Inc., NYC 1998; p. 5 (above left): Rose Hartman; p. 5 (above, center and right):© Timothy Greenfield-Sanders; p. 5 (center): Beth Phillips; pp. 5 (below), 6 (above right, below left), and 7 (below left): Michael Halsband; p. 6 (above left): Paige Powell; p. 6 (below right): Paige Powell Archives; p. 7 (above left): Duncan Buchanan, courtesy of Suzanne Mallouk; p. 8 (above): Catherine McGann; p. 8 (below): © Mark Sink

LIBRARY OF CONGRESS CATALOGING-IN-PUBLICATION DATA
Hoban, Phoebe.
 Basquiat : a quick killing in art / Phoebe Hoban.
 p. cm.
 Includes bibliographical references and index.
 ISBN 0-670-85477-8
 1. Basquiat, Jean-Michel. 2. Artists—United States—Biography.
I. Title.
N6537.B233H63 1998
760'.092—dc21
[B] 98-17166

This book is printed on acid-free paper.
∞

Printed in the United States of America · Set in Bodoni Book

For my mother,
Lillian Hoban

Contents

Preface

Start with the head. (He painted them obsessively.) The hair was a focal point. Shaved like a convict's when he left his home in Brooklyn at the age of fifteen. He said it was a disguise so that the cops wouldn't find him. Shaped into a futuristic blond Mohawk when he hit the downtown scene, recognizable topiary in clubland. As SAMO evolved, graffitist extraordinaire, so did the hair. Now the skull was half exposed; the skinhead fringed with Rasta dreads. Then the dreadlocks, Basquiat's own version of a crown. He said he took the symbol from the King World Productions trademark at the end of "The Little Rascals," but he made it his own.

Next, the eyes. There was that look. He didn't copy it from Warhol, but he knew how to use it. People said his eyes could eat your face, see right through you, zap you like the X-ray vision of his comic-book heroes. He saw things others didn't see. In order to connect, he disconnected. Into paranoia, into drugs, into music, into television. Sampling the culture, spitting it back in scrambled bits.

Then the skin. There was no escaping it; it contained him. He couldn't get cabs. People wouldn't shake his hand. It betrayed him; didn't keep out the world. It was too thin, too sensitive. He had no spleen; no way to filter out poison. In the end it erupted, a surface image of his inner plague.

The feet were often bare. A suit, no shoes. A self-conscious reference to African royalty, arrogant and folksy. He had this dance; bugged out, future-primitive. A hip-hop spaceman from another planet. The walk was something else. Not like a homeboy in new high-tops; a curious lope; half bum, half child.

Basquiat kept no standard records. His life was cash and carry. But there are records, hundreds of them. Drawings, paintings, and notebooks that reveal him like a Rorschach test. Basquiat lived his paintings; he slept on them, walked on them, ate on them. He scribbled the phone numbers of his friends on them, outstanding debts, take-out menus, names of people and places, lists from reference books, his idea of history.

He died of a heroin overdose at twenty-seven, like his heroes, brilliant jazz junkies and artists. According to one of his last notebooks, he planned to buy a saxophone.

BASQUIAT

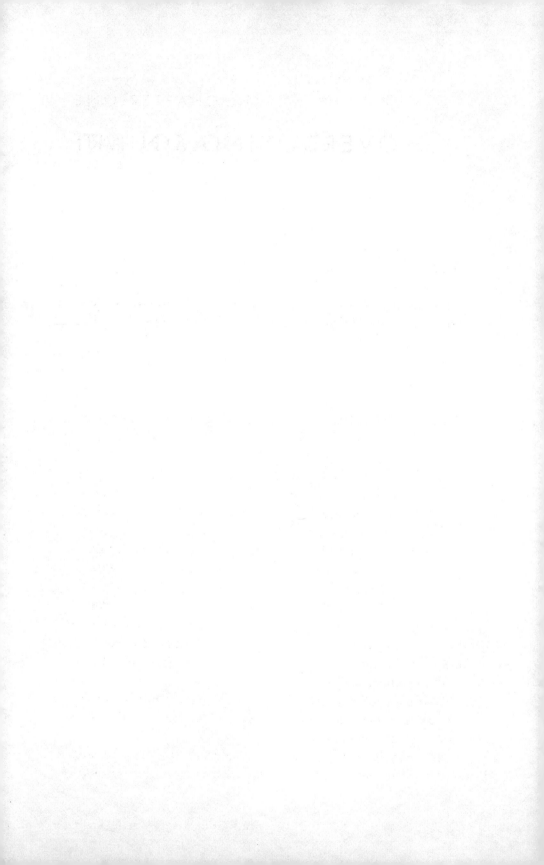

OVERDOSING ON ART

"If you had only twenty-four hours left to live, what would you do?"
"I don't know. I'd go hang out with my mother and my girlfriend, I
guess."

—video interview, Tamra Davis and Becky Johnston, 1986

Friday, August 12, 1988. On the sidewalk outside 57 Great Jones
Street, the usual sad lineup of crack addicts slept in the burning
sun. Inside the two-story brick building, Jean-Michel Basquiat
was asleep in his huge bed, bathed in blue television light. The air
conditioner was broken and the room felt like a microwave oven.
The bathroom door was ajar, revealing a glimpse of a black and tan
Jacuzzi tub. On the ledge of the tub was a small pile of bloody sy-
ringes. There was a jagged hole punched in the bathroom window.
Beneath it was scrawled the legend "Broken Heart," with Basquiat's
favorite punctuation, a copyright sign.

Kelle Inman, Basquiat's twenty-two-year-old girlfriend, was down-
stairs writing in the journal that Basquiat had given her. He usually
slept all day, but when he still hadn't come down for breakfast by
midafternoon, Inman got worried. When she looked into the bedroom
to check up on him, the heat hit her full in the face, like a wave. But
Basquiat seemed to be sleeping peacefully, so she went back down-
stairs. She and the housekeeper heard what sounded like loud
snores, but thought nothing of it.

A few hours later, Basquiat's friend Kevin Bray called. He and
Basquiat and another friend, Victor Littlejohn, were supposed to go

to a Run-D.M.C. concert that evening, and he wanted to make plans with Jean-Michel. Kelle climbed back up the stairs to give Basquiat the message. This time, she found him stretched on the floor, his head cradled on his arm like a child's, a small pool of vomit forming near his chin.

Inman panicked. She had never seen anyone die, although Basquiat's drug binges had made the scenario a constant fear. Now it seemed like the worst had happened. She ran to the phone and called Bray, Littlejohn, and Vrej Baghoomian, Basquiat's last art dealer.

"When I got there," recalls Bray, "Kelle said she had called an ambulance. She took me upstairs. Jean-Michel looked like he was comfortably out cold. He was on the floor, lying against the wall, as if he had fallen down and didn't have the strength to get up, and was just taking a nap. There was a lot of clear liquid coming out of his mouth. We picked him up and turned him over. We shook him, and we just kept trying to revive him. It took a long time for the ambulance to arrive. But for a while, after the guys from the Emergency Medical Service came, we thought he was going to be okay. They were giving him shocks and IV treatment. Victor had to hold Jean-Michel up like this so the IV's would drain," says Bray, stretching his arms out in a cruciform.

Bray couldn't take it anymore. He went downstairs, where Inman, and two assistants from the Baghoomian gallery, Vera Calloway and Helen Traversi, were trying to stay calm. "We tried to take his pulse. His skin was so hot," says Calloway. Baghoomian called the studio just as the paramedics arrived. He was in San Francisco and Helen was forced to act in his stead.

"It was almost like it was some sort of business transaction," says Bray. "They put a tube in his throat and they brought him downstairs. They wouldn't tell us whether he was dead or alive and they took him outside. He had this beautiful bubbling red-white foam coming out of his mouth."

"We all hoped some miracle would happen," recalls Helen, who begins to cry at the memory. Outside on the pavement, a small crowd had gathered in horror and fascination. "I was about to leave on vacation with my wife," says filmmaker Amos Poe, who was a friend of

the artist. "We watched as they loaded his body into the ambulance. I saw his father pull up in a Saab. I kept saying to my wife, 'Jean-Michel is dead.' He really lived out that whole destructo legend: Die young, leave a beautiful corpse."

At Cabrini Medical Center, Basquiat was pronounced dead on arrival. The cause, according to the medical examiner's death certificate, would be determined "pending chemical examination." A later autopsy report stated that Basquiat had died from "acute mixed drug intoxication (opiates-cocaine)." In the months before his death, Basquiat claimed he was doing up to a hundred bags of heroin a day.

Basquiat was buried at Green-Wood Cemetery in Brooklyn five days later. His father invited only a few of the artist's friends to the closed-casket funeral at Frank Campbell's; they were outnumbered by the phalanx of art dealers. The heat wave had broken, and it rained on the group gathered at the cemetery to bid Jean-Michel goodbye. The eulogy was delivered by Citibank art consultant Jeffrey Deitch, lending the moment an unintentionally ironic tone.

Blanca Martinez, Basquiat's housekeeper, was struck by the alienated attitude of the mourners. "They were all standing separately, as if it were an obligation," she says. "They didn't seem to care. Some looked ashamed." People began to leave the cemetery before the body was buried. Ignoring the objections of the gravediggers, Martinez tearfully threw a handful of dirt onto the coffin as they lowered it into the grave.

Basquiat's mother, Matilde, looking dazed, approached Baghoomian to thank him for his help to her son during his last days. Gerard Basquiat later admonished his former wife not to talk to the art dealer. The scene was already being set for a bitter battle over the estate of the artist.

The following week, appraisers from Christie's set to work taking inventory of the contents of the Great Jones Street loft: finished and unfinished paintings, other artists' works (including several dozen Warhols and a piece by William Burroughs), a vintage collection of Mission furniture, a closet full of Armani and Comme des Garçons

suits, a library of over a thousand videotapes, hundreds of audio-cassettes, art books, a carton of the Charlie Parker biography *Bird Lives!*, several bicycles, a number of antique toys, an Everlast punching bag, six music synthesizers, some African instruments, an Erector set, and a pair of handcuffs.

There were also a number of paintings in warehouses: following Andy Warhol's advice, Basquiat had tried to squirrel some of his work away from his ever-eager art dealers. According to Christie's, Basquiat had left 917 drawings, 25 sketchbooks, 85 prints, and 171 paintings.

Artist Dan Asher walked by his old friend's loft and was astonished to see a number of Basquiat's favorite things in a Dumpster: his shoes, his jazz collection, a peculiar lamp made out of driftwood, Sam Peckinpah's director's chair. Asher salvaged a few items; he sold the chair to a collector.

It would be another year before Gerard Basquiat ordered a tombstone for his son. But for several weeks after the artist's death, he was commemorated by a small shrine some anonymous fan had placed by his door. Shrouded in lace, it held flowers, votive candles, a picture of Basquiat, some carefully copied prayers, and a Xerox of a David Levine caricature of the artist, complete with a caption: "In an age of limitless options and limiting fears, he still makes poems and paintings to evoke his world."

A formal memorial service was finally held at Saint Peter's Church in Citicorp Center, on a stormy Saturday in November. Despite the rain, wind, and bleak gray sky, several hundred people crowded into the church. Behind the pulpit hung a portrait of the artist as a young man, superimposed on one of his faux-primitive paintings. One by one, his former friends and lovers remembered Basquiat.

Gray, the band with which Jean-Michel had played at the Mudd Club, performed several songs. John Lurie played a saxophone solo. Ingrid Sischy, editor of *Interview* magazine, read a eulogy. Ex-girlfriends Jennifer Goode and Suzanne Mallouk tearfully read poems. And Keith Haring, AIDS-thin, reminisced about his friend. "He disrupted the politics of the art world and insisted that if he had to

play their games, he would make the rules. His images entered the dreams and museums of the exploiters, and the world can never be the same."

Fab 5 Freddy, who knew Basquiat from his old graffiti days, "interpolated" a poem by Langston Hughes. "This is a song for the genius child. Sing it softly, for the song is wild. Sing it softly as ever you can—lest the song get out of hand. Nobody loves a genius child. Can you love an eagle, tame or wild? Wild or tame, can you love a monster, of frightening name? Nobody loves a genius child. Free [sic] him and let his soul run wild."

After the service, everyone went to M.K., the bank-turned-nightclub on lower Fifth Avenue. Owned by Jennifer Goode's brother, it was one of Jean-Michel's favorite places. In fact, it was his last destination the night before he died. He had come to the club looking for Jennifer. Now people stood around the big television set, sipping champagne and watching a flickering black-and-white video of Basquiat. A photographer from *Fame* magazine snapped pictures of the known and not-so-known: the jewelry designer Tina Chow, and her sister, Adele Lutz, David Byrne's wife. Filmmaker Jim Jarmusch. It was the perfect send-off for the eighties art star; part opening, part wake.

THE NOT-SO-BRAVE
NEW ART WORLD

Basquiat's life spanned an historic shift in the art world, from Pop to Neo-Expressionism, from hip to hype. It was personified by Andy Warhol, the man who was to celebrity what Freud was to the unconscious. When Basquiat was born in December 1960, the Pop decade had just begun. In December 1961, Claes Oldenburg was showing household items in "The Store" down on East Second Street; the following summer Andy Warhol's Campbell's soup cans poured into America's consciousness when they were put on display in the window of Bonwit Teller and in the Ferus Gallery in Los Angeles.

Comic books, television, advertising itself; they all became fodder for the new movement. Mass media was both the new art's subject and its method of dissemination. Even America's landscape—with its Technicolor billboards—was innately Pop. "Pop art took the inside and put it outside, took the outside and put it inside," Warhol wrote in his bible of the era, *POPism*.

At Leo Castelli's gallery, a bastion of Abstract Expressionism, Robert Rauschenberg, Roy Lichtenstein, Tom Wesselmann, and Jasper Johns were showing paintings of modern detritus; bathroom fixtures, Ben Day–dotted bimbos talking in air balloons, American flags, Coke bottles. The Museum of Modern Art's symposium on Pop art, held in December 1962, included an early champion; Metropolitan Museum curator Henry Geldzahler, a Warhol intimate who would become Mayor Ed Koch's cultural commissioner of New York. Geldzahler would also be instrumental in helping launch Jean-Michel Basquiat's career.

The sixties also brought a whole new breed of collectors into the

forefront. Cab-fleet owner Robert Scull and his wife, Ethel, became avid collectors of the new art. One of Scull's passions was to discover the work on his own, buying right out of the artist's studio. The Sculls also liked to socialize with the artists they collected, throwing huge parties at their home on Long Island. This would also be a favorite activity of the nouveau riche collectors of the eighties, who seemed to crave the kind of high produced by being in close proximity to the Artist.

Pop art planted the seeds of the Neo-Expressionist art of the eighties—spawning its aesthetics and hype. Pop is "doing the easiest thing," Warhol had written. "Anybody could do anything." But art was also "just another job," one that could be turned, he soon demonstrated, into a moneymaking machine. Warhol took an American classic, the assembly-line, and applied it to art. He made no bones about it; he called his studio the Factory. Thousands of kids pouring out of art school with Bachelor of Fine Art degrees in the 1970s followed his lead.

They flooded into New York from all over the country in the middle to late 1970s, a new generation of would-be rock stars, artists, dancers, and actors. It was still possible to find cheap apartments in Alphabet City and lower Manhattan. There were few homeless. AIDS didn't exist. The city was an urban frontier, theirs for the taking. Before long, influenced by the Punk movement in England, wildly coiffed young people with multicolored Mohawks and safety-pinned clothes seemed to have taken over the East Village—then still a scary neighborhood full of shooting galleries. CBGB's on the Bowery became a mecca for the new bands: the Ramones, Television, the Talking Heads. Punk-rock boutiques began popping up around St. Mark's Place.

A new Bohemia was in the making, a wild nexus of music, fashion, and art that created a distinctive downtown aesthetic. Punk and the subsequent New Wave movements that quickly took over were a welcome antidote to the sterile Conceptual and Minimalist art that had numbed the art scene during the post-Pop decade, boring both critics and collectors. Even slam-dancing was preferable to the mindless throb of *Saturday Night Fever* music pulsing in the discos.

Like the sixties, this was a multimedia event, amplified by an

English invasion of fashion and music that crisscrossed the Atlantic and was transmuted in Manhattan. It had its drugs of choice; instead of getting stoned on marijuana, speeding on amphetamines, or tripping on LSD, people snorted coke the way the stars in Godard films sucked on cigarettes, or got into cool, strung out heroin. The Sex Pistols replaced the Beatles; cute Paul McCartney became decadent Johnny Rotten, dressed in torn, black rags instead of psychedelic tie-dye. Johnny Rotten gave way to the robotic Devo and Klaus Nomi and the jubilant B-52's.

But there was another, more profound difference. Unlike the sixties, the new cultural movement had no real ideology, no revolution at its core. It was as if the veiled commercialism of such historic sold-out events as the rock musical *Hair* or Woodstock had been stripped of any pretext of politics. No one raised an eyebrow when ex-radical and Chicago 7 kingpin Jerry Rubin became a stockbroker and began to throw networking parties at the Underground.

There was also no generation gap: from the start, adults began to exploit the obvious possibilities. The late seventies paved the way for the eighties, which celebrated the materialism the sixties had rebelled against. New Wave everything from fashion to graphics was soon inundating Madison Avenue. Fiorucci, on Fifty-seventh Street, became the first uptown boutique to combine the new fashion, music, and art. And anything and everything was considered art.

Perhaps the most blatant exploitation by uptown of the downtown art scene was the marketing of the graffiti movement, which galvanized the art world in the late seventies and was completely passé by 1983. For a brief moment the inner-city artists, whose work had been followed for years by transit cops, not critics, were the darlings of Fifty-seventh Street and SoHo. But the "limousine liberals"—upscale dealers and pseudo radical collectors—soon got bored with baby-sitting and found some new neo movement to market.

Real estate played a major role in the new Bohemia and its shifting boundaries; as one area became gentrified, artists migrated to the next new place. At this point, SoHo, the industrial area south of Houston Street, was still full of textile outlets, floor-sanding companies, and riveters—and lofts that artists could live in under the Artist in Residence (A.I.R.) rental regulations. There were few, if

any, residential amenities—Dean and DeLuca was just a tiny little gourmet store. And despite the growing artist population, by Fifty-seventh Street gallery standards, the neighborhood was still practically the Wild West. But by 1979, when Julian Schnabel, one of the first Neo-Expressionist art stars, had his first show at the Mary Boone Gallery on West Broadway, the cross-pollination between the East Village and SoHo was in full bloom. Within the next few years, SoHo would evolve into the Madison Avenue of the downtown scene.

By the end of the seventies, a whole group of downtown clubs had sprung up—from the Mudd Club on White Street in TriBeCa to Club 57 on St. Mark's Place, to Danceteria on Twenty-third Street, raunchy parodies of the fabulous Studio 54 where Warhol and his celebrity cronies—Bianca and Halston and Calvin and Brooke—were hanging out, with one big difference. People didn't just dance and do drugs and hob-nob in these clubs: they were venues for performance art, underground films, New Wave music. The Talking Heads—art students turned musicians—were paradigmatic of the scene. Artists were mixing up their media; music, film, painting, and fashion were recombining in innovative ways. From fashion to music, television was a central reference point for this burgeoning baby-boomer culture.

By early 1979, Jean-Michel Basquiat had established himself as an artistic persona: SAMO, the author of cryptic sayings scrawled on public spaces all over Manhattan—including, strategically, near SoHo's newest galleries. It was the beginning of his art career, and it segued neatly with the "discovery" of graffiti. At the time, it was convenient, but Basquiat had no intention of being lumped into a category with a bunch of kids who bombed trains. In fact, Basquiat was not a true graffiti artist; he didn't work up through the ranks as a "toy," earning the right to leave his tag on certain turf, and he never drew on subways; certainly the stars of *Wild Style*, Charlie Ahearn's graffiti film of the time, didn't consider Basquiat a real member of their group. Ultimately, Basquiat would be the only black artist to survive the graffiti label, and find a permanent place as a black painter in a white art world.

Basquiat's nascent career coincided with the advent of a major art-world revival, from the tiny storefront galleries of the East Village to

SoHo's expansionist West Broadway to the suddenly crowded auction houses. For the first time in a over a decade, a new art movement, Neo-Expressionism, had seduced both critics and collectors. Painting was back; from Julian Schnabel to Susan Rothenberg, artists were reveling in the return of figurativism.

But what radically changed the art world by the time Basquiat entered the scene was money. In the early 1980s, Wall Street's bull market engendered an interesting offspring: SoHo's bull market. The new money of the eighties was increasingly invested into art. By 1983, the art market in New York alone was estimated at $2 billion. Gallery dealers became power players, barely distinguishable in lingo and lifestyle from their Wall Street clientele. Banks began accepting art as collateral for loans. Corporations began stockpiling important contemporary-art collections. Every weekend, SoHo was clogged with a parade of art lovers slumming at openings. At auction houses, packed rooms applauded as records were set for everything from van Gogh's "Irises"—$53.9 million—to $17 million for "False Start" by Jasper Johns.

Chauffeured cars disgorged fur-coated women into tiny storefront galleries in the bowels of the East Village. Eugene and Barbara Schwartz epitomized the new collectors. A wealthy publisher of how-to books, Schwartz and his wife spent most of the mid-eighties shopping for art every Saturday, hitting the hottest galleries in the East Village and SoHo. Collectors like Charles Saatchi, head of the multinational advertising conglomerate Saatchi & Saatchi, acquired a dreadful power: the ability to make and break an artist overnight, as the advertising baron did with the work of Italian painter Sandro Chia, first buying up and then dumping his paintings en masse.

The art boom created a crop of suddenly famous young careerist-artists; Julian Schnabel, David Salle, Francesco Clemente, Eric Fischl, Keith Haring, Robert Longo, Mark Kostabi, and Kenny Scharf. The Whitney's Biennial became a launching pad for the latest stars. Collectors like Don and Mera Rubell soon developed a ritual: hundreds crowded into their art-filled Upper East Side town house for their Biennial opening-night party.

In the eighties, the bifurcated role of art as a vehicle for stardom and art as raw commodity reached its zenith. For the contemporary

artist, success meant instant recognition; magazine covers and Gap ads, not just museum shows. And the new art collectors, unlike those who invested in junk bonds, could at least pretend they had put their money into something of value.

Warhol, a wigged-out psychic, had presaged the whole thing. In *POPism*, he spelled it out for the next generation: "To be successful as an artist, you have to have your work shown by a good gallery for the same reason, say, that Dior never sold his originals from a counter in Woolworth's. It's a matter of marketing, among other things. If a guy has, say, a few thousand dollars to spend on a painting . . . He wants to buy something that's going to go up and up in value, and the only way that can happen is with a good gallery, one that looks out for the artist, promotes him, and sees to it that his work is shown in the right way to the right people. Because if the artist were to fade away, so would this guy's investment . . . No matter how good you are, if you are not promoted right, you won't be one of those remembered names."

Fame and Greed: the Twin Peaks of the eighties art world. The career of Jean-Michel Basquiat cashed in on both. Not surprisingly, he managed to become Warhol's protégé along the way. As an added bonus, a kind of historical footnote to the cynical decade, Jean-Michel Basquiat was black—the first contemporary African-American artist to become an international star.

Basquiat's black identity is manifest throughout his art. Not overtly political, his sense of what it means to be a black man in contemporary America couldn't be more clearly conveyed, whether it's in the grinning heads in "Hollywood Africans," or the poignant tribute to his idol Charlie Parker, "Charles the First" or the ironic "Undiscovered Genius of the Mississippi Delta."

Many of his stylistic trademarks are themselves a recognizable part of the continuum of well-established African-American aesthetic traditions, from the iterated drumbeat brought here by men sold into slavery, to the call and response of gospel, the repeated blues refrain, jazz's improvisational riffing, and the sampling technique of rap.

Basquiat's work, with its ironic use of text—and particularly its erasure—is the visual equivalent of "signifying." As Henry Gates

elucidates in his analysis of black literature, *Figures in Black*, "the black rhetorical tropes, subsumed under signifying, would include marking, loud-talking, testifying, calling out of one's name, sounding, rapping, playing the dozens, and so on . . . Signifying is a technique of indirect argument or persuasion, a language of implication . . . Repetition of a form and then inversion of the same through a process of variation. . . ."

In Basquiat's paintings, boys never become men, they become skeletons and skulls. Presence is expressed as absence—whether it's in the spectral bodies and disembodied skulls he paints or the words he crosses out. Basquiat is obsessed with deconstructing the images and language of his fragmented world. His work is the ultimate expression of a profound sense of "no there there," a deep hole in the soul.

He had few black friends, even fewer black peers. No wonder he found his heroes in jazz geniuses like Charlie Parker. His repeated use of the copyright sign probably owes as much to Parker as to the cartoons he obsessively watched on television. (As with numerous other black musicians who were taken advantage of by the white music industry, Parker's failure to copyright his brilliant compositions cost him his royalties; the record companies profited from work which he did for the price of a recording session.) Basquiat always said he wanted to design a tombstone for Billie Holiday.

Despite the pointed racial references in his work, Basquiat was more in touch with white than with black culture. Like his father, he rarely went out with black women. His generosity toward a group of young graffiti writers was, perhaps, one way to assuage his guilt.

During his lifetime, he was not embraced by African-American critics. In an essay in the Whitney catalogue for the *Black Male* show, Greg Tate wrote, "I remember myself and Vernon Reid being invited to Jean-Michel Basquiat's loft for a party in 1984, and not even wanting to meet the man, because he was surrounded by white people."

Like many middle-class blacks who came of age during the Civil Rights movement, Basquiat was stuck in the crack between two worlds. With the exception of being bused to one primarily white school, he never experienced racial segregation. The racism he con-

stantly encountered was more subtle. He suffered the indignity of
never being able to get a cab. He'd make a ritual act of it, jumping up
and down in the street, ensuring that the driver would stop only if the
artist were accompanied, as he often was, by a well-dressed white.

Basquiat felt like a bum. He pretended he came from the street,
and in the end he went back to the street—for drugs. It was his way of
perpetuating his feelings as a disenfranchised person—as a son, as a
citizen, and as an artist. If the art world wanted to cast him as its wild
child, Basquiat was happy to oblige. It is significant that one of his
favorite source books included a dictionary of hobo signs—and from
it he took not only symbols but poetry. ("Nothing to be gained here.")

His life and career strongly parallel those of Robert Thompson,
a prodigiously talented black artist who died in 1966 at the age of
twenty-nine. Like Basquiat, Thompson lived for a while in the East
Village, had notoriously excessive appetites, adored jazz, and was a
longtime heroin addict. After his first one-man show, writes Stanley
Crouch, he became "the black enfant terrible of the art world." Crouch
brings him vividly to life in his essay "Meteor in a Black Hat":

"His behavior, aesthetic achievements, and career successes
amused, shocked, entertained, scandalized, inspired, made jealous
and awed. Some describe his exoticism as contrived, his high-powered,
loud and rowdy behavior as no more than a ploy . . . he was known for
taking over places when he arrived . . . and for charming his way
through situations where racial animosity bucked against a short
leash. Thompson is recalled as an innocent, a big kid run down on
the fast track he travelled. . . ."

To place Basquiat in the historical arc of African-American art,
from the 1700s through the extraordinary Harlem Renaissance, from
Jacob Lawrence to such outstanding contemporary artists as Marvin
Puryear and David Hammons, is, in a sense, to do him the ultimate
disservice. According to a friend, painter Arden Scott, "Basquiat was
intent upon being a mainstream artist. He didn't want to be a black
artist. He wanted to be a *famous* artist."

But Basquiat's celebrity owes more than a little to an almost in-
stitutionalized reverse-racism that set him apart from his peers as an
art-world novelty. Says Kinshasha Conwill, director of the Studio Mu-
seum of Harlem, "Race will remain into the foreseeable future a ma-

jor, and usually unfortunate, issue. The fact is, it was anomalous to
be an African-American and get that kind of attention for his art.
Other people did exploit his race and try to make him an exotic
figure."

Like all artists whose work mirrors their worlds, Basquiat re-
flected his—that of a black man in twentieth-century America. Few
have done it as successfully. For better or worse, Jean-Michel Bas-
quiat has become the world's most famous black artist. To take off on
his painting "Famous Negro Athletes," Basquiat himself has become
an icon: Famous Negro Artist.

Take someone with the emotional maturity of a child who aspires to
be the Charlie Parker of painting. Place him in a pressure-cooker art
world where quantity matters more than quality, aggressive art deal-
ers push prices through the roof, avaricious new collectors speculate
wildly, auction houses create instant inflation, and the media magni-
fies the entire circus through a hyperbolic lens. Add the race card,
drugs, and promiscuity at every level. Then call it the burnout of an
art star.

In fact, Basquiat's brief life as an artist was a little bang that at-
tracted its own temporary universe of powerful planets, whose orbits
were in every way more constant than his own. He was, in a sense, a
cipher; a black hole too dense to penetrate, whose strange gravita-
tional pull ultimately—and predictably—caused it to implode.

The players who instantly recognized the phenomenon of Jean-
Michel Basquiat and knew how to market it were older, more cynical,
and ultimately easier to analyze than the lonely, alienated, and disen-
franchised artist whose constant need to produce—out of his own un-
trammeled creativity, deep-seated desire for approval, and insatiable
demand for the cash that would buy him drugs—became their ready
source of profit. Basquiat was a canny, coked-out art-world Candide,
with a revolving set of Panglosses, including the Ur-Pangloss of them
all, Warhol. For Basquiat, dying was a way of never growing up.

The story of Jean-Michel Basquiat is not so much the study of
a life as the study of a life style at a particular moment in the latter
half of the twentieth century. Basquiat's life and death tread that pe-

culiarly American line where tabloid meets tragedy. Precisely what energized his art made it impossible for him to survive the system.

We live in a culture that continually cannibalizes itself; Basquiat's life is a modern-day version of Nathanael West's classic tales of culture run amok, *The Day of the Locust*, and, even more to the point, *A Cool Million*, in which Lemuel Pitkin, the American Boy who seeks success in a wildly capitalistic world, becomes a martyr when he is assassinated—after first being virtually torn limb from limb.

Ironically, given his obsession with anatomy, Basquiat deconstructed himself. Perhaps his trademark erasures were his most heartfelt artistic gesture.

SAMO IS BORN

Jean-Michel Basquiat was born in Park Slope, Brooklyn, on December 22, 1960. He was the oldest son of Gerard, an accountant who had emigrated from Haiti in 1955, when he was twenty, and Matilde, a Puerto Rican woman. Jean-Michel used to boast to friends that his grandmother was "the Diane von Furstenberg of Haiti." Says Gerard Basquiat, "We come from an elite, affluent background in Haiti. My family got into some political problems. My mother and father were jailed. My brother was killed in Haiti in the seventies. The Basquiat name is not well-thought of there now."

From the time he was three or four years old, Jean-Michel drew constantly. "Jean-Michel painted all of his life," says Gerard Basquiat, a handsome, nattily dressed man who boasts about his game of tennis. The ability seems to run in the family. "I draw. My brother is a commercial artist. His mother is very artistic; she designed clothes years ago."

Basquiat was also exposed to music at a young age. In addition to the jazz Gerard constantly played at home, Jean-Michel's maternal grandfather, Juan, was the band leader of a small Latino musical group. He played the twelve-string guitar, and Jean-Michel would sometimes sit in on practice sessions. Jean-Michel was quite close to his grandmother Flora, whom he later depicted in a brightly colored painting, entitled simply "Abuelita," the Spanish word for grandmother.

When Basquiat was five years old, the family moved to Flatbush. To outward appearances, his was an ordinary middle-class childhood. But there were some deeply traumatic events. When he was

seven, Jean-Michel was hit by a car and had his spleen removed. "I was playing in the street," he recalled in the videotaped interview with Davis and Johnston. "I remember it being very dreamlike and seeing the car kind of coming at me and then seeing everything through a sort of red focus . . . that's not the earliest memory I have, but it's probably the most vivid." The images of a car and an ambulance would later surface as a repeated motif in his art, as if he were, on some level, always returning to this key scene in his life; an accident which had already happened.

Gray's Anatomy, which his mother gave him in the hospital, as if, perhaps, hoping to provide him with a diagram for healing, was an important early influence; anatomical images and references would become a central image in his work. Matilde aso took him to museums and the theater; "Guernica" was his favorite painting, and he had vivid memories of seeing *West Side Story*. He also remembered watching his mother drawing pictures from the Bible on paper napkins. "I'd say my mother gave me all the primary things. The art came from her," he told Steve Hager, author of *Art After Midnight*.

Matilde was fluent in English, Spanish, and French, and Jean-Michel learned all three languages at home. "She used her artistic talents," says Jean-Michel's maternal uncle, John Andrades. "She had a good eye for colors, and the house was very neat. It was so pretty, everything looked like it could have been out of a magazine."

But Basquiat told friends that she suffered from recurrent bouts of depression that sometimes resulted in violent spells. "When I was a kid my mother beat me severely for having my underwear on backwards, which to her meant I was gay. I was in kindergarten. She beat me for the longest time. My mother was very, very strict," he told writer Anthony Haden-Guest in an interview.

Basquiat shocked many people with various stories about the domestic violence in his family. He told his high school friend Ken Cybulska that his mother had to be committed after she tried to kill them all, by driving the car off the road. He told Al Diaz, who would later become his graffiti partner, that she had tied Gerard to the bed and hit him with a clothes hanger. He told the same story to painter David Bowes. He told Haden-Guest a "terrible story about his mother beating up his father."

"My mother went crazy as a result of a bad marriage to my fa-
ther," Jean-Michel told Hager. "She was beautiful when she was
younger, but she has a worry line on her forehead from worrying so
much." He was more specific in an interview with Haden-Guest. "My
mother was committed when I was a kid . . . about ten, eleven, some-
thing like that," Basquiat told him. "My mother has been in institu-
tions many, many times . . . She's very frail." Basquiat also told Andy
Warhol, who later recorded it in his *Diaries*, that his mother had been
"in and out of mental hospitals."

There were definitely problems. When Jean-Michel was seven,
his parents separated, and Gerard kept custody of the children, mov-
ing the family to a house in Boerum Hill. He says that his wife had
periods of "mental depression," and refers to something mysterious
that happened early in their marriage; Howard Lewis, a neighbor, re-
calls Gerard Basquiat telling him Matilde had tried to stab him with
a knife. "They broke up so often. Back and forth, back and forth.
There was always this conflict. I'm not close to my father's side of the
family and my mother's side of my family hates my father," Basquiat
told Haden-Guest.

Jean-Michel had two younger sisters, Lisane, born in 1963, and
Jeanine, born in 1966. The children were brought up in a family-
owned three-story brownstone on Pacific Avenue, in Boerum Hill. The
semi-gentrified residential neighborhood, lined with trees, is a bit of
an oasis in a somewhat seedy area.

Gerard Basquiat had put himself through night school to become
an accountant. During Jean-Michel's childhood he worked as a comp-
troller for the publisher Macmillan, in New Jersey. At one point, ac-
cording to a neighbor, Monroe Denton, he started a business of his
own; a small shop called L'Etiquette on Atlantic Avenue that sold
Bennington pots and other fancy housewares. He was a jazz afi-
cionado, and owned a prize collection of records, which he did not al-
low Jean-Michel to touch. He loved to cook, a skill he taught his son.
A girlfriend of Jean-Michel's remembers his father cooking dinner,
wearing an apron which said, in boldface letters, "The Boss."

Neighbors paint a picture of Gerard as a stylish sophisticate, who
seemed to hang out almost exclusively with whites, was devoted to
his hobby of tennis, and frequently went away for weekends with girl-

friends. They describe a strict, self-absorbed father who appeared to have little or no understanding of his son.

"He was more like a playboy than a parent," says Sylvia Lennard, who says she took care of his two daughters on the weekends that he abandoned them in the brownstone, leaving them without enough food in the refrigerator. According to Lennard, Jean-Michel was also expected to baby-sit, and cook and care for his sisters.

Gerard dated a number of women, and he had several serious relationships during Jean-Michel's early years. "This particular woman that I was dating when his mother and I separated, Jean-Michel apparently wasn't very happy with it," he says. "Was Jean-Michel unhappy because I left his mother? I don't know, I really don't know. I mean, who knows what goes on in the minds of children. Does a parent have to be responsible for it?"

When Jean-Michel was sixteen, Gerard began to live with a British woman named Nora. "I like to be dangerous. I used to love to live on the edge, to have fast cars and motorcycles," he recalls. "Nora corrected that part of my life."

Although Matilde would sometimes visit on Sundays, neighbors say they never saw her go into the house; instead she would sit on the stoop with her children. A religious woman, she lives today with her family on Covert Street, in an extremely poor section of Brooklyn.

Jean-Michel was sent to St. Ann's, a private school, until the fourth grade. In third grade, he sent a drawing of a gun to J. Edgar Hoover. His early themes, according to his own account, included *Mad* magazine's Alfred E. Neuman, Alfred Hitchcock, and cars.

After St. Ann's, he went to several public schools. For a year, he was bused to P.S. 101 in Bensonhurst as part of an integration program. He made an impression on several teachers there. "He was adorable-looking. When we put on a class play of *Julius Caesar*, he played Caesar," recalls his homeroom teacher, Estelle Finkel. "I'll never forget, during the death scene he got up to see what was going on. He brought the house down. He drew all the time. I realized he had talent that was unusual. I remember he created a comic strip—a cast of ten characters with dialogue." Years later, Finkel went to the opening night at the Palladium—and thought she recognized the work of one artist. To her surprise, it was a mural painted by Jean-Michel.

Cynthia Bogen Shechter taught art at P.S. 101. She says that Finkel asked her to take Basquiat into her class for therapy. She remembers that racism was a problem. "The school was in a completely white, Italian neighborhood. There were only a few kids bused in and it was really difficult for them." The young artist used to wear a batch of pencils sticking out of his hair. "He said he wanted to be a cartoonist, and he drew cartoons all day long. He had a hard time relating to the other kids. He was an angry child."

His artwork, though, was exceptional. Shechter hung on to several of his comics, including one about a mad scientist named Mr. Oopick. She also kept the pieces of a mural Basquiat had torn up in a rage. It's a rather extraordinary work for a young kid from a middle-class background: it shows some tough-looking Harlem gangs called the Suicides and Switchblades. Two of the punks, wearing black T-shirts, are, in fact, equipped with bloody switchblades. Another character is a raincoated man carrying a paper that says "Sextra Sputnik," and there's a soda-fountain scene at an old-fashioned drugstore. The piece is called "The Teenage Gangs of the Fifties." (Shades of *West Side Story*.) Even at this point, Jean-Michel was crossing out words. He was also drawing houses quite similar to the one shown at the Robert Miller Gallery in 1989, entitled simply "A House Built by Frank Lloyd Wright for His Son."

Jean-Michel's bedroom was a crawl-space under the stairs with a mattress on the floor. He had covered the entire thing with drawings. "He was like no other kid. He was always so bright, absolutely an unbelievable mind, a genius," says his father. "A kid that bright thinks for some reason he is above the school system and teachers and rebels against it. He wanted to paint and draw all night. He got thrown out of schools. Jean-Michel couldn't be disciplined. He gave me a lot of trouble."

Basquiat's feelings about his family seemed to be a constant source of conflict. He told girlfriends and art dealers that he had been badly beaten by his father as a child. Gerard Basquiat adamantly denies that he ever did more than spank his son with a belt. But the neighbors remember it somewhat more strongly.

"He used to beat Jean-Michel and his sisters with a belt, on the legs. You could see the welts," says Howard Lewis, who befriended

the family, and was at the time quite close to Gerard. Both Lennard and Lewis also say that on several occasions, Jean-Michel called the police about the beatings. He even told some friends that his father had stabbed him, leaving a small scar on his butt.

"I was under tremendous pressure as a single parent. I was a strict parent," Basquiat says. "But not a severe one. I raised my kids the same way I was raised. I have no regrets about it. I did my best. Write whatever you want about Jean-Michel being an abused child, I know he wasn't. I'm sure he told people this. Jean-Michel also liked to say that he grew up in the ghetto, but he didn't."

Lisane Basquiat also denies that her father was ever abusive. "We got beatings just like any other kid. He was a disciplinarian. Were we abused as children? No. Was my father a child abuser? Definitely not."

Some of Jean-Michel's friends who saw him at home say otherwise. "His father beat the hell out of him," says Al Diaz. "I would see bruises all over him. And he just treated him like shit. His sisters had this great big room and Gerard used to buy them everything. Jean had this little cave of a room where the mattress didn't even fit. I think he thought it was kind of bohemian, he wrote graffiti all over it."

When Jean-Michel was twelve, Gerard got a job working for Berlitz, and the family moved to Puerto Rico for two years. His father bragged to Lewis that Jean-Michel had lost his virginity during their stay on the island. But Jean-Michel shocked some friends by telling them that his first experiences had been homosexual; he had been orally raped by a barber who dressed in drag, then gotten involved with a deejay.

When he returned to Brooklyn, he attended Edward R. Murrow High School, just across the street from his house. He got an incomplete in every course. He was, he wrote in an autobiographical note for an art catalogue, "the only child that failed a life-drawing class in ninth grade."

"I was a really lousy artist as a kid," he told Henry Geldzahler. "Too abstract expressionist; or I'd draw a big ram's head, really messy. I'd never win painting contests. I remember losing to a guy who did a perfect Spider-Man . . . I really wanted to be the best artist in the class, but my work had a really ugly edge to it. There was a lot of ugly stuff going on in my family."

Jean-Michel spent a lot of time with Howard Lewis and Harry Reid, hanging out at their shop, Botanic Planning Limited, which specialized in silk flowers. Once he surprised Lewis by giving him a drawing of Spider-Man, which he signed with a flourish, announcing that it would be worth a lot of money when he became famous. He also spent nights in a print shop in the neighborhood, apparently reluctant to go home. Lewis noticed a big change in Jean-Michel: "He went from a sweet trusting boy to someone who was very, very guarded and moody, bordering on hostile."

"He held a lot in," says Andrades, who worked night shifts at the Transit Authority as a subway engineer and recalls occasionally seeing Jean-Michel standing at a station, waiting for his uncle to drive by in a train.

When he was fifteen, Basquiat ran away from home. "I was smoking pot in my room and my father came in and he stabbed me in the ass with a knife," Jean-Michel told Tamra Davis when she interviewed him on camera in 1986. "I thought I better go before he killed me, you know." He told Diaz at the time that his father had stabbed him when he caught him having sex with his male cousin.

Basquiat shaved his head (he thought it would provide a good disguise) and fled Brooklyn. He packed two suitcases with canned food and camped out in Harriman State Park for several nights. But, he told Geldzahler, "It gets really dark in the woods, and you don't know where you are." At first he lived in a boys' home, but couldn't take the criminal element. After he and some other kids mugged an old woman—they hit her while Basquiat grabbed her purse, he told one friend—he felt so bad that he left. But roughing it on the street was difficult; "All the men I knew were drug dealers," he told Davis.

For a while, Basquiat lived with a Jewish hippie family in a commune on West Twelfth Street in the meat-market district, along with a friend named Alvin Field. Eventually he ended up in Washington Square Park. "I would just walk around for days without sleeping and eating cheese doodles or whatever, because they only cost fifteen cents," he told Davis. "I would drink wine with winos. I was determined not to go home again. I thought I was going to be a bum the rest of my life. Everybody else seemed rich. You would go into a restaurant, and you would think, 'Those fucking rich people,' and you

would hate them." Basquiat would later refer to this period as the worst in his life.

Basquiat used to write long letters covered with Peter Max–like drawings to his girlfriend of the time, Julie Wilson, who was living in Los Angeles. "He told me he was living in that little slide hut in Washington Square Park," says Wilson. Later Basquiat summed up the experience for writer Suzi Gablik: "I just sat there dropping acid for eight months. Now that all seems boring—it eats your mind up."

Basquiat was not the only kid who sought refuge in Washington Square Park. The park was divided up into a loose group of gangs, each with its own turf. "It was kind of a meeting ground for street urchins," says Eric Johnson, a friend who met Basquiat at the time. "There were hippie kids doing acid—playing Frisbee and talking about mantras—who hung out in one area. Then there were these Italian hooligans. There were also a bunch of middle-class kids from Westbeth. There was a splinter group of graffiti kids."

The graffiti gangs—3YB, which stood for Three Yard Boys, SS, Stone Soul Brothers, and Mission Graffiti, or MG—were already bombing the trains, the streets, and a whole parking lot of trucks that lined up on West Twenty-sixth Street. "Jean-Michel was one of the only black kids on the scene. He didn't really get involved in the graffiti stuff," says Johnson. Eventually, the Washington Square group was dispersed when a gang with baseball bats attacked the drug dealers and gays that cruised the park, in a violent melee that made the headlines.

Gerard Basquiat was determined to bring his son home. "I used to go out looking for him at night. I had nightmares," he says. With the aid of the police, Basquiat found his son in Washington Square Park. "His head was totally shaved. I saw him and went to call a police car to ask them to persuade him to come home. Of course, they had to go through all the red tape and so on, taking him to the precinct. After I signed all the papers, we were sitting outside. And Jean-Michel said to me, 'Papa, I will be very, very famous one day.'"

By the time he entered City-As-School in eleventh grade, Jean-Michel Basquiat had a serious attitude and a serious drug problem. He smoked pot constantly, dropped acid frequently, and according to

one friend, had dabbled with heroin. Luckily, he fit right into City-As-School.

City-As-School was an alternative high school designed to help gifted and hard-to-place adolescents realize their potential. The school's founding principle was that the city itself was a great learning institution; kids were given subway tokens to get to classes at places like the Museum of Modern Art and the Hayden Planetarium. Typically, they signed up for three or four activities in a totally flexible format, and checked in with their advisers once a week.

The school was based in a Greek Orthodox church on Schermerhorn Street in Brooklyn Heights. Its teachers were self-confessed left-over hippies. "You walked into this church and went downstairs. It was like a wonderful cave with yellow walls," says Fred Rugger, who taught creative writing at the school. "And there were all these very interesting, energetic, enthusiastic, bright, talented children in there playing. But it was a very special kind of playing that was going on. Kids were having imaginary Zorro sword fights. I mean there was really the sense that somebody might just grab a rope and go swinging through the basement like Tarzan. It was sort of like a little artists' colony."

Two of the staff who got closest to the kids were Mary Ellen Lewis and Lester Denmark, student advisers and co-editors of the school newspaper. "Lester and I were kind of like the mommy and daddy, and the kids were this tribe of sort of bright kids with a lot of promise who had disappointed themselves and other people, but found this opportunity to do something," says Lewis.

City-As-School provided a refuge that was easy to abuse. Basquiat and his friends Shannon Dawson and Al Diaz routinely sold all their tokens so they could buy pot. They would lie about going to classes and instead hang out in Central Park or the West Village. When Basquiat did go to classes, he didn't always cooperate. School friend Ken Cybulska remembers Jean-Michel's hell-raising exploits at the Museum of Modern Art, where he took an art history course with Sylvia Milgram. "Jean-Michel jumped right into one of the exhibits," Cybulska says. "I couldn't believe it." Milgram says Basquiat was one of the few kids she was completely unable to reach. "He was very abrasive and hostile, and it was very disruptive to everyone else. He had a terrible chip on his shoulder from his background. I had al-

ways managed to soothe the savage breast, but not with Jean-Michel.
We became mortal enemies." Basquiat also had problems in the
other art course he took, a figure-drawing class taught by Elliot
Lloyd.

"He looked like this little street kid," recalls Denmark. "He
dressed in rags and wore little psychedelic glasses and had natty
hair." A lot of the kids were tripping on acid, and so did Jean-Michel.
The school was a sexual playground. There were some openly bi-
sexual relationships and various ménages à trois. Jean-Michel be-
came involved with a number of girls, although he could never quite
get a ménage à trois off the ground. But as usual, he took things a bit
further than his peers. Word was soon circulating that Jean-Michel
had been turning tricks in Times Square, and had even contracted
syphilis. "He told me he had been a prostitute on Forty-second
Street," says Cybulska. "Here was this kid who was fifteen who was
like totally jaded. He was laughing about it when he told me."

"Throughout the time I knew him, he was always having an iden-
tity crisis," says Denmark. "It was as if he were always asking, 'Am
I doing the right thing? Am I crazy? Is there something wrong
with me?' He was uncomfortable because he didn't find a place for
himself anywhere, at school, or at home."

Still, at City-As-School itself, Jean-Michel got a lot of encourage-
ment from his teachers, and his writing and drawing began to flour-
ish. "He was really shy and awkward and very insecure when he first
got there," says Diaz, who met Basquiat on the first day of registra-
tion. "He really came of age at City-As-School."

"He was kind of like the Pied Piper at the school," says Lewis.
"If you could get Jean excited about something, his energy drew a lot
of other people in. It was kind of like an adolescent preview of the
same ego and ambition of the SoHo scene." Basquiat soon became
one of the star illustrators in the school yearbook and newspaper,
where SAMO was born in an essay about a bogus religion.

Like much of Basquiat's work, the germ of the SAMO idea was
drug-induced. It started as a stoned joke he and Al Diaz came up
with in the CAS student lounge. "We were smoking some grass one
night and I said something about its being the same old shit. SAMO,
right? Imagine this, selling packs of SAMO! It started like that—as a

private joke—and then it grew," Basquiat told *The Village Voice* in 1978, in his first newspaper interview.

Basquiat improved on the SAMO theme a short time later in a piece he wrote for a Spring 1977 special issue of the school newspaper, the *Basement Blues Press*, which focused on philosophy and alternative religions. Both his awareness of popular culture and his antiestablishment wit are evident in the satire, in which Harry Sneed, a young man searching for some "modern and stylish" spiritual enlightenment, strikes a deal with a sort of religious Fuller Brush man named Quasimodo Jones.

Basquiat sets the scene, which takes place in an office over a Papaya King stand, as if it were a mini-screenplay. Sneed rejects everything Jones offers, including a Zen discount, Judaism, Catholicism, and even "Lennyism," based on the work of Lenny Bruce, the "Beatnick Messiah," before he is finally seduced by Jones's whispered suggestion of "SAMO," which he describes as a faith in which

> . . . we do all we want here on earth and then rely totally on the mercy of god on the pretense that we didn't know . . . we attend service where the Samoid priest places a piece of yarn on our eyes. . . .

The precocious essay was accompanied by a logo, with the caption "A Cosmiconcept" and the slogan "SAMO is all, all is SAMO. . . . SAMO the guilt-free religion . . . and beyond."

There was also an illustrated series of comic-book-style endorsements of the new religion, drawn by Basquiat, Diaz, Shannon Dawson, and another friend, Matt Kelly: "My first experience with SAMO was at the '65 Panther convention. Since then I've left the Panthers to fulfill my life in the SAMO way." "I used to be hooked on speed. Now that I found SAMO, I found the truth."

This page of blurbs was later handed out as a pamphlet, which included the credit "Based on an original concept by Jean Basquiat and Al Diaz."

SAMO also appeared as a persona in a theater-therapy group called Family Life run by psychotherapist Ted Welch. The group met once a week in the auditorium at the old Flower and Fifth Avenue

Hospital between 105th and 106th Streets as part of a program at City-As-School. "The concept was that everything is just the same old thing, that society repeats itself, and you are just stuck in the loop," says Welch. "I think one of the things that he was playing with is that even though kids feel they are not repeating their parents' roles, in fact they are rolling things over in the same old way. It was a piece that really engaged the audience."

One schoolmate who participated in the Family Life group with Jean-Michel remembers SAMO as more of a collaborative joke. "He borrowed a lot of ideas from a lot of people. We sort of thought it was funny. He took it more seriously than everyone else. It fed into Jean-Michel's grandiosity. One of the things Jean-Michel wanted everyone to do was to look at him as the leader or prophet of the religion. Before he ever started doing the graffiti, we used to get on the subway and sit down next to people, and give them these little white stickers that said, 'SAMO as an alternative to the bourgeois,' and things like that. Jean-Michel had a thing against bourgeois living. He kind of portrayed himself as a poor boy living on the edge."

SAMO really began to blossom the next spring. In May 1978, Basquiat and Diaz (who had made a name for himself as the subway writer Bomb-1 several years earlier) hit the streets. Armed with Magic Markers, they scrawled their witty, portentous aphorisms all over SoHo and TriBeCa. Like Keith Haring's "Radiant Baby," the SAMO sayings, adorned with a copyright symbol, soon became a familiar downtown fixture. The *SoHo News* even ran photographs of the graffiti, like a Wanted poster, trying to identify the writer. But Basquiat and Diaz sold their story to *The Village Voice* for $100 instead. In an article in the December 1 issue, Basquiat told the *Voice* that he sometimes wrote up to thirty SAMO's a day. "It's a tool for mocking bogusness," he proclaimed.

"We would take turns coming up with the sayings," says Diaz. "We'd just take a pad and start writing them down. We worked on them together, and we edited as we went. We would add in 'as an alternative to that, as an end to this.' It was real thought out. We'd sit around and write the stuff down before we actually went out to spray it. And we'd start walking up Church Street or West Broadway from Leonard Street. Wherever we got an idea we'd write it."

SAMO writings were inscribed on the Brooklyn Bridge and at the corner of Church and Franklin, on the walls of the School of Visual Art and near the Mary Boone Gallery on West Broadway: "SAMO as a neo art form. SAMO as an end to mindwash religion, nowhere politics and bogus philosophy. SAMO as an escape clause. SAMO saves idiots. SAMO as an end to bogus pseudo intellectual. My mouth, therefore an error. Plush safe . . . he think. SAMO as an alternative to god. SAMO as an end to playing art. SAMO as an end 2 Vinyl Punkery. SAMO as an expression of spiritual love. SAMO for the so-called avant garde. SAMO as an alternative 2 playing art with the 'radical chic' sect on Daddy's$funds. SAMO as an end 2 confining art terms. Riding around in Daddy's convertible with trust fund money. SAMO as an alternative to the 'meat rack' arteest on display . . . 'Come home with me to-nite' & I'm a divorcee blues. SAMO as a result of overexposure . . . SAMO as an end to this crap . . . Soho Too! . . ."

Some critics added their own interpretations of what the acronym stood for. SAMO, they pointed out, sounded suspiciously like (Little Black) Sambo. It was also an anagram of Amos, as in Amos 'n' Andy, famous racist characters Jean-Michel referred to in later work.

At this point, Basquiat and Diaz were spending a significant amount of time with the family of Diaz's then-girlfriend, Kate McCamy, who lived in TriBeCa. Recalls McCamy, "The three of us had a good time, crashing parties, hanging out. Jean was funny, a little bit odd, a tiny bit scary. Jean and I would vie for the attention of my Mom. He was welcomed into the family fold, and he would come here all the time for dinner."

"Our house became their home base," says McCamy's mother, Arden Scott. "They were up to all kinds of teenage mischief. Even then, Jean had drug problems. Even then, he really wanted to be rich and famous and to have recognition. And being who he was, it was easy to get. He had that kind of personality; you always knew when he was in the room." According to Scott, who first met Basquiat when he was about fourteen years old, he was already "doing amazing amounts of drugs. He would hang out in Washington Square Park and sample and experiment with anything."

Basquiat and Diaz were known for their wild antics: at one point

they pretended to hold up a downtown convenience store—everyone hit the floor before realizing the weapons they were wielding were seltzer bottles. Another time, they tried to steal a classic Coca-Cola sign, and were caught by the police. They spent the night in the Tombs. "The police wanted to scare them more than anything else," says Scott. "Even then, Jean understood that the sign was an icon, and he had a real sense of what an icon was, and how that was a way to get rich."

Recalls Scott, "He would just sit in the loft and draw. He would pick up on things so fast. He would give me a little sly look, with that twinkle in his eyes. He was extremely witty and acerbic. He almost might have been too smart for his own good."

Back in Boerum Hill, things were rapidly deteriorating. Basquiat came to school several times with bruises, according to several sources, and one time showed up at Family Life theater so badly beaten up he was walking with a cane. "There was definitely major conflict between him and his father," says Denmark. "His father was a successful businessman, a three-piece suit guy, and Jean was no-where even close to heading in that direction. His father felt it was up to him to get Jean on the right track. He hit him with belts. Jean would have black-and-blue marks," says Denmark, who classifies the beating "as within the realm of normal, not abuse.

"Discipline to him, with a Haitian background, meant taking the hand and the strap to the kid. It was nothing heavy duty. It wasn't like he was coming in and had to be hospitalized. So he had a black-and-blue mark. So his father threw all his records out one night or ripped up his drawings. These things are normal when there is con-flict in the home."

But Ted Welch remembers Jean arriving late for a Family Life group. "He looked like he'd been through something physical. He told me he had been beaten up. But he didn't want to talk about it."

"He came in with a cane," recalls a classmate. "He looked terri-ble. He was bruised. He could hardly walk. Jean-Michel was very closemouthed about his family. He didn't go home a lot. He was always looking for another place to sleep. There were a lot of se-crets and shame." Basquiat frequently stayed out all night, further

upsetting his father. Denmark would arrive at school at seven in the morning, and find Basquiat sitting on the steps. When he was seventeen, he left home for good.

The June 1978 graduation ceremony at City-As-School was held at Fordham University. It was an elaborately planned event, including musical interludes, a play that traced a CAS student's evolution from registration day to graduation, an introductory speech delivered by CAS principal Fred Koury, and a final musical number. Several local politicos were in attendance, including the president of the City Council, Carol Bellamy, who gave the keynote address. The illustrated program included work by "Beatrix Potter and Jean Basquiat, plus a multitude of other meek and mild-mannered souls."

The plan to pie the principal was not the work of a "mild-mannered soul." It was a tricky setup, and had been planned several days before. It required timing, verve, and a complete disregard for propriety. It was also, as were many of Basquiat's exploits, an attention-getting device designed to steal someone else's limelight.

"We brought him backstage in advance," says Diaz, who was graduating that year. "There was an aisle pretty clear all the way down, so he would be able to run. And there was no security. Koury was standing center stage, and Jean just reached around the curtain and, perfect, hit him square in the face. I think it was the worst moment of Koury's life." "I did it as a dare. He was wearing a white jacket, so it looked like a magic trick," Basquiat later said.

Basquiat took off like Potter's Peter Rabbit, disappearing down the aisle and out of the building. The audience was almost too shocked to react. "It all happened with a curious sort of slow-motion effect. People were gasping. There was this collective kind of horror," recalls Welch, who was one of the speakers that day. "It was really like an assassination. Fred was standing at the podium and concluding his remarks, and this hand came out from behind the curtain—you never saw the rest of the individual—and the pie was dumped on Fred's head. The cream completely filled his nostrils, his mouth; he couldn't breathe. I wiped the stuff away, and asked if he were all right. Later I saw Jean-Michel and Shannon and another kid outside, and they asked me what I thought, and I said, 'As usual, your timing was bad.' "

Rugger remembers the event with somewhat more levity. "I have to say it did come off without a hitch. They did it to perfection, which was really quite splendid. The principal absolutely blew a gut. He was pretty peeved."

For several years afterwards, Koury refused to even speak about the incident. "For one brief moment, I thought maybe I had too much faith in the kids. Jean-Michel came up to the office and apologized as contritely as he was capable of doing," he says. "It was a creative prank. He didn't seem to be sorry he did it, but I accepted his apology."

Basquiat snuck back to the school the next day. "It was kind of touching," says Lewis. "He asked me if Fred's eyes were okay, and said he didn't mean to hurt him, and that he hoped he hadn't gotten anyone in trouble. He said, 'I hope you don't hate me.'"

"Looking back, I can see Jean's behavior as that of an abused child. He had this kind of paranoid quality, and he really responded to attention, like a puppy dog. He just lapped up any kind of approval desperately and indiscriminately. He would taunt and goad to the limit, but then sort of pull back and try to be a good little boy. I think, in a funny way, City-As-School was kind of a family for him. You don't have to be a Freudian to see how clearly Jean played out that father fixation. He wanted the approval of Fred Koury so much . . . and he was so hostile to him."

Basquiat never completed his senior year. He was already in trouble for making out with a white girl on the school premises and selling subway tokens instead of using them to get to class. The graduation fiasco was the final straw. "There didn't seem to be much point in going back," Basquiat remarked.

A few years later Lewis ran into Jean-Michel at one of his openings. His first words to his old teacher were, "So, 'least likely to succeed,' huh. Is Fred coming?"

Jean-Michel Basquiat's driving force was his love-hate relationship with his father. Throughout his life, he would search for surrogate parents; his girlfriends, his art dealers, Warhol, desperately seeking the love and approval he had missed as a child. But nothing was ever enough, and sooner or later he would disrupt the relationship, withdrawing into paranoia and pain. Eventually drugs would provide his only escape.

GRAFFITI BRIDGE

Soon after he left City-As-School, Basquiat began hanging out at the School of Visual Arts. He had nowhere to live, and was crashing at places all over the city. But you could track his whereabouts by the writing on the walls.

"I was sort of following the SAMO graffiti," recalled Keith Haring. "They stood out as different and important, interesting little philosophical observations, a kind of concentrated, potent poetry. I first met Jean-Michel one day at the School of Visual Arts, when I got him past the security guard. Then later I saw all these fresh SAMO tags, and I realized he was SAMO."

Kenny Scharf also ran into Basquiat at SVA. "I saw him hanging out in the cafeteria one day. Then the next day, he wanted me to get him into school, and he said they had kicked him out because he was writing on the walls. So I forged him a note from one of the teachers, and he gave it to the guard. We would go hang out in the street, and he would do his SAMO and he would let me borrow his pen. It was all new to me. And I didn't realize that was a big deal, to let someone else use your pen. I used to do this thing with the Jetsons and a TV set. We'd all go around, me and him and Keith Haring, this is even before the club scene."

The three were soon seen as a sort of triumvirate on the cutting edge of the graffiti movement that was coating Manhattan with a spray of Day-Glo doodles. Haring was becoming famous for the white chalk hieroglyphics he created on the matte-black surfaces of stripped-down subway-advertising billboards. His barking dogs, crawling babies, and

leaping dolphins were often combined with more ominous symbology—like spaceships and nuclear clouds.

Scharf regurgitated the "Looney Tune" characters and futuristic appliances of his suburban childhood; the Flintstones, Cadillacs, and television sets were favorite icons. He later extended these themes to objects and installations—covering phone booths and entire rooms with TV-oriented fantasy figures.

Basquiat's work, like Jenny Holzer's slogan-filled plaques, which were popping up around the same time, was stripped-down word-play. Text, an important motif in numerous art movements from Cubism, Surrealism, and Dada right through Pop (Rauschenberg, Larry Rivers), was enjoying a resurgence as subject matter thanks to Postmodernism, and its fascination with deconstruction as exemplified by Paul de Man and Jacques Derrida. One of Derrida's most famous principles was that of *sous rature,* or "under erasure," which became Basquiat's leitmotif. While SAMO was appearing on the walls, Barbara Kruger was inserting sardonic comments into her didactic photographs.

"Jean-Michel got labeled a graffiti artist," wrote Haring in *Vogue* several months after Basquiat's death. "The entire misrepresentation and manipulation of this hypothetical 'group' is a perfect example of the art world of the early eighties. People were more interested in the phenomena than the art itself. This, combined with the growing interest in collecting art as an investment and the resultant boom in the art market, made it a difficult time for a young artist to remain sincere without becoming cynical."

Eye-catching and cryptic, the SAMO graffiti was Jean-Michel Basquiat's unofficial entrée into the art world. "Back in the late seventies, you couldn't go anywhere interesting in Lower Manhattan without noticing that someone named SAMO had been there first," wrote Jeffrey Deitch in *Flash Art.* "His disjointed street poetry marked a trail for devotees of below-ground art/rock culture."

Similar word games, later incorporated into his paintings, would become Basquiat's trademark. They ridiculed the values his father cherished. "This city is crawling with uptight, middle-class pseudos trying to look like the money they don't have; status symbols. It

cracks me up. It's like they're walking around with price tags stapled to their head. People should live more spiritually, man," he told the *Voice*.

Even without the specific sentiments he expressed, Basquiat's poetic vandalism was a classic rebellion against his father. In a piece about the proliferation of graffiti in *The New York Times*, several psychologists treating the young artists raised an obvious point, observing that "their patients, virtually all of whom have less-than-perfect relationships with their fathers, are intent on defacing *his* car, the car of authority." The SAMO writings were a sophisticated example.

A few months after the *Voice* article appeared, Basquiat and Diaz split up. SAMO had served its purpose: the artist was on his way. "Al thought Jean was selling out," said Mary Ellen Lewis. "But Jean just couldn't maintain relationships, even with people who loved him. Jean had this quality of pulling people in and then slapping them in the face. It wasn't intentional, it was something out of his control. And then he couldn't understand why people were hurt."

But it was clear that the two friends had conflicting agendas. Although he had agreed to talk to the press, Diaz preferred to keep his graffiti anonymous. Basquiat, on the other hand, was determined to get the recognition he felt he had earned. Basquiat's first foray into the public eye was telling; he had created an alter ego only to exploit it for promotional and financial gain.

Basquiat officially ended the relationship by killing SAMO off. An epitaph appeared in place of the old philosophical statements. "SAMO is dead," Basquiat wrote on the walls, including the hallway at Patricia Field's place on Eighth Street, where he was now painting sweatshirts, lab coats, and disposable jumpsuits. Field gave him one of his first shows in her boutique; it included eight mixed-media pieces on clothing, foam rubber, window frames, and typewriters— street finds on which he spray-painted expressionistic drips and words like "manmade."

Basquiat never wrote SAMO on subways. But graffiti's popularity in the mid-seventies through early eighties gave the SAMO writings an art-historical significance they might not have had at a different time. His notoriety as the author of SAMO also brought him into contact with a whole group of people who would be highly influential

in his development as a downtown personality. And while he hated being considered a graffiti writer (in fact, he construed references to his work as graffiti-based as racist), he befriended and supported a number of young graffiti artists, including Toxic and A-1.

The marketing of the graffiti movement is paradigmatic of the commodification of young artists during the seventies and eighties—and in some ways presaged Basquiat's roller-coaster career.

Graffiti is arguably as old as cave paintings. Its existence in public rest rooms and on mass transit is a timeless part of the urban landscape. As early as the nineteenth century, graffiti was being considered in an aesthetic and historical light. The Victorians parsed prison graffiti for examples of innate criminality while praising its unconscious genius; by the early 1900s, a number of artists were self-consciously incorporating it into their work—from Apollinaire to Dubuffet's textured scratchings. The appropriation by the intellectual elite of what could be thought of as the automatic writing of the vox populi is a time-honored artistic tradition.

But in the early to middle seventies, when acrylic paints in spray cans were widely available, there was an explosion of graffiti in New York and Los Angeles. In New York, the movement began with ubiquitous sightings of the scrawl "Taki 183," and soon hijacked whole subway cars. These were not the random jottings of individuals, but the coordinated efforts of an entire subculture. The art form was so omnipresent that Normal Mailer wrote a whole book about it in 1974, called *The Faith of Graffiti*. Armies of the night illustrators attacked the mass transit system, transforming it into a large-scale comic strip of colorful characters and logos. The writers signed their works with tags.

The primarily Brooklyn- and Bronx-based gangs responsible for much of the work had hierarchical systems; artists apprenticed with graffiti masters until they had earned enough experience to sign their own tags. The movement was fiercely territorial, with different writers claiming different subway lines as their own turf.

It wasn't long before this outpouring of work on the exterior of public spaces was labeled and brought inside. The first gallery show of graffiti was the United Graffiti Artists show at New York Artists'

Space in 1975, with a catalogue essay by critic Peter Schjeldahl. Fashion Moda, founded by Austrian artist Stefan Eins in a South Bronx storefront in 1978, "as an international cultural concept," eventually became one of the hubs of the graffiti movement.

The art collective gave local graffiti artists a center and also some new venues: city-approved murals. Mayor Koch had mounted an aggressive $6.5 million campaign to expunge graffiti from subways, and writers were constantly dodging transit cops. "They erased history," says Lee Quinones, who was famous for his candy-colored creations signed with the tag Zorro. "It was one of the most hideous art crimes of the decade." Indeed, the city's hard line on graffiti would culminate in tragedy: the death of black graffiti artist Michael Stewart when he was beaten by police during his 1983 arrest.

Originally, most of the graffiti writers, including the Fashion Moda kids, were not interested in SoHo; they were happy bombing trains and storefront security gates. "I'd be afraid to be in a big gallery where they would be trying to make money off me—those people don't even ride subways! My art's not for exclusive buyers. Artists in SoHo get paid to produce more and more of the same stuff . . . I prefer to control the level of what's happening, so it will be slower," Futura 2000 said at one point.

In 1980, Fab 5 Freddy wittily heralded the crossover from the transit system to the art system when he spray-painted an homage to Warhol—huge Campbell's soup cans on the IRT. Said Fab 5, who took his name from the Lexington Avenue No. 5 train, "If you painted on the IRT it was like, 'Yo, he's bad,' you know. That was where some of the best graffiti writers went." "That line established itself in the mid-1970s to be like the Museum of Modern Art, the rolling MoMA," says Quinones.

Graffiti made the cover of *The Village Voice* in 1980. But its watershed occurred in June of that year: Colab (an artists' collective which had been founded in 1977 by some hungry East Village artists to help them get grants) and Fashion Moda combined forces to produce the Times Square Show, which officially introduced graffiti to the art world.

The show, jammed into a former massage parlor, included everything from sex toys to punk art to graffiti. The run-down building in the porno district was the perfect place for the raucous, in-your-face

art. The birth of the eighties art movement could not have found a more appropriate crèche for its unimmaculate conception.

"I went to the Times Square Show every day," Jeffrey Deitch told the authors of *New, Used & Improved*. "If you trace the history of art in the 80's you will find that the show was responsible for bringing all the elements together. It mixed graffiti artists, feminist political artists and all kinds of new people like Keith Haring and Kenny Scharf who weren't part of the group. It literally forged the uptown-downtown union that has been responsible for many of the most interesting developments in art today." Writing in *Art in America*, he called the show an "art funhouse," and singled out Basquiat's contribution, "a knock-out combination of de Kooning and subway spray paint scribbles."

Other forces were also converging to bring graffiti aboveground. Fab 5 Freddy curated a show in the fourth-floor gallery of the Mudd Club, called *Beyond Words*, in April 1981. It included the "graffiti-based-rooted-inspired" works of Lady Pink, Dondi, Futura 2000, Fab 5, Phase II, Rammellzee, Zephyr, Daze, Crash, and SAMO (the only tag with a copyright). Fab 5 invited underground movie star Patti Astor to the opening party—and told her about *Wild Style*, Charles Ahearn's film on graffiti which was just going into production.

Released in 1983, *Wild Style* starred, in addition to Fab 5, the graffiti masters Lee Quinones, Crash, Futura 2000, Daze, and Lady Pink. Astor played an uncharacteristically naive reporter checking out the scene. The film also documented the other hip-hop art forms—break dancing and rap music, which were quickly picked up on by white New Wave clubgoers. ("Graffito" literally means scratch, the term used for the sampling technique deejays use in hip-hop and rap music.)

Soon after working on the film, Astor opened the Fun Gallery with partner Bill Stelling. It was the first gallery in the East Village, and it quickly became a showcase for graffiti art. Says Ahearn, "I think the graffiti movement and the downtown movement were like two electrical charges that created lightning bolts. There were these indigenous street artists and then there were these middle-class artists who were looking to get out of the art system. They didn't know much about each other, and when they connected it created a tremendous amount of energy."

Graffiti began showing up everywhere: As a backdrop for a per-
formance by Twyla Tharp. In a full-page advertising spread in *New
York* magazine. On record covers. On T-shirts. In Absolut ads. Art
mavens Dolores and Hubert Neumann were among the first to plug
into the movement's radical chic. They collected the art and culti-
vated the artists. In June 1983, Dolores Neumann organized a sym-
posium at the Sidney Janis Gallery; it was packed with collectors,
dealers, and graffiti writers, who quickly covered a thirty-six-foot
blank canvas with spray-painted work as gallerygoers gawked.

The event was so successful that Janis asked Neumann to curate
a show that December. The post-graffiti show included work by two
dozen of the hot subway bombers like Daze and Crash, as well as by
Keith Haring, Kenny Scharf, and Basquiat. Basquiat's contribution
was a painting called "Esophagus," which included several heads, as
well as some anatomical and scientific references.

Not everyone was impressed. Kim Levin savaged the post-graffiti
artists in a review, calling Basquiat's work "tame." Wrote critic Arthur
Danto, "Daze and Crash, for all the vividness of their imagery and
the phosphorescence of their coloration, are pretty feeble . . . Their
trouble is knowing too little and knowing how to do too little. They
need the benefits of a good art school. Energy alone can only carry
you so far."

Both events were videotaped by Art/New York. "Some of the
artists came and asked me to sell their work, which I did without a
commission," explained Neumann to video interviewer Marc Miller.
"A workshop developed as a result, and the continuation of the de-
velopment of their art partly took place in our home, which was quite
exciting." "Graffiti is not just a style," said Lady Pink. "It's an entire
underground culture." Added Janis, "They made the transition from
subway surfaces to surfaces on canvas. They were arrested for one,
now they are getting paid for doing the other."

Dealer Tony Shafrazi was also on hand. Shafrazi was a graffiti vet-
eran; in 1974, he had made headlines when he spray-painted Picasso's
"Guernica" with the foot-high, dripping-red words "Kill Lies All." Al-
though he told the guard he was an artist, he was ejected from MoMA.
Not surprisingly, his SoHo gallery was one of the first to show graffiti
art. Jamming a "Radiant Baby" painter's cap on his head, he smoothly

explained that the art "contributes a new gesture, a new way of expressing a sign."

The rap sound track to the video included the lyrics "The art we do visualize an abstract image that we all despise. Graffiti rock the house ... graffiti shock the house ... graffiti is what it be about." Listening closely, one could hear the various tags intoned: "Hey Jean-Michel, you're doing swell, we hear you got real clientele ..."

Galleries in Europe jumped on the graffiti train, flying the artists over for parties, openings, and one-man shows. But there's a difference between being patronized and having an art patron. "I didn't need a mother. I can set my own alarm clock and get up in the morning. They like to think that they shaped the work," said Daze of the Neumanns. "But they didn't really." Despite their fidelity to the work (they were still collecting it in 1987), some of the artists felt the Neumanns acted like social workers.

Says Toxic, a graffiti artist who later spent a lot of time with Basquiat, "It's kind of fucked, because you take a seventeen-year-old kid who had no money—I'm talking like whatever money we had was from selling weed or acid. And you give him like seventy-five thousand dollars, with no one to help administer it or anything like that. I crashed up BMW's, I flew girls all over, like to Paris for a week, I went to Disneyland every weekend. I think we lived a second childhood with a lot of money and nobody to tell you what to do. Everybody was just like yes-men."

Toxic hung out at the Neumanns', and even went out with their daughter Belinda for a while. "We couldn't figure out why this lady would have fourteen motherfuckers from the Bronx hanging out in her crib at any given time, with these three daughters running around in these little Catholic school skirts. Dolores is cool. She did it because she loved graffiti. But she is so naive. Naive and a millionaire."

Robert Hughes poked fun at the whole debacle in a 1984 epic satirical poem published in *The New York Review of Books*:

> As Disco-Owners turn to Connoisseurs;
> Historians to the urinous subway fly
> To scribble theses on "The Spraying Eye";
> From Kutztown and the Bronx graffitists throng

To find, though Art is short, Reviews are long;
Our purblind *Virtuosi* now embrace
Keith Boring and Jean-Michel Basketcase.
The spray-cans hiss, the ghetto-blaster shrieks,
Above the din, Dolores Gruesome speaks:
". . . My *Noble Savages*, on sneakered feet,
Flock to the doors of Fifty-seventh Street;
The infant dauber, who Mayor Koch appalls,
Now sprays on *Belgian Flax* instead of walls;
The matrons twitter and the Cash-Bell rings,
I serve Hawaiian Punch and Chicken-Wings. . . ."

But graffiti was no sooner inflated by Fifty-seventh Street than its "bubble" letters burst. Early promoters were among the first to get bored with the movement. In 1983, Shafrazi had trumpeted, "The new artists are the heirs to the continuing tradition of rebellion, play and adventure which is art. They are the champions."

Shafrazi still shows work by Haring, Scharf, and Basquiat. But it's been years since he's hung a canvas signed with a tag on his gallery walls. "Real graffiti is done by kids eleven to fourteen in public places," Shafrazi told *Village Voice* writer Elizabeth Hess in 1987. "Some of the artists incorporated graffiti images into their work the same way environmental artists used dirt . . . I have no interest in it."

Only two years earlier, Shafrazi had mounted a one-man show of work by Futura 2000. "We broke ground under the name of graffiti, and then we were relegated to the back car," Futura told the *Voice*. Inner-city kids who had been wined and dined and limo'd all over town were left high and dry. They were still considered radical, but they were no longer considered chic.

Critic Suzi Gablik wrote about the exploitation of the graffiti movement in her 1984 book, *Has Modernism Failed?*: "Are we confronted with yet another instance where mass-consumption capitalist economy expands into a taboo area in order to transform private behavior into a commodity? Does becoming part of the art establishment give new meaning and purpose to these artists' lives, or has it merely spawned another money-making game for its participants, while weakening graffiti's soul energy as 'outsider' art?"

Gablik talked to a number of graffiti artists, including Futura 2000, Keith Haring, and Fab 5 Freddy. "A lot of people who approach us think we're not really hip to their game. I'm not motivated to sit on my ass for the rest of my life and be somebody else's race-horse," Fab 5 said. "What I do is motivated by other things than being an art star." But Basquiat preferred not to talk about graffiti at all. "People are getting credit now for graffiti as if it were something new, but they're really fifth or tenth string," he told her.

Video interviewer Marc Miller asked the artist about SAMO. "That was a really, really long time ago . . . with some friends from high school. We used to just drink Ballantine ale all the time and write stuff on the walls, and throw bottles . . . just teenage stuff . . . There was no ambition in it at all." Miller asked Basquiat to recite some SAMO sayings. He refused. "It would be too embarrassing to bring it up now. It was like stuff from, you know, a young mind." "Coming from the graffiti side, . . ." Miller continued, "you must know . . ." Basquiat interrupted him. "All those people? I know some other ones coming from the academic side too."

Basquiat was more open in his interview with Davis and Johnston. "It was sort of like a product that I did with Al Diaz. I was about sixteen or so, seventeen." "Did you know that you were going to stop doing stuff on walls and start painting on canvas . . . did you have any idea that you wanted to hit the gallery circuit?" "No, I was more interested in attacking the gallery circuit at that time. I just thought about making fun of the paintings that were in there more than about making paintings. The art world was mostly Minimal when I came up. I thought it alienated people from art. It seemed very college . . . That talk about graffiti is endless. I don't really consider myself a graffiti artist, you know? And then they have this image of me [as a] wild man, a wild, monkey man, whatever the fuck they thought . . ."

Basquiat's first show at the Annina Nosei Gallery would include a printed page of the text that appeared in his "poem drawings." The list included a number of SAMO sayings. "Plush safe . . . he think." "Pay for soup. Build a Fort. Set that on Fire." "The whole livery line bow like this with big money all crushed into these feet."

"Let's go back to the postpunk lower Manhattan no-wave New York . . . and hip-hop's train-writing graffiti cults pull into the station

carrying the return of representation, figuration, expressionism, pop-artism, the investment in canvas painting, and the idea of the master-piece," wrote critic Greg Tate in a *Village Voice* piece eulogizing the artist. "Whether the writers presaged or inspired the market forces to all this art commodity fetishism and anti-Conceptualist material is a question still up for grabs. But just as the classic blues, rock and soul cats were the romanticized figures who made the very idea of a Hendrix seductive to the mods, it was the invigorating folk culture of the graffiti writers—operating at a subterranean remove from the art world—that made them all the more mysterious, manageable and ultimately dismissable and set the salon stages and sex parlors of the postmods up to be bedazzled by Basquiat."

Not surprisingly, graffiti's commercial promoters were primarily white. And Basquiat's African-American supporters, including Greg Tate, became bedazzled by the painter only after his death: during his life he got little or no black support.

"I think the two similarities that Jean and graffiti in general had in common was that people wanted to harness a wild animal," says Quinones. "They couldn't control him, and they couldn't control graffiti. The art world was bland and they wanted something on their walls. Jean-Michel's work is very anti-artworld, you know. It's almost like a curse. And people still love that. They love being cursed at."

NEW YORK BEAT

The capital of the downtown scene was a hip dive called the Mudd Club. Located at 77 White Street, just a few blocks below Canal, the club was an instant incubator for the about-to-be-famous—from Klaus Nomi to Lydia Lunch, from David Byrne to Kathy Acker. It was started by a character named Steve Mass, who envisioned himself as a kind of radical Renaissance man, in October 1978.

After studying creative writing at the University of Iowa in the sixties, Mass came to New York, where he started an independent publishing company. He also got involved with the underground filmmaker Jack Smith. By the seventies, he had retrenched to his family's business—an ambulance and medical-supply service that provided him with a sizable income but little artistic outlet. Mass was casting about for a new idea—some sort of cultural venture. He got together with filmmaker Amos Poe (whose 1977 film *The Blank Generation* documents the early punk movement in the East Village), art curator Diego Cortez, and singer Anya Phillips.

After some misadventures (first Mass, Cortez, and Phillips went off to Memphis to make a film about Elvis), the Mudd Club, modeled after a club Cortez had seen in Chicago, emerged in a loft building owned by artist Ross Bleckner. Cortez lied and told him it would be a quiet cabaret, then got Brian Eno to design the sound system. "It was supposed to be the antithesis of Studio 54," says Mass. "All I had was fifteen thousand dollars to start it. It was the lowest-budget nightclub in history. It's named after a famous persecuted individual, Samuel Alex[ander] Mudd, the doctor who treated John Wilkes Booth after he shot Lincoln," he says, half joking. "The club was deliber-

ately subversive. This was the underground downtown art and rock version of 54," said Cortez. "It was a phenomenon."

That was an understatement. People were soon lining up to get into the dark, loud Tribeca cavern. There was nothing extraordinary about the space itself; its only permanent decoration was a series of airplane maps plastered on its narrow bar and a series of TV sets hung above it. What was extraordinary was the energy generated by cramming a standing-room-only crowd of punk-rockers, performance artists, painters, designers, dilettantes, and uptown and bridge-and-tunnel tourists into a several-story loft space. The fun-house atmosphere was boosted by theme nights, live performances (the B-52's did their first concert at the Mudd Club), drugs, and sex in the gender-free bathrooms. Mass quickly spotted an obvious trend: he turned the fourth floor into a rotating gallery, becoming the first of the art-in-club showcases.

Eventually, a door policy was established—a steel chain instead of Studio 54's famous velvet rope; the most outrageous characters were given preference, guaranteeing that the club's clientele would be eye-popping. Celebrities like David Bowie, Brian Eno, Iggy Pop, and Sid Vicious started hanging out. And, of course, Warhol. "New York's fly-by-night crowd of punks, posers and the ultrahip has discovered new turf on which to flaunt its manic chic. It is the Mudd Club, a dingy disco lost among the warehouses of lower Manhattan . . . For sheer kinkiness, there has been nothing like it since the cabaret scene in 1920's Berlin," gushed *People* magazine six months after it opened.

The Mudd Club was a major fashion statement. Women took to re-creating B-movie stars: bouffant blond hair, heavy makeup, serious décolletage. Even the ordinary dress code was funky-glamorous. "Skinny ties, fifties-type jeans, black spandex, lots of makeup. Sunglasses were the ultimate accessory," recalled Mudd Club regular Stanley Moss. "Every night was a theme. It was like dress-up. Cowboy Night, Arab Night, Beach Night, Drag Night. But I think it was the music that brought people together more than anything else. It was kind of the clarion call."

Recalls actor Vincent Gallo, a friend who played with Basquiat's band, Gray, "If you had an unusual physical presence or dressing

style, or unusual hours, or any kind of subversive behavior, you could have an identity for two or three hours a night. The rest of the day you'd have to live like a vampire hiding from the light. The people who came together in the place didn't do it because they were looking for a kick. They did it because it was the only place they felt at home. The Mudd Club was a universe that had its own heroes and celebrities, its own important people and its own leaders." (Of course there were also Wall Street types looking for the latest scene.)

Anita Sarko was the deejay. Says Sarko, "People would be so freaked out by the music I was playing that they would throw bottles and ashtrays. I'd always be ducking for cover, until they built me a Plexiglas booth. The first people who caught on to me was this group of kids—Jean and Michael Holman and Vincent Gallo. They understood what I was doing."

Basquiat and his gang were among the younger set at the club. They'd dance in a territorial circle, like a teenage tribe. "We'd go to the Mudd Club and dance all night long," recalls Nancy Brody, an early friend.

But even in a roomful of outrageous characters, Basquiat stood out. He would lurk in the back of the cramped space, dancing by himself. In the sweaty darkness, with its relentless pulse of punked-out people, the women vamping like fifties sitcom housewives or glammed out in thrift-store black, the men buttoned into too-small suits, he was a star. His blond Mohawk started midway toward the back of his skull, and his head darted in and out like a serpent's. He held his arms close to his sides, jerking rhythmically to the music. "He looked like a *Tyrannosaurus rex*," said Michael Holman, who played with Basquiat in Gray.

His frenetic energy, idiosyncratic choreography, and weird hairstyle made him a favorite with the club regulars and with Sarko. "His group would come in at three a.m. I started mixing the new electronic music coming out of England with old funk. Being a very good dancer, Jean caught on right away." One night, Basquiat and Haring covered the deejay booth with intricate drawings. Apparently Mass did not appreciate the gratis artwork; he had it scrubbed off the next day.

At the time, Basquiat found bed and board wherever he could. "I was living from place to place," he told Davis and Johnston. "I used

to live from money I found on the Mudd Club floor. I used to hold a ladder of an electrician sometimes, as a part-time job." He would show up for "caveman dinners" of steak and potatoes that Stanley Moss threw every week for his starving downtown friends. Basquiat tried to set up a tab at One University Place, the restaurant where Julian Schnabel cooked. It was run by legendary Max's Kansas City founder Mickey Ruskin, who often bartered with artists. But Ruskin wasn't interested.

Sometimes Basquiat worked for Chris Sedlmayr, who owned a construction company called Clamp Down, which later built some of Gray's sets. "He would always show up for the SoHo gigs," says Sedlmayr. Sedlmayr, a frustrated artist himself, admonished Basquiat about the harsh realities of the art world. He recalls one occasion when he was lighting a Schnabel show at the Mary Boone Gallery, and Basquiat was helping adjust the tracks. "Schnabel came in in a mink coat, and custom-made pigskin orange shoes. Just two days before, he had been washing dishes. I was this bitter thirty-two-year-old sculptor, and I tried to give Jean a sense of a real work ethic."

Basquiat used to spend time at Sedlmayr's loft, hanging out with his twelve-year-old son, Theo. Says Theo, "He copied my drawings. My crowns, cars, airplanes, and houses became part of his work." Sedlmayr senior, who regularly worked for the Leo Castelli Gallery, was horrified to discover that Basquiat had scribbled graffiti on a rolled-up Warhol "Mao." "He wanted contact with Andy in the worst way," he says.

Throughout this time, Basquiat was hawking his paint-splattered T-shirts, sweatshirts, and postcards on West Broadway. He wrote enigmatic words similar to his street poetry on the clothing; the postcards were small collages that were layered with Xeroxes of drawings and photographs and included his trademark word games. Basquiat had abandoned his Peter Max–like doodles and was making artifacts that owed an obvious debt to Robert Rauschenberg. From early on, his subject matter derived from contemporary popular culture—from baseball teams to the Kennedy assassination. In one postcard, he made an anagram out of the PEZ logo.

His ambition was self-evident. One day, he finally worked up the nerve to approach Warhol when he was eating lunch with Henry

Geldzahler at a restaurant called WPA. Warhol showed a postcard to Geldzahler. "Too young," said the cultural commissioner. Warhol bought it anyway. (It would take several more years for Basquiat to find his way into the Factory.)

Cortez, who became one of the artist's earliest supporters, noticed Basquiat at the Mudd Club immediately. "I remember being on the dance floor and seeing this black kid with a blond Mohawk. He had nothing to do with black culture. He was this Kraftwerkian techno-creature, sort of a caricature of the future. He wore this long green trench coat and jeans. Here was this nineteen-year-old kid from a middle-class background who looked like a Bowery bum and a fashion model at the same time. He never had a place to sleep or any money. He told me the SAMO graffiti things were his. I was surprised. I told him, 'Stop asking people for money. If you want to make money, start doing paintings and drawings.'"

Nick Taylor remembers the first night he spotted Basquiat, dancing his strange "bugged-out" robotic dance all by himself back near the stage. "We went to Dave's luncheonette. We hung out with this older guy who was an art teacher of mine, and Jean showed him these Xerox collage postcards and baseball cards he was making. Jean was explaining all these theories about tearing down the gallery system. He wanted to start a guerrilla group called Art Corps. His idea was to go over to 420 West Broadway and throw buckets of paint over the front of the building.

"Every night we'd go to the Mudd Club and stay until ten a.m. in the morning and then go to sleep," says Taylor. They'd have breakfast at Dave's or the Kiev, where Basquiat had a tab. A few years later, Basquiat would paint a portrait of Joey, the short-order cook at Dave's; in the funny, lyrical "Eyes and Eggs" (1983), a black cook in a chef's hat is holding a frying pan with two fried eggs in it; the whites of his eyes match the egg whites.

Basquiat was obsessively carrying around the William Burroughs book *Junky*. When he didn't get picked up by girls, he would hustle, or crash wherever he could. He stayed with Maripol, a jewelry designer known for her work with Madonna, and her boyfriend, photographer and director Edo Bertoglio, in their loft on Bleecker Street and Broadway. Maripol remembers him glued to the window one

night, watching a car crash on the street below; he had just finished painting a similar scene.

For about six months in late 1979, he lived with Alexis Adler, another club kid, in a railroad apartment at 527 East Twelfth Street, between Avenues A and B. "He was just a very wild kid," says Adler. "He stayed in the back room. We had no furniture, and this was like his gallery. He was starting to bring people around to look at his work. Diego Cortez came here and saw his stuff. He was always very serious about it, even if other people just thought he was scrawling on walls. He'd bring in old TV's from the street, and boxes and briefcases, and just make them into pieces of art, you know. They were really interesting and some were just exceptional," she recalls.

Adler also remembers Basquiat's constant creative energy. "I would wake up in the morning, and there'd be like a new section of the floor painted, or the room totally rearranged, or a new piece of artwork, like a baseball mitt (appropriated from Basquiat's friend John Lurie) attached to a box. He would walk around in a bathrobe he found on the street, and he always carried around a little red cassette player." His favorite records, which he would play all night long, were David Bowie's "Low" and "Heroes."

They would get by on eggs and grits. "He just relied on other people to sort of take care of him," says Adler. "He always knew that he had something, and that was his drive. I mean he just had this spark. It was in his eyes. You meet a person like that very rarely."

Adler was studying art history and organic chemistry, and Basquiat derived some of his early symbols from her books. Adler saved an early notebook, as well as a number of poems Basquiat wrote at the time. "It had a lot of those symbols he was working on, chemical formulas, organic compounds, and stuff like that that he found in my science books."

Basquiat left a drawing of a car, and the words "Famous Negro Athletes" on the door in the apartment. (It was still there in the early nineties, despite the many offers Adler had received to sell it.) Adler kept some of Basquiat's "manmade" T-shirts, sweatshirts, and lab suits, scrawled with various words: "Mao, Olive Oyl, Milk, Radiator."

Basquiat's guardian angels were not always women. For a while, Basquiat stayed with Wayne Clifford on Fifty-ninth Street and Seventh

Avenue. Clifford lived with an older gay friend, and he and Basquiat occasionally made money as male hustlers. One time, Clifford recalls, Basquiat played a prank by calling the suicide hotline, then amused himself by speaking in cryptic phrases, naming colors, making up nonsense. Clifford taped him on a continous loop—they both considered it a bit of performance art.

According to several friends, Basquiat also stayed with a man named Tony in Chelsea. Tony bought him pastels. "He was a nice, gentle guy," says Ken Cybulska. "I don't think they were sleeping together." But Al Diaz recalls, "Jean was staying with this guy over on Nineteenth Street, near the Joyce Theater. Every once in a while he would disappear. When he showed up with new shoes, I knew he had been hustling. One time he told me he was messing around with someone who worked at the Eighth Street Playhouse. They had a master-slave relationship and Jean would walk him around on a leash. He told me he enjoyed sex more with men."

Basquiat also stayed with Arlene Schloss, whose loft on Broome Street served as a performance art space and club, called A's. "Jean-Michel basically opened the place by playing with his band, Gray. I remember he played in his pajamas," says Schloss, who recalls Basquiat using A's as a studio. "He made a lot of stuff here, painting T-shirts on the floor."

Gray, which defined itself as an art-noise band, consisted of Basquiat and a couple of other Mudd Club regulars, Taylor, Vincent Gallo, Michael Holman, and Clifford. Basquiat came up with the name, possibly derived from *Gray's Anatomy*.

Gray was soon getting regular gigs at the Mudd Club. Jean-Michel was the leader; he played bell and synthesizer, or clarinet, or sometimes just raked a comb across a guitar. Holman played drums, and Taylor played guitar. Shannon Dawson played trumpet. Sometimes a girl named Felice Rossen played bass. "We started this school of style we called 'ignorance,' " explained Holman. "Nick and Jean and me and Wayne, we were all about this concept of controlled naïveté. It was like, 'Boom! Ignorant!' It was ignorance as an aesthetic. We would do these raw, wrong things that somehow worked. I think Jean's painting was a great example of 'ignorance.' "

Basquiat wrote some of the lyrics to the band's weird assortment

of songs, which sounded like industrial music, not unlike today's technopop. "He would read a few things from *Gray's Anatomy*, like Brains and Hands. That's what Jackie Onassis was saying. 'His brains were in my hands,' " explains Holman. Basquiat named their repertoire: "La Dopa," "Industrial Mind," "Origin of Cotton," "Popeye," "Braille Teeth," "Six Months," "The Rent," "Drum Mode." Another song was called "Mona Lisa." "Jean would lie on the floor, and he would just read this poem," said Holman. "It was kind of based on the song by Nat King Cole."

Many of the titles of these songs, including "Origin of Cotton" and "Mona Lisa," later became the basis of paintings. Gray played at the Mudd Club, ABC No Rio, Hurrahs, the Rock Lounge, and Tier Three, and at some of the other clubs that were opening up in the wake of the Mudd Club. They even played at Leo Castelli's birthday party.

At one point, the band built an elaborate set at the Mudd Club out of scaffolding mounted on the metal security gate that acted as a stage curtain. Each band member was strapped in at a different level. "We were playing this repetitive dirge stuff, and the gate comes down with all the band members in it, and I remember looking out into the audience. Everyone was in a state of shock!" says Holman.

When Basquiat wasn't holding court at the Mudd Club, he was hanging out at Club 57, in the basement of a Polish church on St. Mark's Place. Club 57 was managed by performer Ann Magnuson. While the Mudd Club prided itself on its downtown, deadpan cool, 57 was like a kitsch nursery school. Scharf and Haring staged hilarious black-light parties there. Magnuson started a movie series called Monster Movie Night. Performance artists John Sex and Klaus Nomi— a sort of operatic angel-robot—were regulars.

"They were the cools," says Scharf of the Mudd Club. "And we were the groovies. The cool Mudd Club people were on heroin, while we were on mushrooms. They'd just pose and dangle their cigarettes and lean against the wall. But we'd be up there on stage making fools of ourselves."

"Our primary god was television," says Magnuson. "I could have made a million dollars off the graffiti on the men's room walls."

Basquiat hung out with Scharf, Sex, and Nomi, and for a short while was Nomi's lover. "Jean-Michel and Klaus liked each other.

Jean loved it when Klaus spoke German. But he gave Klaus gonorrhea four times. Klaus got pissed off when Jean wouldn't help pay for the medical bills," remembers Joey Arias, a singer/drag performer who was a good friend of Nomi's and is the executor of his estate. A few years later, Nomi became the first downtown celebrity to die of AIDS.

In the summer of 1979, a British entrepreneur named Stan Peskett, who was trying to start an ongoing art collective called Canal Zone, invited a group of graffiti artists to paint some huge canvases in his loft. He and Shafrazi had both gotten funding from the Shah of Iran to invest in the New York underground art scene.

One of the first people he met on the scene was graffiti artist Fab 5 Freddy, who was energetically trying to promote himself. Freddy had arranged a story with *The New York Times*, which agreed to shoot a graffiti-painting session at Peskett's loft at 533 Canal. Although the *Times* piece never ran, and the loft later burned down, the party brought together a number of downtown characters: Freddy, Quinones, Holman, and Basquiat, who was invited by Jennifer Stein, a girlfriend who lived in the building.

"Jean-Michel was wearing this T-shirt that said 'Gumby Is Bad!' " recalls Peskett. "He did this big fifteen-foot multiple-choice piece with questions about Lee Harvey Oswald and Coca-Cola. Nobody knew who SAMO was until he signed it. He and Jennifer were making these baseball cards that they sold outside the Metropolitan Museum."

"We would be very abusive," recalls Stein. "We would stand outside the museum and yell things about art and freedom. We would make about fifteen dollars a day. Our main goal was to get food. I thought Jean-Michel was the most dangerous person I have ever met in my life. He was completely unique, wild and brave. He wore a painted coat and played a toy sax. He told me he had been a male prostitute in the West Village. He and Al Diaz used to sleep in abandoned buildings. For a while he was living on Avenue D." For a few months, Basquiat lived with Stein at 533 West Broadway.

"He and Jennifer hung out a lot, smoking pot," recalls Quinones. Quinones, Basquiat, and Fab 5 collaborated on some plastic backdrops for Unique Clothing Warehouse, a huge punk general store on lower Broadway. "I would do some cartoony imagery and then Jean would come in and explode it with commentary, poems, and stuff."

Basquiat also worked making T-shirts at Unique Clothing Warehouse, until he got fed up with the low wages and quit, throwing a handful of his xeroxed postcards into the air like confetti.

Basquiat hoped to hook up with Fiorucci, the uptown answer to Unique. The idea was that he would sit in a Plexiglas booth on the floor of the boutique, painting T-shirts. But the Fiorucci connection self-destructed after Basquiat dragged a wet painting into the store to show Maripol, who was Fiorucci's art director. Julie Wilson was with him.

"We took mushrooms and hung out on St. Mark's Place for a while, where the painting got run over by a bus," she says. "Then we got on the train at rush hour with this painting that had this thick wet glop on it. It was wall-to-wall people and Jean-Michel was holding it up in the air, and it was getting on everyone's clothes. Somehow, we got off at Fifty-ninth Street, and we go up to the offices at Fiorucci, and Jean leans the painting up against the wall. We were feeling more and more stoned and watching all these people walk by in their million dollar outfits. And this woman brushes by in a big fur coat and takes half the painting with her!" Maripol rushed Basquiat out before he could cause a further ruckus. "Jean-Michel was in a total daze," says Wilson. "But he said, 'Oh, fuck them, I don't need them anyway.' " Typically, Basquiat's high jinks had sabotaged a potential business relationship.

One morning, Basquiat appeared on Arden Scott's doorstep. "He showed up at six a.m., bringing coffee and croissants," she recalls. "He wanted to talk. He was obviously at a turning point in his career. Things were starting to take off. He had so much coke with him. It was as if he had to get high to make this decision. He knew that if he made it, he would become rich and famous. But it was not a healthy sign for the future that he had to do dope and tremendous amount of alcohol. The drugs were definitely his ally for going ahead with it. It couldn't have been easy."

The Times Square Show, which took place that June, gave Basquiat his biggest boost since the early days of SAMO. The show, widely considered an art-world turning point, placed him at ground zero in what was quickly recognized as a new art movement.

Wrote Peter Frank and Michael McKenzie in *New, Used & Improved,* "Given the art world's perpetual hunger for something new and raw, the Times Square Show hit like a dose of free-based cocaine." Basquiat's work, which he was still signing SAMO, covered an entire wall in the decrepit building at Forty-first Street and Seventh Avenue, and was an instant hit with both the public and critics.

By now, Basquiat had become a minor celebrity in the small, incestuous downtown world. He appeared regularly on Glenn O'Brien's weird live public-access cable show, *TV Party.* A sort of proto–David Letterman show (according to O'Brien the talk show host would later call it an influence), it lived up to its name. It was basically an on-air party that featured all of O'Brien's cronies.

Viewers would call in and pepper Basquiat with questions about SAMO. "Hey, how did you finally get Buckwheat on the show? I thought he was dead. Are you going to get Spanky and Alfalfa too?" asked one caller, much to Basquiat's delight. "Yeah, we're making a comeback." He laughs. But the smile freezes on his face when the caller suddenly adds, "Let me ask you a question—didn't you snatch my chain last week on the subway?"

Meanwhile, Maripol had been talking to Fiorucci about making a film about the underground art scene, and O'Brien had written a script. Eventually, they managed to get $350,000 from Rizzoli. They began shooting in December 1980. The film was called *New York Beat* and Basquiat was the star. He didn't even have to audition to get the leading role; playing himself. A starving artist, he wakes up in a hospital, is released, gets evicted from his apartment, and receives a kiss from an angel, played by New Wave star Deborah Harry, the lead singer of Blondie.

The movie, which was directed by Bertoglio and featured a number of downtown musicians, including Tuxedo Moon, Kid Creole and the Coconuts, and the Contortions, was never completed. But Basquiat took up residence in the production offices above the Great Jones Cafe. Directly across the street from the loft he would occupy when he was rich and famous, it gave him, at least temporarily, a room of his own.

LOWER EAST SIDE
GLAMOR QUEENS

"Into the laps
of black celebrities
white girls fall
like pale plums from a tree
beyond a high tension wall
wired for killing
which makes it
more thrilling."

—Langston Hughes, "Mellow"

Although *New York Beat* was never released, Basquiat's life at this point would have made a perfect downtown movie, an edgier version of Susan Seidelman's film *Desperately Seeking Susan*; it had the same characters, the same look, the same locations, the same sensibility. The very fact that he had been chosen to star in the film was an indication of his visibility. Besides being a known entity on the club circuit, Basquiat was developing a reputation for being quite a lady's man. It was during this time that Basquiat and Madonna, both ambitious young artists on the scene, became lovers.

"I got into nightclubs before I was even a painter," he told Anthony Haden-Guest. "Because I was the omnipresent kid, you know." Women, he said, had always liked him; "I don't know why. I was just a cute kid."

By now, Basquiat's blond Mohawk was gone, and he was wearing his hair in various forms of dreadlocks. "He could of been in the Hair

Hall of Fame," says Brody, who remembers Basquiat dressed in a green parachute suit accessorized with a tiny red tape recorder when she first met him.

About five feet, ten inches tall, Basquiat had been a runner as a teenager, and he had an athlete's grace. His charisma and sex appeal were magnets for women of all ages. Basquiat was aware of this power, and his confidence often bordered on cockiness, but he never seemed to feel completely comfortable in his own skin.

His self-conscious shuffle, like his occasional stammer, was a protective device that helped insulate him from the attention he craved but could not always withstand. He enjoyed portraying himself as a bum—not just as a comment on the racism he often felt, but as an homage to the Beat movement. Like a lot of young artists, he idolized Jack Kerouac. But Basquiat's identification with bums went somewhat deeper; even at the peak of his success, he felt disenfranchised. And he eagerly disowned his family. When people asked about his background, he would pretend he was a street urchin, and friends were often surprised when they learned that his father was a middle-class accountant.

"The first time I met his father, with a tennis racket in a business suit, I was shocked," says Vincent Gallo. "Jean had this identity of a poor ghetto urchin who really aspired to kind of bourgeois things."

Basquiat resembled his father in more ways than he would have cared to admit. While Basquiat ridiculed his father's behavior, he emulated his choice of women. With the exception of one or two brief encounters, virtually all of Basquiat's lovers were white; indeed, a number of them were classic blondes. "I'd like to write a book about sleeping with all the glamor queens of the Lower East Side," he jokingly told one girlfriend.

Jean-Michel layered relationships the way he layered his paintings; spontaneously, with an idiosyncratic mix of instinct and verve. And like his paintings, they repeated obvious patterns and themes. Basquiat was unable to sustain an undivided focus; disruption seemed to be a constant compulsion.

His romances would begin obsessively, the artist in hot pursuit until he made his conquest, at which point he would drop the confused object of desire. Then, suddenly, he would attempt to rekin-

dle the relationship. The second acceptance—a kind of return of the prodigal boyfriend—was a double victory, and he sometimes continued a fling, on and off, for years.

These women seemed to accept that Basquiat was different—that the normal rules did not apply. Basquiat's perpetual fear of betrayal was self-fulfilling; he couldn't maintain a single emotional bond—whether it was to friends, lovers, or art dealers. Eventually, he would even turn on his mentor and the man he considered a surrogate father, Andy Warhol.

His relationship with Eszter Balint, a fourteen-year-old Hungarian actress, provides a typically picaresque *mise-en-scène*. It's perhaps a sign of the times that the twenty-year-old-artist's involvement with a minor was considered perfectly acceptable.

Balint, who lived with the Squat Theater troupe founded by her father, Stephan Balint, first met Basquiat in 1980. At the time, the theater, located on Twenty-third Street in a run-down storefront, was doubling as a club. A pretty and precocious brunette, who later starred with John Lurie in Jim Jarmusch's 1984 cult classic *Stranger Than Paradise*, Balint had just returned from a theater tour in Europe. When she walked into the theater that night, she was instantly swallowed up by a sweaty crowd that had gathered to watch a dance contest.

The three judges were Deborah Harry, Glenn O'Brien, and Anya Phillips, a member of the Contortions. The tiny space was jammed with people standing shoulder to shoulder; steam fogged the bow window that looked onto Twenty-third Street. The first prize was $50, a poster, and an autographed album by the Contortions. The early contestants were the usual club kids and punks, dancing in conventional couples. "Jean-Michel came out by himself," says Balint. "He danced this strange solo dance. He was by far the coolest, really original."

Basquiat's choreography—a combination of natural elegance and stylized, beboppish boogie-woogie—wowed the audience. But he was awarded second prize. As usual, Jean-Michel was penniless; he wanted money, not a signed album and a poster. When Phillips handed him the album, he had a temper tantrum. "I don't want this record, ma'am," he announced. Then he threw the record on the floor and

stamped all over it. Without another word, he strode out of the club. It was hard to say which performance was more impressive, his solo act or his acceptance speech.

Balint ran into him again when she became a regular at the Mudd Club, where Basquiat was performing with Gray. He seemed to be its artistic persona. Occasionally he just lay on the floor of the stage, playing whatever was near him, while the other members provided the background beat. "They were very experimental. Some of it was really good, some of it was just a come-on," says Balint.

"I was inspired by John Cage at the time," Basquiat would later tell *The New York Times*. "Music that isn't really music. We were trying to be incomplete, abrasive, oddly beautiful." He could have been talking about himself.

At the time, Balint had a crush on Basquiat's childhood friend Danny Rosen, who had a small part playing her boyfriend in *Stranger Than Paradise*. That didn't deter Basquiat. "He would literally follow me around," says Balint. "I'd be dancing with a circle of friends and he would just appear. He was really charming and beautiful."

Basquiat was still staying at Maripol's huge loft on the corner of Bleecker and Broadway. One night, he brought Eszter home. "I came in in the morning and they were so cute. They were in bed together, just giggling," says Maripol, who tried to lecture them on birth control.

When *New York Beat* resumed shooting in January 1981, Basquiat moved back into the production office above the restaurant, which was just around the corner from Robert Rauschenberg's studio. Every morning the crew would arrive to find Eszter and Jean-Michel still asleep in a tiny alcove at the back of the office. "He drew cars, buses, an ambulance above the bed in oil sticks," recalls Balint. Sometimes the pair would be woken up by John Lurie or Rosen, shouting Basquiat's nickname, "Willie Mays."

Balint acted in one scene of *New York Beat*, a fashion show, which was filmed in the Rock Lounge. Basquiat wanted her to be the girl with whom he drove away into the sunset, but Deborah Harry gave the star his final screen kiss. Not long afterwards, Basquiat appeared as a graffiti artist in the Blondie video "Rapture."

Balint was totally infatuated with Basquiat. "You could look into

his eyes and see a thousand miles of history," she says. "There was so much mystery in him. He was so deep."

They spent their nights hanging out in clubs. They ate breakfast at Bini-Bon, the cozy hole-in-the-wall on Fifth Street and Second Avenue that became famous when Jack Henry Abbott satisfied the rage in the belly of the beast by stabbing Richard Adan, a young actor who was working there as a waiter. They also went to 103, a twenty-four-hour coffee shop with tables built on a disorienting diagonal. It, like the Kiev, was a regular stop for people straggling out of the clubs and after-hours joints.

On other nights, they would go to Bowlmor on University Place, which every week had a retro night. The bowling alley would be transformed into a scene from *Leave It to Beaver* or *Donna Reed*, with the downtown crowd dressed like the stars of their favorite childhood TV shows. The Roxy, which had been converted from its earlier incarnation as one of the seventies' hottest roller-skating rinks, was another destination.

They'd end up wherever Basquiat was crashing. Sometimes he'd stay in Balint's bedroom at Squat Theater, which did not provide much privacy. Basquiat seemed to be focusing on Balint exclusively. But just when they were getting close enough for her to begin thinking he was her boyfriend, he informed her that in fact there was someone else—a young woman named Suzanne Mallouk.

"I have to go into the bathroom with you and tell you something," he told Balint, one night at the Mudd Club. Given the couple's itinerant lifestyle, it must have seemed like an appropriate place for a private revelation. "I've met this woman, and I have to be with her," he confessed. Balint, by this time a worldly-wise fifteen, was heartbroken. But she told Basquiat she understood. "I was pretty upset. But he didn't have me out of his system. He came back for more. I began seeing him off and on. It was sort of delicate."

Especially when a tug-of-war erupted over Basquiat's affections. "I remember the first time that he called me after we broke up. He told me he and his girlfriend, Suzanne, had had a fight. She was very aggressive and obsessive and wouldn't let go." One morning, Mallouk even came over to Squat Theater and demanded to be let in. "They had a showdown. She said 'I love you, and I know you love

me.' " Mallouk actually insisted in getting into bed with Basquiat, ignoring Balint's presence. "She had a lot of power in the relationship," says Balint. "He always ended up by going back to Suzanne."

Balint continued to be friends and occasionally lovers with Basquiat, but they were never again as close. Balint woke up one morning after spending the night with Basquiat to find Madonna in the loft. She had dropped by to pick up some of her things. "I stayed in the bedroom," says Balint. "It was sort of a soap opera. He loved to have one woman discover him in bed with another woman."

Like most of his girlfriends, Balint remembers Basquiat lovingly. "I think he was a genius. There was so much more to him than what was on the surface. You wanted to find out and understand. It sounds corny, but there was something really special about him. He was so straight from the heart. Everything he did was spontaneous, there was no premeditation—sometimes that could be painful. He was not tactful, and some things he did were downright offensive. He had a lot of personal demons having to do with his childhood and parents. He was not a well-balanced, happy guy. But the word 'charisma' was invented for him. He was part of an exceptional period. But what he was doing transcended what a lot of people were doing. He took it to a further level."

Basquiat first met Suzanne Mallouk, with whom he had one of the two major romantic relationships of his life, in early 1980. He quickly became obsessed with the tall, half-Palestinian woman with the white skin, jet-black hair, and green eyes who was tending bar at a dive called Night Birds. She was an aspiring singer; her performing name was Ruby Desire.

Mallouk was born in Toronto, Canada. Her parents had emigrated from Palestine in the forties. In some ways, her childhood eerily echoed Basquiat's. Her mother claimed to be a witch, actually casting spells on her enemies. According to Mallouk, her father's Middle Eastern background influenced his "child-rearing philosophy, which was based on respect gained through fear." That, she says, could include corporal punishment. As she got older, Mallouk felt increasingly uncomfortable in his presence.

Like Basquiat, Mallouk left home at fifteen. "I had a choice to go

to a Catholic girls' school and live there or go to this art high school, so of course I chose that." After she had an abortion, she returned home for a brief, depressed interlude. Then she entered her punk phase, shaving her head, doing speed, and working as a dishwasher. She became obsessed with a poet whose book she had seen advertised in a magazine—by coincidence, the poet was Rene Ricard, the critic who would initiate Basquiat and Keith Haring into the art world with his *Artforum* magazine article, "The Radiant Child."

At eighteen, Mallouk took her dishwashing savings, sold her belongings, and hopped on a plane to New York City, arriving on Valentine's Day, 1980. She lived in hotels for transients, including the Martha Washington, and got a job waitressing during the day at Max's Kansas City. At night she worked at a "sleazy, sleazy bar called Night Birds." It was there that Basquiat first saw her and was instantly smitten, although they didn't immediately become involved.

"I was only about nineteen, and he would come in and stare at me," says Mallouk. "I thought he was a bum. I was scared of him." Basquiat wouldn't even buy a drink. He only interrupted his silent adoration to occasionally feed a quarter into the jukebox. "It went on for anywhere from three to six months," she says. "He would come in every day. I would just ignore him." One day, he was discussing the exotic bartender with Debbi Mazar, the makeup artist on *New York Beat*. (Mazar has since become a well-known actress.) It turned out the two women were friends, and Basquiat asked for a formal introduction.

It was a slow courtship, given the dizzying speed of most downtown encounters. Every night he would walk Mallouk home from work. One night he came up to her place for tea. "He had no place to live and we had become friends. He told me he slept in the park. So I let him move into my apartment as a roommate. He didn't pay rent. He was totally broke. I would say, 'You've got to get a job, help me out here,' and he would say, 'I'm gonna be a famous artist!' And I would laugh at him. And he would get paint all over my floor. He was a total mess, worse than a child, crayons everywhere."

At first, she says, the two were just roommates. "Jean-Michel would sleep on pillows on the floor. I was totally in love with him, but I was really shy and terrified of sex and wouldn't sleep with him,"

says Mallouk. "Sometimes he would get aggressive with me, and I would start to cry, and he would stop. He had nowhere else to go and I thought he was just using me, so we would get into terrible fights and I would tell him to leave and he wouldn't."

Meanwhile Basquiat was drawing incessantly, and Diego Cortez was acquiring as many drawings as he could. "Jean-Michel was not that organized. There were drawings all over the floor, and Diego would come by regularly and take them, so I started keeping a book and would make Diego sign so we knew what he was taking," says Mallouk.

Fed up, Mallouk fled to Canada. At first, Basquiat refused to leave the apartment. "He was very depressed, and all he had with him was this little tin car filled with crayons, and a little radio. That's all he owned in the world," says Mallouk. "So he just put those two things in the room, and lay on the pillows and stayed there sleeping for about a week, crying." (Old Tin, the name of a company that made the antique toys he would later collect, became a reference in his paintings.)

The tone of the relationship had been set: Suzanne as the gorgeous victim and Jean-Michel as the brilliant, childlike bum. "I couldn't get rid of him. I loved him, but I thought he was freeloading," says Mallouk. "So I moved out. I sublet the place to another painter, Stephen Lack [an actor who starred in David Cronenberg's *Scanners*]. But Jean-Michel wouldn't leave. He stayed with Stephen until his wife moved in, and then he started crashing in all different places."

Recalls Lack, "There was an old car drawn in dirt on the window of the apartment. Eventually Suzanne degenerated into an artistic fish-wife. We gave her about fifty paintings Jean had left at the apartment, and we saved the refrigerator he had painted. They were her legacy."

No sooner had Mallouk left town than Basquiat began a mini-relationship with a fellow artist named Patti Anne Blau. A self-described nice Jewish girl from Long Island, Blau was studying at Parsons. She initially met Jean-Michel through her friend Allison Ross, who she says was going out with Wayne Clifford. The four of them would cruise the clubs in Ross's beat-up yellow Nova. Basquiat gave Blau his phone number, which changed about once a week, so

she could call him and tell him when she had pot. She had visited him at the *New York Beat* production office on Great Jones Street.

Basquiat flirted with Blau, but she kept her distance from the wild young artist. "I'd say, 'Listen, I'm not going out with any black guys.' I was scared." But the more she refused him, the more ardently Basquiat pursued her. "I'd come home at night from a party, and he would be sitting outside my house on the steps. I thought he was very attractive, and that was all the more reason to say no."

Cortez, who was organizing a show at an alternative space called P.S. 1, invited both Blau and Basquiat to meet him at his loft. Once Blau saw Basquiat's work, she was more receptive to his advances. "Somehow that elevated him from the club scene," she says. "I remember the first time I slept with him, it was after Keith Haring's New Year's Eve party at the Mudd Club. I was with Allison and we went to like a hundred parties that didn't work out and we ended up at the Mudd Club. And Jean-Michel just walked up to me and stuck his tongue in my mouth, and then we left."

They ended up at the loft of Jeff Bretschneider, a drug dealer who ran a sort of round-the-clock salon, where they bumped into a group of friends, including Leisa Stroud, John Lurie, and Arto Lindsay. "We did some drugs and we left. And I remember going back to Jean's house with him, when he lived on Third Street, between First and Avenue A. It turned into an incredible sex marathon. I stayed with him for like three days."

They barely left the apartment. One night they took a limousine to see the movie *Reds*. "He was a really hyper guy. He used to wake up in the middle of the night and think people were taking his money," she recalls.

But the romantic interlude with Blau had its own interlude. Between New Year's and the New York/New Wave Show in February 1981, Jean-Michel went to the Caribbean with another girlfriend. "I was really upset," says Blau. "When he got back he called me and told me he had a terrible time and he thought about me constantly. He said I should meet him at Gallo Nero, on West Broadway. And that he wanted to be my boyfriend."

Before the big rendezvous, Blau went to Astor Place and got a short, punk haircut. An hour later, she met Basquiat. But when she

took off her scarf, he told her she looked like G.I. Joe. "Wait a month until my hair grows back," she told him. But by the time her hair grew in, Suzanne was back in the picture; Basquiat had traveled to Toronto to bring her back to New York.

"He was totally self-involved," says Blau. "To be Jean-Michel's girlfriend you had to have no personality, no needs, nothing. Serve him. He was like a whirlwind. If you were what he wanted in his whirlwind, it was fine."

Meanwhile, Basquiat was living off money he borrowed from Glenn O'Brien and Maripol. The artist had once done his art in the street; now he found his art supplies there—cardboard, foam rubber, and discarded lumber. "The first things I made were windows I found on the street," he told Tamra Davis. "I used the window shape for a frame, and the painting was on the glass part." He also painted on doors. "And then when I first made some money, I went and bought some canvas."

NEW YORK/NEW WAVE/NEW CAREER

I n the next few months, Basquiat's outrageous claim to future fame began to pan out, thanks primarily to Diego Cortez, who was busily creating a niche for himself as an independent art dealer and curator. Like everyone else, Cortez had invented a new hip identity; his real name was James (Jim) Curtis. In a typical eighties irony, rumor had it that he was the guard who had ejected Tony Shafrazi from the Museum of Modern Art after he vandalized Picasso's "Guernica"; the apocryphal tale had first been published in a profile of Cortez in *File* magazine. In fact, Cortez did work as a security guard protecting "Guernica," but not at the time of Shafrazi's notorious act.

Cortez had grown up in a lower-middle-class family in Wheaton, Illinois, a tony suburb of Chicago. A former campaigner for Barry Goldwater, Cortez turned radical—and came out of the closet—when he attended Wheaton College, where he founded the second Gay Liberation Front and got a degree in film. When he graduated, he began doing performance art work in a mostly Spanish neighborhood, and adopted a Hispanic name. "It had a lot to do with social and political content. Racial issues have always been a strong thing to me."

After graduate school at the University of Chicago, where he was part of a circle including artists Vito Acconci, Nam June Paik, and Dennis Oppenheim, he moved to New York in 1973. Like many of the other movers and shakers in the downtown scene of the time, Cortez migrated into the art world from independent film. One of the founders of Colab, Cortez was intimately involved with the art-in-public-spaces movement, and helped come up with the list of artists first shown in the Times Square Show.

Says colleague and friend Alanna Heiss, "Diego was groping for a new role. He wanted to manipulate and control people's talents. It's all about borrowed power. I call it the Diaghilev Problem and I see Diego as a prime example of it."

Now Cortez was planning another seminal show: he wanted to put the whole downtown cultural scene on display. He decided to include the Basquiat canvases he had been hoarding, along with the new work on salvaged materials, in the big show he was curating at P.S. 1.

P.S. 1 was the jewel in the crown of the alternative space movement that evolved out of the SoHo-loft video/performance/installation art scene of the 1970s and straddled the gap between galleries and museums by showing art in public, government-funded spaces. Founder and director Alanna Heiss was one of the prime movers behind the funky new alternative spaces that had opened up in offbeat, vacant buildings all over New York. She had originally conceived of the alternative space as a kind of perpetually itinerant venue for art. "Having worked in museums, I wanted to avoid the kind of efforts that went into maintaining these huge buildings or structures in New York. There were so many different kinds of real estate available."

Operating out of her "office," the phone booth at CBGB's, in 1972, she eventually organized the Institute for Urban Resources, which included several unique spaces, such as the Clocktower, to exhibit the "parallel world that was starting to build up around the punk scene." P.S. 1 was the largest of these spaces. "What I wanted to do was to create an art center/museum that would deal with some of the things I was seeing in the clubs. My other choice was to open my own nightclub," says Heiss.

P.S. 1 opened in an abandoned elementary school in Long Island City, Queens, in 1976, with a critically acclaimed installation show, *Rooms*, in which 100 artists were each given a room to transform into a work of art. By the time that Cortez (who among his other jobs had been selected by postal-clerks-turned-art-mavens Herbert and Dorothy Vogel to guard their collection when it was shown at the Clocktower) organized the New York/New Wave show, in February 1981, P.S. 1 had become the Whitney of alternative spaces.

"New York/New Wave was the most excessively crazy and successful show we had ever organized," says Heiss. Thousands of people

trekked out to Long Island City the day after Valentine's Day, 1981. There were lines to get into the four-story Victorian building. The buzz was out: this was it, the new art movement, the stuff that was going to replace the Minimalism that had, like an invasion of body snatchers, plagued SoHo for the last several years, filling the galleries with podlike conceptual jokes: series of boxes, empty canvases, forms without content but with plenty of concept. The crowds surged through the several floors of the rambling building as if it were a New Wave Mecca. It felt more like an East Village block party than the opening of an art show.

Kay Larson wasn't impressed. "No one seems too clear what constitutes punk art," she wrote in *New York* magazine. "Is it truly a style, or just the lookalike product of a bunch of young music lovers with safety pins in the earlobes . . . this fevered exhibition looks less like an explanation than an advertisement for a Club Med–Mudd Club party." Wrote John Perreault, of the *SoHo News*, with a certain amount of prescience, "In some sense, the show is in celebration of celebrity, about pose and about clothes . . . is the imagery a mockery of celebrity, a send up? It's probably a little bit of both: instant fame and a criticism of such."

Cortez had gathered material straight out of the helter-skelter of the downtown scene, a circus-kitsch assortment of 1,600 works by 119 artists. "I wanted to document this period when there was such a crossover between art and music." He summed the aesthetic up in a single word: "Neo-Pop."

"I think people were expecting an introduction to New Expressionism, but the show wasn't about painting at all," said Cortez, who was prominently billed in the poster. One thing was eminently clear: this was to art what punk was to music. Self-consciously in-your-face fun, anarchy without ideals, the work without work.

There were documentary photographs of CBGB's, the Mudd Club, and Club 57. There was work by some of the better-known musicians: Chris Stein, Alan Vega, and David Byrne, who contributed some large photographs. What galvanized everyone's attention, though, were the huge murals by a dozen graffiti artists: Lee Quinones, Fab 5 Freddy, Daze, Rammellzee, Futura 2000. Cortez had hung some enamelized

sheet metal up in the gym area for the graffiti artists to work on. They were doing their tags and collaborating on a portrait of Debbie Harry.

Basquiat had been singled out from his peers. "Jean had come in before everyone else and kind of freaked out on a piece of metal, and he also had made a thematic sign for the New York/New Wave show. The works were halfway between his SAMO stuff and images that were kind of smeared, and everything was very violent and frenetic," says painter Brett De Palma, who also had work in the show. "And then Diego decided to feature him in his own room."

Basquiat's work was the sensation of the show. He had painted fifteen pieces on canvas, found lumber, and foam rubber; raw, child-like renderings of cars and cartoony characters and oddly literate nonsense words.

One painting featured half a dozen simple masklike heads. A beige drawing with one large head, several cars, and the repeated word "Aaron" showed definite Twombly influences. There was a vertical, layered cityscape. A white-on-black painting of a car included the admonition "Plush Safe, He Think," a statement Basquiat had formally scrawled on walls. "He was the only one I thought so fantastic that he had to have paintings on canvas," said Cortez.

"I walked over to try to talk to Jean," says Quinones, who was working with Jean and the other graffiti artists. "But he was just so engulfed in his work, and he was walking all over it. The only participation he wanted from the other artists was for them to walk all over it also."

Basquiat had his own method of collaboration. When everyone left, he went around the space labeling the work of each artist in his unmistakable scrawl, as if appropriating an entire movement. "That really impressed me," says Nick Taylor. "Everybody saw that show and Jean's work and after that night it was never the same."

To complete the portrait of an ambitious young artist, Basquiat proudly stuck a photograph of himself up near his work. "It was like 'This is my work and this is me,' " says Taylor.

"I remember standing in front of Jean-Michel's work with the director of Philip Morris," says Heiss. "We were paralyzed. It was so obvious that he was enormously talented. I realized when I saw it

what Leo [Castelli] had said to me about discovering Jasper Johns, that anybody can see these things. It doesn't take a genius. You have to be practically blind not to see it. Jean-Michel was the person in all the huge number of artists who stood out. I hadn't seen anything like it for ten years. And given that he was being shown in a space where Robert Ryman had shown, it placed him in an art-historical context for the first time."

Painter Sandro Chia fell in love with one piece and offered Cortez $1,000. He was outbid by Christophe de Menil, who paid $2,500. But the P.S. 1 show did more than earn Basquiat some money; it earned him recognition. The young artist had been discovered.

Village Voice critic Peter Schjeldahl asked Basquiat if he had ever heard of Dubuffet. Jean-Michel replied with an arch no, although chances are he had. "I would not have suspected from SAMO's generally grotty defacements of my neighborhood the graphic and painterly talents revealed here," wrote Schjeldahl, who called Basquiat "the most impressive individual in the show after Mapplethorpe . . . He has flair, humor and an almost automatic abstract elegance. What he will make of it all remains to be seen. I'd be sad but not terribly surprised if he never painted again."

Henry Geldzahler, who had not seen the artist since he was hawking postcards on West Broadway, came out to P.S. 1 and "just flipped out." Soon afterwards, Geldzahler resigned as Cultural Commissioner so he could devote himself full-time to tracking Clemente, Schnabel, Haring, Basquiat, and the other emerging art stars. "Think of me with Ed Koch and his antigraffiti program walking around with Keith Haring and Jean-Michel on my shoulders," said Geldzahler of his latest aesthetic discovery.

Geldzahler asked Cortez to introduce him to the artist. He went to look at Basquiat's work at 101 Canal Street, one of the places he had crashed, and bought a half a refrigerator door collage for $2,000. "I deliberately overpaid him. I wanted him to trust the world a bit. The same day I bought the painting, I took him to an art store and bought him a hundred dollars' worth of paper. At that point he didn't even know what acid-free paper was."

Chia was so impressed with the work that he told Annina Nosei about it. She immediately bought a painting, and she soon began

courting Jean-Michel. "It had no title and it wasn't even stretched," says Liz Gold, an assistant at Nosei's gallery. "But she said that Basquiat was an artist she was really excited about."

"I'd seen his work before, but it was the P.S. 1 show that convinced me," Nosei said. Emilio Mazzoli and Swiss art dealer Bruno Bischofberger also saw the work. Mazzoli expressed an interest in giving Basquiat a show at his gallery in Italy. Says Bischofberger, "After the New York/New Wave show, I went to Diego's apartment and bought about thirty drawings and twenty-five paintings." A year or so later, Bischofberger would give Basquiat a show in Zurich and become Basquiat's international dealer.

"After the P.S. 1 show," says Michael Holman, "that was it. Jean was on his way, and we were like discarded baggage. We felt bad, because Gray wasn't going to be the same without him."

Recalls Jennifer Stein, who hadn't seen Basquiat much since the Canal Zone days, "I couldn't believe how beautiful his work at the show was. He seemed really excited, like the man with the golden arm."

Jean-Michel basked in the attention, alternating between shyness and an unabashed appetite for celebrity. "He just wanted to know if Warhol was going to come to the show and buy everything," says De Palma. "That was his dream from the beginning." But he and Suzanne also hid under a table a lot of the time and amused themselves by watching people's feet, according to Fab 5 Freddy.

"Jean couldn't even afford materials back then. And he was just crashing at people's houses, and leaving drawings in exchange for staying there," says De Palma. In fact, many of Basquiat's pieces were on loan from Stanley Moss, a Mudd Club regular who had lent Jean-Michel money for materials and had bought a few of his early primitive sketches. Even in his early days, Basquiat was quick to forget beneficiaries. Later he called Moss up and told him that the works were still the property of the artist.

But Basquiat tried to share a bit of the wealth. After Geldzahler bought the refrigerator door, Jean-Michel asked his friend Kai Eric to organize a celebratory meal for a few friends. "We went to John's Restaurant on Twelfth Street. And we had the whole back room with one long table. Arto Lindsay was there, Glenn O'Brien, Steve Lack, Suzanne Mallouk, and Tina Lhotsky," says Eric. "He had taken tar

paper and chalk, and done maybe twenty-five little drawings for everyone, and he just tore them off and handed them to each person. He gave me this little ambulance."

"Jean felt really guilty about becoming successful when all his artist friends were poor and struggling," recalls Lhotsky. "He sat at the head of a table of about twenty people and Diego was passing around Jean's new Walkman. He had a Grace Jones tape in it, 'Pull Up to the Bumper, Baby.' Jean looked a bit uncomfortable with his brand-new success. But soon afterwards, he started painting little crowns on his work."

Basquiat had barely started making conventional art, but he was already being tapped by an international gang of art dealers. At City-As-School, the adults had been extremely supportive. But in the trenches of the downtown art world, it was a totally different story. The new authority figures in Basquiat's life clearly had their own agenda. And from the start, Basquiat seemed to repeat a pattern with his dealers. First he would establish a surrogate-parent relationship, then he would destroy it.

Says Geldzahler, who at one point received a letter from Gerard Basquiat thanking him for his interest in Jean-Michel, "Everything in Jean-Michel's life was a recap of his relationship with his father, about not being accepted. The dealer-artist relationship is like that between parents and children, and not just for baby artists, for all artists."

From the instant he set eyes on the young artist at the Mudd Club, Diego Cortez had recognized Basquiat's potential—both artistic and commercial. In a sense, Cortez was his first de facto dealer. Ever since the New York, New/Wave show in February, Cortez had been bringing collectors and critics over to the loft he shared with Massimo Audiello on Thirty-sixth Street to look at his ever-growing stash of Basquiat scribblings. Jeffrey Deitch and Henry Geldzahler had both already bought works from him.

Now Emilio Mazzoli, a wealthy Italian gallery owner, was looking at the stacks of drawings and canvases that Jean-Michel had left with Cortez. Mazzoli was well known in Europe for his intimate association with the Transavantgarde art movement. The term, coined by a

friend of his, critic Achille Bonita Oliva, was exemplified by the three lucrative C's, Francesco Clemente, Enzo Cucchi, and Sandro Chia, the European Neo-Expressionists. It was Chia who had first brought Basquiat to Mazzoli's attention.

At this point, Basquiat's work was rather minimal, and he was still signing his paintings with the tag SAMO. Mazzoli found the graffiti-like art fascinating, quintessentially American. He bought $10,000 worth of work on the spot, and arranged with Cortez to give the artist his first solo show that May in Modena.

Jean-Michel had never been to Europe. Cortez went with him to Rockefeller Center to get a passport, his only official document. At twenty, Basquiat, the eternal child, did not have a driver's license, a Social Security number, or any credit cards. But he already had an attitude, and his outrageous looks and equally outrageous behavior caused international havoc.

The trip to Modena was in many ways a prototype of Basquiat's future travels: it involved large amounts of cash, equally large supplies of drugs, uruly visits to the local nightspots, and the requisite frenetic art production, under the gimlet eye of whichever dealer had arranged a show.

The maiden voyage began inauspiciously. When Cortez, Audiello, and their young protégé landed in Italy, Jean-Michel was carrying the entire show under his arms. "There were these Carabinieri looking at us very strangely," says Audiello. "This black kid with a Rasta hairdo carrying all this stuff."

Recalls Cortez, "It was like tubes of drawings and paintings rolled up, and the customs officials didn't know what to make of it. Should they let this material in? Tax it? They kept Jean-Michel separated from us. He was probably stoned, and he was tired and had been up for days. And the customs guys just gave him a really hard time."

Cortez, Audiello, and Basquiat met Mazzoli for dinner in Modena. But after that first night, they were given complete responsibility for Basquiat. "He was always looking for pot," says Cortez. "He always wanted to get stoned, and stay out late, and find clubs and stuff, and Modena is like a nowhere place. Jean-Michel was drawing all the time, so Mazzoli was buying him as much paper and canvas as he

could give him to make more and more work. And then he bought all the drawings. Not all of them were good. So I told him to edit more and he got into cutting up his drawings and making collages."

"The whole thing was a culture shock for Jean-Michel," says Audiello. "He defended himself by withdrawing into technology and drugs. He just listened to American music on his Walkman all the time, and went around taking these funny Polaroids."

At one point, Audiello found himself holed up with Basquiat in the hotel. The artist was tripping on acid. "The LSD made him very charming and sweet. He bought as much junk food as he could swallow, chewing gum, bags of chocolate. And he had the TV on all the time, and of course he didn't understand a word of it. He had paper and pencils and charcoal and ink. I was looking out this big window onto the highway, with cars roaring by. Everything was hazy in this yellow fog. The view was famous from Bertolucci's film *1900*. I felt sick. That site was historical, it was this glorious revolutionary past. And there was no trace of it anywhere. I was horrified by the emptiness. Then I looked at what Jean-Michel was drawing. He was making barbed wire, and cannons, and plows, which the workmen of the time used as weapons, since they had no guns."

Basquiat wanted all his appetites satisfied immediately, and he soon developed an obsession for a frumpy blond whore. "He really wanted a prostitute," says Massimo. "And he decided it had to be this woman. She wasn't even pretty. She was old, a mother, nothing like the trendy types he hung around with in downtown New York. But he just kept saying, 'La puttana! La puttana!' He wanted her so badly. Five minutes after he arrived in Modena, Jean-Michel knew where to get anything he wanted."

Basquiat spent time in the gallery, painting more pictures. His companion was a small, nearly blind child. "They were very sweet together," says Audiello. "I kept thinking, these are the last pictures this kid, who might have been nine or ten, might ever see. He spent all his time at Jean-Michel's side."

The paintings Basquiat did were all on very large canvases, nearly 80 by 82 inches; perhaps Mazzoli wanted more for his money. In one, a red man, arm raised in a threat or plea, is shown on a beige background on which are sketched an airplane, an ambulance, and

several cars. It's signed "SAMO, 81." In another, more abstract paint-
ing, a skelly court, a frequent image at this time, floats against a dull
green background. This time, the car crash is nearly obliterated by
an orange scrawl. In an even larger painting, about 79 by 111 inches,
the crown, an airplane, and a house marked S, another favorite im-
age, dominate one side of the canvas, while a white-on-black skelly
court anchors the other.

"Jean-Michel couldn't wait to leave Modena. All he wanted was
money. Full-time money, and more money," says Massimo. When he
got back to New York, Basquiat gave his friend Brett De Palma a re-
port of Modena's cultural hot spots. "Like the main club there is
Snoopy's Joint, man, that's their idea of hip you know." "He was al-
ways measuring hipness," says De Palma. "Because he was so natu-
rally hip. So he went and hung out, and played the video games and
took drugs, and bombed the town with his tags, drawing those little
cars. I saw them when I went. He told me he would just take acid in
his hotel room, and draw from the TV set the whole time. His whole
defense was this aloofness. To completely go off into his own world, to
protect himself."

De Palma, who showed in Modena a week or two after Basquiat,
understood the young artist's frustration. "Immediately you got to this
studio and they start throwing materials at you. And if you don't
do the work they throw at you, you are not going to be invited back,
and there are thousands of people in line behind you. I think I made
eight thousand dollars for the paintings I did, and he was better-
known than I was and only made four thousand. That's racist."

Still, Basquiat celebrated his new-found wealth in style. "You're
not going to believe this," he boasted to Patti Astor on his return to
New York. "I just made thirty thousand dollars!" "We sat in the
bushes outside Club 57," recalls Astor. "It was the night of Keith
Haring's black-light show, one of those super-sicko affairs. We were
pretending he was the King of Egypt, which is not surprising since
we were both tripping on mushrooms."

After his first one-man show in Modena, Suzanne Mallouk was tem-
porarily out of the picture again. But Basquiat never lacked for
female companionship, and his next conquest was Tina Lhotsky, the

self-styled Queen of the Mudd Club. He called her "Big Pink," a nickname that originated with two black men, who saw her sauntering down the street in a pink, polka-dotted sixties dress. Their relationship began in the late summer of 1981.

Lhotsky, a big, plush blonde who looked like an East Village version of Jessica Rabbit, was an underground filmmaker and actress. She arrived in New York in 1974, from Cleveland, on her way to art school in Nova Scotia. Like many of her peers, she fantasized about making it as an artist—any kind of artist—in New York.

"I confess I wanted to be a painter, but then I thought I'd become a tissue-paper artist. And then I decided to get into film and video. I was filmmaking for a while, and then I got into being a multimedia-scene person," she says.

Lhotsky was part of the first wave of artists to move into the East Village in the seventies, and she got involved with the Mudd Club at its inception. Like many downtown characters, she reinvented herself as a larger-than-life persona, a sort of archetypal B-movie bombshell and lethally overgrown Lolita.

She was also the Mudd Club's unofficial den mother, who put her stamp on the scene by organizing various theme nights—from a Joan Crawford Mother's Day Celebration to a morbidly ironic salute to dead rock stars, complete with $10,000 worth of props, including an organ and real funeral caskets. She even had herself crowned "Queen" at a special ceremony at Saint John's Cathedral.

"The downtown scene was an escape fantasy for neophyte kids," she says. "The city was dirty and ugly, so we all dressed up in these costumes. I was like the Queen of the Scene in those days. That was my full-time job."

Like many East Village relationships, Lhotsky's first encounter with Basquiat occurred on the street. "I was walking down the Bowery in full regalia, in operatic makeup with my Dynel blond ponytail attached to my punked-out bouffant do. Jean-Michel was carrying a huge bag of McDonald's hamburgers. He saw me, and caught my eye, and said, 'You want some?' It was his way of flirting. This was before he had made it and started wearing his hard, people-proof mask." But he seemed too young and innocent, and Big Pink rejected his advance.

One night, after an art opening that had, typically, turned into

a twenty-four-hour party, a whole gang of downtown regulars was hanging out in the kitchen of Basquiat's friend Mary-Ann Monforton, mercilessly ridiculing a writer from the *East Village Eye*, the paper that chronicled their scene.

Eventually everyone except Basquiat, Lhotsky, and Patti Astor (an even more glamorous bombshell than Tina) had left. Basquiat and Monforton were occasional lovers (in fact, he had given her and several others gonorrhea). No one was sure where he planned to sleep that night.

"Patti was waiting for Jean-Michel to make his move," says Lhotsky. "I think they had been sleeping together a little. Jean-Michel had to decide which one of the two belles he wanted to go with. He said he was going to walk me home, and Patti left."

Lhotsky, who almost always dressed as if she were attending a masquerade, was wearing a "big old Civil War style dress." She and Basquiat decided to take a stroll in what passed for a garden in the East Village, a fenced-off plot belonging to the Men's Shelter. Somehow, the two got locked in.

"Jean-Michel freaked," recalls Lhotsky. "The fence was about fifty feet high." They tried scaling it, but they were interrupted by the police, who trained their searchlights on a young black kid with dreadlocks and a buxom blonde in a vintage dress.

"Is he bothering you?" asked the cops. "He's my date," Lhotsky answered. "Then I pleaded with them in a whiny little voice. But they gave Jean-Michel a really hard time. He was pissed that I told them that I was with him. He said that was a dumb thing to say because they were racist."

Safe at Lhotsky's, they made grilled cheese sandwiches and climbed into Lhotsky's tiny cast-iron hospital bed covered with leopard-print sheets. "He was dark, and soft and passionate. He really got into making love. It was hard not to get hooked on him."

Basquiat had several rather noticeable scars—one that ran from his chest to his groin, from the operation to remove his spleen after his childhood car accident, and a smaller one, on his buttock. "He showed me that scar and told me that his father had stabbed him there," says Lhotsky. "He told me his father had tried to kill him."

But Basquiat quickly changed the subject. A little while later, he

disappeared. When he came back, he began drawing on the floor, which had been painted silver. "Jean-Michel used all the crayons, pencils, and paints in my house," recalls Lhotsky. "Right before he left, he scribbled a little penis on the underside of my Mammy Doll toaster cover."

The affair with Lhotsky would continue for several years. Not too long after it began, Mallouk and Lhotsky ran into each other at the Gem Spa newsstand on Astor Place. "She was wearing a beautiful blue scarf that I bought in Paris. I hadn't been able to find it for weeks, and I really missed it," says Lhotsky. "So I blurted out, 'That's my scarf!' 'Oh, I found it lying around Jean-Michel's house,' she said. Then she squinted her eyes and said, 'It's mine now. Rules of the game,' and walked away."

According to Lhotsky, Jean-Michel's meanderings didn't really affect his deep feelings for Suzanne. "Jean-Michel loved Suzanne and talked about her to me, and even asked my advice about her, but he betrayed her daily," says Lhotsky. "Every once in a while, Suzanne would break up with him, and Jean-Michel would grab his heart and say, 'Oh, I just had a love attack for Suzanne, and it hurts.' "

In the summer of 1982, Lhotsky returned from a visit to New Orleans and visited Basquiat at his Crosby Street loft. "Someone had given him a voodoo shrine and when I saw it I laughed, because my gift to him was a piece of chalk from Marie Lavau's grave. She was the Voodoo Queen. I felt he needed protection."

That same day, Lhotsky gave Basquiat a tarot card reading. "I said, 'Jean-Michel, if you don't change, something really serious is going to happen to you when you are twenty-six or twenty-seven.' It was accurate. But I don't think he was listening to me."

Meanwhile, another courtship was in the works: Annina Nosei had used the summer to seal her relationship with Basquiat. Cortez ran into the dealer in Berlin, where she interrogated him about the painter. By September, when Cortez returned to New York from Europe, Annina had given money to Jean-Michel for art supplies, promised him a show, and suggested he use the basement of her gallery as a studio. She told the artist she would find him a place to live and charge the rent against the sales of his paintings, the

first of many rather unorthodox arrangements in the artist's short career.

Basquiat's new art dealer was steeped in European art history. The daughter of a classics professor, Nosei was born in Rome. She studied at the University of Rome, where she received degrees in literature and philosophy. She wrote her thesis on Marcel Duchamp. Soon after she graduated in the early sixties, she began working for Ileana Sonnabend, then the leading dealer in Europe representing American Pop art. "For anyone who wanted to see the latest from America in the sixties, there was no place in the whole of Europe like the gallery of Ileana Sonnabend," said Nosei. In 1964, she received a Fulbright Fellowship and moved to America, where she taught at the University of Michigan in Ann Arbor.

Nosei's interest gravitated to the avant-garde and she began traveling with John Cage and his performance group, and "participating in happenings." She was offered a job at UCLA. Through Robert Rauschenberg, she met art dealer John Weber and they were married in 1967. In Los Angeles, Nosei was exposed to the best of the Minimalist artists, from Dan Flavin to Carl Andre. She was one of the first dealers in America to show Mimmo Paladino, Sandro Chia, and Francesco Clemente.

In October 1979, she opened a gallery in SoHo, and began showing the work of David Salle, Donald Newman, and Richard Prince. "My taste is difficult and extreme. I always advise collectors to buy works of art that demonstrate extreme fantasy and extreme sensibility," Nosei said in an interview published in *The Art Dealers* by Alan Jones and Laura de Coppet.

Nosei quickly targeted her "intellectual collectors" as an audience for Jean-Michel Basquiat's work. "At the time, I was putting together major sales to important collectors who were buying, for example, the Germans. I told them that they should have a work by Jean-Michel also, for $1,000 or $1,500 more on the bill of $25,000 they had already run up. This worked quite well: these collectors gained an early commitment, told their friends, and all of a sudden, Basquiat's paintings were found in collections beside more well-known artists, as the youngest of all." In a way, Basquiat was Nosei's "readymade" art star.

Nosei was an interesting combination of elegance and thrift, academic erudition and aggressive art hustling. As volatile as many of her artists, she was one of the first dealers to recognize the new painting movement and one of the least able to profit from it in the long run. Her association with Basquiat would prove to be a defining moment for both of them.

Now that she had forged a business relationship with Basquiat, Nosei was as good as her word. One of the first things she did was make a deposit for the room in the Martha Washington Hotel on East Twenty-third Street, where Basquiat had been living for the last few months with Suzanne. Shortly afterwards, in September 1981, the two moved to Nick Taylor's apartment at 39 East First Street, right across from the apartment they had once shared at number 68.

Suzanne, as usual, tried to institute some sort of domestic stability. But at times Basquiat demonstrated a real macho streak. "He would say, 'Go to your room, Suzanne,' " says Taylor. " 'Nick and I want to have a drink.' " And he continued to see a variety of other women.

Basquiat had rekindled his relationship with Patti Anne Blau, wooing her with fried chicken one day when she was visiting Edit DeAk, a downtown critic and curator who had discovered a number of young artists. Basquiat liked to flaunt his love of soul food as a form of self-parody; an "Out for Ribs" sign on his door would later become a trademark.

"He tried to have sex with me in the back of her loft," she recalls. "He told me he really missed me, and he wanted to have an affair. He said his girlfriend Suzanne was back, and he was living with her, but she was just his maid. I said 'What's in it for me?' And he said, 'Pleasure.' "

Blau's loft on Eleventh Street soon became a weekend retreat. "He would come over on Friday nights and he would bring like a ton of drugs, a big thing of pot, coke, lots of cash, pizza, wine, shopping bags. My house would be a mess in five minutes. Everything on the floor. He'd just get into the bed. I had all this space and paper and crayons and he used to just hang out and draw. We'd go to the movies, or he'd give me a hundred dollars and say, 'Go to Balducci's and get me some olives and keep the change.' "

"Everything he touched was some kind of art. He wrote down my phone number in different color crayons. He was a very big influence on my life. When you're an artist, you're a vessel for this intensity and you just live until you burn. He was kind of a demon."

Nobody knew about the relationship, and it provided a convenient escape for Basquiat. For two whole days, nobody could reach him to ask for money, drugs, or drawings. "He used to wear just an orange Batman sweatshirt, with his huge schlong hanging down, and paint," says Blau. One day Nosei somehow got the number of Blau's loft. "I told you never to call me here," Basquiat screamed into the phone.

"We did a lot of really fun things together. We use to go dance at the Reggae Lounge. One day we went with a coke dealer in a limo to make deliveries. I remember we drove across the Brooklyn Bridge, and I loved it, so Jean asked him to drive across it again."

Basquiat, though, was getting more and more edgy. One time, when they were headed down to Chinatown to get some pot, they had trouble getting a cab, and he began screaming. "It just wasn't fun to be with him anymore," says Blau.

The long-suffering Suzanne had had enough. "I was obsessed with him, and he was obsessed with me too. It was so sick." She fled to Paris, where she stayed with her sister for several months.

By September 1981, Basquiat had embarked on his ambitious career: he was officially esconced in a SoHo gallery. His notorious sojourn in Annina Nosei's basement had just begun. He was off to an accelerated start. Basquiat had always lusted for fame, but the speed of his ascent owed more to the excesses of the era than to his own obsessive drive. It was a decade when the rag-to-riches routine—from Wall Street to SoHo—could virtually be accomplished in a nanosecond, a period that was saturated with success stories, from Ivan Boesky and Michael Milken to Julian Schnabel and David Salle. Basquiat was a perfect child of the zeitgeist. His flamboyant behavior—from painting in designer suits to traveling everywhere by limo—soon established him as an archetypal 1980s art star.

The period 1981–1982 would prove to be pivotal for the artist. Almost overnight, the anonymous SAMO gained an identity: the

exotic painter Jean-Michel Basquiat. By the end of 1982, the home-
less street artist was well on his way to becoming an inter-
national art star. The art boom was gathering speed, from the funky
storefront galleries of the East Village to the swank new spaces in
SoHo. Everyone wanted to cash in on the young painter's wildly pro-
lific talent.

He was ill-equipped to deal with these rapid changes in his life,
and the almost grotesque hype associated with him from the start.
Basquiat's father had punished him for bad behavior; the art world
rewarded him, enabling the artist to self-destruct. Like everything
else about Basquiat, it was a stylish performance.

Whether it was women, drugs, clothing, food, or limos, Basquiat
had no concept of moderation. He lived the way he painted. Anyone
pulled into the maelstrom soon began to understand why the images
on his canvases floated like flotsam and jetsam on a jagged sea of
hostility, paranoia, and irony. Filled with fragmented references, his
canvases reflected his (black) humor, insatiable curiosity, and liter-
ally encyclopedic mind-set. Basquiat surrounded himself with refer-
ence material while working, appropriating icons and text the way
jazz musicians quote melodies.

Basquiat deliberately refused to impose an obvious formal order
on this visual anarchy. Instead, his paintings iterate and reiterate the
personal, historical, and cultural chaos he felt as a black man living
the dysfunctional American dream.

Basquiat invented his own genre: a calulated stream-of-self-
consciousness. "I don't know how to describe my work because
it's not always the same thing. It's like asking Miles, well, how does
your horn sound?" he told Davis and Johnston in their videotaped
interview.

"The musician of disordered sound, the poet of decomposed lan-
guage, the painter of the fragmented visual and tactile world; they all
portray the breakup of the self, and through the reassemblage and
rearrangement of the fragments, try to create new structures that pos-
sess wholeness, perfection, new meaning." Heinz Kohut's observa-
tion in his book *The Restoration of the Self* could just as easily have
been written by an art critic reviewing one of Basquiat's canvases.

Says Robert Farris Thompson, a Yale professor and African art

expert who spent time watching the artist work and questioning him about his creative process, "I think that Basquiat's work is an auto-biographical search for wholeness."

He couldn't find it anywhere. Not in himself. Or outside himself. Not in drugs or in making music. And certainly not in the astonishing list of women he turned to. Suzanne Mallouk, the girlfriend who went to bed one night with a street urchin and woke up next to a celebrity, was the longest-standing relationship of this period. During this time he also had a significant romantic relationship with a man, painter David Bowes. Very few of his objects of desire refused him. But none of them could fill his inner void.

DUNGEONS AND DRAGONS

"Let's talk about that story that you're being locked in a basement and ordered to paint."

"That has a nasty edge to it. I was never locked anywhere. Oh Christ. If I was white, they would just call it an artist-in-residence, rather than saying all that stuff."

"Do you feel your ethnic background helps or hinders you?"

"I don't exploit it."

"Do you feel that others exploit it?"

"It's possible. Now I've put my foot in my own mouth. Turn off the camera, man."

—Jean-Michel Basquiat interview with Marc Miller,
Art/New York Video Series

Down in the basement of the Annina Nosei Gallery, at 100 Prince Street, Basquiat was painting up a storm. The room was filled with a haze of pot smoke. There was a mound of coke on a table, a couple of funky chairs, and a boom box, playing a steady stream of Charlie Parker. "Jean-Michel," came the taut voice with the rich Italian accent. "I'm bringing someone down."

Basquiat continued painting as Nosei, a slender dynamo with a stylish perm, burst into the studio with two middle-aged collectors in tow. "What is that image you are working on?" asked one of the women. Basquiat swung around and came toward her with the paintbrush, as if he planned to splatter her with paint. Then he backed off. The woman laughed and sat down in a chair, continuing her childish questions as Basquiat returned to his canvas. Basquiat hated it when Nosei interrupted his work.

Don Rubell and his wife, Mera, got a kinder reception when Keith Haring took them to visit Basquiat in the basement. "Of course we were curious. We went downstairs," said Rubell. "And there was this stunningly beautiful person with a Cy Twombly book in one hand, and painting with the other. At first we thought it was a little suspicious, but soon we saw that he was really terrific. We were totally astonished, and we immediately bought two paintings."

Collector Doug Cramer remembers being shocked at seeing Basquiat in the basement. "He was painting away. He looked like a slave, or very close to it."

It was the fall of 1981, and Basquiat's presence in the pit of the Annina Nosei Gallery was already creating a stir. Just the year before, the young artist had been living in Washington Square Park and painting graffiti in the street. Now his canvases were fetching prices of $5,000 to $10,000 and were selling faster than he could paint them. "It wasn't handled well," said Rubell. "He quickly became a commodity: 'Come and watch the artist perform.' He could put out two or three paintings a day. It was easy to take advantage of him."

"He constantly needed money," says Nosei. "So I sold paintings in order to give him money. But then he would be upset that I had sold the paintings."

Several times a week, Nosei's assistant, Liz Gold, would walk Basquiat over to the Citibank at LaGuardia Place and Bleecker. "He was like a lost child. Annina would make out a check to him. I would get him twenty-five hundred dollars in cash one day and five thousand the next. He would keep it in his pockets." Gold said it didn't all go for drugs. Jean-Michel loved the good life. He bought suits at Armani. He had limos pick him up from the gallery, after work, especially if he was going out with a girl.

In contrast, Nosei was notorious for her pecuniary peculiarities. Several former gallery assistants recall her idiosyncratic cost-cutting tactics: Wastepaper was recycled as notepads. The serrated edges torn off of postage stamps were used like Scotch tape. Food left anywhere near her was either instantly devoured or taken home so she could use it when she was entertaining guests. Once she screamed at Basquiat for jotting down a telephone number on the gallery's letterhead. "That paper costs a nickle a piece!"

And yet there was something similar about the artist and the dealer. They both had mercurial temperaments and could be sweet one minute and hostile the next. They frequently displayed paranoid behavior. And they shared a voracious passion for art and an equal passion for money.

But their ways of dealing with money were completely at odds. Nosei would account for every pen and paintbrush. "She really kept tabs on it and kept that against sales," said Gold. "Jean-Michel would sometimes come in and say, 'Hey, I sold five paintings, where's my fifty thousand?' and so she would pull out her books and say, 'I bought you two stretchers, and three cans of paint.' Poor guy, because he didn't understand what was happening. She would sit him down and say, 'Look, I'm happy to send an assistant to buy supplies for you at Pearl Paint . . .' and he didn't get it, because all he saw were the paintings going in and out. Jean-Michel had no sense of what was happening to him, and it was all happening much too quickly."

Gold frequently found herself forced to function as the buffer between Nosei and Basquiat. She also had to help assuage Nosei's other artists, who were not amused by Basquiat's instant celebrity. And then there was the constant traffic in and out of the gallery. Sometimes Basquiat's friends would come to visit, but mostly there was a steady stream of collectors.

"Every top collector but Saatchi came in," said Gold. "What I didn't like about it was it was kind of like show-and-tell—'Look what we have down here.' Anytime an important collector came, it was like, 'Let's go down to the basement.' I think it was really disruptive to his work and no good for his psyche to have these idiotic collectors come down, and it happened all the time. After they left, he would go wild."

Still, she looked back on her three and a half years with Nosei as "a wonderful period. Sometimes I just feel like writing a letter saying, 'Thank you for letting me be a part of history with you.' "

Nosei recalls the artist with a mixture of personal nostalgia, parental disapproval, and critical acumen. "He was fast, very fast," says Nosei. "I can say that there are very few people that do not bore me, and Jean-Michel didn't bore me. He had read things, and he was

capable of making fast and original associations. You know, his mind would not be trite. And so he was poetic."

The Public Address show at Nosei in October 1981 was a group exhibit that included works by Barbara Kruger, Jenny Holzer, and Keith Haring. The whole back room was devoted to six paintings by Basquiat, stylized portraits of such subjects as an Indian, a rabbi, and a policeman. At this point, Basquiat's work could easily have been labeled urban folk art.

The rabbi, painted in black on an uncharacteristically pink background, looks vaguely like a Chagall. The words "Gold, tin, tar and asses" appear in a box on the lower part of the canvas. The Indian has a barbed-wire-like line around his rectilinear body, and two tepees, a frequent motif at this time, appear in the distance. The power of "Irony of Negro Policeman" is its title. In another painting, a lavender-tinted janitor, a crown superimposed on his hat, brandishes a broom like a scepter, while near him a garbage can, marked "ashes" (a play on "ash can"), is also marked with a crown. Characteristically, Basquiat has elevated a common man to royalty. There is also a frightening skull, bristling, stitched; a Picasso-influenced Frankenstein.

It was the first time that Jean-Michel's work appeared on the walls *inside* a SoHo gallery, and it made an indelible impression on his friends from the streets and the clubs. "I remember going to his first show and Annina had her daughter Paulina serving wine," says Vincent Gallo. "And I thought, 'God!' I was shocked that one of our friends had kind of made it into that league so quickly.

"Jean had a tape of Spoonie Gee on a cassette box, almost as if it was a party. It was the first time I had seen him do large work, real paintings. I couldn't even imagine buying the art supplies for that kind of work. It was half Jean's friends from the old days, like his real friends, hipsters, and half people we had never seen before. It was kind of a misty, rainy Saturday night and SoHo was a different SoHo then. And it was kind of dead, other than this opening. Francesco Clemente had had a show, and Julian Schnabel had had a show, but Jean's show was right up there with the beginning of this whole new movement of art. And there we were, people who hung out in the

Mudd Club and places like that, and suddenly we were in SoHo in some fancy gallery mixing with people of the art world who had never really had a connection with us before. And I remember when Annina's daughter came out serving wine, in a beautiful dress. It sounds ridiculous, but it was the most startling thing at the opening.

"You could see at that point that they were catering to Jean. That he was having his ass kissed by people who would have a hundred percent disregarded him in every other way. It was the first time I realized that an artist was the only person who could kind of move through the classes as an outsider. There was no doubt at all that Jean was going to be successful. I thought he was the greatest painter and the greatest poet, but I couldn't believe that somebody out of this kind of secret society that we had could become so commercial. Jean was always an operator. He was playing a kind of shy, awestruck routine but at the same time making very kind of calculated maneuvers."

Basquiat, says Gallo, looked "very cool. He was wearing an Armani suit with paint-spattered pants and he was smoking a lot of pot." (Like Warhol's wig, Basquiat's paint-spattered designer clothes would, at least for a time, become an instantly recognizable icon.)

The day after the show, Jean-Michel, who had been up all night partying, rode out to Brooklyn in a limo with two friends, musician Arto Lindsay and Jeff Bretschneider. "It was about six-thirty and I was getting dressed," says Gerard Basquiat. "Jean-Michel was wearing a pin-striped suit and he came into the kitchen and he said, 'Papa, I've made it.' And he gave his younger sister Jeanine a pocketful of money."

Recalls Bretschneider, "He went in and gave money to his father, and he was very concerned about his sister. He went there to park the limo out in front, to walk in with his clothes, and to show his father he had made some money. But I know he walked out of there feeling really empty. Like whatever he went back for wasn't there." It was the first time Jean-Michel had seen his father since he had run away from home several years before.

Although his stint in Nosei's gallery was soon being referred to as the "dungeon period," the basement was actually a large space most

artists would be happy to work in. It had a skylight and two windows, which looked onto brick walls. There were storage racks for Basquiat's work. And Nosei provided him with an assistant to stretch canvases and run errands.

Basquiat discussed the arrangement in an interview with Anthony Haden-Guest. "She offered me a studio. It was the first time I had a place to work. I took it, you know. Not seeing the drawbacks until later . . . It was right in the gallery, you know. She used to bring collectors down there, so it wasn't very private. I didn't mind. I was young. It was a place to work, which I never had before."

Basquiat usually didn't show up until sometime in the afternoon. He would make a stop at Dean and DeLuca for food. He didn't have keys to the basement, so Liz Gold or his assistant would let him in. He would turn on his boom box (for a while he was painting to Ravel's "Bolero," which he played so obsessively that Nosei would stamp her foot upstairs to make him stop) and start painting on several canvases at once, walking all over the pictures and leaving his trademark footprints.

"He would move from one canvas to the other like a ballet dancer," said Gene Sizemore, who worked as Basquiat's assistant for half of that year. "He was extremely graceful, agile, and athletic. He worked very fast. He would step back to see what he had done, without ever breaking his rhythm, very reminiscent of Ali in his prime, backpedaling with his guard down, but totally in control."

Sizemore was employed by Nosei in the mornings and by Basquiat in the afternoons. "Jean got a real kick out of paying me more to work for him than Annina was paying me." To Sizemore, the studio arrangement in Nosei's basement was grotesque. "It was almost like he was down there in ball and chains to crank these things out. Annina sold things before they were finished. And she would go into the basement storage area when Jean-Michel was not there and pull works out to offer collectors. So Jean-Michel and I agreed that works couldn't be sold until they were signed. At one point I was caught in the middle. I was supposed to get Jean-Michel to sign three paintings. He came in like a whirlwind, doing this and that, and he didn't sign them. So I had to sign the paintings before they were sent out to a collector." Another time Sizemore painted the blank sections of a canvas that

had been moved from one stretcher to another; no one seemed to notice.

"They were doing a cash business at the gallery," said Sizemore about Nosei's dealings with Basquiat. "Jean-Michel would be wearing some old-man kind of cheesy pajamas and house slippers and he'd have these dreadlocks and there would be several thousand dollars in cash sticking out of his pockets. He'd go down to Canal Street and buy two hundred dollars' worth of cassettes in the afternoon. He was so hyper. You never knew what he would do. Sometimes he would just want to go and buy materials. Sometimes he would work for thirty minutes and then leave. He didn't seem to know a whole lot about art. One time I mentioned that his work had elements of Twombly, and the next day he had bought a beautiful expensive coffee-table book on Twombly, to learn about him. It wasn't uncommon to see Jean-Michel come out of Annina's office pissed off or confused, but with a pocketful of money."

After Basquiat was paid, the two would go off to Pearl Paint for supplies—Liquitex acrylic paints and boxes of oil sticks. Basquiat also liked to use color Xeroxes, which he would glue to the canvas. When they inevitably buckled, Basquiat said he could solve the problem by putting glue in a hypodermic needle and injecting it under the surface, a technique he never actually employed. Once he asked Sizemore to find him the *goldest* gold paint he could find; the oil-based paint that Sizemore bought at a hardware store became a favorite color.

There were some regulars who dropped by the gallery to visit Basquiat. Larry Gagosian, who had been business partner with Nosei several years earlier, was a frequent visitor. The following year he would give Basquiat his first one-man show in Los Angeles. Henry Geldzahler used to show up. Tony Shafrazi befriended Basquiat at this time. Then there were some of his regular pals: Glenn O'Brien, Edit DeAk, and Maripol. Downtown poet and art critic Rene Ricard made a habit of hanging around and begging Jean-Michel for work. "Please," he would plead. "I love this one. Give it to me. I deserve it." Ricard truly appreciated Basquiat's work—and his body. He loved to walk around talking about the size of Basquiat's cock.

But it was Rene Ricard who scripted the star's formal intro-
duction to the art world. In his long and elegiac article, "The Radiant
Child," published in *Artforum* that December, Ricard wrote, "He
has a perfect idea of what he is getting across, using everything
that collates his vision . . . If Cy Twombly and Jean Dubuffet had
a baby and gave it up for adoption, it would be Jean-Michel. The
elegance of Twombly is there . . . and so is the brut of the young
Dubuffet."

Sometimes, less scrupulous friends would pick scraps (graffiti
artist Rammellzee called them scribble-scrabbles) up off the floor to
sell to Nosei later. According to Sizemore, Nosei was so paranoid she
banned Basquiat's graffiti friends from the basement.

Other friends, to whom Basquiat had generously given away his
drawings, painted doors, windows, TV sets, and lab coats when he
was poor and unknown, now showed up routinely to sell their wares
at the gallery—something Basquiat never forgave.

"He was very, totally tortured, and in a lot of pain, mostly because
of the stupidity of the people around him, and the loneliness that
brings," says Nosei. "He needed them because he was so desperate,
so that he would hang on to people that he basically despised."

Other, older friends were dropping out. "He became the very
thing that he put down," said Al Diaz. "I guess he decided more than
we did that he was gonna play this art game. We went our separate
ways. I was still being a kid, a rebel. He was gonna be successful. He
was just starting to climb the ladder."

One time Mick Jagger came in. Basquiat was thrilled. "Yo, want
to do some coke?" he asked Jagger, according to assistant Joe LaPlaca.
"I'm into jogging," Jagger replied.

Arden Scott paid a visit to Basquiat in the basement and was up-
set by what she saw. "There was coke falling all over the place. It was
so awful it made my skin crawl. I told him, 'You can either be a great
artist or a great tragedy.' He smiled, and said, 'Why can't I be both?' "

"It was really a bad model to have an artist in the basement mak-
ing work," said Cortez. "It was like, 'I've got this black laborer in the
basement. Look at this kind of zombie freak circus person making
art.' She would drag all these suburban white people that she was

bringing in there. It was embarrassing to Jean-Michel's closest friends that he was spending all his money on drugs and limos. It was a very sad beginning."

Cortez had wanted to get Basquiat into a gallery like Sperone Westwater, or Leo Castelli. "Annina wasn't what I thought would be good for him. But she coerced him into her gallery while I was away in Europe, and gave him money." Now she wanted Cortez to turn over all of Basquiat's work to the gallery. Fed up, he confronted the artist and dealer in person.

"I think Jean-Michel felt guilty. I was in Annina's office and she called him up from the basement. He came in looking like a four-year-old. It was humiliating. She said, 'Diego refuses to give your work back.' I walked out. I said, 'Go ahead and sue me.' She had her lawyer send me a letter. I sold all the works to Bruno Bischofberger. I felt as hurt and betrayed as I ever had by any artist. Everyone was seduced by him and his genius and then was crushed."

Basquiat's treatment of Cortez was an early example of his notorious fickleness. He would turn on his early supporters, seduced instead by whoever made him the most lucrative short-term offer.

"I think he wanted to be exploited," O'Brien later told filmmaker Geoff Dunlop. "He wanted someone to take his work and sell it and make it as valuable as possible. He was a young guy, and he was black, so it was easy to have this kind of babe-in-the-woods scenario. But Jean-Michel wasn't stupid. He knew what was going on. He certainly complained about every dealer he ever had, but I think in some cases it was blown out of proportion. If you believed what you heard, you would think that Annina had him chained in the basement and went down there to give him food and drugs and didn't let him out. I don't think it was like that. He was having a good time."

Rumor had it that Nosei kept Basquiat high on coke so that he would crank out work. Even his friends thought this might be the case. Nosei was certainly aware of the drugs in the basement, but it is extremely unlikely that she encouraged his coke habit. In fact, she was highly health-conscious. "I confronted him because I thought he was taking heroin, and I said, 'If you are going to do that, at least take some orange juice and vitamin B.' He was angry that I brought up the heroin, and he said, 'Don't you dare say that. My father will find out.' "

Jean-Michel bought most of his coke from Jeffrey Bretschneider, who lived on Twenty-third Street and Seventh Avenue; "between the Chelsea Hotel and Squat Theater" were the directions he'd give first-time visitors. Bretschneider's apartment served as a kind of drug den and cross-cultural salon of the early eighties. After Club 57, after the Mudd Club, after the last after-hours joint had wound down, a group of regulars would congregate in Bretschneider's place and hang out until it was time to start the club crawl again. John Sex, John Lurie, Deborah Harry, Chris Stein, Henry Geldzahler, Billy Idol, Michael Stewart, Cookie Mueller, Klaus Nomi, Rammellzee, Fab 5 Freddy—the list sounds like a downtown social register. "Nobody worked," explained Bretschneider, himself a kid from the suburbs. "Everybody seemed to have underground incomes."

Basquiat left a number of paintings and drawings at Bretschneider's apartment, and asked him to try to sell them to David Bowie. Every day, he would show up with a friend, musician Arto Lindsay, for hours of coke snorting. "Whenever I got a new shipment of coke," said Bretschneider, "I would invite them to come over and taste-test it. I'd give them a one-on-one cut. We'd sit there listening to new music all day and then go out to the clubs. We never discussed art." (Lindsay says with amusement that this is a slight exaggeration of their activities.)

One time Basquiat came over to Bretschneider's and brought Nosei with him. "I thought it was strange and unorthodox to bring this older woman over," said Bretschneider. "But she came in and was fascinated with the place. She said it reminded her of the sixties."

In the winter of 1981, Basquiat was working round the clock on paintings for his upcoming solo show that spring. He began "Arroz con Pollo" in Nick Taylor's apartment. But he stopped painting for several days, and Nosei gave him money to take some time off. He scrawled the name "Culebra" on the wall, and the next day arrived in Puerto Rico to visit his friend Leisa Stroud, John Lurie's ex-girlfriend.

"I didn't even know he was coming," said Stroud. "I didn't have a telephone, so there was no way to communicate. It was very remote, you could only get there by a single ferry a day. Jean-Michel arrived

with this girl named Valda. He had a mad crush on her, but she left after a week, because they weren't getting along. Rene Ricard arrived the next day. Jean-Michel had cartons of acrylic paint in jugs, and when they were unloading the plane, a carton fell and paint spilled on the runway. It was there for a long time."

Basquiat had noticed Valda Grinfelds long before she ever met him. "He told me he had always admired me in my party dresses at the Mudd Club when I was high on quaaludes," she recalls. In the beginning, he introduced himself as 'Willie.' I didn't know his real name until he came into Danceteria and invited me to his first show at Annina's. We finally clicked one night at Bowlmor on University Place. The first night I took him home, he got a nosebleed. It was sort of ominous."

But these were happy days for Basquiat. "Later he told me that when he was taking a cab home from my place, he drove down Park Avenue. The sun was coming up, and the Pan Am building was still illuminated. He just said, 'It made me feel like a king.' Not long after that we went to Culebra." (A self-portrait of the time, a simple crowned figure, is called "The King.")

Grinfelds was impressed by the level of Basquiat's ambition. "I remember we met Annina at a restaurant on Houston Street where there were a couple of Warhol drawings on the wall. And Jean said, 'You know, I want to be able to trade him one of my drawings.' And eventually he did. Jean always knew what he wanted. Whether it was a woman or fame."

Basquiat brought several rolled canvases with him to Puerto Rico. " 'Arroz con Pollo' originally had other images on it," says Grinfelds. "When we were in our hotel room in San Juan before we flew to the island, there were three saintlike images of men in the background, tall, regal, kind of spiritual. The color of the painting was salmony pink. But he painted over that in Culebra. If you scraped out the yellows and oranges, you'd find the original background. The picture is about a dinner we had with Rene at the house. He would just leave the canvas out on the porch in the rain, and I would have to drag it in."

He would also drip paint all over the porch, and, says Ricard, "leave the place in a shambles like a rock star." Ricard spent a lot of

time on his hands and knees, scrubbing up after Basquiat. "I was a little housewife. I would be cooking." According to Ricard, the painting, which depicts him as an evil missionary about to be boiled to death by some natives, originated with a chicken dinner that he was preparing. "He did this horrible caricature of me as a white missionary, with a black woman on the side, dreadful, evil," says Ricard. "He was drawing with oil sticks and painting things out in acrylic. It went through many permutations."

Rene Ricard had started out as a poet. As with many eighties art-world players, his initial association had been with Warhol—and oddly enough, given Basquiat's future fate, with Edie Sedgwick. Ricard appeared in Warhol's deadpan film *Kitchen*, starring Edie, who is inexplicably killed at the end of the movie. He also appeared with the moribund Edie in Warhol's *The Andy Warhol Story*, playing Andy, which consisted of him peppering Warhol with insults as the camera ran, much to Warhol's annoyance. At one point, Ricard got himself excommunicated from the Factory by taking one of Warhol's films too literally; he gave the young man Warhol had wanted to star in *Blow Job* a blow job. He also starred in Eric Mitchell's 1980 film, *Underground U.S.A.*, with Patti Astor, Cookie Mueller, and Taylor Mead.

In the late seventies, Ricard became an art critic, exploring the clubs and artists' studios with his friend Edit DeAk, with whom he was currently living. Besides curating shows at Artists Space, DeAk co-edited the art journal *Art-Rite* with Walter Robinson from 1973 to 1978. She had a keen eye for new art, and was one of the first to champion Basquiat. Ricard, an impish man with the overripe air of a raunchy monk, had taken upon himself the mantle of Eighties Art Critic. "At the end of the seventies, the art world was moribund and I set out to revitalize it," he wrote in *Vogue*. "Not only would I help create the eighties socially, I could give it a literature, a style." Or, as Warhol put it in his *Diaries*, Rene Ricard is "the George Sanders of the Lower East Side, the Rex Reed of the artworld."

The poet-critic and nightcrawler set about creating a canon; the first painter to be anointed was Julian Schnabel. Soon afterwards, Ricard, who had been picked up by a young boy at an after-hours

club, woke up in Maripol's loft, and saw a large painting by Jean-Michel. "I called up the editor of *Artforum*, Ingrid Sischy, and told her I had my new artist. She said, 'What's his name?' and I said, 'I don't know.'"

It didn't take Ricard long to find out that the creator of the work he admired was the artist who had done the SAMO graffiti he had seen at the Mudd Club, in a show curated by Keith Haring. "He was one of the chicest boys in town. He was entirely familiar in all the clubs."

Back at DeAk's he discovered that she had a Basquiat on the wall that up until now he had failed to notice. Ricard lost no time introducing himself to the artist, who invited him over to see the work he had in the apartment on First and First.

"He had absolutely no money, but he went to Balducci's and bought a dozen ravioli and made some fresh tomato sauce, which he sprinkled with fresh-ground Parmesan. It was the kindest gesture. I was very touched. I said to him, 'I'm going to make you the most famous painter in America.' He asked me, 'Can you put me in the ring with Schnabel?' And I said, 'I can set the date.'"

"Jean was magical," says Ricard. "It's not normal to have that much happen in such a short time. It was some sort of historical predetermination. Nineteen eighty-one was the *hora mirabilis;* you had Schnabel, Jean-Michel, Keith, John Ahearn."

In Culebra, Basquiat painted and drew constantly. Several of the paintings depict fishermen with their catch, including a large canvas called "Culebra."

He explored the island with Grinfelds and Stroud. But he was afraid of almost everything; the water, the dark, even the cows. "He didn't know how to swim," says Stroud. "I took him scuba diving off a little island off Culebra. I gave him fins and a snorkel mask. He was just like a three-year-old—he was so excited by the incredible fish."

But the pleasure soon turned to fear. "He had smoked all this pot and he started getting paranoid every time there was a little wave," Stroud says. "He flipped out. He thought he was drowning. I had to drag him back to the boat by his dreadlocks."

"He didn't like nature," says Grinfelds, succinctly. "And he was

hypersensitive. If I mentioned the idea of a nuclear holocaust to him, for instance, he would completely freak out and turn white. He would be totally horrified. I've never seen anyone in my life react that way."

When Stroud's dog got hit by a car a few days later, Basquiat lay down on the ground, overcome with grief. "It was as if our mother had died or something," says Stroud. Perhaps the incident brought back memories of his own traumatic childhood car accident. A vet saved the animal, which had a compound fracture.

That night Basquiat made a lot of drawings. He drew Stroud and the dog on the beach, both as skeletons. He drew angels with the Superman logo, which Ricard, infatuated with the artist, thought were self-portraits.

"He drew men with fish, men with their bones exposed. But he would only go into the water up to his ankles after his one snorkeling experience. He was just like a little kid," says Stroud. "I have pictures of him jumping and laughing." The paintings from this time are simple, with bright, tropical colors.

Says Ricard, who frankly lusted after him, "Jean was alone in the house in Puerto Rico, drawing. That's when he told me about this deejay he had had a relationship with in Puerto Rico and said he fucked older men. He wrapped his dick around his neck like a stole. It was huge, really massive, not circumcised."

Ricard, the self-described "defrocked priest of the art world," says that Basquiat asked Valda to leave because "he wanted to be alone with me. He would take any opportunity to have me see his penis. He used it as angler bait. He had to have someone to have sex with all the time. His life was sex. He was into everything. He was a whore. He had turned tricks on the Condado when he lived in Puerto Rico. He was into sex for power, and then there was his heart. A woman could never really be it for him. The love of his life was Andy."

Basquiat rejected Ricard's advances. Instead, he drew lewd pictures of himself and Stroud and wrote dirty words in Spanish on them. "I was supposed to hide them from my boyfriend," says Stroud. "We used to flirt all the time, but it never got serious."

By the time he left, Basquiat had gotten used to the flora and fauna of the island, and he later visited Stroud several more times.

He said he wanted to get a place on Culebra. "He talked about how miserable he was in New York," says Stroud. "How he had no friends. How everybody just used him. That people were rummaging through his garbage for discarded work. Everyone he had ever given a drawing to had sold it. Everyone was coming to him and asking for drugs and money."

There were other constant frustrations. "Jean-Michel always told me he was the only blue-chip black artist," says Grinfelds. "He was very angry because Leo Castelli refused to take him on, and people dissed him because he was a black man, an outsider."

Like most of his relationships, the one with Valda Grinfelds ran hot and cold. "He kept proposing marriage to me all the time we were in Culebra," she says. "But I refused. A relationship with Jean was a high-maintenance affair. It was like being sucked up into a whirlpool. There was no way to keep your own identity intact."

Their relationship would continue, on and off, even after Grinfelds's "green card" marriage to someone else. At one point, she worked for Basquiat, building frames. "When I told him I was getting married, he immediately called up and invited me to Saint Moritz," she says. After watching him inject a "massive" amount of heroin, she tried to convince him to go to a rehab clinic. Valda was one of the few women with whom he discussed his heroin habit, since she had also used dope. "Jean wasn't a filthy junkie. He was never an addict in the classic sense. The definition isn't the same for everyone." Just a few months before Basquiat's death, he had a lengthy discussion with Grinfelds about a child, Noah, whom he believed he had fathered on a trip to New Orleans.

"There was something one couldn't quite explain, some mystery of Jean-Michel," says Grinfelds. "You could see it in his eyes. And it used to scare people, what his eyes looked like. Or if you weren't scared, there was something compelling about him. And he knew that, he worked it. Some people couldn't take it. He was a brilliant painter, a horrible egotist, he was a total selfish brat, he was a kind, gentle, pained spirit, he was a hurt little boy, an arrogant old man, and everything in between. He was just a rare person. Look at his art."

When Bretschneider and Maripol arrived in Culebra for a visit a month later, there were still traces of Basquiat's visit. "You could see

paint all over Leisa's floor," says Bretschneider. Basquiat left Stroud with a pile of paintings and drawings. He brought "Arroz con Pollo" back to Nosei in New York. The finished piece, acrylic and oil stick, is a crudely rendered domestic scene: a she-devil brandishing a fork waits at the table for dinner; a roast chicken served by a skeletal figure with a barbed-wire halo. The painting was featured in Basquiat's solo show at the Annina Nosei Gallery in March 1982.

CROSBY STREET: UP THERE

"For long-term results, there is nothing like the artist as a public personality. . . . The element of outrage attracts publicity and publicity attracts buyers."

—John Russell Taylor and Brian Brooke, *The Art Dealers*

"I had some money, I made the best paintings ever. I was completely reclusive, worked a lot, took a lot of drugs. I was awful to people."

—Jean-Michel Basquiat, *The New York Times*

In early 1982, soon after the Public Address show, Jean-Michel moved into 101 Crosby Street, to a rambling loft in the seven-story building that overlooked what was then a Mobil gas station. Annina Nosei had arranged for Basquiat's new abode; the rent was to be paid in paintings. It was a pivotal move. This was the first time that Basquiat had a place of his own that was large enough to paint in. For the previous four years, he had slept in strange places all over the city, in Washington Square Park, in abandoned buildings, on the floors of people's apartments and lofts, in a tiny alcove in the production office for *New York Beat*, leaving trails of drawings and paintings strewn like Hansel and Gretel's trail of crumbs. Itinerant, homeless, living like a bum.

Crosby Street marked a completely new phase in the artist's life. He was starting, as his idol Warhol would say, to get "up there." He was also starting to get out there. The place was sparsely furnished; a

haphazardly hung sheet separated the unmade bed from the rest of the space. The kitchen looked like it had been lifted out of Dean and DeLuca, complete with shiny stainless-steel industrial shelving. Visitors pressed a button labeled, in Basquiat's neat scrawl, "tar." Another word game—an anagram of "art" and "rat"—it also referred to tar, as in the oil-based building product, as in being tarred and feathered, as in the roofing for shantytowns, as in being black in America.

This bell was in constant use, especially after Basquiat disconnected his ever-ringing phone. His better-heeled or more desperate friends and fans would send telegrams. But most people would just drop by and buzz. Whoever was working as his assistant, and during this period Basquiat began to hire the first of his series of ambitious factotums, would look out the window and identify the visitor to the artist, who would give a thumbs-up or -down. Between Basquiat's endless parade of women and the small band of graffiti artists who clung to his coattails, the loft was always crowded with hangers-on.

"There would be a group of people sitting in a corner freebasing, cooking down the coke," said Bretschneider. "Jean-Michel would be where there was light, and color, with his paintings. But every once in a while, he would go over and hunch above the torch and smoke. He fueled his art with drugs. And then he slept for days."

Suzanne Mallouk chose this opportune moment to reappear on the scene. Returning from Paris, she went straight from the airport to the East Village, dragging her two suitcases. "I had nowhere to go, so I went to the Pyramid Club." Basquiat was at the bar, drinking a margarita. "He dropped his drink when I walked in, and he walked up to me, and he said, 'I'm famous now, and I'm rich, and I have this big loft in SoHo and you have to move in with me.'

"But I said I couldn't because I was over him. So he pushed over the table and threw his drink at the wall. The next day I called him and moved in. We used to dress like Darla and Buckwheat. He was doing huge amounts of cocaine and he had a hole in his nose. I did it with him. I wrote down how much he was spending on drugs. At that time he was spending two thousand dollars a week on coke and pot. Then he started freebasing."

There were usually piles of food and coke spread around, and

loose cash everywhere. A constant stream of people came in and out
of the loft, doing drugs, eating, hanging out. Basquiat's coke habit
had escalated and he made life hell for Mallouk.

"It was definitely a stormy, fiery kind of relationship," said Bret-
schneider. "Basically hit and caress." Sometimes, people had to in-
ferfere. Joe LaPlaca said he had to pull Basquiat off Mallouk one
time when he was beating her violently.

"Our relationship was very S & M, but not in a physical way,"
says Mallouk. "I lived there for about six months. It was complete
hell. He had black paper on all the windows so he could sleep during
the day. He was obsessively painting. He'd paint like five paintings at
once for five days and then sleep for a week. He came to almost re-
sent all the money, and he got rid of it as soon as he got it. It became
a joke. He would buy all these Versace and Armani suits and would
paint in them, and then throw them away.

"One day, he went out and bought maybe three color TV's, a big
recording thing, stereos, suits. I mean he must have spent ten thou-
sand dollars, and he came back with the delivery guy and they un-
loaded it all and then he sat down on the couch and started crying
like a little kid. 'I don't want anything else, do you, Suzanne?' He
would buy cakes and fill the whole refrigerator with French pastries
until they would go bad. He was doing so much coke that he would
wake up in the middle of the night, screaming, 'The CIA is going to
kill me.' So we put a sophisticated alarm system on all the windows.
He thought the CIA was going to kill him because he was a famous
black man.

"He wouldn't talk for two weeks on end, and then he started see-
ing other women and stuff. He was very unpredictable. One minute
he'd ask you to marry him, and the next minute he was scowling like
you had done something terrible. I never stopped being in love with
him, though. I truly believe he was brilliant. I think he was a genius.
And to watch him paint! To be with him was like being in another
world. He saw things in a certain way."

Stephen Torton, Basquiat's assistant at the time, had first seen Bas-
quiat around the Mudd Club in 1978, and even shared a few joints
with him. "He'd never say thank you. He'd just dance away," says Tor-

ton. The son of a one-time painter, Torton had spent several years in Europe. When he returned to New York in the spring of 1982, he looked up John Lurie, who was about to start filming *Stranger Than Paradise*. They went to visit Basquiat, who was having a big party at the loft that night to celebrate his opening in a group show at the Marlborough Gallery, called, accurately enough, *The Pressure to Paint*.

"So we go over and he's in the bathtub with a big bag of cocaine," recalls Torton. "And he's saying, 'I need a doorman. I need a bouncer,' and he's freaking out. So I said I'd be the bouncer. They all just looked at me." Basquiat told Torton he'd pay him $150 to man the door, $50 up front.

Patti Anne Blau also visited Basquiat that day. "I went over and Suzanne was there, and Jean really got off on it. So he went and put on our favorite song, Marvin Gaye's 'After the Dance.' And he ran and got me some paper and crayons so we could draw. And he told Suzanne to go clean the kitchen. I was embarrassed. I mean I was flattered too. Then, at the party, he more or less ignored me. And that was supposed to be acceptable because he was the star."

That night Torton got a lot of practice with the Siskel and Ebert door system. "I spent the whole night at the door. And Jean-Michel would stand in the window, and give a thumbs-up or -down. I threw out Steve Kaplan, who Jean-Michel hated because he had called him a 'pickaninny artist.' " Kaplan was notorious for crashing parties and openings for the free food and liquor. "Jean ran downstairs to see Steve publicly humiliated," recalls Lhotsky. It was not the first or last time that Basquiat would bait Kaplan. "I think David Hockney and David Byrne and Eric Mitchell were there," says Torton. But the party ended early, when the upstairs neighbors called the fire department.

When Torton went to collect the balance of his bouncer's fee, Basquiat offered him a job building stretchers. At first Torton refused. At the time, he had a steady source of income; he was dealing drugs. Valda was trying her best to put a few frames together, but Basquiat wasn't satisfied. Eventually, Torton agreed to the new job. Basquiat's instructions couldn't have been simpler. "Just use whatever materials are here." So Torton began constructing stretchers and frames out of carpet tacks, rope, canvas, and wooden moldings.

Everyone, including Larry Gagosian and private dealer Perry

Rubenstein, who bought two of the earliest pieces constructed by Basquiat's new assistant, was pleased with the results. Rene Ricard would single them out in *Artforum*; "For a while it looked as if the very early stuff was primo, but no longer. He's finally figured out a way to make a stretcher . . . that is so consistent with the imagery . . . they do look like signs, but signs for a product modern civilization has no use for."

The next week, Basquiat took off for Paris with one of his girl-friends of the moment, a beautiful, strung-out, androgynous-looking model for Valentino named Laura (not her real name). He gave Torton a list of chores, including putting a lock on the elevator and installing shutters, since Basquiat, who was using a lot of coke, usually slept most of the day. Torton had his own flair. With a dramatic flourish, he reached out the window and pulled in the existing iron shutters. The partnership was formed. Over the next two weeks, while Basquiat was in Europe, Torton built dozens of the raw-looking stretchers that so impressed dealers and critics when they were shown several months later. The rough-hewn frames are still singled out as one of Basquiat's original innovations.

Basquiat returned from Paris a few weeks later, along with Laura and a new habit. She had brought some dope with her. Soon all three of them were doing it; in fact, Torton was dealing it. Basquiat had dabbled with heroin before, but now he began snorting it regularly.

John Lurie, one of Basquiat's earliest downtown friends, soon became disgusted with Basquiat's new behavior. Says Lurie, "He used to ask me how to achieve the John Lurie bohemian style of living, but he became macho and cruel. He turned into Don King. Anybody I slept with, he slept with too. He stole Torton from me. And he got really glorious about the heroin thing. That was what really changed him."

By now, Suzanne had moved out, but she and Basquiat continued to have unfinished business. Her parting gesture several months later would be characteristically dramatic: one day Torton looked out the window to see her making a bonfire of Jean-Michel's paintings.

"I had all these paintings in the place where we had lived together," says Mallouk. "Big ones, little ones. When Jean-Michel and

I broke up, he made all those Xeroxes of Venuses and tore them up and gave about ten of them to me and said, 'This is you, a ripped-up Venus, the goddess of love.' I had his things all over my walls. Some of my girlfriends were really worried about me, because I was really obsessed and strung out and my house was like a shrine to him. They told me I had to take the paintings down."

Mallouk decided to turn the catharsis into a ritual act. "I was so obsessed I did a spell. I planned the whole thing out." Mallouk chose the date based on the number twenty-four. "It's my favorite number and three is a virtual number and eight is infinity. I did it at exactly midnight, on the first day of my period, when there was a full moon. I thought if I did things in increments of three, the spell would be three times as strong and wouldn't come back on me." Mallouk walked over to Crosby Street, turning in circles in multiples of three, and carrying a big garbage bag full of paintings.

"I dumped the paintings and poured lighter fluid on them and set this huge bonfire in front of his house and burned all his paintings. He was looking out the window, and I was just standing in the shadows."

"Poor Suzanne," says Torton. "She was trying to exorcise him. I said, 'Jean, I don't know if you care, but there's somebody burning paintings of you in effigy.' He went downstairs in a beautiful and peaceful way." But Mallouk continued to suffer. Rene Ricard took to calling her "the Widow Basquiat."

Basquiat had a number of overlapping relationships in Mallouk's wake, including one with painter David Bowes, a slender, ethereal-looking artist whom he had first met in early 1980. They would hang out, playing word games; the British expression "piker" never failed to delight Basquiat. "The definition of 'piker' is "shiftless famer, tight-wad, cheapskate," says Bowes. "He really liked the fact that it was a readymade poem."

Just before the Times Square Show, Basquiat crashed at the apartment of Bowes's brother. "I saw a lot of him in those days. He was just a tornado of activity," says Bowes. "He filled the apartment with drawings and sheets of loose-leaf pages covered with his fantastic poems and those cryptic notes. He had piles of collages and color

Xerox materials. And he was playing music. He would always tune my guitar to some totally atonal key."

Now that Basquiat was a rising star, he saw Bowes less frequently. But when he was breaking up with Laura, the artist suddenly sought Bowes out. "He was a little strung out about it, and I was very touched that he came to find me and talk to me. He was all inside out, run ragged and raw. He told me that she really reminded him of me." Bowes was also in a problematic relationship with a woman, and the two commiserated, finding consolation in each other.

For a period of about three weeks, Basquiat and Bowes were lovers. "It went on intensely for ten days, and then two weeks later again," recalls Bowes, who says it was his only homosexual relationship. "We were very, very close, but it wasn't something I could sustain." According to Bowes, Basquiat was comfortable with his bisexuality. "He was this kind of truly exotic creature and had a kind of omnidirectional passion."

In July, Basquiat showed up on Anna Taylor's doorstep looking for consolation. Taylor was an aspiring singer who had had a brief romance with Basquiat several years earlier. "I would see him a lot at the Mudd Club, during that period when he had the blond Mohawk. I had a baby blue plastic guitar and I would play with the amp turned way down," she recalls.

In those days, Taylor was living in a storefront on East Tenth Street, which Basquiat filled with all kinds of objects. He painted over a sandwich board, turning the words "roast beef" into "Roast Braille teeth." He also wrote stacks of poetry on yellow legal paper. "He would bring it over and I would read it, and punch holes in it and tie it up with string. He used to wear a tweed overcoat over flannel pajamas."

But, says Taylor, Basquiat was always excessively vulnerable. "He would get himself worked up into a state. Then he would accuse me of some kind of betrayal. He was very fragile and insecure. He depended on other people to help him out, and then he resented them for it."

In 1980, when Basquiat was in Bellevue Hospital with a furious rash on his legs, Taylor had brought him a small toy piano. "Sometimes in the middle of the night he would call me and say he was scared, and ask to come over. And he would just sit there and shake,"

she says. But the relationship had evaporated when Taylor got in-
volved with artist Duncan Hannah, and Basquiat began living with
Mallouk.

Now he was sitting in front of her house with a peace offering, a
drawing of a skull, with a fist and a mosquito coil, "for bad energies
crossed." He took her out to dinner. "There was a line at Barbetta's,
but we didn't have to wait. The maître d' just whisked us in. Jean-
Michel sat there and chain-smoked Camels and ate his leg of lamb."

Things soon got complicated. Torton and Taylor had a one-night
stand, which Basquiat immediately discovered. "Don't you see who
he is? He's just an imitation of me," he told her in a rage. But Taylor
knew that Basquiat was seeing Madonna at this point; she had seen
the singer's "little notes in pink ink and perfectly slanted hand-
writing" in the loft.

"I think in retrospect that Stephen *was* kind of copying Jean-
Michel," said Taylor. "Torton wanted to change his background and
his future and be more like Jean-Michel. He adopted his speech pat-
terns and way of dancing and his friends. They were a great team and
enjoyed each other, but then Stephen had to betray Jean-Michel be-
cause everybody did. Stephen played right into it. It became a bad tri-
angle and finally caused a breach between Jean-Michel and me." It
also ultimately ended Basquiat's relationship with Torton.

At the time, Jean-Michel was also seeing Saskia Friedrich, the
seventeen-year-old daughter of Heiner Friedrich (founder of the Dia
Art Foundation). Her stepmother was Philippa de Menil, daughter of
art collector Dominique and heiress to the Schlumberger oil fortune.
"I met Jean-Michel in the elevator at Maripol's house," says Fried-
rich, an attractive, well-heeled young woman with a light accent. "He
was living at Crosby Street. There were a lot of all kinds of different
people there, constantly hanging out, and the television was always
on. He was sort of nominated this 'genius kid' but at the same time he
was struggling with the racism in the art world, and people were like
buying him, you know. And it was all happening so fast, it was all
like boom, boom, boom, boom, boom."

The fling with Friedrich could get somewhat abusive; Basquiat
would fly into a rage and abandon her at clubs, and she'd return to
his loft only to find him with someone else. He'd show her pictures of

Suzanne. "He used to talk about her in a sort of nostalgic way." But Friedrich was enthralled by the artist. "He was very attractive, definitely sexy," she says. "I think the biggest attraction of all was that he was just going all the way, like he was just trying to search out the ultimate reality of his being. He had this sort of life force, this presence, you know?"

Friedrich stopped seeing him only when she showed up one day and discovered Suzanne there. "I was still in love with him, and it took me a long time to get over it, because it was so crude and because things happened so fast," says Friedrich.

"Jean-Michel and I had broken up, but we were still seeing each other," says Mallouk. "Whenever I went over there, I would see these telegrams from her, 'I love you. Kiss, kiss, kiss.' You could just see the German accent in these things."

Soon afterwards, Mallouk discovered she had a serious case of gonorrhea. "I was in the hospital for three weeks on IV antibiotics, and I knew Saskia was sleeping with Jean-Michel, so I called her and I warned her. One day I was over at his house, and she was buzzing the bell, so he let her up and said, 'Saskia, I am in love with Suzanne. She's my real girlfriend. We have problems, but she is the one I love.'" The scene repulsed both women. Mallouk grabbed Friedrich by the hand, and together they strode out of the loft.

Despite his sometimes brazen misogyny, Basquiat was always surrounded by willing women. "There were no such things as girlfriends," says Torton. "There were only nights. These girls would humiliate themselves. They would grovel at the door. It was really amazing. They wouldn't leave. We would have to go to hotels like the Waldorf and St. Regis. We couldn't find places to paint."

Basquiat was making paintings as fast as Torton could climb into Dumpsters and pull things out to build the stretchers. "I would go out in the middle of the night and find the stuff. I was making things that looked like what the circus leaves behind. I was just one of his arms. We made over three hundred paintings. Annina told him, 'Be careful. In three years he'll be saying he's the painter.'"

The frenzied activity was fueled by a massive amount of drugs. Jean-Michel's PIN code for his Citibank account was "So What?"

after the Miles Davis tune. "It had about twenty-eight thousand dollars in it and we went through that in a month," says Torton. "We'd break all our freebase pipes so we wouldn't do any more drugs, and then we'd just walk over to St. Mark's Place and buy a whole new set."

Torton describes their daredevil attitude: they both enjoyed flaunting their drug use. "We would be freebasing and Nora and Gerard [Basquiat] would be coming up in the elevator. I remember going out with them when we were so high it was really terrifying," he recalls. "We were watching the elevator come up and freebasing until it hit the fourth floor, and then we hid the pipes. We went out to a restaurant and were just passing envelopes of coke back and forth under the table and going to the men's room. We used to love to get high and then go to Tennessee Mountain in SoHo and then go home and vomit. That was really fun, because he would paint with a huge garbage pail next to him, and just keep vomiting into a plastic bag, and it would fill the pail and I would empty it.

"Freebasing is the sickest thing in the world," says Torton. "It's existentialism in a crystal, because you're smoking, and you can't wait to feel it, and then you blow it out, and it's already over. This siren goes off in your head. Jean-Michel knew all the dealers, but I also provided a lot of contacts. At one point I started calling everybody up and telling them to stop selling us coke. That caused one of our first big fights."

No matter how successful he got, Basquiat always feared failure—as if he felt that any minute the approval he had finally won would be suddenly withdrawn. "He would say, do you think I'm going out of fashion, do you think I'm washed up? That was his favorite expression," says Torton. But he couldn't stand being a success either. His real heroes ended up bums, bankrupt, dead."

From the time he first started making money, Basquiat was known for his inordinate generosity; he would hand out fifty- and one-hundred-dollar bills to bums, or tuck cash into the pockets of homeless people sleeping on the street. "Bums were like Budhist monks to him," says Torton.

Basquiat's attitude toward money was as conflicted as his attitude toward success: on the one hand, by deliberately mismanaging his fi-

nances, he was, once again, rebelling against his accountant father. On the other hand, he lavished gifts on girlfriends and hangers-on, as if he were somehow trying to buy love.

Meanwhile, he was spending hundreds of dollars a day on food at Dean and DeLuca. He also bought—and stole—art supplies from Jamie Canvas. "We'd spend four hundred dollars, but steal two hundred, because he loved the idea that they were too intimidated to stop him," says Torton. "We used to do it blatantly. We used to run around giggling like children, and I had a big shopping bag, and he would just run up with me to a shelf of oil sticks and knock them all into a bag, and they would just look at us in horror.

"He was really into the joy of excess. Money was lying all over the loft. And then he would get freaked out when these kids would come over and steal a hundred-dollar bill. He loved the silence of the drugs. It was the only way he could block these people out. They were so persistent, the buzzer would buzz at any hour. And people would come up and tell him their problems and he would give them money to go away. One time he gave me five hundred dollars, and said, 'Take A-1 to a hotel, I need to be alone.' But after three days he was back; they threw him out because he was tagging in the hallway. I used to call Jean-Michel 'Baby Stalin,' because he surrounded himself with idiots."

Along with Fab 5 Freddy, Basquiat organized Sunday trips to the Museum of Modern Art for the gang of graffiti kids that formed his constant coterie. "He wanted these guys to have some culture," says Torton.

Whenever he could, Basquiat sought refuge from the fray. Limousines, those ultimate eighties status symbols, provided a frequent escape route; in order to counter the downsides of his success, Basquiat seemed to continually increase his conspicuous consumption.

"One of the gloomiest things we used to do is he would make me rent a limousine, and we spent many a night just watching TV and driving around," says Torton. "It was the expression of all-time loneliness. There is nothing so gloomy as a limousine and nowhere to go with it."

Basquiat's first one-man show at the Nosei gallery in March of 1982 was a huge success. Even his father showed up. "When I walked in,

it was a thrill. One of the great moments of my life. To see Basquiat on the wall, my own blood, my son," said Gerard Basquiat.

But Jean-Michel was ambivalent about his father's participation in his art-world celebrity. Recalls Lurie, "He came to my house at seven in the morning of the day of the show. His nose was bleeding, and he was crying. He was terrified to go to the gallery because his father was going."

Among the paintings on exhibit were "Arroz con Pollo," "Self-Portrait," Untitled (Per Capita), and "Peso Neto." "Peso Neto" shows a gallery of black crowned and haloed heads, interspersed with skelly courts. "Per Capita" (one of two paintings with this title) includes several of Basquiat's ongoing themes: A black boxer wearing Everlast shorts holds an Olympic torch in one hand, transforming him into a subversive Statue of Liberty. A halo glows above his head, and above that are the words "E Pluribus." On one side of the canvas is an alphabetical list of cities, with their populations; on the other are the words "Per Capita." The self-portrait is telling; a wild-haired black man with bared teeth, brandishing an arrow.

Eight "poem drawings" were also displayed. These were essentially SAMO-like sayings, minus the SAMO tag; in fact, some of them had earlier been spray-painted on walls. "Famous Negro Athletes" distilled two of Basquiat's favorite icons into an elegantly simple logo: a crown and a baseball sandwich the words. "Old Tin," with a copyright sign, labels a child's version of a car. "Origin of Cotton" embellishes an unadorned square. Then there was "Tar Town," which pronounced definitively, "Jimmy Best on his Back to the Suckerpunch of his Childhood Files," a prose poem with an intensely autobiographical note, which Basquiat recycled several times. Finally, the deceptively simple statement, "No Mundane Options."

Critic Jeanne Silverthorne saw Basquiat's conflicts writ large on the canvases. "Painting after painting features boxers, winners and/or losers . . . Every victory is a betrayal, every survivor an arriviste. With views like these, Basquiat . . . must feel some queasiness about his own notoriety . . . To a certain extent Basquiat does seem at odds with himself."

Lisa Liebmann gave the show a rave in *Art in America*. "The linear quality of his phrases and notations, whether graffiti or art, shows

innate subtlety . . . Basquiat's mock-ominous figures—apemen, skulls, predatory animals, stick figures—look incorporeal because of the fleetness of their execution, and in their cryptic half-presence, they seem to take on Shaman-like characteristics. These drawings are also beautifully textured, often with layers of chalky paint that evoke the postered walls of abandoned buildings."

It was left to Citibank art consultant and critic Jeffrey Deitch to capture the quintessence of the artist's current status. "Basquiat is likened to the wild boy raised by wolves, corralled into Annina's basement and given nice clean canvases to work on instead of anonymous walls. A child of the streets gawked at by the intelligentsia. But Basquiat is hardly a primitive. He's more like a rock star, seemingly savage but completely in control; astonishingly prolific, but scornful of the tough discipline that normally begets such virtuosity. Basquiat reminds me of Lou Reed singing brilliantly about heroin to nice college boys." It was an apt analogy.

Recalls Nick Taylor, "I remember that night at Annina Nosei's, he came up to me, and he was stoned out of his mind on coke. He was taking all of his friends one at a time to the back room to do coke with him. And he says, 'Man, I'm set for life!' He knew he was going to be successful. Every painting in the show had already been sold."

Along with the unanimous critical acclaim came an ever more insistent demand for the work. Basquiat's frenzied production, already a problem for the painter at the Nosei gallery, was quickly becoming an institutionalized part of the myth.

THE PIG MERCHANT

In June, several months after his triumphant solo show, Jean-Michel left New York to meet Nosei in Modena for a second show that had been scheduled at the Mazzoli gallery. Astonishingly, the art dealers expected Basquiat to make enough work, just a week before the show, to fill the gallery. This time, Basquiat stood Nosei up.

"He deliberately missed his plane to make up with some girl-friend. A few days later he called me and said, 'I'm here, I don't know what to do, come right over.' So we got there, and the hotel room was a mess," recalls Nosei. "Jean-Michel only had a little tennis bag, room service, his shoes, everything was on the floor. It was an incredible mess! Mazzoli had never seen anything like that. 'How can he manage?' he asked me."

But no one doubted that Jean-Michel would manage to paint. The canvases were ready and waiting. "We went over to the studio that Mazzoli has for the artists. The idea was that Jean-Michel should make a lot of paintings there and then stay for a show, and we would make a book. But Jean-Michel didn't want to do it," says Nosei. "He was sleepy. He didn't like Mazzoli, he had different hours, he was impossible, and he made all these paintings and then he left."

If Basquiat was going to be forced to fulfill the dealers' ambitious agenda, he planned to do it in his own way. Right before he left for Italy, he had showed up unexpectedly at Kai Eric's loft at 101 Canal Street, where he had once crashed, and persuaded Eric to join him. "Listen, man, nobody speaks English over there. I want you to come

over with me." Eric hesitated. "I'll pay for your ticket," Jean-Michel promised, with his characteristic desperate mixture of generosity and need.

Suzanne Mallouk, who despite her ritual exorcism, was still sporadically involved with the artist and also came along for the ride at the last minute. "I said I wasn't going," she says. "And he said, 'Then when I get back you better be out of my house.' " But on his way to the airport, Basquiat had second thoughts and went back for her.

The trip began in classic Basquiat style. They drove to Kennedy Airport in a limousine, sipping champagne. Basquiat was wearing a paint-splattered fishing cap and an Armani sports jacket. Recalls Eric, "His luggage consisted of a duffel bag and maybe one extra suit. He was just going to buy stuff from the finest store in town, or have room service go and buy it for him."

Jean-Michel didn't go anywhere without his own sound track, and the trip to Italy was no exception. "He had this huge, state-of-the-art Panasonic boom box, and a two-square-foot carton filled with his cassettes," says Eric. Not surprisingly, TWA insisted Basquiat check the sound system.

When the trio arrived in Rome, the boom box had been reduced to broken components. "We didn't complain about it at all," says Eric. "We jumped in a cab and on the way into Rome we saw an electronics store, and Jean-Michel bought a brand-new boom box, even better. Then we went to the Hotel de Ville. Right on the Steps, with an amazing view of the city. When we got there, there was a bottle of champagne waiting in the suite."

They hung out in Rome for a week, checking out the restaurants, cafés, and clubs. Eric rented a little red sports car. He acted as chauffeur, since Jean-Michel didn't have a license or know how to drive, and the three took off for Modena. There was something exotic about driving through the mountains, listening to New Wave music.

"It was snowing," says Eric. "We got to the top of the mountain and all of a sudden there was snow everywhere. And Jean-Michel said, 'Stop! Stop!' and we got out of the car and put the boom box on the roof. We were listening to Brian Eno's 'Chemistry,' which is very electronic. Jean-Michel was into music from Talking Heads to Miles Davis, and everything else in between."

They explored the villages around Rome. "We'd walk around at noon in some of these little Italian towns, and the piazzas would be empty," recalls Eric. "It would be like a Sergio Leone film with Clint Eastwood in some sort of a showdown. We'd be in the square and the sun would be blazing, and the dust would be blowing across the street, and our little party would be like visitors from another planet, you know. Time travelers with a beatbox booming out this electronic kind of very hypnotic, sensual music. At noon in Italy, everybody is taking a siesta, and the only people we saw were noonday junkies rustling in the shadows of archways."

When they arrived in Modena, Emilio Mazzoli treated his guests to a lavish lunch. Mazzoli, who looked like a cross between an Italian Henry Geldzahler and Santa Claus, was a gracious host. But the painter and his would-be patron had some trouble communicating. "He had like sixteen kids, who were all sitting with us at the table," says Eric. "He was a very, very wealthy man, and a very, very friendly man, and he was trying to entertain us, but he couldn't understand what we were saying."

Mazzoli had seen Basquiat's amazing productivity on the last trip, and he had big plans for the artist. Now that he was back for a week or two, the dealer was determined to cash in. "Eventually we got taken over to this industrial section of town, where there was a whole hangar that had been rented for Jean-Michel to paint in," he says. "It might have been ten thousand square feet, with fifty-foot ceilings."

By now Basquiat knew what to expect. In the cavernous space, workmen were constructing enormous canvases, twenty-five by fifteen feet in size, according to Eric. "I was really wondering whether Jean was going to be able to handle something of this scale," he says. "But he seemed totally unfazed. He had no preconceived notions of what he was going to do, and he just began painting. The spontaneity was incredible. Then, when the spontaneity began to run out, he started picking up all these books to copy from. Children's books on dinosaurs, dictionaries."

Modena itself was not particularly inspiring. Says Eric, "It looked like a suburb of Alphaville. All the streets were named after scientists—Enrico Fermi, Einstein. We were staying in this military-

green marble cube of a hotel perched on the edge of an industrial plain."

Jean-Michel later told a friend that he felt like a freak when he walked through the streets of Modena. The young kids dressed in sports clothes had never seen anyone like the artist, with his dreadlocks and paint-smeared suits.

In a piece written after the artist's death, Frederick Ted Castle recalled his brief encounter with Basquiat, Nosei, and Mazzoli in Modena. Mazzoli, recounted Castle, was impatiently waiting for Basquiat to complete a series of works he had commissioned. Castle was invited along to the dinner where a negotiation over the works took place. Basquiat seemed to be on a hunger strike; he ordered only clear broth, which he didn't eat, while Mazzoli feasted on sausages. Mazzoli spoke no English and Basquiat spoke little Italian, so Nosei acted as translator. According to Castle, Mazzoli wanted to publish Basquiat's prints and pay him with just a few artist's proofs. Basquiat wanted to be paid for the edition in its entirety. Basquiat stubbornly held out until Mazzoli angrily caved in. As Castle pointed out, "He never trusted people and he figured they were out to screw him." Usually, he was right.

The trip wasn't all work. Jean-Michel had a knack for finding the trendiest nightspots, especially when the three were in Rome. "We would hang out at night at this place called Il Paradiso, which Jean-Michel had discovered. It was like a superelegant burlesque-caviar bar. It had about a hundred little velvet sofas, all facing the stage. And they had these fifteen-minute doses of exotic entertainment. There would be a mariachi singer, and some sort of Marlene Dietrich–type stripper, and then the red velvet curtains would close and flames would be projected on them," Eric says.

Every night, they'd phone home, begging Jeffrey Bretschneider to join them, and describing their favorite hangouts, including Il Paradiso. "It was weird," says Bretschneider, "but when they told me about those flames, it reminded me of Dante's Inferno, and I got an image of the first taste of hell."

By the end of two weeks, Basquiat had covered eight huge canvases with his trademark doodles. At least one painting reflected his reaction to being forced to produce on demand: a skeletal male

with a halo, leading a flame-colored, fatted cow; both appear to be imminent sacrifices.

Basquiat was fed up, and he decided to leave immediately. The three raced to the airport, just in time for the next flight. As usual, however, his spontaneous behavior was thwarted by the authorities.

"Jean-Michel had something like a hundred thousand dollars in cash," recalls Eric. "It was in American dollars, and he didn't want to declare it. We each had about thirty-five thousand stuffed into our boots."

Jean-Michel and Suzanne waited in the ticket line while Eric returned the rental car. "We only had twenty minutes left to catch this jumbo jet to America. When I got back, Jean-Michel was standing with Suzanne in the middle of the lobby," says Eric. "He was wearing that same paint-splattered fishing cap and Armani jacket, and his dreadlocks were sticking out. And he was kind of smiling and waving in slow motion, like Stan Laurel. Suzanne's eyes were bugged out."

The reason was soon apparent. "On either side of Jean-Michel were two Italian policemen with Uzis, and a detective in a trench coat from Interpol. They took us into the bowels of airport security. All our luggage was there, including the cardboard box full of cassettes, which had somehow remained intact for the whole trip. I think they thought we had drugs. You know, because Jean-Michel was black, and he didn't fit any profile. They found the money right away. They were very polite about the whole thing. They marched us through the airport to Interpol. It was like *The Man from U.N.C.L.E.* They wanted to know where we got the money. We told them Jean-Michel earned it. And it was like, sure, this black guy made a hundred thousand dollars for eight paintings. They didn't believe it for a minute."

The three were interrogated for an hour, Italian style, over cups of espresso. After Mazzoli verified that Jean-Michel had been paid for his artwork, the luggage and money were returned. Amazingly, they even managed to make their flight.

Back in New York, Jean-Michel handed Eric $800. But after that the friendship cooled. "He used to come over and call me on a daily basis, but now the calls were coming fewer and fewer. He was smoking cocaine, and that produced a very touchy paranoia and edginess.

He was just very sensitive. And he began to see all kinds of conspiracies. It must have been hard on Suzanne, because here he was at the height of his fame, with all this money, getting a taste of the good life, and already he was getting disenchanted. He was surrounded by all these people who wanted him to buy drugs. He was still riding high. But in the next six months he started to bite the bit. You can only glad-hand so many people so long, before it begins to kill your spirit."

Meanwhile, Basquiat's efforts in Modena were already paying off for various art dealers. "I had to buy the paintings back from Mazzoli," says Nosei. "And I gave some money to Jean-Michel and I sold the paintings to Bruno." "There was all kinds of double-dealing going on behind his back," says Brett De Palma.

Perry Rubenstein, who began collecting Basquiat's work after being introduced to it by Mazzoli, understood the complicated dynamics of the situation. "I'm sure Jean-Michel just got sick of being there. And having him paint the show *in situ* was just a money-saving tactic, knowing the parties involved," he says. "From the perspective of the dealers, there was frustration with an impossible and uncontrollable artist. Mazzoli felt that one experience was enough for him. I think Jean-Michel perceived he was just a producer of material from the dealers' point of view. This is when he really began to feel he was making pictures for the white man, and you can see it in his subsequent work. 'Mercanti di Proscuitto' [sic] . . . is a clear reference to the pork dealer Emilio Mazzoli."

"Ultimately it came back to an assembly-line attitude," says De Palma. "Once the work was done, the dealers became very possessive of it, and tried to control it. Jean used to say, 'It's like feeding the lions. It's a bottomless pit. You can throw them meat all day long, and they're still not satisfied.' "

"They set it up for me so I'd have to make eight paintings in a week, for the show the next week," the angry young artist told writer Cathleen McGuigan, when she interviewed him for *The New York Times* Sunday magazine. "That was one of the things I didn't like. I made them in a big warehouse. Annina, Mazzoli and Bruno were there. It was like a factory, a sick factory," he said. "I wanted to be a star, not a gallery mascot."

GO-GOING WITH LARRY

"It's cute to be 20 and be pursued when hundreds of young artists are dropping their slides off . . . but the crass fast-turnover speculators' market can have a deleterious effect on an artist's future career. . . . We are no longer collecting art, we are buying individuals. This is no piece by SAMO. This is a piece of SAMO."

—Rene Ricard, "The Radiant Child"

Larry "Go-Go" Gagosian, always on the prowl for a deal, first came across Basquiat's work by chance, at the Public Address show, in October 1981. "I went over to Annina's because Barbara Kruger was a friend of mine and she said she was in this group show," he said. "I had never heard of Basquiat. I'd never seen his work. I had never heard of SAMO. I knew nothing about him."

Gagosian, a private dealer who had a business arrangement with Nosei, was familiar with all the other artists: in addition to Kruger's trademark photographs-with-aphorisms, there were several portentous Jenny Holzer pronouncements, some of Keith Haring's radiant doodles, and six Basquiats—large foreboding heads. Gagosian says he was instantly struck by the young artist's paintings. "I just got, you know, like a shiver," he recalled in an interview in the art-filled office of his gallery in the former Park-Bernet building on Madison Avenue. "I just thought the pictures were really kind of electric. One was an incredibly dense, intricate painting of a head that looks like a skull with the teeth just kind of bristling, like an architecture inside the brain. I'd never seen anything quite like them."

Gagosian acquired several paintings on the spot. He also met the artist, holed up, as usual, in the back room and smoking an enormous

joint. "He was in Annina's office wearing some kind of work clothes that were splattered with paint. I was startled to see a black artist, and particularly one that was—you know—with the hair. I was taken aback by it, and kind of put off, I guess, because I just wasn't prepared to relate to someone who looked like that. He reminded me of Mike Tyson, the fighter. But as soon as I started talking to him, he had this kind of high, sweet voice, and he was disarmingly articulate. And I just felt immediately comfortable and uncomfortable, which was a feeling that I had as long as I knew him."

It was probably mutual. If Martin Scorsese were making a movie about the art world, Gagosian would be a central character: the dealer as Armani-suited hustler. From his sleek helmet of silver, brush-cut hair to his spotless calfskin loafers, Gagosian has an almost sybaritic air of luxury; a *fin de siècle* finesse.

In the two decades that it's taken him to master the art world, Go-Go has more than earned his nickname; he's notoriously relentless in his pursuit of the deal. Wrote Grace Glueck in *The New York Times* in 1991, "His cocky presence, insatiable ambition and meteoric success in the resale market—that is, works that are resold or traded after their original purchase—have made him, for many, a symbol of the bullish 1980's, when artworks were traded like Wall Street commodities."

Gagosian's secret of success is the knowledge that anyone will part with anything—if the price is right. This basic business concept was a relatively new one in the art world, and Gagosian has been credited with virtually inventing the secondary market, starting with his extraordinary coup in 1985 of seducing Burton and Emily Tremaine, whose legendary postwar art collection—including Piet Mondrian's "Victory Boogie Woogie," resold to Si Newhouse for a reported $11 million—had long been the grail of both auctioneers and dealers. Typically, he contacted the Tremaines with no prior introduction—he simply found them in the phone book and chatted them up.

Gagosian sought out treasures that weren't for sale and offered them to a select list of clients, like Newhouse, British advertising mogul Charles Saatchi, and Hollywood master-of-the-universe David Geffen. His unorthodox techniques—xeroxing, for instance, pages from magazines and art books and offering works that at the time

weren't his to sell—earned him a great deal of resentment from his colleagues, who still considered dealing a gentlemanly profession. He once asked a journalist who was about to interview him an interesting hypothetical question: "If somebody says somebody was in trouble with the law, you can't print that, can you?"

Gagosian has had his share of business disputes, and he has succeeded stealing artists from other galleries by doing what he always does: making them an offer they can't refuse. He wooed David Salle away from Mary Boone. But when he snared Peter Halley (who was reportedly given a $2 million cash bonus, something both Gagosian and Halley denied in depositions), Ileana Sonnabend responded with a multimillion-dollar lawsuit eventually settled out of court in Gagosian's favor. Halley, who says he went to Gagosian because he was offered a "very attractive contract," later left the gallery reportedly because he didn't feel the agreement was being fulfilled.

Gagosian has also had the occasional legal problem, starting with the repo man who at one point appeared for a car Gagosian refused to make payments on. (He claimed it was a lemon.) John Seed, who worked at Gagosian's Los Angeles gallery in the early eighties, tells tales of a marshall showing up at one point, and says he had to deliver checks to at least one person who had successfully sued the dealer. Gagosian denies ever being confronted by a marshall. But some of his past employees have been uncomfortable enough with his business ethics to leave the gallery.

Gagosian has sustained his high-wire act, even in a bear market, by leveraging his gallery to the hilt: there have been millions of dollars' worth of bank liens on his art holdings.

Although documents filed with the New York County Clerk for 1990 and 1991 showed that he owed the IRS some $13 million dollars, the IRS later acknowledged that it had filed the claim twice and that it was not Gagosian Gallery Inc. but the consigner of several works of art to the gallery, a company called Contemporary Art Holding Corporation, that owed the money—$7 million. Gagosian has no current financial connection to this corporation, which was formed when he and several shareholders acquired the Richard Weisman collection. Nonetheless, if he sells the two art works consigned to his gallery, the IRS may claim the proceeds.

There are also past Civil Court Summons for unpaid debts in the early 1990s, ranging from Busters Cleaning Corp. to Rizzoli Journal of Art. All of these disputes have since been settled. But Gagosian is in the midst of a new dispute: he is currently being sued by Ralph Lauren, from whom he rents his gallery, because he has put his rent in escrow until water damage to the space has been repaired.

Says one source, "If you work creatively with accountants, you can put off taxes and personal debts for extended periods of time. His whole gallery runs on a crisis mentality."

But Go-Go has never been one to let a few debts cramp his style. His Upper East Side carriage house, originally designed for Christophe de Menil, has its own lap pool, and he recently acquired two town houses from David Geffen. Toad Hall, his $8 million estate on East Hampton's posh Further Lane, was designed by Charles Gwathmey and formerly owned by François de Menil. There Gagosian hosts his famous summer soirees, where he premieres films in his private screening room for an elite group of friends—people like Geffen, Ron and Ellen Delsener, Jann Wenner, Claudia Cohen, Bruce Wasserstein, Mick Jagger, David Salle, and Eric Fischl. The mix of artists and collectors is as socially stimulating as it is potentially lucrative. Although he claims not to have any backers, Gagosian at one point became partners with Peter Brant in 575 Broadway, now the site of the SoHo Guggenheim. (They later scotched the deal.)

Gagosian told one interviewer that all of his revenue is "self-generating capital . . . I've never had a backer, never had a partner, never had a rich uncle, never had anything like that. With the money I made I've reinvested—*parlayed* it, I guess, is the word."

Chauffeured around town in an Audi station wagon, he never stops working the cellular phone. In the last ten years, he has on several occasions been responsible for the highest prices ever bid at auction. And his three galleries are among the toniest in the world: in addition to his elegant penthouse headquarters at 980 Madison Avenue, he has a beautifully renovated, garagelike gallery at 136 Wooster Street in SoHo, and he recently opened a spectacular space on Camden Drive in Beverly Hills, designed by architect Richard Meier. It's right next to Mr. Chow's, Basquiat's former home-away-from-home in L.A.

But perhaps one of Gagosian's biggest achievements was bonding

with Leo Castelli in the mid-1980s. For four decades, Castelli has been the world's most famous and revered art dealer, and receiving his imprimatur is the art-world equivalent of being knighted by the queen. The match at first seemed ludicrous; the courtly old-school gentleman and the brazen supersalesman. "When he wants a painting, he goes to any price to get it," Castelli told *Forbes*, admiringly, in 1990. Gagosian had wowed the older dealer in 1987, shortly after the death of his wife, Antoinette, by selling some of Castelli's holdings so that he could pay the estate taxes. Gagosian managed to turn around the $1.5 million deal in twenty-four hours. Gagosian has never been subtle: he was not above trying to buy Castelli's friendship with a $7,500 Patek Philippe watch.

Their business association was mutually beneficial: It was Castelli who introduced Gagosian to Si Newhouse. Three years later, Gagosian would make headlines by acquiring for Newhouse Jasper Johns's painting "False Start" at a Sotheby's evening sale for the record-breaking price of $17.1 million—the highest ever paid for a living artist. His partnership with Castelli conferred and enduring level of art-world respect; he is now considered a world-class dealer, not just a secondary salesman. At both his uptown and downtown spaces, Gagosian has mounted what even competitors acknowledge are museum-quality shows of work by artists ranging from Francesco Clemente to Egon Schiele.

Gagosian epitomizes the ethos of the eighties: the conspicuous merger of art and commerce. An art-world Trump, he has perfected the art of the art deal.

Gagosian was not always such a highflier. His father, an accountant for the city of Los Angeles, was also an actor who ran the Armenian Connection, a theater group in Fresno with which William Saroyan was affiliated. His mother had bit parts in several movies, including one by Orson Welles, and later dabbled in painting. After working in the lower echelons of the William Morris Agency (as did, famously, David Geffen and Michael Ovitz), Gagosian began his art career in the mid-seventies peddling kitschy posters near UCLA, his alma mater, from which he graduated in 1969. Within a year he had opened his own art gallery and was catering to the collecting tastes of

real-estate developer Eli Broad and *Dynasty* and *Love Boat* producer Douglas Cramer.

Says Broad, "Larry was very aggressive in the early years. He had lots of courage. If you wanted to acquire art and knew what you wanted and told Larry, he'd find it. He made things happen."

In 1979, he moved east, opening a SoHo gallery that he ran with Annina Nosei. At this point his knowledge of the New York art world came primarily from "a combination floating crap game/little art dealership in the ground floor of Leo Castelli's building. I was sort of friendly with those guys and we'd sit around, and we'd play cards sometimes, and try to do little art deals, and [I'd] keep my ear open. I learned a lot just being there, and Leo was in the building."

Before long, Gagosian bought a space there, sight unseen; lacking the funds, he traded a Brice Marden painting and $10,000 for it. One of the first artists he and Nosei showed was David Salle. By 1980, he had moved back to Los Angeles, but he continued to do some business with Nosei. In 1985, he opened his own gallery in New York, this time in Chelsea, and quickly became the leading secondary dealer.

An expert negotiator, Gagosian has never discovered new talent. Instead, he deftly plucks the best of what the art world has to offer— whether it's art or artists—from others. And nobody gets in his way. Once, legend has it, Gagosian actually offered to trade Alfred Taubman a house he already owned for some paintings he wanted from Taubman's collection. (Gagosian says that he simply wanted to trade Taubman art for real estate.)

When Newhouse decided to sell some of his art collection directly to Sotheby's, ostensibly cutting Gagosian out of the deal, Gagosian quickly brought in David Geffen, who "cherry-picked the cream of Newhouse's collection," according to one source, paying about $40 million for works on which Gagosian earned a three percent commission—about $1.2 million. "Larry always finds the angle and runs with it," he says.

Douglas Cramer has bought art from Gagosian since his earliest days in L.A., and estimates that nearly a third of his collection— which includes over five hundred pieces—was acquired from the dealer.

"Larry loves being the center of gossip—a month doesn't go by when you don't hear that he is overextended and about to fold," says Cramer. "There's a lot of envy. But he's a classic survivor. He's always made more sales faster than anyone else. He's a wonderful negotiator. He has an encyclopedic memory for what art is where. Larry always takes the opportunity to get to every collector's house and look at every wall. He would have Polaroids of what was hanging in my house, and I never knew how he got them."

According to Cramer, such feints served both parties well. "Larry is brilliant at putting together a number of people from one end of the country to another. He starts off a whole chain reaction. I have sometimes been part of trading something I never thought I would trade, to get something I never thought I would have a chance to own. It's miraculous the way he keeps all those balls in the air and makes them land in the right time and the right place. If the art world were a circus, Larry would not only be the ringleader, but the high-wire act and the man shot out of the cannon."

But another source sees it differently. "What motivates Larry is the deal. It's not even the money or toys he surrounds himself with, whether it's a Ferrari or anything else. Those give him very little pleasure. He only lives from transaction to transaction."

Such wheeling and dealing becomes quite convoluted. In a totally unregulated industry, the law is caveat emptor. "The business of art-dealing has an implied lie," explains another dealer. "If you bring something to be sold, and you agree to a selling price, it lets the dealer sell for a certain amount above your price without telling you, and keep the difference. In any other business, that would be considered fraud. But in the art world, everyone understands it."

Gagosian's relentless bargaining is done in a non-stop round of phone calls, in which the ante is constantly being upped. And Gagosian never lets go. Says this source, "He will call twenty times a day without fail. Once you buy something, he keeps on calling you. Most people have a set of social rules they conform to. Larry doesn't. Everything is breachable. 'No' is never an answer."

Basquiat was no exception to Gagosian's take-no-prisoners business approach. He had planted the seeds for a long-term relationship with

the young artist during his first conversation with him in the back room of Nosei's gallery. Not that doing business with Basquiat was exactly a sophisticated process. Anybody with the right attitude and the right amount of money could purchase something from the painter, who was constantly in need of cash to support his various habits.

"We became friends, and then he moved to the studio on Crosby Street, and I started buying work from him directly and Annina got furious," says Gagosian, who quickly began to take advantage of Basquiat's ability to churn out paintings instantly in return for the cash he always needed for drugs. "But you know, there was no other way to work with him. It wasn't like I was going behind Annina's back. It was just that the way work left the studio was always kind of unstructured. He was always accusing me of ripping him off. (Indeed, Basquiat complained to one friend that Gagosian had never paid him for an entire show.) "But I never consciously or unconsciously ripped him off. It was the way he chose to be paid, in cash, or in barter, or with clothes, or like he'd say, 'Well, buy my girlfriend a trip to Paris,' or something."

On a certain level, Gagosian felt he had met his match when it came to playing fast and loose. "He was nobody's fool. I never heard anybody get the best of him. When he'd walk in the room, he would send out an energy that would blow everybody else away, without trying to. It was this kind of natural power that he had, that was unmistakable, and I think it made some people very nervous. And I think it turned some people against him. He was the victim of a lot of envy. I take pride in the fact that I could almost keep up with him, because he was very, very smooth."

Gagosian may have been Basquiat's only dealer who was, in some sense, a kindred spirit. They both reveled in bad-boy behavior—whether it was their attitude toward women, partying, or challenging the system. In an article in 7 Days in 1989, journalist Deborah Gimelson attributed some of Gagosian's success to his "perverse charisma." "All the people Gagosian has associated with are people with power and position. They can't afford to be naughty," she quoted one dealer as saying. "So Go-go is their bad boy, the renegade. They get vicarious pleasure out of his antics. . . ."

Gagosian's rapid rise soon made him the subject of rumors rang-

ing from how he acquired funding and art to whether or not he harassed young women on the telephone, something he adamantly denies. Besides his early reputation as a renegade, the dealer shared another trait with Basquiat. According to those who know him well, despite his business acumen, Gagosian has a childlike helplessness when it comes to ordinary day-to-day necessities.

"He's like the art dealer-cum-rainman. He's a gifted dealer, a genius," says one observer. "His memory and ability to digest and retain information is extraordinary. Yet he can't even make a cup of coffee for himself. He is totally dependent on other people. He has to have a full staff in the Hamptons, a full staff at his house in New York, and a big staff at the gallery. Everyone is there so he won't be lonely."

Still, there have been few obstacles to Gagosian's success. In addition to Newhouse and Geffen, his clients have included Keith Barish, Carl Icahn, Ron Perelman, and the late Gianni Versace, who not long before his death decorated his town house with contemporary art, including paintings by Basquiat and Schnabel.

"You have to understand the audacity of this guy and that this is a world where there are no rules," says a source. "It's one of the last vestiges of laissez-faire true capitalism. It's run and gun. It's a great place for pirates. And everyone becomes a beneficiary and a victim if you're in it long enough." Basquiat was both.

In April 1982, Nosei and Gagosian organized a show in Larry's Los Angeles gallery, which occupied a warehouse on Altmont Street. By now, Basquiat had his enfant terrible act perfected, and the trip to Los Angeles was a classic example. Between Gagosian's aggressive business dealings and Basquiat's outrageous behavior, it's difficult to say who was exploiting whom.

It began even before the artist left New York. First, Basquiat persuaded Gagosian to fly out several members of his entourage. "I bought first-class tickets for Jean-Michel, Rammellzee, Toxic, A-1, and Fab 5 Freddy," says Gagosian, rolling the names out like rap-record labels. "Annina was furious because she thought I was really spoiling them. But I thought it would be fun. And maybe I was trying to impress them, because I'm not above that."

Soon after the flight took off, Basquiat and his coterie were cozily ensconced in the first-class section. Basquiat took out a quarter-ounce of coke and dumped it on a cocktail plate. "I've never seen anything like it on a plane," says Gagosian, laughing. "It was like these four kind of rough-looking black kids hunched over a big pile of coke, and then they just switched over to these huge joints, and they sat up there and smoked them. It was just wild. They had their big hooded ski glasses on, and big overcoats. The stewardess freaked. I was terrified. I thought, 'Oh God, we're going to jail.' "

But Jean-Michel remained completely cool. "The stewardess came over and she said, 'You can't do that on a plane. The authorities are going to be waiting for you,' " recalls Gagosian with obvious relish. "Jean-Michel just looked up at her. He had perfect timing and he said, 'Oh, I thought this was first class.' "

Nosei was forced to act as the chaperone. She grabbed the coke from Jean-Michel and flushed it down the toilet. The high jinks, however, had just begun. Jean-Michel was staying with two of Gagosian's factotums, Fred Sutherland and Steve Koyvisto. Matt Dike, another Gagosian assistant, was the designated chauffeur and baby-sitter. Within hours of arriving in Los Angeles, Basquiat would nearly get arrested.

The evening of the opening, the artist, who had spent the last several days partying, was nowhere to be found. "There was some concern about where he was," says Claudia James, who worked for Gagosian at the time. His whereabouts were soon common knowledge. Jean-Michel was with Ulrike Kantor, a forty-something art dealer, and the ex-wife of one of L.A.'s better-known collectors. "There were conflicting reports," says Gagosian. "She was saying that he couldn't get it up, and he was saying he was a prisoner of her bed. But he was late for the opening."

Kantor had met the painter at a dinner at gallery owner Jim Corcoran's. Apparently, it was lust at first sight. "I took one look at him and he at me, and we both said, 'Oh my god,' " she recalls.

"I just wanted to meet him, not necessarily to sleep with him. He was one of those people that is totally fascinating. He had what you call an aura. I sat next to him at dinner and five minutes later, we left." After going to a few clubs, they went back to Ulrike's place, a

Frank Lloyd Wright house, where Basquiat holed up with his new lover for several days.

"He had the most well-proportioned body I've ever seen in my life," she says. "He was slender, but there was something very powerful about him, like an animal. The night we spent together really left an impression on me. One morning, my daughter saw him in the bathtub, and said, 'Mommy, that's the ugliest man I've ever seen.' He smoked Gauloise cigarettes constantly. I kept telling him he should quit. But he said, 'Picasso lived until he was ninety years old.' "

Once again, Nosei was forced to play mother superior. "What did you do?" she screamed at Go-Go. "You let your artist be vampirized by this woman. Call her up and tell her to send him here." "Why?" asked Gagosian, somewhat amused by the whole thing. "Because he's a minor. And she will take paintings from him!" At least the dealers had their priorities straight.

"So Larry called Ulrike," says Nosei. "And Jean-Michel was crying, 'Get me out of here! I don't have a car! I don't know where I am! I want to leave!' I got on the phone and said, 'Ulrike, this could have been your son. Couldn't you have spared him? He's a little kid, nineteen years old.' All she said was, 'Annina, I want to talk to you—we could make business.' But I told her I didn't want to make business with a person like her. I mean this idiot, a woman of my age. I was very angry."

"She kept calling my house and gallery," says Kantor. "I wouldn't answer the phone. Annina protected him like a dog. That was her little property. He said, 'She just wants to put me in the basement and make me work. I'm going to be big in spite of her.' "

Eventually Gagosian sent a car to pick Jean-Michel up. "Larry was freaking out," says Dike. "He thought she was going to steal Jean away from him."

The opening was a huge affair. The cream of L.A. collectors, dealers, and even a few celebrities showed up. Jean-Michel hung out in the back room, smoking pot. Recalls Dike, "Jean was wearing a Walkman and giving everyone an evil stare, and wouldn't talk to anyone, including all the heavy-duty collectors. He could have won the Asshole of the Year award that night. He was a brat before he was

famous, and a brat after he was famous. But the paintings were incredible."

The show was completely sold out. Eli Broad, Thomas Ammann, and Scott Spiegel snapped up all the paintings. One Los Angeles critic coupled the review of Basquiat with one of a show by Julian Schnabel, the artist of the moment. "Basquiat's works are direct and furious reflections of a decadent, sadistic society. Calligraphic markings, puerile stickfigures, symbols of angels and devils, black men and white men, teeth bared, wearing crowns, carrying scales of justice. Robotoid eyes roll back to show that the brains are fried, there is no hope. There seems to be almost no distillation or interpretation. It is as if the city itself crawled on these canvases and stomped around."

Or Jean-Michel's demons worked themselves out in paint; there was a fierce "Red Warrior," and two of the canvases—festooned with real feathers—were entitled "Tar and Feathers."

"It was one of Jean-Michel's best shows," says Claudia James. "But he was already acting disturbed. There was this dynamic going on of he was the bad child, and Annina was saying, 'Come on, be good,' and Larry was kind of playing on that a little bit, because he thought he was more hip. Jean was smoking pot and listening to headphones the whole time. He was rude to collectors, turning on his heel and walking away. In my opinion, it seemed that even at that time he knew what was going on. That he was being used. And he went along with it, but begrudgingly. And then he would be angry and act out. It wasn't as if he had no inkling of how the system worked."

"Basquiat was a very paranoid guy. It was probably the coke. I remember one morning he showed me his nose, and he said, 'See? There's a hole right through it.' He wasn't bragging. He was really shaken by it and I don't think he did coke for at least a couple of hours after that," says Gagosian. "He needed constant sources of excitement, in whatever form that took, whether it was money or sex or drugs or pain. He was just like a kind of tragic figure, someone who when they just can't get any more, ends up with a feeling of this crashing emptiness, and finally just implodes."

Gagosian had arranged a private party at the China Club to celebrate the opening. But Basquiat insisted on making a drug-related detour. "Jean was always wanting you to do something illegal and

putting your life in jeopardy," says Dike. "So we went and got like an eighth of an ounce of coke, a big bag of pot, and various other things. We were driving along and these cops get behind us. Jean's got dreadlocks out to there, and this big hat, and one of those intense suits, you know, with paint on it. And the cops stop us, thinking the car was stolen."

The artist flashing his bank book did not convince the law. "The cops didn't believe it when Jean said he was a painter. They thought he was some big drug dealer or something. But just as he was about to go through his pockets, they got a call about a robbery right down the block, and they had to let us go. I was sweating bullets. And it didn't even faze Jean. It was like he knew all along he wasn't going to be arrested, or thought he was so high on the hog that nobody could touch him, and he walked into the party like nothing was wrong."

Dike saw the Gagosian-Basquiat relationship as mutual exploitation. "Larry knew he could make a lot of money off of this guy," he says. "And I guess Jean knew it too. But it was a sick, weird thing. Jean was kind of getting snowed a little bit. He was being babied by Larry. It was like, 'Anything the guy wants, get him. If he's horny, go get him laid.' "

"Larry and his clients were profoundly, desperately cynical people, who used their power to collect souls," says John Seed. "Larry had to pay people to be around him, in the sense that his employees, clients, and associates were never people who liked him. The really wealthy were entertained by him, but that doesn't mean they liked him. Larry's view is that all human beings really add up to in the end is what they can buy."

According to Seed, Gagosian and Basquiat complemented each other. "Basquiat was so fucked up that Larry found someone he could rescue. Jean-Michel could suffer all the shit of the world, but was still a world-class manipulator who could keep up with Larry. He could both punish Larry and play the lost boy. People like Larry and Jean-Michel spend their lives making sure they surround themselves with people who will disappoint them and betray them, because they have betrayed themselves so badly. What was Larry and Jean-Michel's relationship like? Sharks and piranhas."

Basquiat stayed in California for several months. It was the first of several long Los Angeles sojourns, interrupted by trips to New York, as well as a brief trip to Zurich for a show at the Bruno Bischofberger Gallery.

For a while, he was living at the Chateau Marmont, in the Belushi Suite. "He was always into historical ironies," says Stephen Torton, who flew out to Los Angeles with Basquiat along with Rammellzee in October. Typically, Basquiat bought first-class tickets, paying for them in cash—$5,000, in $100 bills. "We almost missed the flight because they didn't think the bills were real," says Torton.

Basquiat maintained his nocturnal schedule in L.A. "He never got up, he never went to the beach, he would just go to nightclubs and then sleep. Rammellzee and I would just sit there waiting for him to wake up, and I made all these little drawings," recalls Torton. "I remember when he looked at them, he got really pissed off. He said, 'You should never change your mind about a line.' "

They went to Maxfield's, a tony boutique that was Basquiat's favorite clothing store in L.A., and bought matching Armani suits. Then they piled back into the rented limo. Basquiat and his entourage seemed to be an irrestistible target for the Los Angeles police. Once again, he and his cronies were nearly busted.

"I was the chauffeur," says Torton. "Jean-Michel and Rammellzee were in the back. We were going from club to club. The cops made us get out. Jean and I put our hands up. But when Ram put his hands up, he started combing out his hair. The cops got furious, but he said, 'They were already up there, I thought I might as well use them.' They thought we were drug dealers. But the car was rented by Gagosian's gallery, so eventually they let us go."

Torton and Rammellzee stayed with Basquiat for a week. At the end of the month, they all flew back to New York, just in time to catch Becky Johnston's "Ciao Manhattan" party, held at Port Authority. Johnston, a well-known screenwriter (*The Prince of Tides*), had been involved with Basquiat. Later, she and Tamra Davis would conduct one of the few videotaped interviews with the painter.

TO REPEL GHOSTS

B y the summer of 1982, Basquiat's relationship with Nosei had visibly deteriorated. He had been selling his paintings surreptitiously to various dealers for months. "It was strictly cash and carry," said Lawrence Luhring, a former director at the Nosei gallery. "I would go over to Crosby Street and give him six thousand dollars to get a painting. There would be a lot of hundred-dollar bills lying around, a pile of coke on a mirror, and a lot of people coming and going. You could never tell if he would want you to hang out, or he would tell you to get the fuck out. I was trying to get Jean-Michel to sign up with the Bon-Low Gallery, where I was working. Then I went to work for Annina. That made him angry at me. Annina has her own problems, but I really believe she respected Jean-Michel."

But Basquiat was fed up with Nosei, and when he was back in New York in August, he severed his ties in a typically dramatic way. While Nosei was away in Europe, he and Torton went to the gallery armed with switchblades. "We were totally high on dope," says Torton.

They went down to the basement, where Basquiat began to separate the paintings he thought he owned from the ones that belonged to Nosei. Then he began wildly slashing his canvases as Torton pulled them off the stretchers. "We made a big pile of all the cut-up paintings. He destroyed the ones he didn't ever want to be sold. It was like a cowboy movie," says Torton.

Torton hid a small painting of cars in his coat sleeve to surprise Basquiat later. As a final touch, the artist and his accomplice poured a bucket of white paint over the pile of shredded paintings. Obliterating the work. Seizing the moment.

"It was an act of control," says Fab 5 Freddy, who ran into Basquiat that night in the East Village. They celebrated his liberation with a cognac at the Red Bar. "It was a laugh, a joke. Jean had a great sense of humor, and it was like, 'Yo, man, I fixed her. I went in there and slashed all those paintings. I'm out of there, man.' He knew how to get even. He knew how to use the power he had. He understood very clearly the power of the work, and he understood the commodification of the work. Basically, it was a symbolic way of cutting those ties. So we toasted the whole shit.

"Jean-Michel had a clear sense of history, and he knew certain gestures would be remembered and he knew the word would get out. Also, part of the symbolism was that here these people may think they have this wild black man in this basement that's uncontrollable. A lot of the rumors were racially inspired. But he was like showing people that he was in control. So that was a thing that he knew would raise everybody's head, because that was a point in time when paintings was the hottest thing. They was as hot as junk bonds."

Nosei said Basquiat told her he slashed his work since he couldn't reuse the canvases, because "ghosts" of the previous pictures were showing through. "So he destroyed them all, he cut them, and the cutting of the canvas became good, fantastic. He knew inside himself the piano keys his genius could play. He knew the silences, and he had incredible ability. But he also lost it sometimes and he knew when to censor his own images," she says. "I am stingy, so I would have saved parts of those paintings. But the size was wrong. He never did any more in that type of style."

Nosei threw a tarp over the ten intact works left in the gallery. "Don't remind me of these," she told Liz Gold. She had a hunch they might be worth even more someday. She was right.

Basquiat had totally destroyed the paintings. But the ghosts had not been vanquished.

Today there is no artist working in the basement of the gallery. Indeed, Nosei, like many other SoHo dealers, has relocated to Chelsea. But Basquiat had left his mark. Through the early 1990s, a towering structure of wooden slats with a crudely painted image of a black man wielding a stick stood by the door to the coffin-shaped

space where he used to work. On bits of overlaid paper are some of
Basquiat's typically suggestive word games: "32. The disposal of a
bonanza. 33. Refreshments and ethics. 34. Tough yarns." Then a sad,
scrawled litany of dead black artists: "Young Billie, Young Lester,
Young James . . ." Basquiat was always writing his own epitaph. The
piece was called "To Repel Ghosts." It doesn't.

In the subterranean room where Jean-Michel Basquiat rocketed
to international success while painting himself into a coke-crazed
corner, there was still one file cabinet with a Magic-Markered scrawl
of a skull that looked like it was drawn yesterday. Behind a huge can-
vas on the wall, a bit of Basquiat graffiti was reverently preserved. A
small parade of Keith Haring's "radiant babies" climbed the far end
of the space. Souvenirs of famous, dead boys. Radiant babies that left
their unfinished writing on the wall.

Basquiat's violent departure from the Nosei gallery gave Bruno Bi-
schofberger an opening he had been waiting for ever since he had
seen the artist's work at the New York/New Wave show in February
1981. "I thought it was the most interesting work in the show," he
says. Soon afterwards, he acquired a number of Basquiats from Diego
Cortez.

Up until now, Basquiat had consistently resisted Bischofberger's
advances. The dealer had approached him during his solo show at the
Nosei gallery, but Basquiat, angry because he felt that Bischofberger
had been the benificiary of the dispute with Cortez, rejected him.

"He came to Annina's and he was begging to do a show. I was
playing it cool and telling him I didn't want to," he told Tamra Davis.
Now that Basquiat had left Nosei, he finally agreed to make Bischof-
berger his international dealer. (Indeed, Bischofberger claims their
"exclusive deal" dated back to the spring of 1982.)

But Basquiat clearly had his own interpretation of exclusivity.
"After Annina, he felt very unhappy," says private dealer Jan Eric
von Löwenadler, who ran the Bon-Low Gallery. I went up to his stu-
dio and bought a few paintings, and then he gave us a lot of work on
consignment. We had a verbal deal to represent him and do a show.
Then, after about two weeks, he all of the sudden came in with Larry

Gagosian and took them all back. None of my assistants stopped him. They said he was high. Maybe somebody offered him cash or something. At the time, commitments were worth nothing."

Meanwhile, Bischofberger gave Basquiat a one-man show in his Zurich gallery, in September 1982, of works he had acquired. Torton recalls that he and Jean-Michel flew to Switzerland for the opening, only to discover that none had been scheduled. Their stupefied week-long stay was paradigmatic of Basquiat's dealings with Bischofberger.

Says Torton, "When we first got to Zurich, it was like, 'What are you doing here? It's not an opening.' And there was this momentary expression on Jean-Michel's face, as if he had imagined he had become a famous artist, and maybe he wasn't. It was touching."

They turned the trip into a pleasure spree. The two scored heroin in a square near the gallery called Bellevue. "Every day we went and bought our little dose," says Torton. "We had gotten dressed up for the trip, and I was wearing nice shoes and beautiful RayBans and a suit and silk tie. Everybody kept coming up to us because I was white and they thought I was his manager."

Bischofberger took them to his birthplace, the mountain town of Appenzell. "I remember driving along the road in the Mercedes and Bruno offered us a joint," says Torton. "He was just such a sophisticated guy, and he brought it out at the perfect moment. We smoked the pot as we were driving down a country road. They went to a local carnival, where a Felliniesque village scene took place. There was this bumper car thing set up on the mountain," says Torton. "So we got in and bought forty rides' worth of coins. And we were riding in the bumper cars and bashing into Bruno.

"And all of the sudden, it seemed like the whole village came out, and sort of ganged up on Jean-Michel because he was this sort of exotic bird. They were really smashing us hard. We were laughing hysterically."

But Bruno never neglected to get down to business. "Another time, Bruno pulled out a huge envelope of these drawings that he had bought from Diego for like fifteen hundred dollars that had never been signed and asked Jean-Michel to sign them." (Basquiat's 1982

painting "Bruno in Appenzell," contains only one word, "Essen," perhaps a comment on the dealer's voracious appetite for art.)

The Bischofberger-Basquiat relationship mirrored those he had with most of his other dealers—but on a grander, global scale. What Bischofberger provided that nobody else had, however, was a real connection to Warhol, who until that time had managed to avoid the raunchy young man pestering him to buy postcards and T-shirts.

On his frequent trips to New York, Bischofberger always made a daily stop at the Factory. "Andy loved to go with me to galleries and see the artists whom I liked. You know which are the upcoming stars especially in the eighties when this whole new boom of painting was going on. Andy was very thrilled to go with me to all kinds of shows."

On October 4, 1982, Bischofberger was in New York for the auctions. He had already had Warhol do portraits of a number of his artists, including Chia, Cucchi, Clemente, and Halley. Now he suggested bringing his latest discovery, Jean-Michel Basquiat, up to the Factory for lunch, so the two could trade portraits.

"Down to meet Bruno Bischofberger (cab $7.50)," recorded Warhol in his *Diaries*. "He brought Jean Michel Basquiat with him. He's the kid who used the name 'Samo' when he used to sit on the sidewalk in Greenwhich Village and paint T-shirts, and I'd give him $10 here and there and send him up to Serendipity to try to sell the T-shirts there. He was just one of those kids who drove me crazy. He's black but some people say he's Puerto Rican so I don't know. And then Bruno discovered him and now he's on Easy Street. He's got a great loft on Christie Street [sic]. He was a middle-class Brooklyn kid—I mean he went to college and things—and he was trying to be like that, painting in the Greenwich Village.

"And so we had lunch for them and then I took a Polaroid and he went home, and within two hours a painting was back, still wet, of him and me together. And I mean, just getting to Christie St. [sic] must have taken an hour. He told me his assistant painted it."

Stephen Torton, who delivered the painting to Warhol, has his own recollection of the occasion. "He asked me and Suzanne to go along. He said, 'We've earned this.' It was just so beautiful. The first thing Andy said is, 'Are you still selling your paintings for a dollar?'

[Factory photographer] Chris Makos took about twelve Polaroids of Andy and Jean-Michel together, and Andy asked me when he could do my portrait. God, it was exciting. We got back in the car, and as soon as we got to the studio Jean-Michel grabbed a Polaroid and started covering a portrait that he had from a series that he did of Mr. Chow. They were these little five-by-fives with extruding corners. And ten minutes later, he said, 'Bring it to him,' and I grabbed the painting. I was covered with paint because it was still wet and I ran into the street. I stopped a van and I said, 'I'll give you ten dollars if you take me to Union Square.' "

Torton, still dripping, delivered the portrait to Warhol, who took one look at his clothes and asked, "Who painted this, you or Jean-Michel?" Says Torton, "I said, 'What do you care? You never touch your paintings.' "

The moment also impressed Bischofberger. "I had an agreement with Andy that whenever I wanted a young upcoming artist which I thought was really interesting to be portraited [sic] by him, I could bring him there and Andy would do a portrait of him, and I would select or propose a painting in trade. It didn't have to match in value at all. It was just a friendly thing. When I came with Basquiat, Andy said, 'Is he really a great artist?' And I said, 'He is *going to be* a really great artist.' Basquiat didn't really want to stay for lunch. He went home to the studio, and when we got up from lunch about two hours later, Jean-Michel's assistant came running up with a painting of Andy that was still wet. The whole Factory and everybody who was there was admiring it, and Andy said, 'I'm really jealous. He's faster than I am.' Those were his words. I can still hear him saying that."

For Bischofberger, the moment was bittersweet, since Warhol exacted his end of the bargain and ended up coming out ahead. "He sent one of his assistants to Jean-Michel's to choose a painting, and he came back with a really great one, that was already mine in my head. But then when Andy had it I didn't want to make a big story of it. I told Basquiat, but it was too late. It was already gone."

Former *Interview* magazine editor Bob Colacello describes the portrait in *Holy Terror*, the book he wrote about his experiences with Warhol, as "this twisted stick figure with shards of hair framing his

head, like a voodoo halo. Primitive and stylized, it captured Andy's frantic strangeness, his sadness, and his sweetness."

Warhol was suitably impressed. According to Colacello, Andy told Basquiat, "I haven't even picked out a Polaroid yet, and you're all done. I mean, you're even faster than Picasso. God, that's greaaaat."

"Andy no longer saw Basquiat as a rough-looking black boy who might mug him, but as a rising star of the art world, whose paintings were going for $20,000 in Düsseldorf and Zurich."

Even more remarkable than Basquiat's speed was his hubris. The double portrait, entitled simply "Dos Cabezas" (Two Heads), is a split screen, with Warhol's image and Basquiat's image, joined at the head, given equal space.

In many ways, the Fun Gallery show, which ran from November 4 through December 11, 1982, was Basquiat at his best. Says the gallery's director, Patti Astor, "The Fun show was a way for him to get back to his roots, for kind of a breath of fresh air away from all that SoHo bullshit. He knew that he could do what he wanted for us, with no one standing over him, saying, 'My collectors want that.' "

The paintings he had feverishly created on the half debris, half stretchers built by Torton had a rough energy and nasty edge. Anyone who wondered how Basquiat felt about his privileged position as the only well-known contemporary black artist just had to look at the painting in the window: "St. Joe Louis Surrounded by Snakes" showed the boxer, one of Basquiat's heroes, encircled by sharkish white managers. "That was Jean-Michel," said Suzanne Mallouk.

The installation was as self-consciously raw as the paintings; jagged emblems of his current state of the art. There was the self-portrait that was "NOT FOR SALE." And many of the most powerful paintings were homages to his personal heroes: "Charles the First" (Charlie Parker); a white-on-black untitled portrait of Sugar Ray Robinson, consisting simply of a spectral head with Basquiat's trademark crown; a similarly spare rendition of Jackie Robinson, with the epitaph "Versus." Take it or leave it; this was Basquiat's basic vocabulary clearly—and unapologetically—spelled out. (The prices ranged from $6,000 to $10,000.)

According to Torton, Basquiat was initially quite reluctant to do the show. "I'm not doing this East Village shit!" Torton says the artist told Astor. "I'm out of here. I'm at the Whitney."

But once he had agreed to it, Basquiat turned the installation of the show into its own celebratory event. "Every period in Jean-Michel's life, without any irony, should be defined by the predominant drug," says Torton. "The Fun Gallery was *fun*. We were high on opium." Basquiat, Torton, and Bill Stelling, Astor's partner, were up all night hanging the show. "Jean was going nuts and changing the paintings all the time," says Astor.

"We soaped the windows and Jean drew little crowns," says Torton. "I remember at four a.m. there were two more paintings that Jean wanted, and they were back at the house. So I ran all the way to Crosby Street. I tied these paintings, grabbed a cab, and ten minutes later they were on the wall." "I left the gallery at three a.m. When I walked in at noon the next day," Stelling recalls, "Jean-Michel was still standing there painting, not satisfied."

It was the opening of the week. Crowds filled the street outside the gallery. "When I went to that fucking opening, and I seen the crowd," says Fab 5 Freddy, "I was like, 'This is incredible.' It was like a Hollywood premiere, you know. Or like getting into a hot club. It was really cool to see all the little graffiti kids mixed with the collectors." "All the big collectors were there," says Stelling. "The Schorrs, the Neumanns, the Rubells, Elaine Dannheiser."

Basquiat and Torton were resplendent in matching Armani suits. "This was the period when Jean-Michel began to believe his own press," says Astor. "He was into conspicuous consumption." Joe Barrio, a friend of Torton's, was hired to be the bouncer. Mallouk manned the door to make sure stars got VIP treatment. Bischofberger cruised into the East Village in his Mercedes for the event. Although he had originally pressured Basquiat not to show at the Fun, he later said he liked the work. "I think it was the greatest show of his life. I went about twelve times to see it and brought numerous people. The opening was great too, it was a mixture of street kids and elegant people."

Paul Simon was there, but his attempt to buy "St. Joe Louis" for $8,000 was, ironically, thwarted by Ricard. Recalls Astor, "Rene had this hissy fit because he said he was supposed to get the painting."

Basquiat's date for the evening was Madonna, wearing, recalls Anna Taylor, "a cute-boy hat."

There was another star turn; Annina Nosei swooped into the gallery and bought a painting. "She ran to the opening like a Sherman tank and bought a piece," says Astor. "Her point of view was, 'He slashed the paintings, but I've got customers.' She paid me a good price for it too."

Lawrence Luhring helped Nosei drag the heavy wooden triptych into a cab. It was called, appropriately, "The Philistines." A few days later Nosei sold it for a considerable profit. "I bought the painting for seventy-five hundred," she boasts. "And I sold it for fifteen thousand. But Jean-Michel never got the seventy-five hundred, because that's how business is. What did he get from the Fun Gallery? Nothing."

"I told him he should do it, that it would be fresh," says Torton. "But he never forgave me. He said they ripped him off." Basquiat later told an interviewer, "I did that show as a favor to the Fun Gallery. I never got paid for that show. It was so unprofessional it was sickening."

But Basquiat had publicly reclaimed himself—personally and artistically. He had celebrated some idols and vanquished some demons. "The reason Jean-Michel wanted to do a show at the Fun Gallery was to reestablish his credibility with his peers, with the graffiti artists," says Stelling. "To show that he was as down and of the street as they were. I think that was a big conflict in him. Perhaps he felt he had sold out by riding around in limos and selling his work through blue-chip galleries. And the Fun show was truly the most personal thing he ever made. He put up walls to divide the space into these different areas to create a kind of progression of paintings. He really had a vision."

"It was his first show after leaving Annina," says Astor. "Jean-Michel wanted to make a statement." It was a transcendent one. Like the "symbolic" slashing of his work, just a month earlier, it instantly became part of the myth-in-the-making that was Basquiat's life.

Nosei agrees that the Fun show marked a new phase in the artist's career. "Jean-Michel started out very well, he got very comfortable with that style, and he got to a very high pitch of stylistic achievement. But then his work was becoming too kitsch. So he

destroyed those paintings, he cut them. And the cutting of the canvas became good, fantastic, because in the new paintings at the Fun Gallery the canvas is not really stretched, things are sticking out, their violence is really wonderful. He becomes again shamanistic."

Basquiat was determined that the fruits of his most recent labors not be lost: In a completely uncharacteristic move, he secretly stashed most of them in a warehouse in Washington Heights, where they were discovered only after the artist's death. According to Bischofberger, he was also particularly concerned that the paintings not be sold to speculators during the show and insisted Astor tell him who each buyer was.

Even so, Bischofberger managed to convince Basquiat to sell him a painting, "Piscine Versus the Best Hotels," which he later "reluctantly" sold to the Schorrs. Ever the businessman, Bischofberger couldn't refuse their request that he include it as part of a big package deal of work by Stella and Rauschenberg. "They kind of blackmailed me. And then they just bluntly told Basquiat. I hated that Basquiat would think I would just sell it after he had given it to me. I hate even more not to have the painting."

When the Fun was over, sometime early in the morning, Basquiat ended up alone with the bouncer, who drove him home in a rented van. "Sometimes he would have affairs all through the morning, and sometimes he would find himself totally isolated and alone. That night he went home by himself," says Torton. "Without a girlfriend, without anything, without even me to be there to talk about how successful it was."

The critics did that. Wrote Nicolas A. Moufarrege, "Jean-Michel's show at the Fun Gallery was his best show yet. He was at home; the hanging was perfect, the paintings more authentic than ever." "Gut emotions lie behind the phrases and images, not the desire to make neo-expressionist commodities," said critic Susan Hapgood in *Flash Art*. For Basquiat, as well as for the East Village art scene, the Fun show was a peak of pre-hype creativity. The "neo-expressionist commodities" were soon to take over.

"I felt much more happy about all this in the beginning, when I was coming from the extreme situation of not having any money at all; and then there was the fact that there weren't many black

painters—so I had the feeling that I was doing it for people other than just me—and the fun of being the youngest and being pitted against the adult element," Basquiat said of his own success in a September 1983 article in *Art News*. "I like the business part of it, the notion that I'm working for myself." But Basquiat also seemed to feel the hint of a Faustian bargain, adding, "Maybe I'm selling my soul to the devil or something."

Soon after the Fun show, Bischofberger's role as Basquiat's exclusive worldwide dealer began in earnest. "It was one of those Bruno moments where he like works himself up and pops the buttons on his blazer, which isn't that hard to believe, because he's so big anyhow. At that moment, of course, Bruno saw the cash register," says Perry Rubenstein. "He just knew that it was a unique moment in this guy's career."

According to Bischofberger, this "shake-hand" agreement lasted from 1982 until Basquiat's death. "I told him never to sell anything to anybody else, which he promised firmly," says Bischofberger, who from that day on did whatever it took to ensure that he got most of the artist's work.

MAOS AND CASH COWS: BRUNO BISCHOFBERGER'S ART OF COMMERCE

"Switzerland is my favorite place now, because it's so nothing. And everybody's rich."

—Andy Warhol, *In His Own Words*

Bruno Bischofberger genuinely loved art, but like Warhol, he never lost sight of the bottom line. More than any of the other eighties dealers, Bischofberger was king of his own brand of art-world mergers and acquisitions.

Seated in the sunny office of his gallery overlooking the Lake of Zurich, Bischofberger, resplendent in a monogrammed shirt and double-breasted blazer, cuts an impressive figure, more like the billionaire CEO of a multinational company than an art dealer. The gallery is silent as a church, but Bischofberger, who jokingly says, "I was and still am the *omnivorous* art dealer," remains one of the most powerful players in the international art market.

This is the man who in 1972 won an unprecedented dozen races at the Cresta Run, the famously dangerous ice-sled chute that snakes down a nearly vertical mountainside in Saint Moritz. According to *Sports Illustrated*, which documented the feat, "No man can win constantly on the Cresta without a monumental reserve of gambler's guts and an intrinsic disdain for danger." Tales of Bischofberger's skill at navigating the stubby sled, nicknamed a "skeleton," which is ridden in an inelegant, belly-down style, are legion among the elite group of the Saint Moritz Tobogganing Club. And it is a perfect metaphor

for his nonpareil skill at negotiating the equally slippery and serpentine convolutions of the art world.

Throughout the decade Bischofberger swept into New York on a monthly basis, making whirlwind visits to the artists' studios and auction houses, and purchasing art at an unparalleled rate. Using seemingly endless amounts of disposable income (he at one point actually carried a gym bag full of cash), he acquired vast holdings in Schnabel, Chia, Condo, Clemente, Salle, Cucchi, and Warhol. Now he had added Basquiat to the list.

Although Bischofberger was based in Zurich, he had a free-lance assistant in New York, Beth Phillips, who helped keep track of his dealings with various artists. "Millions of dollars changed hands," she says, of Bischofberger's business dealings.

Of course, there were a number of dealers trafficking in Basquiat's work at every point of his career. And Basquiat himself often sold art directly to collectors.

But, throughout the years, Bischofberger managed to buy and sell more Basquiats than virtually any other dealer, and today he owns arguably the best collection of the artist's work. "Seventy to eighty percent of his work between the end of '82 until he died passed through my hands—except the ones he kept, which was a considerable amount," he says.

Bruno accumulated "EuroBasquiats," says one art writer. "They were like Eurodollars being circulated until they had peak value." But Bischofberger's influence was more than monetary; it was Bischofberger, whose business relationship with Andy Warhol dated back to the late sixties, who finally got Warhol to adopt Basquiat, and who orchestrated the collaboration series between the artists.

Bischofberger pages lovingly through the catalogues that line his shelves for the Basquiat shows he organized in Tokyo, Paris, Madrid, London, and of course, Zurich; the beautiful book of drawings he published in 1985. He exudes an air of cultivated prosperity; if he is not the master of all he surveys, he is certainly the acquisitor of all he desires. Over the last three decades, Bischofberger has amassed some of the world's largest holdings in collectibles, from eighties art to fifties glass. "He's like a Hoover," says Barbra Jakobson. "Bruno is the *ultimate collector*," says Peter Brant, who coproduced the

Warhol film *L'Amour* with Bischofberger in 1970, and who, along with Bischofberger and Joe Allen, became the backers of *Interview* magazine in 1971.

Bischofberger is a fascinating amalgam of the consummate collector, the wealthy patron, and the avaricious entrepreneur. During the peak of the art boom, he was notorious for flying in on the Concorde, setting up headquarters at the Regency or St. Regis, and going on a nonstop buying spree. Dealers tell stories of Bischofberger buying huge hoards of artwork over the phone, while furiously pedaling on his hotel room Exercycle. He would then hit the road, visiting as many studios and galleries as his exhausted assistants (including his protégé, collector Thomas Ammann, who would become a world-famous dealer in his own right) could handle, wheeling and dealing the entire time.

According to Phillips, his New York–based assistant/secretary, he insisted on a car phone in his limo before the technology really existed. Using a clumsy and expensive industrial model made by Motorola (the phone cost $4,000 and had batteries that constantly ran down, thanks to frequent calls to Europe and Mexico), Bischofberger, like the obsessed general of a one-man art army, would rap out a staccato list of orders from dawn to dusk.

These rapid-fire instructions, delivered in his idiosyncratic English, covered anything from how much cash to dole out to his various artists (in any given week his budget could include close to $200,000 in advances to Warhol, Salle, Clemente, Schnabel, and Basquiat, who often got $10,000 a pop); to when to send a truck to transport the artist's work from the studio to the warehouse, where it was shipped to Zurich or to various foreign collectors; to what to offer Sotheby's for a valuable vase; to which furniture to buy for David Salle at 50/50, an antiques store Bischofberger favored; to the arrangements for a dinner party of twelve, including Schnabel, Clemente, Basquiat, and Warhol, at Chrisella, one of his favorite restaurants.

Bischofberger's generosity was often indistinguishable from his greed: at his spread in St. Moritz, he built a small ski chalet that served as a studio, just in case any of his visiting artists felt like producing some work.

This same dichotomy was apparent in his relationship with

Basquiat, who often spent time with the dealer in Switzerland. He was capable of emptying the artist's studio in one fell swoop with a thick bundle of cash, which went immediately for drugs. He would convince Mary Boone to take Basquiat on as an artist, only to make sure he got Basquiat's best work. He arranged for Basquiat to collaborate with his idol, Warhol, but managed to persuade Basquiat to sell him his share of the collaborations, after Warhol's death.

Says art dealer Howard Read, "He's like the George Soros of the art world." (Without, of course, the philanthropic streak.) "He leverages assets against other assets. He'll buy eleven thousand pieces of Russell Wright china and warehouse it and just wait until that ship comes in."

In addition to his other collectibles, Bischofberger has a world-class collection of prehistoric artifacts, a museum-quality collection of photographs, and thousands of pieces of decorative art, including glass, ceramics, and furniture. "You would have to hollow out one of those big mountains in Zurich to store it all," says Phillips.

Bischofberger's compulsive collecting habit dates back to his childhood. He was born in 1940, the son of a Zurich doctor. At the age of twelve, he was already collecting antiques and pieces of Art Nouveau, perhaps inspired by his father, who had a modest collection of medieval art. He went to the University of Zurich, where he studied art history, archaeology, and "*Volkskunde*, which is a kind of anthropology of the so-called civilized cultures and includes folk art." He wrote his doctoral dissertation on eighteenth- and nineteenth-century folk art from eastern Switzerland, "which is the richest in the whole Alpine region."

Characteristically, Bischofberger was also collecting the stuff; by the time he was in his early twenties, he had acquired an enormous collection of Swiss folk art, from painted furniture to cow bells, and had published his thesis as a book. According to Phillips, Bischofberger's method of acquiring work from the peasants was fairly straightforward: he bought them drinks and charmed them until they would practically give it away. In 1992, Bischofberger's collection became the basis for the Museum of Folk Art in Stein, Appenzell. (Bischofberger still owns a huge collection of folk art, "but this

is so marginal to me as an art dealer. It is not even one percent of what I do.")

In 1963, while he was still working on his doctorate, he was offered the space for an art gallery. He started out selling antiquities and medieval pieces. After six months, he decided he would prefer to show paintings, and began with a small show of work by the French artist Auguste Herbin, borrowed from a friend.

By his second show, in January 1964, Bischofberger had made a significant and daring leap into contemporary art; he approached Ileana Sonnabend, and asked her if she would "borrow me works for a Pop art show. I showed everybody, Rauschenberg, Johns, Warhol, Oldenburg, Lichtenstein, Wesselmann, Jim Dine, even Chamberlain." It was one of the first Pop art shows in Europe. Bischofberger, then twenty-four, had put himself on the map.

"Pop art was still looked at by practically everybody as something very unserious. They mixed up the iconography of Pop with the intention of how to sell it. They thought it was a vulgar American way to commercialize art, because its iconography was deriving from advertising. They thought it's some roller-coaster art, some nightclub art," he says. Just as significant as Bischofberger's first foray into American contemporary art was his meeting with an American contemporary artist, Roy Lichtenstein. "He was the first one I met. He came to the opening. I gave a dinner in an old traditional guildhall with sixty of the major collectors in Zurich."

Soon afterwards, Bischofberger traveled to New York, where he followed Sonnabend's advice to seek out Leo Castelli and got Castelli to introduce him to Andy Warhol. According to Bob Colacello, the ever-entrepreneurial Fred Hughes (who ran Warhol's business affairs) instantly recognized Bischofberger's value on the international scene. Bischofberger was socially close to a number of wealthy industrialists, including Greek shipping tycoon Stavros Niarchos, Italian auto magnate Gianni Agnelli, and German manufacturer Gunther Sachs, whom he had originally met on the Cresta. It was Sachs's older brother, Ernst Wilhelm, who gave him the collateral to buy his first Warhols.

Bischofberger had convinced Warhol to sell him eleven paintings for $422,000. Says Bischofberger, "I never had a backer who was a

partner in the gallery. My first deal with Andy I had to guarantee. I was so naive. I had gone to Catholic boarding school and learned Greek and Latin and philosophy. I didn't know anything about money or business or how banks functioned. I asked Ernst Wilhelm Sachs, who was a collector, if he would lend me artworks as collateral. He wouldn't give me the money, but he would guarantee the money at the bank, which is practically the same thing. I offered him that if I buy eleven paintings, I would give him second choice at cost prices without giving me any profit. And he guaranteed me this whole sum. It was a big risk. I brought the whole thing in cash with me to New York. I thought that's how Andy wanted it. It was in thousand-dollar bills."

Bischofberger had begun his global art empire in style. Wrote Colacello in *Vanity Fair*, "One of the first dealers Hughes cultivated was Bruno Bischofberger, who walked into the Factory one day in the late 60's and bought 11 early Warhols from Hughes for $422,000. Bischofberger soon became the leading promoter of Warhol portraits in Switzerland and Germany; his first 'victims,' as Warhol sometimes called his subjects, were the Munich industrialist Gunther Sachs and his then wife, Brigitte Bardot."

Says Colacello, "Bruno was brought to the Factory by Rainer Crone, who was doing a book about Andy. He came in with a suitcase full of cash, and that's how Bruno got into Andy's life. He was this sort of colorful character who would wear these funny costumes. He would step out of a limo wearing Appenzell peasant garb."

Bischofberger may have dressed in knickerbockers like a Swiss local yokel, but he had grand plans for how to commercialize Warhol's then flagging career. It was, claims Bischofberger, his idea to approach Warhol to do society portraits after first commissioning one of himself. "I asked him, 'Andy, couldn't you do portraits where I could go to people and could ask them if they would like to have you do their portrait?' And Andy said he would very much like to do that and I suggested we could work out a size and an amount of how many you do and the price." Bischofberger reels off a detailed account of the prices per number of panels.

"I was able to convince a number of people who were among the world's wealthiest," he says. "Some really great characters like

Stavros Niarchos or Gianni Agnelli, who were close friends and who became clients." Bischofberger kept a close watch on Warhol's prices; in the May 1970 auctions at Sotheby's, he and Peter Brant together bid a record price of $60,000 for "Soupcan with Peeling Label." It was widely considered, and even reported in *The New York Times*, that the two had deliberately bid the price up, although they both denied it.

Bischofberger's next scheme turned out to be a gold mine; it was also a great critical success. By 1970, Andy had decided that "painting was back," and Bischofberger asked him to do multiple portraits of a single subject in a number of sizes. Bischofberger even had a subject in mind: he made a special trip to New York to suggest that Warhol paint a series based on the most prominent figure of the twentieth century—Albert Einstein.

"I thought Einstein is like the man of the century and he was a great personality and the fantastic way he looks. And Andy said, 'Yeah, that's great, but I've been thinking about it and I'd like to do Mao.' Of course my chin dropped. I thought, which wealthy Eastern collector wants to hang Mao in his office, who is a Communist leader of this big China which is a big threat for all of us? And I said, 'Andy, why for heaven's sake is it Mao?' and he said, 'Oh, you know, Mao is the most famous person on earth.' And it's probably true. In China who knows Einstein? But every other Third World person knows Mao, plus all of us know him, as well. He is certainly known by millions and billions more people."

If Bischofberger thought he had an exclusive deal for the extraordinary Mao series, of which he immediately bought ten, he soon learned otherwise. "I was very often in a way innocent in the way I did business even with my own artists. A few months later Andy told me, 'Bruno, I did some other Maos.' And he had done without telling me this series of like thirty or forty small Maos plus another forty this size, plus five or six gigantic ones of fifteen feet high. And I'd sold only two of my ten, which were seven by five feet. . . . I was a little bit unhappy when all those other Maos happened."

Warhol offered Bischofberger first choice of the other paintings, but they were out of his price range. Bischofberger was determined

not to let Warhol trick him out of artwork again. "From then on when I commissioned things I always made sure I had it in writing."

Bischofberger continued to commission work from Warhol right up to the artist's death, everything he thought he could sell, from a series of children's toys to Warhol's "Reversals" series, in which the artist, an expert in recycling, produced negatives of much of his previous work, to publishing a limited edition of photographic "Exposures."

Bischofberger's appetite for acquiring all sorts of objets was perhaps rivaled only by Warhol's; together they did the gallery and antiques circuit, scarfing up everything from decorative art to Venetian glass to Navajo rugs. Bischofberger tells an amusing story about hours spent with a Navajo rug dealer, with Warhol minutely examining each of a stack of hundreds before requesting "the three cheapest, I like them all so much."

Meanwhile, as different art movements came and went, Bischofberger's art business continued its exponential expansion. At one point in the early seventies, he attempted to start a Fifty-seventh Street gallery of his own, lining up Annina Nosei as the assistant-director. "Thomas Ammann, who had worked with me for eight years, was going to be a big part of it," says Bischofberger. "We came to New York together in 1972 or 1973 and rented a space that became the Andrew Crispo Gallery and is now the Robert Miller Gallery." According to Bischofberger, the gallery never got off the ground because the space was occupied by the New York Jets, and by the time they were willing to vacate it, the recession had kicked in. For the next seven years, he rented the gallery to Crispo, who was later involved in a notorious murder case.

Bischofberger moved from Pop to Minimalism to the Pattern and Decoration artists shown by Holly Solomon in the seventies, buying up quantities of Robert Kushner and Kim MacConnel. Says Solomon, "Bruno would come and buy a whole show and then sell it. What he couldn't sell, he would sell at a later date for even more money."

Says Bischofberger with pride, "I love to buy all of my artists in bulk. [D.H.] Kahnweiler did the same thing with Picasso and Braque. I have a much larger inventory than most of my colleagues."

But such practices could have a deleterious effect on the artists involved. Says writer Allan Schwartzman, who was the director of the Barbara Gladstone Gallery in the early eighties, "The work was cheap. Bruno owned more Pattern and Decoration art than anyone else, and controlled the market. Then he decided that Kushner and MacConnel weren't the Johns and Rauschenberg of the future, and he abandoned them."

Bischofberger was one of the first to start showing the Trans-avantgarde artists (Chia, Clemente, and Cucchi), and he lost no time jumping onto the Neo-Expressionist bandwagon, easily riding the new art boom with the same expertise he displayed on the Cresta Run. Says Schwartzman, "Bruno was there at the birth of the eighties market. What he did was pinpoint certain individuals that had an aesthetic and mercenary appeal and were most willing to play the game. He always got in early, when he could get good prices, and he would sit on the work until the value went up. If you remained a step ahead, there was a lot of money to be made."

Says a Warhol intimate, "His business dealings with Andy were impeccable. But Bruno could ruin an artist's career. He created a bubble that had to burst. Bruno was the king of the overnight success. He was the quintessential eighties dealer, very good at hyping the artist. And, being in Switzerland, he sold the American artists' work back and forth to their American galleries, which caused the price to constantly rise."

Wrote Warhol in his *Diaries*, after visiting Julian Schnabel with Bischofberger, "Bruno sure knows how to spoil artists fast. There's this whole group of kids doing this bad art . . . Then Bruno comes along and says, 'I'll buy everything,' and these kids get used to big money, and I don't know what they'll do when it's all over—oh but by then it'll be something different I guess."

As usual, Bischofberger was right on the money. His business deal with Basquiat coincided with the rise of the East Village, and the art movement with which it was soon associated, Neo-Expressionism.

FUN: THE BABY BOOMERS' BOHEMIA

"I used to wonder what young artists would turn out like who grew up with Andy Warhol's pictures on the wall as acceptable art and thousands and thousands of television images stored in their minds. The result is the East Village."

—Henry Geldzahler

"Bohemia used to be a place to hide. Now it's a place to hustle."

—John Russell

Once again, the East Village was the crucible for an art movement. In the fifties, it was Abstract Expressionism; in the eighties, it was Neo-Expressionism and graffiti; Robert Hughes dubbed it "the Montmartre of the Neo." But while the first movement shifted the tectonic plates of the art world from Paris to New York and shaped Western culture for the second half of the twentieth century, the second movement was merely a trendy fashion statement, a bleep on the radar—or in this case, video screen—that galvanized a decade, and then evaporated; a transient youthquake whose primary movers and shakers died young or grew middle-aged.

The differences between the two movements were as pronounced as the differences between the two generations; between Modernism and Postmodernism, between postwar and post-Warhol art. Or, as one writer put it, "The Abstract Expressionists came together to promote a cause, while the East Village artists gathered together to promote themselves."

In 1951, the Abstract Expressionists put themselves on the map with the Ninth Street show. Wrote Calvin Tomkins in *Off the Wall*, "Most of the artists just came in, argued over space, and hung (or rehung) their own paintings. In the end there was sixty-one works by sixty-one artists, a brave display and the first chance anyone had had to see the full extent of the Abstract Expressionist conquest—a great many of the paintings in the show reflected the new, free-swinging, gestural style. Hundreds of people came to the festive opening (a banner had been stretched across Ninth Street), and for some of these it was a revelation." *Life* magazine published a famous photo of the avatars of the new movement, "The Irascibles."

When the Fun Gallery opened on East Eleventh Street thirty years later, it set the stage for a mini-boom and its inevitable crash. The short-lived East Village art scene that began and ended with Fun, which closed in 1985, was a microcosm for the art world at large and in every way prefigured the eighties art boom.

The Fun Gallery was founded in July 1981 by B-movie star Patti Astor and her partner, Bill Stelling. "Fun started the East Village, says P.P.O.W. cofounder Wendy Olsoff. "It defined it." Like most of the East Village galleries, Fun seemed to spring overnight from some organic downtown spore. The club scene, with its myriad funky art installations—graffiti and performance art at the Mudd Club, black-light and theme shows at Club 57—had given birth to the East Village gallery scene, which was really just an extension of the same round-the-clock downtown party.

"Like any exciting moment, it's always a question of people, timing, and the economy," says Stelling. "I met Patti when she was making a movie called *Underground U.S.A.* I had this storefront that was being used as a textile-design studio on Eleventh Street between Second and Third Avenues. We came up with the brilliant idea of showing works by friends in this tiny eight-by-fifteen-foot space. We had no name for it, and Kenny Scharf said, 'Why not call it Fun?' "

A big part of the fun was Astor herself, a major downtown character who, like Lhotsky, Ann Magnuson, and Gracie Mansion, had cannily reincarnated herself as a faux personality—in her case a sort of Marilyn for the eighties.

Astor, who came from Cincinnati, where her childhood dream was to be a prima ballerina, went to Barnard in the early seventies, before dropping out and moving to San Francisco. There she met filmmaker Eric Mitchell. When she returned to New York in 1976, she hooked up with Mitchell, and they both responded to a casting call for Amos Poe's *Unmade Beds*. Before long, Mitchell began making his own film, and Astor, along with Rene Ricard, became one of the stars of *Underground U.S.A.* By this time she had perfected her fifties persona: she bleached her hair platinum blond and squeezed her voluptuous body into a tight skirt and sweater.

Her next film was Charlie Ahearn's *Wild Style*, which starred real-life graffiti artists, most of whom she later exhibited at Fun. She was working for Stelling, who at the time was running a roommate referral business. Astor was already showing art; Futura 2000 had painted a huge mural in her Lower East Side apartment, when Stelling suggested they open an art gallery. They funded the new venture with a $500 tax refund that Astor had just gotten.

The first show at the new gallery was of work by Steven Kramer, an artist and keyboard player for the Contortionists, who just happened to be Astor's former husband. The next show was of new paintings by Kenny Scharf. In short order, Fun also showed most of the major graffiti artists, including Fab 5 Freddy (Bischofberger, eager to get in on the graffiti movement, showed up at the opening and interrogated Astor, who had no idea who he was), Futura 2000, Lee Quinones, and Dondi White. Says Fab 5 Freddy, "The original idea behind Fun was that they [the graffiti artists] didn't like cold, quiet galleries with white walls. They wanted a gallery that was like the work itself, a place to show and see our friends, and to play music and dance. We were a little posse. We helped put the East Village aesthetic on the map."

Six months later, Astor and Stelling moved the gallery to East Tenth Street, where it soon became the talk of the art world. The event that firmly established Fun was Scharf's show in September 1982, which included a number of huge, spray-painted canvases of Hanna-Barbera characters—twisted versions of the Flintstones and the Jetsons, and a black-light room that was a miniature version of his later installation at the Palladium.

To Ricard, the show was emblematic of a new movement: Painting, he announced, had replaced underground movies and "the rock scene, sperm of the great club period of the second half of the 70's. "Fun is the apotheosis of what Edit DeAk has called 'Clubism,' but it just happens to be taking place in an art gallery," he wrote. "Patti uses art to star in. She is in a tight spot now. She is Edie in a way but she is also Andy Warhol and . . . Leo Castelli. In fact, when I look back on the 80's what I'll remember as the high point is Kenny Scharf's opening a few weeks ago at Patti Astor's Fun Gallery. . . ."

Almost immediately, more galleries began springing up within a ten-block radius, side by side with Ukrainian and Indian restaurants and neighborhood bodegas. "The art world loves underdogs, pioneers striving to succeed against all odds. And part of the appeal of the East Village galleries is their continuation of the American dream in the very place where generations of powerless immigrants started out before them, and scatterings of beats, hippies and punks dropped out," wrote Kim Levin in *The Village Voice*.

Mansion's March 1982 press release announcing her gallery is characteristic of the spirit of the time: "Gracie Mansion, New York's Second Most Talked About Contemporary Personality, proudly announces the opening of her new gallery, GRACIE MANSION GALLERY, LOO DIVISION, at 432 E. 9th St., Suite 5, NYC, N.Y. Gracie has turned her W.C. into a gallery for the viewing at close range of intimate works of art by lower Manhattan artists. Out of an aversion (albeit spurred by jealousy) to large, open well-lit spaces, she has designed a gallery where prospective buyers can view the work in an environment more closely approximating the size of a standard East Village Apartment. . . ."

Like almost everything else in New York City, the story of the East Village is a story of cheap real estate and rapid gentrification. "When we looked at the first spaces, we saw a lot of shooting galleries," says Mansion. "We'd go in and there'd be Plexiglas shields and escape routes in the back, and that's why the rents were so low. These landlords were dying to get somebody in there that wasn't going to be a wholesale drug outlet. They were so open that they were set up like bank tellers. You could get a place for five hun-

dred dollars. In fact, we were probably getting ripped off at five hundred."

The gallery was so small, says Mansion, who ran it with her partner, Sur Rodney Sur, that "when I wanted to show somebody a canvas we'd stretch it across the street, and the cars would have to drive underneath it." The first wave of the East Village was in full swing. Said Mansion, who used a $200 tax return to pay for her first opening, "The thing about the East Village was that it was not premeditated. It happened spontaneously. I didn't know there was a Fun Gallery. We didn't know there was a market at all. We had no idea. But I started selling work from the first show and it just kind of exploded because there were so many artists in the East Village. Everybody was doing art."

Like their precursors, the theme nights in clubs, the early East Village shows were often organized around a single, ironic concept. The shows were so impromptu that when Mansion lost her apartment, "We moved all the furniture into the gallery and called it the Salon show." Mansion also had a Couch show. Perhaps her most celebrated event was the Famous show, a hundred not-famous artists' portraits of the famous. The show was so crowded that the most famous artist of the time, Julian Schnabel, couldn't push his way in. The mob caused a traffic jam that prevented buses from traversing St. Mark's Place. Mansion, wearing a "Pollock" dress painted by Mike Bidlo, spent a good part of the evening pacifying the local policeman.

By early 1983, there were another half a dozen new galleries in the area, including 51X, Civilian Warfare, Nature Morte, Piezo Electric, New Math, Sharpe, Tracy Garett, International with Monument, P.P.O.W., and Pat Hearn, among others. They provided a showcase for all the starving artists living in the East Village who couldn't get their work shown in SoHo—and some artists who could, but liked to thumb their noses at the establishment.

"There was a sense of fun that you don't get in SoHo," says Olsoff. "It almost felt like a college campus." Agrees artist Freya Hansell, "It was very young and very playful. You could do or make anything, and people would be interested." Says Walter Robinson, a critic and painter who chronicled the scene for the *East*

Village Eye, "For me it was like a long party with a whole new crowd, in which we were in charge instead of being young, clueless interlopers."

The galleries were part of a tight-knit network of artists. "It was a very strong community feeling," says Mansion. "We all went to each other's openings and brought collectors. If a big collector or dealer came by, we'd be on the phone saying so-and-so is around the corner. I remember when Grace Glueck did her first big article on the East Village, and when she came down to look around, it was supposed to be a surprise. But we were all telling each other which gallery she had just left. There was a lot of innocence of spirit that went into the beginning of the East Village. We were all pretty naive. I really thought it was almost a political thing I was doing. That this was giving access to people in the neighborhood to show the work. I really thought that when people came down and they bought it, they truly loved it. I had no idea that people were buying art as an investment. People would come and beg for a piece, and then it would go up for auction. That really hurt."

The seeds of speculation that fueled the eighties art boom were already in evidence. By mid-1983, the second wave of the East Village art movement, the area had become a high-profile destination for collectors, critics, and artists, says Olsoff. "The collectors were interested in finding some new and fresh talent. They had money and they weren't scared. Limos started pulling up right away. There was a lot of jealousy when one of the big collectors got out of his car the day we opened. Any dealer can tell you ludicrous stories about people buying and selling art that hadn't even been taken out of the crate yet. It was obvious to everyone that it was unhealthy." "The key word is 'deal,' " wrote Nicolas A. Moufarrege. "Last year it was 'show.' "

If the press had had a brief love affair with graffiti, it was nothing compared to the prose spewed over Alphabet City. It was impossible to open any New York–based publication—from mainstream magazines like *New York* to the *SoHo Weekly News*—without finding a piece about the East Village art scene.

Meanwhile, many of the galleries had expanded to larger spaces, with considerably higher rents. East Village landlords were quick to cash in on the neighborhood's newfound trendiness, offering shorter

leases at double or triple the previous rent. Some of the newer deal-
ers, like Deborah Sharpe, Tracey Garret, and Pat Hearn, had ambi-
tious business plans. In November, Hearn's stylishly renovated space
(she spent $20,000 refurbishing it) opened on East Sixth Street; two
years later she would move to a SoHo-sized space on East Ninth
Street. Says Hearn, "I remember counting the galleries, and it went
from like six to sixty in eighteen months." "A hierarchy is develop-
ing," commented Jeffrey Deitch about the boom. "It has changed
from pure democracy to oligarchy."

There were usually limos parked outside postage stamp–sized
spaces, with notable collectors like Eugene and Barbara Schwartz
strolling out to make that week's purchases. They cruised SoHo and
the East Village every weekend in their chauffeured car, stopping at
dozens of galleries in a single morning. They were not alone; Lenore
and Herbert Schorr, Don and Mera Rubell, Si, Victoria, and Caroline
Newhouse, and Elaine Dannheisser were among the first collectors to
discover the new scene.

Says Stelling, "It was an alternative art scene where you could
buy a painting for less than a thousand dollars. Collectors always
wanted a bargain. In the first season we had four shows, and then
moved to a space on Tenth Street. The first people that noticed the
gallery were other artists. Keith Haring brought Bruno Bischofberger
down. What was amazing for me is that Fun was a place where kids
from the Bronx came for openings and would be smoking gigantic
joints right next to Park Avenue ladies with their chauffeured cars
waiting outside. It was kind of a neutral territory, and people re-
spected each other and had fun. The day the Kenny Scharf show
opened, we had Estelle Schwartz (an art adviser who is no relation to
Eugene Schwartz) down at the Fun Gallery with some collectors. The
roof alarm went off, and Estelle freaked out. She threw on a mink
coat, jumped in her Mercedes, and drove off. That's when I knew she
wasn't a serious collector."

At one point, the Guggenheim took its members on a guided
tour. That season two alternative spaces—Artists Space and P.S. 1—
devoted surveys to East Village art. Wrote Craig Owens in *Art in
America*, "Despite attempts to fabricate a genealogy for the artist-run
galleries of the East Village in the alternative space movement of the

'70's, what has been constructed in the East Village is not an alternative to, but a miniature replica of, the contemporary art market—a kind of Junior Achievement for young culture-industrialists."

The proliferation of art and artists was followed by Walter Robinson and Carlo McCormick in the *East Village Eye*. They nailed the whole scene in *Art in America*'s summer 1984 issue. "Taken as a package, the East Village art scene is so much 'ready-made' that it seems uncanny, a marketing masterpiece based on felicitous coincidences. Besides having its own artists, neighborhood, art press and distinctive gallery names, the East Village scene has its own day (Sunday) and its own gallery architecture—small tenement storefronts, with no back room and no storage . . . And as for ambience, the East Village has it: a unique blend of poverty, punk rock, drugs, arson, Hell's Angels, winos, prostitutes and dilapidated housing that adds up to an adventurous avant-garde setting of considerable cachet." They concluded that the East Village art scene "suits the Reaganite zeitgeist remarkably well."

Even Ann Magnuson, manager of Club 57 and an East Village veteran, complained in a *New York Times Magazine* cover story about "the collision of sushi and souvlaki in the marketplace, the influx of white, middle-class art students into a poverty-stricken area. Rich art patrons traveling from uptown to downtown floating like spores through the air, looking for canvas and attaching themselves like fungus on a piece of soggy, white Wonder Bread."

The artists themselves were inadvertent gentrifiers; a whole new residential and commercial real-estate market mushroomed to satisfy the burgeoning new population, pricing the old tenants—and many of the artists and galleries—right out of the neighborhood. Apartments that had been renting for just over $100 were now going for $700 to $1,200. In 1983, the Christadora, an abandoned settlement house on Ninth Street and Avenue B, sold for $1.3 million; by the following year it had been resold for $3 million to a developer who converted it into a luxury co-op building.

The art scene peaked between 1984 and 1985, when there were upwards of seventy galleries in the East Village. Within the next year, more than half would close, including Fun, New Math, and Civilian Warfare. "There was something about going to a slum that

faded after four years of stepping over drug dealers and garbage cans to get into a gallery," says Olsoff.

And there was already talk of a reactionary new art movement, Neo-Geo, with its own stars, including Peter Halley and Jeff Koons, whose coldly cynical chrome bunny rabbits could not have been further removed from graffiti or Neo-Expressionism. "The periods of time when things were in fashion became smaller and smaller," says Mansion. "People triple their prices in three years, and then it's over."

By the time Timothy Greenfield-Sanders appropriated the format and title of the famous photograph of "The Irascibles," for his po-mo picture of the East Village elite, "The New Irascibles," in the spring of 1985, it served more as a memorial to an historical moment than a document of the present one. Claiming that the East Village had "excommunicated" them, Haring, Scharf, and Basquiat, by now the toasts of SoHo, refused to sit with their peers, and the photographer agreed to shoot them separately. But somehow, Basquiat missed the photo op.

Both Astor and Stelling took to wearing sweatshirts that proclaimed "The Original Is Still the Best," but the Fun Gallery closed that summer, unable to sell enough art to cover its rent—which had escalated from $175 to $1,800—or its exorbitant European shipping bills. Its passing was appropriately commemorated with graffiti: someone spray-painted "No Mo Fun" across the abandoned storefront. To help recoup her losses, Astor held a fire sale of Fun Gallery memorabilia, including a $4,000 Kenny Scharf answering machine.

"The larger artworld easily took over the monster and used it for their own ends," said Walter Robinson in a published interview. "First it created the East Village by giving it a certain amount of attention and then it projected all of its own negative qualities onto it and destroyed it." The East Village, like many of its artists, became a victim of its own success.

WHO'S THAT GIRL?

B y now, Basquiat was indisputably a star in his own right, but his next girlfriend, Madonna, would soon eclipse him.

They went to the same clubs, danced to the same music, and dreamed the same dreams: To be rich, beautiful, outrageous, famous. To meet the right people, make the right connections. It seemed inevitable that their cookie-cutter paths would cross, however briefly. It happened in the fall of 1982.

Several people take responsibility for the introduction. Two members of Gray, Michael Holman and Nick Taylor, say they met her first, at the Mudd Club. Madonna, like Basquiat, enjoyed keeping a number of relationships in the air at a time. She and a friend, Erica Bell, a gorgeous black woman, used to do the club scene, "terrorizing" any attractive male in sight. Recalled Bell in a *New York* magazine piece, "She would say, 'Rica, I'm the best-looking white girl here, and you are the best-looking black girl here, so let's do it.' Then we'd push people off the dance floor and take over. We'd pick out the cute boys, go right up, and without saying a word kiss them on the mouth. Then we'd take their phone numbers, walk away, and while the guy was still watching, crumple up the number and throw it away." She tried a similar approach with Michael and Nick, who, unbeknownst to her, were roommates.

"We met Madonna on the Mudd Club dance floor," says Holman. "She made dates with both of us for the following week, on the same night. On the appointed day, Madonna called Nick. But she got me. And I said, 'What the fuck is this? I thought we were going out together.' And I gave the phone to Nick, who had the same reaction."

They both refused to see her. Madonna, who had the same sort of aggressive sexual intensity as Basquiat, couldn't accept having her advances turned down. She called Nick from Detroit, where she had gone to visit her father. "I said, 'Hey man, you fuckin' jilted me," recalls Taylor.

Madonna rescheduled for the following week. In the meantime, Holman called her up and asked her out, and she again made the date for the same night she was seeing Taylor. So they both went together to meet her at another club, Berlin. "And we just laughed at her!" says Holman.

Taylor ran into Madonna a few more times at the Mudd Club, and became friendly with her. The next time he saw her was at Bowlmor. "It was Retro Night and everybody was dressed like the fifties with greased-back hair."

Basquiat was also hanging out at Bowlmor that night. He arrived in style, chauffeured by Steve Torton in their fifties Plymouth. He had given Taylor a bag of pot to hold on to, and now he came over and asked for a joint. "With Jean, everything was always in massive quantities. So I pull out this big bag of pot, and I offer Madonna a joint. And she said, 'Do you always carry that much pot?'" recalls Taylor. "The whole time, Jean and her were checking each other out. So I introduced them. They really hit it off. They were really cute together. It was right after that she came out with that song 'Everybody.'"

Ed Steinberg, who produced the "Everybody" video, has a different story. Steinberg, the founder of Rock America, was one of the first people to see the entertainment value of the then purely promotional music videos distributed by record companies. He began to rent videos to the Ritz, Danceteria, and other clubs around town. He used to throw loft parties with multiple monitors, all cued up to a Blondie video.

Steinberg had known Basquiat for several years, ever since the artist and two of his friends, Wayne Clifford and Danny Rosen, showed up unannounced at his loft on East Twentieth Street and informed him that he was supposed to videotape them.

"Jean-Michel had a new recording Walkman," says Steinberg, "and he had sampled a lot of street sounds. So we used that and just

improvised. I used to go all over the city sampling different scenes with Jean for these art videos—bums on the Bowery, hookers, pimps, dealers. And sometimes I would hire him and his friends to do graffiti on backdrops for the music videos I was producing."

Steinberg also knew Madonna—he had met her when she was an extra in a music video he had made. One night we were at Lucky Strike, on Stuyvesant Place. I was talking to Madonna and I went over to say hello to Jean-Michel. Then he left. She said, 'Who is that guy? I want to meet him.' Madonna didn't have a fixed address at the time, so I had them both come to my place. They started hanging out together after that."

"A desired sexual effect . . . Six of us courting an American madonna," Basquiat wrote in one of the notebooks published by Larry Warsh in 1993. Before long, Madonna was staying at Crosby Street. Even then, she had a strict regimen; she got up early, exercised strenuously, and ate health food. She and Basquiat may have had the same ambitious aspirations, but their styles could not have been more different. "I remember being over there one time when everybody was doing drugs and Madonna was eating these brand-new things that I had never seen before, carrot chips," says Eszter Balint. "We were supposed to go see Madonna at some club where Jellybean [Benitez] was deejaying, but Jean was so stoned that he couldn't go. He wanted to take a bath, and he asked me to stay with him, in case he passed out."

It was at this point that Anna Taylor started seeing missives from Madonna all over the loft. "Little notes in pink ink and perfectly slanted handwriting," she recalls. "Very girlish. The kind of thing you notice from across the room. Always very businesslike, like, 'had to go.' " But it wasn't until she had seen Madonna with Basquiat at his Fun show opening that Taylor realized they were an item.

Steve Torton was used to seeing new women in Jean-Michel's bed on a regular basis. "One day I came over to the loft and Jean-Michel was all excited, and he said, 'Guess who I slept with last night?' He got really pissed off when I told him I had never heard of Madonna." Torton took several rolls of film of the couple playing silly games with an artichoke. Torton would drive them to Barbetta's, Basquiat's favorite Italian restaurant, and to Lucky Strike. Once Gerard Bas-

quiat, who tended to appear in his son's life when things were look-
ing up, took Madonna and Jean-Michel to One Fifth Avenue for
lunch.

At one point, Madonna threw a party at the Crosby Street loft.
"That's the first time I met A-1, EZG, Ram, and Toxic, all those graf-
fiti kids from Fashion Moda," says Nick Taylor. "Everyone [except
Madonna] was getting stoned on angel dust. Madonna turned on the
tape machine and everybody jammed. I remember around that time
Madonna lived on Fourth Street between A and B. It was a really
sleazy neighborhood, filled with street gangsters. She had these two
little Hispanic kids that were kind of her bodyguards. She'd bring
them everywhere, to Lucky Strike, to Bond's, the Mudd Club."

Taylor recalls a dinner at Barbetta's with Basquiat and Madonna.
"Jean was this male chauvinist, and Madonna was into sexual energy.
The relationship was kind of like an act for both of them in a way," he
says. "It was before these two people were so famous, but it was like
a regal, arranged marriage."

Meanwhile, Mallouk, who had "left Jean-Michel I don't know
which of the numerous times," picked up a *Village Voice* and saw a
picture of Madonna—wearing *her* coat. "I realized she must have
been staying at the loft."

That Thanksgiving, Basquiat brought Madonna to Glenn O'Brien's
place on Mott Street. "He had told me about her. He said he had this
girlfriend that was going to be a great singer. Then he just showed up
with her," says O'Brien. "I thought she was black when she walked
in, because she had what she later told me was the only suntan she
had ever had in her life. Her hair was dark, and it was done in kind of
dreadlocks style. She was very sweet. When I talked to her about it
later, all she remembered is that Jean and I smoked about a million
joints."

Basquiat went back to L.A. that December, and Madonna soon
joined him. "I picked her up at the airport for him," says Dike, "and
drove her to Larry's and they got into a big fight about something right
away. I had the car, so I'd drive her around town.

Like Basquiat, Madonna had a relentlessly roving eye. "I thought
she was this ugly little tomboy girl. But she was very nice to me,"
says Dike. "She was sort of coming on to me, and Jean-Michel got

mad. I had a big fight with him about it. They had gone out before he came out here and he was really psyched about her."

Kenny Scharf remembers Madonna vamping in Basquiat's bed, above which he had nailed a photograph of Warhol torn out of the newspaper. Ever since Scharf's first show at Fiorucci, Jean-Michel had been on the warpath against him. "We'd be at a party and he'd just stare right through me. He would terrorize me." Once, when they were both in Italy, Basquiat had gone around eliminating Scharf's graffiti. Another time, he had ripped Scharf's artwork off the walls of a mutual friend. Scharf was always trying to mend the rift.

"I was in L.A., and I knew he was staying at Gagosian's," he recalls. "This was one of my overtures of friendliness. I called him up and said I wanted to come visit. When I got there, he was just hanging out, and Madonna was lying in bed, acting like this vixen. Then Jean left the room, leaving me alone with her. And she was being incredibly seductive. I thought it was really weird. I was like, 'What is this about? This is his girlfriend.' "

But Madonna impressed Gagosian with her businesslike attitude. She and Basquiat were staying at Gagosian's place on Market Street in Venice, just down from Tony Bill's restaurant. Basquiat slept half the day, but Madonna kept her routine. "She's a very disciplined woman. She would be on the phone in the morning to the agent and doing yoga and running on the beach, and she didn't do any drugs," he says.

"Jean-Michel told me she was going to be a big star, which was perceptive, because at the time she was just starting out. It was during that period when she wore those crosses, and she was not this aerobic kind of monster. She was a softer Madonna.

"I remember on Christmas Day I took them over to my mother's house in the Valley, and my mother had never seen Basquiat or Madonna before. When they walked into her kitchen, she was about ready to call the police," says Gagosian.

Madonna had her own worries; having safe sex with Basquiat was a primary concern. "I remember Christmas Day as being beautiful but frustratingly warm," Gagosian continues. "We were out at this beach house, and Madonna had the Yellow Pages in her lap and she

was feverishly looking for a pharmacy that would deliver condoms to Malibu on Christmas Day. They were just striking out, calling one after another. Most of them were closed. I think they finally had to buy about two hundred dollars' worth. I don't think Basquiat really knew how to use them. He was sort of fascinated with their objectness. Like they were cult things, like tribal art.

According to Gagosian, Madonna stayed in Los Angeles from six to eight weeks. "I think that most of their relationship took place out here, because after she got back to New York, she took up with Jellybean [Benitez] again. Jean-Michel was extremely distraught about it. Because people rarely left him. He almost drank himself to death."

Basquiat was so upset that Fred Hoffman, who copublished some Basquiat prints, and had spent a lot of time with the artist, had to come to his rescue one night. Recalls Gagosian, "He had to put him in the shower and walk him around, because he'd consumed a bottle and a half of rum in half an hour or something like that, trying to kill himself with booze. He was very, very despondent over Madonna going back to Jellybean and basically ending their relationship, because he really thought this was a special love of his life. I think he felt she was an equal, somebody who really had her own career, and he was impressed by the fact that she was a professional."

Back in New York, Madonna told several people that she couldn't stay with Basquiat because of his drug problem. She complained to Torton about Jean-Michel's vampire hours. "She said he never woke up before four or five in the afternoon and she never saw the sun. She said she couldn't take it. I saw her at Bond's and I said, 'How's Jean?' and she said, 'He's on dope. I went over there tonight and he was nodding out on heroin. I'm not having anything to do with that.' She moved out, just like that, totally emotionless." At one point, she showed up to collect her things, surprising Balint, who was in Basquiat's bed at the time.

Brett De Palma remembers Basquiat's reaction to Madonna's dumping him. "I met her with him one night, and then the next day he said, 'Oh man, she broke my heart, man. She broke my heart.' I asked him what happened and he said, 'She wrote me a note and said it was

all a big mistake. It wasn't meant to be.' It was kind of like she was on a faster ride than he was."

Although their romantic fling was short-lived, Madonna had fond memories of the young painter who was almost as driven—but not nearly as health-conscious—as she was. When the Whitney Museum mounted a Basquiat retrospective in late 1992, she was one of its funders. More than a decade after her brief relationship with him, she vividly recalled Basquiat in a short essay she wrote for *The Guardian*, to commemorate a show of his work at the Serpentine Gallery in London, in May 1996:

> . . . He had the presence of a movie star and I was crazy about him. He carried crumpled-up wads of money in the pockets of his paint-splattered Armani suits. Money he felt guilt about having. Money he always gave away to his less fortunate friends.
>
> I remember Jean-Michel's tag, SAMO, which was accompanied with a little crown and I remember thinking he was a genius. He was. But he wasn't very comfortable with it. I remember all the girls were in love with him and one night I looked out of his loft window and saw a girl whose heart he had broken burning his paintings in a big bonfire. I wanted to stop her and rescue his paintings, but he didn't seem to mind. He said it was their fate.
>
> I remember him getting up at 3 am and sleep-walking to an empty canvas. He stood inches away from it and proceeded to paint the most minuscule figures and what he did was so beautiful and instinctual and I stood watching him with dumbfounded amazement.
>
> He was one of the few people I was truly envious of. But he didn't know how good he was and he was plagued with insecurities. He used to say he was jealous of me because music is more accessible and it reached more people. He loathed the idea that art was appreciated by an elite group.
>
> When I broke up with him he demanded I give back the paintings he had given me. Not because he didn't think I deserved them, but he was obsessed with the idea that I would sell them. He was so paranoid. Of course, I was heart-broken

but I complied. Now I couldn't buy one of his paintings if I wanted to.

When I heard that Jean-Michel had died I was not surprised. He was too fragile for this world.

I remember one summer having dinner with Andy Warhol, Keith Haring and Jean-Michel at Mr. Chow's and feeling like the luckiest girl in the world to have known him. . . .

But even Madonna couldn't monopolize Basquiat's attention. Before long, he was involved with another woman. Barbara Braathen, a beautiful blonde from North Dakota, who had moved to New York to become a private art dealer, had met Basquiat just before the Fun Gallery show. "Suzanne and he had just broken up," she says. "He told me how horrible it was to have her standing down on the street, burning his paintings. He was still seeing Madonna. He told me I was different than everybody else, because I was not afraid of him."

Although the relationship lasted intermittently until the artist's death, she had no illusions that it would be serious. "One night he just showed up with an overnight bag," she says. Shortly after she slept with him, she found herself at a dinner table with five other women, all of whom, it turned out, had also been sexually involved with Basquiat.

Braathen would get a call from him at any hour of the day or night, "from two a.m. to two p.m. He knew I loved him, and he loved me, but beyond that there was nothing, and he liked that a lot. That's why he kept coming back, I guess. I was like his hearth. He was practically dead before I realized we had a genuinely supportive relationship to each other. No matter how blue you were, or how angry you were, or how needing you were, he would be there." Braathen was so convinced of Basquiat's innate goodness that she claims he actually cured her of a vaginal infection. "I thought, I'll never catch anything from this guy. He just heals me, you know?"

At the same time, Braathen was attracted to Basquiat's bravado. "There was almost no boundary with Jean. He had the nerve to really do or say anything to anybody. He was always surveying what was happening, and able to describe it with one line of witty, sharp analy-

sis. He had a one-of-a-kind charisma. But he was volatile. He could become this little asshole boy, or he could be this big, gorgeous guy, completely in control."

In late 1982, Marc Miller, a curator at the Queens Museum, interviewed Basquiat at Crosby Street for Paul Tschinkel's Art/New York video series. The interview captures the artist's irreverent sense of humor and dry wit. Basquiat never suffered fools gladly. Indeed, he demonstrated his attitude by conducting much of the interview with a mouth full of food.

MM: I think that people are classifying you as an expressionist.

JMB: Expressionist? . . . That happened a long time ago, didn't it?

MM: Well, there's like a New Expressionism.

JMB: Oh, expressionism—well, art should be expressive. Or something or other.

MM: And so you're seen as some sort of primal expressionist, is that, I mean—

JMB: Like an ape? . . . A primate?

MM: Well, your art schooling is—

JMB: Oh, I've had none.

MM: Let's talk a bit about your images. What, you just did this duck recently?

JMB: Yeah, yeah. I like the duck because it's like, you know, it's very simple.

MM: And that actually, it looks less like a duck than like a, one of these big ducks that hunters use.

JMB: That's what it's based on. It's more based on a decoy duck than an actual duck.

MM: Most of your images you tend to repeat quite a bit. Is that true? I mean, once you get an image you—

JMB: Such as?

MM: Well, such as, say the bones. You've been working on bones quite a bit.

JMB: That's anatomy. I mean Anatomy.

MM: . . . You were just thumbing through some books and pictures and hit upon these pictures of skeletons or—

JMB: . . . I went out and bought some books that are about anatomy. . . . I guess my first instinct would be to do a head . . . which I try to fight every once in a while. That's why I kind of like this duck.

MM: There's a certain, let's use the term, crudity, to your heads . . . Do you like it that way or would you like to get them more refined in a realistic way?

JMB: . . . I haven't met that many refined people. Most people are generally crude.

MM: Yeah? And so that's why you keep your images crude . . .

JMB: Believe it or not, I can actually draw.

MM: . . . You're what, Haitian–Puerto Rican, is that—Do you feel that's in your art?

JMB: Genetically?

MM: Or culturally . . . I mean for instance, Haiti is of course famous for its art.

JMB: That's why I said genetically. I've never been there. And I grew up in, you know, the principal American vacuum, you know, television mostly.

MM: No Haitian primitives on your wall?

JMB: At home? . . . Haitian primitives? What do you mean? People?

MM: No, I mean paintings. . . . Where do the words come from?

JMB: Real life, books, television.

MM: And you just skim them and start including certain—

JMB: No, man, when I'm working I hear them, you know, and I just throw them down.

MM: . . . It's just spontaneous juxtapositions and there's no logic?

JMB: . . . God, if you're talking to like Marcel Duchamp—or even Rauschenberg or something—

MM: What's this?

JMB: Fleas.

MM: Fleas? And below that?

JMB: A drawing of a flea.

MM: . . . And then we have leeches?

JMB: Leeches.

MM: What's the difference between a leech and a parasite?

JMB: Hardly any.

MM: And why do you have "46" in front of leeches? Again, just stream of consciousness?

JMB: There's a long list of leeches on this planet . . . this is like "46" and "47" in a list of thousands.

Basquiat won his verbal duel with Miller, but he was less successful at dealing with his own problems. Jennifer Stein, who by this time had given up selling postcards and was bringing up a young daughter, became Basquiat's cook that winter.

Stein contributed more than cooking skills. Basquiat would send her to the Astor Place Bookstore for source books—which she randomly selected by their covers. "I would just buy things on subjects that I thought were interesting. All the books were shrink-wrapped in plastic. I got him books on ancient history, linear measurements, and mathematics. He would just open the book and copy it into the paintings."

According to Stein, by now Basquiat had a serious heroin problem. "I worked for him for about six months. I was a pretty good cook. But he didn't eat anything. He was spending an enormous amount of money on drugs. About five hundred dollars a day. Part of the time, he was out at Larry's and when he came back he was unbelievably fucked up on drugs. He and Toxic were freebasing heroin. At that point he would stay up for days and days. He was getting so high that I knew I would be the one to find him dead. I told him I didn't want to work for him anymore because it was too scary."

Both Tony Shafrazi and Perry Rubenstein recall a telling incident. Basquiat had fixated on a roast chicken in his refrigerator, a portentous image which haunted him for weeks. "He saw it as a vision of himself—it was like this cooked chicken was a premonition of his own death," says Rubenstein. Recalls Shafrazi, Basquiat "ran over here from Crosby Street. He was totally shaken and traumatized. He said he had a vision of himself as the chicken. The dismemberment and dislocation had appeared so raw and visible to him."

According to Torton, Basquiat was particularly upset during this time because an early girlfriend told him she was pregnant with his child. "She said, 'I need four hundred dollars for an abortion.' And

Jean-Michel was saying, 'Wait, wait, wait.' She asked if he were going to pay for it or not. He was very ambivalent. Of course, he thought that she didn't want to have the baby because he was black. But she told me she considered him seriously mentally ill, and that's why she didn't want to have it. It didn't help him to have this woman barge in and not even be willing to discuss the possibility of having the child. He was like crying for days."

CALIFORNIA SUITE

In early December, Basquiat returned to Los Angeles, where he stayed, on and off, through his next show at the Gagosian gallery, in March 1983. His relationship with Stephen Torton did not survive the move.

In many ways, Basquiat's relationship with Torton was as important as any romantic relationship he had at the time. From 1981, when he hired Torton as a bouncer, to 1983, when Torton left Los Angeles after a fight with Basquiat over Anna Taylor, the two lived together, worked together, and got high together. Torton served as companion, assistant, drug dealer, bodyguard, chauffeur. Torton, whose scruffy good looks belie his thoroughly middle-class childhood, has an insouciant, boyish charm. Like Basquiat, he acted as if he were a supersophisticated street urchin. For a while, the two had an almost symbiotic relationship, according to Torton, who seems to have styled himself Basquiat's Boswell.

"We weren't in love, although some people probably thought we were," says Torton. "But it was work love. I'm sure for him it was the same as it was for me. We just worked all the time. I felt like he was like the Witness Protection Program. I would just sit there waiting for him to wake up and then I would work. He used to tabulate what he owed me right on the paintings. He was paying me five hundred dollars a week."

Basquiat was very specific about what he would allow his assistants to do. They were never allowed to contribute to the "artistic" content of a painting. "I painted with him, or rather *for* him is the word. The paintings were always undoubtedly his. He would

suddenly say 'Stop!' and if I didn't stop at that exact moment, he would get pissed off. The whole idea was that I was supposed to paint like a housepainter. I knew what he was going for. I wasn't allowed to paint little faces, because that wouldn't be housepainterly enough."

But Torton's biggest creative contribution was the increasingly wild-looking frames he built. "It was such a relief to climb into Dumpsters and pull things out of them and make sculptures. Once I made this wooden piano that he painted. Another time I made a cross for the Barbara Gladstone Gallery that he just painted a little skull on. I was just being an interpreter. The weight was on his shoulders to create all this junk or art or whatever. But he was really into it. He was into the future and the work lasting. People would worry that the work was so fragile that it wouldn't last, and he would get this kind of nervous smile on his face because he knew we would be lucky if it lasted for twenty-five years. On the other hand, he wanted to be here forever. I mean this guy could read a newspaper and look for his name like nobody you ever saw."

Basquiat, who didn't have a license, had decided he had to own a 1950s Plymouth he and Torton saw on the Bowery in the middle of one night. He gave Torton $4,600 in cash to buy it. But although Torton got a bargain, paying only $2,600, Basquiat was blasé about the new purchase. "I threw down the change and he didn't even look up from the TV. He didn't appreciate my efforts. I didn't mind that, but I was afraid he had already lost interest in the car."

Torton became the chauffeur, driving Basquiat and Madonna to Barbetta's and to Lucky Strike. But when he drove Anna Taylor out to his parents' house and spent the night with her, it ended his relationship with the painter. "It was romantic. I thought, 'Boy with Car Gets Girl.' But Jean-Michel wanted to know where I was, and when I told him, he kicked a pail of paint, and it just went all over the paintings. He just went nuts. This was just three days before we were supposed to leave for California."

Recalls Taylor, "Jean-Michel was furious." He said, 'Don't you see who he is, he's just an imitation of me?' I do think in retrospect that Torton wanted to change his background and his future and be more like Jean-Michel. He adopted his speech patterns, and his way

of dancing and his friends. They were a great team, but then Stephen had to betray Jean-Michel because everybody did. It became a bad triangle and finally caused a breach between Jean-Michel and me." (Of course, Taylor also knew that at this point Basquiat was involved with Madonna.)

Basquiat flew to L.A., leaving Torton to drive cross-country in the vintage Plymouth, which continually broke down. When Torton arrived the first thing he discovered was that Matt Dike had perfected his framing style. "Forgeries!" Torton announced. Dike had used a broken-up picket fence behind Gagosian's place to produce a series of slatted surfaces that Basquiat painted on. Recalls Dike, "Jean-Michel was feeling sort of uninspired. He was really bummed out by the generic canvases they were rushing him to paint, so I started dragging in all these wooden fences and saying, 'Dude, paint on these. These look really cool.' "

Torton and Basquiat went out to dinner; Basquiat amused everyone by pretending he was the food critic for the *New York Times*, and ordering everything on the menu. After dinner, they piled back into the car to pick up artist George Condo, a friend of Basquiat's. But Torton soon realized that the car's brakes were completely shot. He and Basquiat managed to coast off the highway exit and right past Gagosian's house before screeching to a halt. Soon afterwards, the car was stolen. But by that time, Basquiat and Torton had decided to call it quits.

Basquiat gave Torton $800 and sent him home. "We were sitting in the West End Cafe in Venice. And I was worried. I had worked for him a long time, and I had all his money-spending habits, and I didn't know what I was going to do, and he said, 'You can do anything. But if I couldn't paint, I would be a bum on the street.' It was very touching." Shortly after he returned home, Torton got a call from L.A. "I thought it was going to be like, 'Jump on the plane. We're having a show! Come on! These guys can't paint.' " But his fantasy was short-lived. It was Larry Gagosian, asking him if there was any insurance on the stolen car.

It was at Gagosian's suggestion that Basquiat settled into the first floor of the dealer's Market Street house, which Dike called the Nemo

Pad because of its steel-clad, futuristic design. He lived there for a period of several months, some of which he spent with Madonna. The plan was that he would use the place as a studio to paint the work for his upcoming show. Says Dike, "He didn't even get started on the show until a couple of weeks before it happened. He painted the whole thing under pressure. And he flew Rammellzee and Toxic back out here, and it was just nuts."

Basquiat enjoyed the laid-back L.A. lifestyle, although his antics still managed to shock. In one notorious instance, he was invited for dinner at the home of Marcia Weisman, an important collector who was the sister of Norton Simon. Basquiat scandalized the other guests by keeping his Walkman on throughout dinner.

At another point, Gagosian brought him to one of Cramer's famous black-tie Christmas Eve events. "He and Larry showed up after dinner with two or three Hollywood bimbos," says Cramer. "Jean-Michel was very loaded. He was high on everything. A lot of people get high on Christmas, but he had a special high of his own and he was making me very nervous around all the art and antiques, dropping ashes everywhere. I finally politely asked Larry to take him away. About half an hour later, my son came running downstairs and announced, 'There are two people doing it in my bedroom.' It was Jean-Michel and one of the bimbos."

"Jean-Michel's relationship with Larry was very symbiotic. He liked to be paid for works of art quickly in cash. Larry would make good deals, buying five or six paintings at a time," says someone who worked at the gallery at the time. But, according to one friend, Gagosian was not above charging Basquiat for a couch he burned during his stay.

Suzanne Mallouk paid an ill-fated visit, just a week after Madonna had come and gone. "She had no time for all of his stuff, and he was kind of hurt by her because she walked out on him," Mallouk says.

Although she had begged Basquiat to fly her to Los Angeles, she felt stranded in Larry Gagosian's house, a "high-tech architectural maze." Once, she even found herself imprisoned in one room, like an abandoned wife in Bluebeard's castle. "Larry had so much valuable art in there that every door to every room automatically

locked behind you and you had to carry a key in your pocket,"
she says. "Nobody had told me this, so they would leave for the
gallery, and I would constantly be locking myself in. There was
one room with a tiny, shallow goldfish pond, and I was stuck there
for hours and hours." Mallouk finally jumped through a small win-
dow into the central core of the house, "which was kind of like a hol-
low tube. And I stayed in there, singing, because it echoed." Mallouk
watched Basquiat paint "Eyes and Eggs," but it was a depressing
visit.

Basquiat kept everyone busy. "Jean made a total mess of Larry's
place, just destroyed it," says Matt Dike. "He was the biggest slob
I've ever seen. The first day, he flooded the place. He was like a
three-year-old kid, but huge. It was nuts trying to deal with him.
Larry had him in the house so he could keep tabs on him, and I was
supposed to keep my eye on him, because Jean would do things like
disappear. And he would get loaded a lot. Getting drugs was no prob-
lem. I mean you could always buy massive amounts of drugs: coke,
heroin, pot, quaaludes, everything."

"Matt used to run these kamikaze raids for Basquiat," says Gago-
sian, who claims he was unaware that most of them were to procure
drugs. "I was already too old and just couldn't go beyond a certain
level, you know, I'm still a businessman. But he'd keep Matt up until
dawn."

Gagosian recalls an incident that poignantly illustrates Bas-
quiat's pathetic inability to cope with his new lifestyle—which never
quite provided him with what he needed. "I remember one time
Jean-Michel had this brand-new Mercedes convertible, black, beau-
tiful, immaculate, that he had just rented. Of course, one of his girl-
friends was driving it, because he didn't have a license. It started to
rain, and it was just like another one of these epiphanies, because
they didn't know how to get the roof up, and they were scurrying
around this new Mercedes, trying to figure it out, while the rain was
coming down on them."

During his Los Angeles sojourn, Basquiat began working on a series
of prints with art dealer Fred Hoffman, who with his partner, Joel
Stearns, later published them as a book. Hoffman spent several in-

tense months with the artist. He would later name his newborn son Jean-Michel.

"Day and night I was devoted to Jean-Michel," recalls Hoffman, who arranged to convert Basquiat's drawings into acetates for silk screens. "He'd leave the drawings in the morning, and by the time he came in by eight at night, we had a stack of screens against the wall, and then he would just say, 'Put that one on that painting and squeegee it yellow.' He'd paint in and out of these screens."

Hoffman enjoyed introducing Basquiat to new source material from his extensive art library. "I turned him on to the sketchbooks of Leonardo once, and so he made this five-part print. The images took him maybe twenty minutes to draw. He was always going so fast you never could take the time to teach him anything. He would draw right on the acetates, which we would photograph from the back so he wouldn't have to draw backwards. One day I came over to see how he was doing on the print, and all the acetates were lying all over the studio. I said, 'Let me pick these up for you, so they won't get screwed up.' But he said, 'No, leave them right here.' "

Hoffman watched as the acetates became nearly obscured by the detritus in the studio. "So finally you could hardly see them, there was so much junk around. The next time I went back, they were hanging on the wall. And he said, 'They're ready, take them.'

"What he had done is trashed them as a way of aging the art. And it was a perfect example of Jean-Michel. Because these were printed on parchment paper. What he did was he reflected on Leonardo, so he used his own trashing process as a way of aging them to create their own patina. He was also very conscious of Rauschenberg, and using junk as a way of making art."

Over the next few months, Hoffman would see Basquiat in many different situations—from deejaying at a club to a near-catatonic state. Hoffman paints a picture of someone whose constant creativity was in itself a source of conflict.

"I was struck by his energy, his directness, by his confidence and his talent. He seemed to think he knew what he wanted. Which struck me as both negative and positive," says Hoffman. "He had a very fresh and astute take on things, so just to be around him, you'd see the world differently. He was very penetrating to the essence of

things. I think the reason he was so into drugs, besides his family problem, was that he was always taking too much of reality. I don't think any human being at that age could handle that kind of implosion. He was in a way a great synthesizer of information. He was sort of like an open channel."

Despite his belief in his own talent, and his grandiose ambitions, Basquiat's extreme vulnerability was obvious to Hoffman. "He had an elusive sense of himself, of his center. I mean when he was in front of a canvas, he was out there, he had complete confidence. He would take such risks, he was so dicey. He knew what he was doing, and he could be conscious and unconscious simultaneously. But he didn't know how to deal with the world when he was open. His biggest problem was that he didn't know how to close down or stay grounded."

Hoffman was constantly amazed by Basquiat's productivity. "One night at Larry's, I went over there around midnight and he had about ten canvases, all blank, about eight by six feet each. He started painting on them and about three hours later he sort of chuckled and said, 'I'm going to paint the history of Los Angeles art today.' And he started painting in the style of Diebenkorn, in the style of Sam Francis, a couple of others. He whipped through these paintings that were sort of pastiches. I dozed off and woke up at dawn, and about a three-inch square was left on each of the paintings. All the rest had been whited out. And he used that little square to make his own work. He played off all of that to make his own paintings."

According to Hoffman, Basquiat was wary of Gagosian. "He didn't trust Larry. He admired him as an art dealer. We would all hang out together and have a great time, but Larry would always say, 'How about another painting?' I mean Larry is a businessman. Larry would get paintings that Jean-Michel wanted to keep."

At one point, after Basquiat returned to New York, Hoffman arranged for him to paint a portrait of Richard Pryor. But the deal ultimately fell through. "It was right after Pryor torched himself, and he was incredibly paranoid. Nonetheless, we arranged through this woman for Jean-Michel to come in and do a painting of Richard. Pryor agreed to pay for his airfare."

When Basquiat and Pryor met, the comedian told Basquiat that he had bought the rights to the Charlie Parker story. Basquiat

planned to do a Pryor portrait that incorporated some collage of Parker-inspired ideas. But a few days later, Pryor decided not to commission the portrait. Basquiat gave him the sketches he had made. "Then he was so upset that he went over to Larry's gallery and painted around the clock for two days this whole suite of Charlie Parker paintings, and some of Miles, too."

Hoffman also became the West Coast distributor of a rap and instrumental album Basquiat produced with Rammellzee and Al Diaz. The music on the 45-rpm album was fairly standard for the period, but its striking black cover, with a big white crown top-center and some characteristic doodles and renderings of bones above the legend Tartown Records Co., 1983, in Roman numerals, is a classic Basquiat.

Hoffman was present one night when Basquiat nearly OD'd. "He came close to having a psychotic reaction one night to drugs. I think it was cocaine. He just got totally disassociated, didn't know where he was, got almost catatonic. I had to hold him to make sure that he understood that he wasn't dead. Then he came out of it. I stayed until dawn, until it was over. He put me through a lot, but he was special."

If Basquiat had rushed the work for the March 1983 Gagosian show, as Matt Dike recalled, it wasn't apparent from the twenty-five paintings that were unveiled at the March 8 opening. Among the works were several of his most memorable: "Eyes and Eggs"; "Hollywood Africans," a double-entendre which is both an ironic reference to the limited number of black movie stars and a triple portrait of Jean-Michel—"self-portrait of a heel #3", Rammellzee, and Toxic during their Los Angeles days; "Self-portrait as a Heel, Part 2," a black, dreadlocked image on a bright green background; "Tuxedo," a white-on-black silk screen filled with minuscule, meticulous diagrams and text on subjects ranging from Al Jolson to fossils; and "Big Shoes," a spare canvas with the words "Origin of Cotton" and a simple memorial to Charlie Parker's dead young daughter, Pree—a crucifix and her birth and death dates, "51–53."

There were also three powerful paintings from the Fun show—Jack Johnson, Sugar Ray Robinson, and St. Joe Louis.

Wrote L.A. critic Suzanne Muchnic, "Basquiat looks like the real thing, not a painted interpretation, and therein lies the difference

between his work and much New Wave or Neo-Expressionist paint-
ing ... We see art that delivers a graphic punch and conveys a
convincing air of urban anxiety. Current works seem less painterly than
the batch he showed here about a year ago, but what they lack
in surface interest they make up in brutish stylishness ... He reminds
me of Rauschenberg, not in style but in the way he gathers information
from dozens of sources and comes off as a contemporary reporter."

The opening itself was glamorous even by Hollywood standards.
"It's like a Hollywood premiere ... all this energy and vitality," Ir-
ving Blum told the gossip columnist of *The Hollywood Reporter*. He
was in town with Roy Lichtenstein. Also present were Gene Kelly,
Diandra Douglas, and producer Steve Tisch.

"It was a wonderful spring evening in Los Angeles," reminisces
Jeff Bretschneider, who flew out to California for the occasion. "It
was a huge, garagelike space, and it was swarming with people. I
went with John Lurie. It was a fucking mob scene, like a lot of open-
ings in the eighties. It was not about what work was on the walls, but
which people were in the room."

Bretschneider taped the event for posterity. "I decided to video-
tape people's reactions to Jean's work. One young couple told me it
was the biggest con they ever saw. Another guy told me he was one of
Jean-Michel's best friends. I had never seen him before, but people
were already saying they were 'a friend of the artist.' I met another
woman who said she had a friend who owned five Basquiats. Five
Basquiats! One for each home! Shenge [a friend who would later be-
come one of Basquiat's assistants] was rolling joints in the office,
where Jean was hanging out. Suddenly, Gagosian comes in with Roy
Lichtenstein, this icon, and introduces him to Jean."

When Basquiat took off for the private dinner after the show,
Bretschneider left too. But, it seemed, Jean did not intend to include
his New York friends. "I saw Larry's Mercedes pull up beside my
rental car," says Bretschneider. "And I looked at Jean and we ex-
changed smiles. Then they just pulled away. Jean and Larry and
Larry's beautiful girlfriend. Jean was already moving up the ladder."

That same month, Basquiat made it into an American museum. Two of
his paintings, "Dutch Settlers" and Untitled (Skull), were included in

Portrait of the artist as a young
star: Basquiat, crowned in his
trademark dreadlocks.

Basquiat at eleven years old, already a serious artist.

Basquiat with the art-noise band Gray. Members (*left to right*) are: Vincent Gallo, Wayne Clifford, Nick Taylor, and Michael Holman.

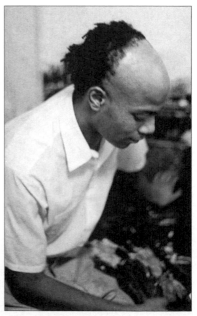

Basquiat in 1979—sometime between his blond Mohawk period and the advent of dreadlocks.

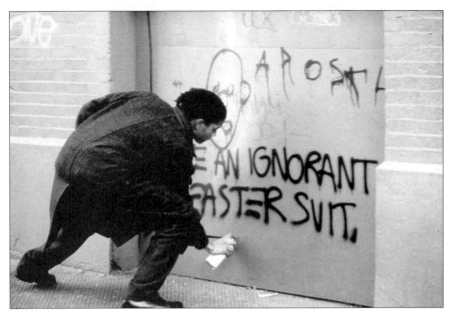

Basquiat in a still from the 1980 movie *New York Beat*, writing one of his original graffiti phrases.

Basquiat painting in Switzerland, during one of many visits to the art dealer Bruno Bischofberger.

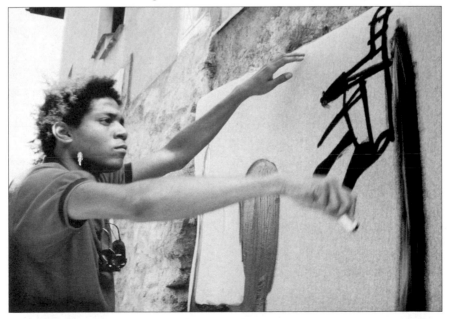

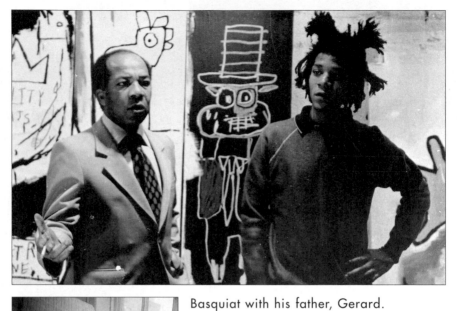

Basquiat with his father, Gerard.

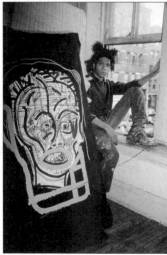

Basquiat in the window of his Crosby Street loft.

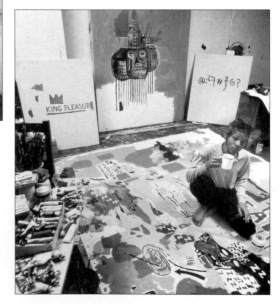

Basquiat in the studio at Great Jones Street.

Annina Nosei was Basquiat's first art dealer; he worked in the basement of her Prince Street gallery.

Larry Gagosian, known as Go-Go during the eighties for his aggressive art-world tactics. (Photo: © Timothy Greenfield-Sanders)

Mary Boone, SoHo's "It" girl, was as famous as her gallery of art stars. (Photo: © Timothy Greenfield-Sanders)

Basquiat and Torton in an image-conscious moment at the Bruno Bischofberger gallery in Zurich. (Photo: © Beth Phillips)

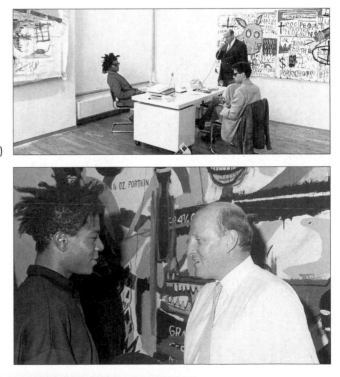

Basquiat with Bruno Bischofberger in front of a Warhol-Basquiat collaboration.

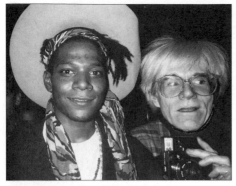

Basquiat and Warhol club-hopping
at the Tunnel.

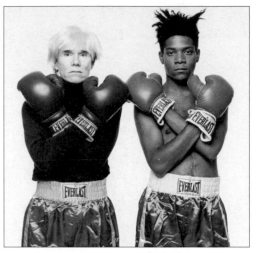

Warhol and Basquiat pose for a poster
of their show of collaborations.

Basquiat and
Paige Powell.

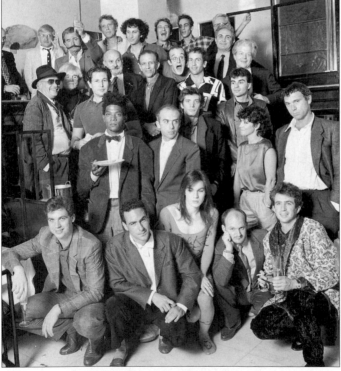

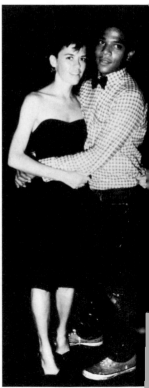

Basquiat at Mr. Chow's, in a group shot with his peers,
including Francesco Clemente, Julian Schnabel, Kenny
Scharf, and Keith Haring.

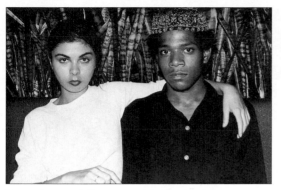

Basquiat and Suzanne Mallouk.

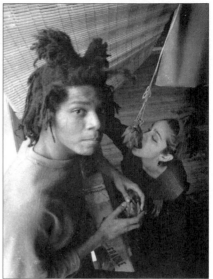

Basquiat and Madonna.

Basquiat and Kelle Inman.

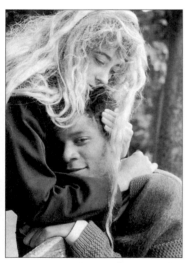

Basquiat and Jennifer Goode.

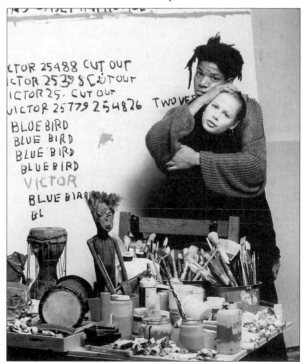

Vrej Baghoomian, Basquiat's last art dealer.

Basquiat at his show at the Cable Building, just several months before his death. (Photo: © Mark Sink)

the 1983 Whitney Biennial. Among the other artists shown at the Whitney for the first time were Keith Haring, Jenny Holzer, Barbara Kruger, David Salle, and Cindy Sherman. In a show that featured the new generation of artists, Basquiat, at twenty-two, was one of the youngest.

Since 1932, the Whitney Museum's Biennial has been a much-ballyhooed, and often lambasted, art-world litmus test; in all senses an augur of artistic currency. The 1983 Biennial was no exception. According to the preface in the show's catalogue, the selected work demonstrated the emergence of a new art movement after a decade of pluralism.

As Jane Bell wrote in the summer 1983 issue of *Art News*, "The Whitney Biennial has striven to delineate the evolution of a new, heroic species of work that has dragged itself out of the formless ooze and sludge of the past decade. The style of painting comes half out of the Expressionist tradition and half out of street art such as murals and graffiti, with a strong injection of popular imagery . . . In general, images of skeletons, nuclear explosions and seemingly agonized and agonizing sex, as well as the iconography of subway and schoolyard vandalism, all leap from the Whitney walls in a cacophony of riotous color and crudely applied lines."

Calling the Biennial a "more heavily budgeted and sanitized Times Square Show," Bell singled out Basquiat's work as exemplary. "We shouldn't forget Jean-Michel Basquiat, either. His short-lived notoriety as 'SAMO,' the poetic graffiti artist of SoHo, made him one of the most noticed, if also invisible, characters in lower Manhattan, but his ultraserious skull, an untitled acrylic-and-oil-stick work on canvas, shows him up as, literally rather than colloquially, one of the 'baddest' artists in the show."

After the Biennial opening, Basquiat found himself seated near Mary Boone at Don and Mera Rubell's glitzy party. While a few observers claimed to see "sexual sparks" between the two, the only romance being pursued was that of the deal; a future business bond was being formed. Before long, Mary Boone would become one of the next in Basquiat's revolving door of dealers.

Nineteen eighty-three would turn out to be a watershed year. Painting was back—and so were collectors. Suddenly, the art world was excit-

ing again. The thrill was evident at the crowded openings and record-setting auctions and in the ultraenthusiastic press. Figurative art, or so-called Neo-Expressionism, ranging from the work of Robert Longo to that of Susan Rothenberg, was pervasive.

Even Hilton Kramer, notoriously the spoiler, was seduced by the new movement. In an essay called "Signs of Passion," he wrote, "Not since the emergence of Pop art in the early 1960's have we seen anything of comparable consequence in the realm of contemporary art . . . Art is once again a medium of dreams and memories, of symbols and scenarios . . . It has reacquired its capacity for drama. . . ." Kramer ended on an uncharacteristically upbeat note: "Neo-expressionism . . . so abounds in those precious 'signs of passion,' its appeal is irresistible."

Arthur Danto also saw the movement as momentous—but he focused on its monetary implications. "All at once there was something important enough for collectors to acquire—*growth* art one might call it—art destined, in analogy with certain legendary stocks, to appreciate enormously in value over time. . . ."

Danto compared the new movement to Abstract Expressionism and Pop art in its self-perceived art-historical importance and instant collectibility. "The Neo-expressionists appeared in terms of scale and frenzy to be in this league. 'Buy before it is too late!' was the implicit imperative, and a market was made . . . It was a moment of heady effervescence, like the discovery of oil."

The time lapse between an art movement and the market for it had, like everything else in the twentieth century, vastly accelerated since the 1950s. For Neo-Expressionism, they were virtually simultaneous; in the 1980s, supply and demand were in perfect sync.

From a marketing point of view, the timing of Basquiat's career couldn't have been more perfect: he emerged into public view as a literate street poet on the crest of the soon-to-crash graffiti movement and surfed right into Neo-Expressionism, a jazzy black hero who shared with Jenny Holzer and Barbara Kruger a fashionably Postmodernist obsession with text.

CHAPTER SEVENTEEN

THE COLOR OF MONEY: THE ART MARKET OF THE EIGHTIES

"What strip mining is to nature, the art market has become to culture."

—Robert Hughes

N ew York's brave new art boom was unofficially launched with the staccato strike of an auction house gavel in May 1983. The piece was thirty-one-year-old Julian Schnabel's "Notre Dame," a thickly encrusted plate painting, which sold to a private collector in Maryland for a whopping $93,500. To many, it was a watershed moment; the art market had resoundingly bounced back after a lengthy recession. The reaction was euphoric: in the early days of the burgeoning new market, nobody could have predicted the level of excess and hype to come.

A hint of the new art-lust had been glimpsed a decade earlier when Robert and Ethel Scull auctioned their seminal collection of Pop art at Sotheby's Parke-Bernet, on October 18, 1973. The near pandemonium among a public and press who had not paid much attention to art since the sixties was captured on film in a documentary by E. J. Vaughn and John Schott, *America's Pop Collector: Robert C. Scull—Contemporary Art at Auction.*

It's all there, recorded in cinéma vérité, a virtual blueprint for the eighties: the venal color of money, the overweening hubris of the bourgeois connoisseur, the instant glamour, the sycophantic press, the wounded and bemused artists, the avid Japanese. The auction

was picketed by the Art Workers Coalition, a precursor of the radical Guerrilla Girls. The auction house was packed to overflow with an ostentatiously dressed audience who applauded each record-breaking bid. Willem de Kooning's "Police Gazette" sold for $180,000; Jasper Johns's "Double White Map" went for $240,000—Scull had originally bought it for $10,500. The only blacks in sight were the white-gloved movers, who, like mimes in a minstrel show, silently spirited each piece of art—Johns's bronze "Ale Cans" ($90,000), say—onto the auction block.

The total proceeds from the sale of works from the Sculls' carefully culled collection of vintage American art was $2.2 million. When the bidding frenzy was over, Robert Rauschenberg approached Robert Scull, and mock-punched him. "You didn't send me flowers," he complained to the self-congratulatory art- and artist-lover. "I've been working my ass off for you to make that profit." The sale had appreciated the work, Scull explained, surprised by the outburst. But Rauschenberg was not assuaged. "You buy the next one, okay, at these prices," he insisted. "Let's make a deal."

"Art is supposed to be such a fine, tony, cultured thing, and suddenly people are bidding wildly, like it was a commodity, just like any other," Scull told the filmmakers. "And I think at Parke-Bernet, that's art without the floss of culture. Over there it's hard, cold money and business. Over there, you've got to write a check out. There's no fooling around and talking about the aesthetics of art. There's just talk about the money of art."

Barbara Rose ranted about the auction in *New York* magazine, "Not since S. Klein's Washington's Birthday sale have I seen expressions of such gross avidity and naked cupidity . . . a situation in which fine art objects, because they are unique and rare, come to be a major medium in the international exchange, the trading beads of the jet age. That is why auction sales now attract people who once haunted Las Vegas and Monte Carlo. . . ." She could easily have been writing about the eighties.

The Scull auction was a dress rehearsal for the boom that swept the art world ten years later. In 1983, latter-day versions of the Sculls rode down to the East Village and SoHo in their chauffeured cars,

fell in love with art and the artists who made it, and aggressively attended the auctions where the same work, greatly appreciated, sold (often by these same collectors) at ever more astronomical prices.

In the documentary, Scull tells a *Wall Street Journal* interviewer, "Knowing the artists, commissioning works, believing in an artist . . . suddenly he's living with you every day . . . What happens is that ownership is involvement, acquisition is involvement, and with art it's probably the most exciting kind of involvement. Of course, owning a nice share of IBM is an involvement too . . . but with art you're into something else. You're into a different kind of high."

Mera and Don Rubell, major Basquiat collectors, would echo Scull's words. "It's such a wonderful moment when you connect with an artist's energy. It's our great passion to go to the artists' studios and experience this aura."

Not surprisingly, when the eighties rolled round, Ethel Scull jumped right on the bandwagon. "I felt like I was back in the sixties," she said. She took the proceeds of the auction of ten paintings from her share of the couple's bitterly contested estate and did what her husband (who died in 1986) had always done: went on an art-buying spree and acquired works by the hot new eighties artists: Jeff Koons, David Salle, and Jean-Michel Basquiat. (Her son, John, also played a role in Basquiat's life; the owner of a limousine service, he occasionally chauffeured Basquiat to openings.)

As collectors, Robert Scull, the self-made owner of a cab fleet (Scull's Angels), and Ethel, his princess wife, were quintessentially American. Besides his other haute-bourgeois habits, Scull subscribed to the notion of built-in obsolescence: the Pop auction was not the first time he had abandoned a movement; in 1965, he dumped all his Abstract Expressionist works. Tom Wolfe royally sent the Sculls up in his essay "Bob and Spike."

"Bob and Spike are the folk heroes of every social climber who ever hit new York. What Juarez was to the Mexican mestizo—what John L. Sullivan was to the Boston Irish—what Garibaldi was to the Sardinian farmers—what the Beatles are to the O-level-dropout 8-pound a week office boys of England . . . what Moishe Dayan is to the kibbutzim shock workers of the Shelphelah—all these are Bob

and Spike to the social climbers of New York. In a blaze of publicity they illuminated the secret route: *collecting wacked-out art. . . .* From hoi polloi to haute monde, just so!"

Writing in the early sixties, Wolfe even maps out the "game" of "collecting the latest thing," which remained pretty much unchanged twenty years later: buy the work hot from the studio, get publicized for buying it, fuel the competition among collectors and galleries. Wolfe neglects to include the final triumphant step: reselling the work at auction for a huge profit. The Sculls flamboyantly played out the whole scenario, and the coup de grâce was the *Über*-sale. Only in retrospect would it become clear that the Scull auction was a major turning point in the market for contemporary art.

A number of factors converged to create the extraordinary, decade-long art bonanza that ultimately self-destructed, like an elaborate pyramid scheme, in late 1989. The juggernaut started in May 1980, when the auction houses broke all historical records with Impressionist, modern, and contemporary art sales totaling a staggering $55.8 million. Despite the occasional dip, each subsequent sale over the next five or six years seemed to set new records as prices soared into the stratosphere.

The art market, which by 1983 was estimated at $2 billion in New York City alone, mirrored the American culture and economy at large. The infamous eighties excesses extended to every aspect of the art world, from its gala openings to its over-the-top auctions to its self-referential media coverage.

During Ronald Reagan's first term, the American economy had dramatically pulled out of the recession it had experienced in the middle to late seventies. The national doldrums—financial, cultural, and political—finally seemed to be lifting. Reaganomics was making itself felt—from Wall Street to Museum Mile. The new optimism that pervaded the country was more than a recovery; it was a palpable shift in the zeitgeist. A specter was haunting America—the specter of entrepreneurialism. The protagonist of Tom Wolfe's *Bonfire of the Vanities*, Sherman McCoy—the entrepreneur as Everyman—embodied the new ethos: The Culture of Money.

Critics pegged the eighties as a twentieth-century Gilded Age; its

newly minted corporate tycoons and smug young Masters of the Universe the modern-day equivalent of robber barons.

Wrote Debora Silverman in *Selling Culture*, "There was a deeper correspondence between the political program of the Reagan White House and the emergence of an aristocratic consumer culture at Bloomingdale's and the Metropolitan Museum. The idealization of non-American nobilities provided the elements of a new cultural style concordant with the politics born at the first Reagan inauguration: a style aggressively dedicated to the cult of visible wealth and distinction."

As John Taylor put it in his book *The Circus of Ambition*, "Reagan's rhetoric unleashed the greatest celebration of wealth—wealth as virtue, as a good in itself—that the country has experienced at any time in the twentieth century." "Greed is good," proclaimed Michael Douglas in Oliver Stone's cynical ode to the times, *Wall Street*.

This "celebration" was manifested in myriad forms of conspicuous consumption that often included art, from the increasing number of museum-quality collections assembled apparently overnight by Wall Street raiders, to glitzy parties thrown at the Temple of Dendur, in the Metropolitan Museum, which by the mid-eighties had become a sort of A-list social club for the wealthy.

The bull market on Wall Street trickled—or rather gushed— directly into SoHo and the East Village and the auction houses: the Money Culture was addicted to acquiring art; for its corporate walls, for its museum-donation tax write-offs, for its newly renovated Hamptons mansions. If in the 1960s anything was art, in the 1980s anything *would sell*. Said Eugene Schwartz at one point, "Collecting is the only socially commendable form of greed."

A new class of collectors emerged. Call it art appreciation: invest now, show it off to your friends, sell it at a higher price later. Said Robert Hughes at the time, "If you want to go in for a crushing but tasteful display of economic power, even the rawest junk-bond trillionaire knows that art is the best way."

The Steinbergs were a perfect illustration of this phenomenon. Gayfryd Steinberg met her billionaire husband, merger-and-acquisition king Saul, at a dinner party given, appropriately enough, by art dealer Richard Feigen. The Steinbergs' collection, which includes an im-

pressive number of Old Masters, ranged at the time from Titian's "Head of John the Baptist" to a trifle by Renoir that decorated a powder room in their palatial Park Avenue apartment.

In 1989, Gayfryd threw Saul a legendarily lavish fiftieth-birthday party, spending millions on the creation of life-sized tableaux of famous paintings. A few years later, Steinberg, who had been politicking to become a member of the Metropolitan Museum of Art's board of trustees, turned the museum into a banquet hall for his daughter's $3 million wedding reception. Said Feigen admiringly of the man who was one of his major clients, "Steinberg is one of the greatest collectors of our time. He's brilliant. He's nice. He's funny. He's passionate, plus he's got a huge fortune."

The Steinbergs were in good company. During the early to middle eighties, British advertising tycoon Charles Saatchi, who established his own museum in 1991, wielded extraordinary power in the art world, making and breaking artists by buying their work in bulk (as he did with Sandro Chia), only to precipitously dump it several years later.

Basquiat had his own select clique of collectors, including Elaine and Werner Dannheisser, Herbert and Lenore Schorr, Donald and Mera Rubell, Dolores and Hubert Neumann, and Eli and Edye Broad. What all these collectors had in common was an apparently insatiable craving for the new; a Jones for the latest art trend.

In a certain sense, the psyche of the eighties art collector dovetailed neatly with Basquiat's; collecting can itself be viewed as a form of addiction. Wrote Werner Muensterberger in *Collecting: An Unruly Passion*, "Like hunger, which must be sated, the obtainment of one more object does not bring an end to the longing. Instead, it is the recurrence of the experience that explains the collector's mental attitude . . . Obtainment in whatever way, bought, found or even acquired by scheming or tricky means of thievery—works like a mood regulator and provides the owner with a potential sense of success or triumph, and occasionally grandeur, as is the case with the winner at the gaming table or the astute buyer in the auction room."

Mitch Tuchman, the former editor in chief of the publications at the Los Angeles County Museum of Art, owns more than a thousand pieces of Bauer pottery. He is also author of *Magnificent Obsessions*,

for which he interviewed several dozen collectors. "One of the things that amused me was the number of people who talked about their collection as an addiction without any of the consequences of an addiction," he told *The New York Times.*

Art dealer Richard Feigen is a case in point. "Some people drink or gamble; I collect painting," he said, adding, "If someone has been hurt as a child, they turn to objects because objects can't hurt you back." An acquaintance of Robert Scull's once called him a "painting addict," who "took art in the veins, a mainliner."

An exponentially growing art world helped feed the collecting monkey. In 1983, some thirty-five thousand art students graduated from various institutions; there are close to a million self-titled artists in America, of which an estimated ninety thousand live and work in New York City. In 1970, there were about two hundred galleries in New York; by the mid-eighties that number had tripled.

The incredible demand for new artwork gave dealers an unprecedented amount of control over collectors, who were put on waiting lists for the work of certain artists and sometimes forced into package deals that included purchasing inferior work in order to be ensured first pick. In *Art & Auction,* Stuart Greenspan wrote about these "growing hordes who line up to buy the latest art as if they are waiting to purchase a ticket to a Madonna concert."

A new profession, "art adviser," emerged to help guide the growing number of collectors and corporations (there were now over a thousand that had significant art collections) who wanted to invest in art. Some, like Jeffrey Deitch, who founded Citibank's Art Advisory service in 1979, were affiliated with financial institutions. In the early 80's, banks began to accept art as collateral against loans. "If someone has a $10 million art collection, we would generally loan them $5 million," Deitch told *The Wall Street Journal.*

Meanwhile, the wheels set in motion by the Scull auction had gathered speed. It had not been lost on the auction houses or the galleries that there was a bona fide market for contemporary American art. The works of "emerging" artists were now being auctioned, and for the first time the auction houses began to compete directly with the dealers. This increasingly young and ambitious breed stopped at nothing to aggressively market their hot new discoveries, whether it

was David Salle, Eric Fischl, Julian Schnabel, Robert Longo, Keith Haring, or Jean-Michel Basquiat. The artists themselves, like their yuppie counterparts in banking and real estate, had an outspoken agenda; unlike their Abstract Expressionist progenitors, they were self-confessed climbers at least as obsessed with fame and fortune as with form and content.

Their rapidly produced work had an avaricious new audience. The thrill of the chase, something hitherto known only to the blue-blooded rich, was increasingly the sport of a generation of nouveau riche collectors. "The chase and capture of a great work of art is one of the most exciting endeavors in life—as dramatic, emotional and fulfilling as a love affair," said the then director of the Metropolitan Museum, Thomas Hoving.

The love affair with art seemed to extend to the general public. In 1983, 4.5 million people attended the Metropolitan Museum; about 40 million a year visited art museums across America. Stoking the desire of the masses, the media viewed the ever-growing art bubble as one superlative headline.

Wrote Hughes in *Time* magazine in June 1985, "The new mass public for art has been raised on distorted legends of heroic modernism: the myth of the artist as demiurge, from Vincent van Gogh to Jackson Pollock. Its expectations have been buoyed by 20 years of self-fulfilling gush about art investment. It would like live heroes as well. But it wants them to be like heroes on TV, fetishized, plentiful and acquiescent. If Pollock was John Wayne, the likes of Haring 'n Basquiat resemble those two what's-their-names on *Miami Vice. . . .*"

If art as a spectator sport was on the rise, so was a relatively new phenomenon: rampant art speculation. Although investing in art for monetary gain is hardly a new concept (Richard Rush's popular guide to the subject, *Art as an Investment*, was published in 1961), the eighties took the gambit to dizzying new heights. Abstract Expressionism engendered the American art star; Pop art created the hard sell; Neo-Expressionism conflated both.

"When Neo-Expressionism came in," Martha Baer of Christie's told *The Wall Street Journal*, "people got excited because an artist's prices could double or triple in a year."

"There are not only more people collecting," said Mary Boone, "there are more people collecting for the wrong reasons, basically as the latest get-rich-quick scheme. They buy art like lottery tickets."

The hyperinflation also created a thriving secondary—or resale—market, of people eager to cash in on the work that was constantly changing hands. Larry Gagosian excelled at this game, and his current success is due to the expert skill with which he turned over expensive art—often clinching the deal with no more than a transparency or a well-timed fax.

Says private dealer Andrew Terner, "As a dealer in the eighties, you were supplying what seemed to be an insatiable demand. The phone was ringing constantly, morning, noon, and night. It was like the Wild West. I could buy a painting in the morning and sell it in the afternoon in a different country for three times what I had paid for it a few hours earlier. That's how insane it was. Most dealers were like commodities brokers, and there was no difference between the collector and the dealer. In a sense, every collector *was* a dealer."

Says veteran art dealer Ivan Karp, "It became an hysterical interval and it distorted the entire art scene completely. The people who were buyers were uninformed about what had merit. They bought recklessly. They bought what they read about and they paid scandalous prices for them. Schnabel was the only name that certain people knew. They were told if you bought a picture for five thousand, it would be fifty thousand a year and a half later, and in certain cases it was." (Indeed, Basquiat's prices at auction increased five hundred percent between 1982 and 1984, when Christie's sold his first work for $20,900.)

The influx of Japanese money—especially after the International Plaza Agreement in 1985, which revalued the yen, raising its worth by nearly a hundred percent against the dollar by 1987—further raised the stakes. "Prices went up on a weekly basis," says curator Klaus Kertess, who founded the Bykert Gallery in the late 1970s. "A fairly large number of Japanese who did not have a particularly real sense of the worth of works of art paid outrageous prices, sometimes ten times as much." When Christie's auctioned van Gogh's "Sunflowers" in 1987, it was a Japanese buyer, Yasuda Fire and Marine Insurance,

that bought the painting for $39.9 million—three times the earlier world record.

The auction houses played a pivotal role in the instant inflation. "The auction houses were the ones who set the prices. They acted as megaphones for the art market. We dealers had to follow them," says Feigen. "We became disposable. There was the impression in the eighties that art had been converted into a financial market. Sotheby's saw themselves as a financial-services organization, and art as the financial instrument."

In 1983, shopping-mall mogul A. Alfred Taubman took over Sotheby's and forever changed the rules of the game. Instead of selling to dealers, Sotheby's now cut them out of the loop and appealed directly to the growing art-buying public. At one point Taubman told *The Wall Street Journal*, "Selling art has much in common with selling root beer. People don't need root beer and they don't need to buy a painting either. We provide them with a sense that it will provide a happier experience."

Taubman also instituted several controversial new practices that made the getting and spending of art at auction a commercially lucrative enterprise for everyone involved. "He took a very intimidating institution in the public's mind and turned it into a retail operation," says Terner. "People bought their chips and went down to play with them."

On the selling end, Sotheby's offered art owners a guarantee on the sale of a work. If the work didn't sell, the owner still got paid whatever was guaranteed. This meant there was virtually no downside to selling art, because one made money even if the work failed to sell, and either way the price was instantly inflated. On the buyer's end, the auction houses actually began to act as banks, lending money to potential bidders. It was a win-win situation.

As Hughes explained it in a November 1989 *Time* magazine cover story, "The beauty of the loan system, from the point of view of the auctioneer, is twofold. It inflates prices whether the borrower wins the painting or not: like a gambler with chips on house credit, he will bid it up. Prefinancing by the auction house artificially creates a floor, whereas a dealer who states a price sets a ceiling. And then, if the borrower defaults, the lender gets back the painting,

writes off the unpaid part of the loan against tax, and can resell the work at its new inflated price."

The loan system gained notoriety in 1987, when a new art-world record for the sale of a work at auction was set: $53.9 million for Vincent van Gogh's "Irises." The painting was bought by Alan Bond, who borrowed more than half the money—$27 million—from Sotheby's.

These practices helped turned the formerly genteel auction house into the equivalent of one of Donald Trump's Atlantic City casinos. The evening sales became major social events, where wealthy collectors reveled in displaying those other trophies, their wives. Wrote *The New York Times*' John Russell, "Posterity is likely to marvel at the extent to which, in the month of May, 1989, [auction rooms] doubled as gambling room, vanity parade and surrogate stock market, with overtones of bullring, prize ring, cockfight, dogfight and manfight. It was as if the collective unconscious of the newly monied world had come out of hiding and every last instinct of greed and cupidity and ostentation was let loose."

Collector Asher Edelman was even blunter: "The auction is a hog-pen environment. People are coming to auctions to show how rich and important they are. I think it's wonderful. It creates a great form of patronage. So I welcome the hogs to the hog pens."

If the 1973 Scull sale presaged the eighties art boom, the Schnabel sale a decade later defined it. There was the notorious Mary Boone, taking the unprecedented action of putting up a painting for auction at Sotheby's Parke-Bernet that was only four years old. There was the painting itself, a textbook example of Neo-Expressionism, painted by the eighties' first real art star, Julian Schnabel. And there was the inflated price—almost $100,000, already perceived as a product of pure hype.

" 'Getting out of hand' is a phrase heard more and more as prices for art works sold by dealers or at auction go up and up and up," wrote Grace Glueck a month after the Schnabel sale—which took place in a week of auctions at both houses that brought in a record-breaking total of $67 million.

Said Christie's Martha Baer, "It was a frustrating period for us. On a daily basis, we were aware that it was out of control, that there

was an unsavory element to it. Works of art were absolutely thrown at us for sale. We barely had to leave our desks."

And the greatest demand was for the schlock of the new. "Eighty percent of the telephone calls I receive are for young artists: Schnabel, Basquiat, Salle, etc. . . ," Sotheby's Lucy Mitchell-Inness told the *New Art Examiner*. "Much of the work should never have left the studio. It was unedited. The dealers were greedy and undisciplined about it, and the artists were just as greedy as the dealers for their sales."

Says Richard Feigen, "It didn't do anybody any good to have artists like Basquiat having work that had sold for ten to thirty thousand selling for six figures. What happened to him couldn't have happened to him that fast in another era. Richard Bellamy or Leo Castelli would have demanded a substantial body of work before promoting him to such a star status. Basquiat was put on the menu of hot artists and demands were made of him. It's like taking a six-year-old piano prodigy and sticking him on the Carnegie Hall stage, starting a career so early that the artist burns out."

The center would not hold: like the eighties economy, which crashed on Black Monday, in October 1987, the art market was gearing up for its own big fall.

Basquiat's sycophants had become a constant drain, and the artist often sought sanctuary in various hotel suites. Lhotsky recalls a night she spent at the Ritz Carlton in early 1983. Basquiat had talked her into leaving a party for Kathryn Bigelow's stylish biker film, *The Loveless*, in which Lhotsky played a role. He met her in the hotel lobby, tipping the cabdriver with one of the fifty-dollar bills that was sticking out of his pockets. Up in his suite, he quickly stripped and pushed Lhotsky toward the bed. "It was very animal-like behavior. Sort of like beavers jumping around in the woods," she says. "Jean-Michel was into sensation then, quick action, immediate gratification, high energy, results."

Lhotsky watched from the bed as Basquiat began to riffle through the vast array of art books he had strewn around the suite; Picasso, Cy Twombly, Michelangelo, and da Vinci. "He was sketching up a storm and studying those books. He told me he was ripping off ideas from the Masters, because how else were you supposed to learn any-

thing. He seemed to appropriate the most from the Picasso book." Lhotsky enjoyed sharing Basquiat's "trade secrets."

When they got hungry, Basquiat ordered ribs from a take-out place. "They came in this huge cardboard box, and he looked really strange gnawing them on the bed. He kept the ribs warm by putting them on the radiator. They looked so funny, sitting there in this hotel suite," she recalls.

Lhotsky says that on at least one occasion, Basquiat hit her. And, like Monforton and several of his other lovers, she discovered she had picked up gonorrhea from him. He gave her money for medication. "The thing I remember most about Jean-Michel was how hard it was for him to deal with the whole thing of going from the street to being famous, and then to have everybody sort of leeching onto him. It really made him kind of crazy. And he could get mean. Jean-Michel had been so abused that he continued the pattern, and was abusive. But then he was also so charismatic. My image of him was always with these pockets full of crumpled-up bills. He'd always pay for everything, because he felt so guilty."

That April, Basquiat had a solo show that, although tiny, would prove in its own way to be a turning point for the young artist. A highly elitist affair, it was arranged by Paige Powell, the advertising director of *Interview* magazine, with whom Basquiat had recently become romantically involved.

Powell had decided to become more than Basquiat's lover; she was attempting to manage the young artist's career. Both would prove to be equally difficult tasks. Powell was one of the few people in Basquiat's life to have the courage to talk to his father about his heroin addiction, something Basquiat never forgave.

But ultimately, her major role would be that of liaison between Basquiat and Andy Warhol. It was through his relationship with Paige Powell that Basquiat finally became closely involved with his mentor. Within the year, he would become Warhol's artistic collaborator, and by late August 1983, he would move into the Great Jones Street loft that Warhol owned, where he would live for the rest of his life.

Powell first met Basquiat in 1982, when Jay Shriver, a Factory assistant she was dating, brought her down to the painter's studio

on Crosby Street. Slender, with a slightly freckled, all-American face, the prim-looking Powell had a penchant for people on the fringe, much to the despair of her ultraconservative parents.

"My mom belongs to all these bridge clubs and she went to this party once, and one of her best friends said, 'Oh, we feel so sorry for you that your daughter was involved with this black drug addict,'" says Powell with chagrin.

Basquiat instantly charmed Powell with his mixture of earnestness and eccentricity. "When I first started going out with him, it was in the summer. It was so hot and he came to my door all dressed up in this wool suit with a bow tie," she recalls. "One time we went to the movies, and he came back with eight different ice cream cones, and he said, 'I want you to have your pick.'

"Jean-Michel had so much style. Every two weeks his hair would be a different cut. Like a topiary sometimes. He was very charismatic, he could charm absolutely anybody when he wanted to. He exuded this highly sexual, highly creative energy. He really was extraordinary. I truly believe he was a genius."

Powell, who at one point said she actually considered marrying Andy Warhol and adopting a child with him, lost no time in trying to nurture the exotic young artist. She told Andy that Basquiat needed help, but Warhol's observation about Basquiat's condition was "Well, gee, he just wants to be famous." Says Powell, "Andy used to hide from him because he was afraid."

He was also afraid of Basquiat's coterie. One time, Powell brought one of Basquiat's graffiti friends, A-1, to the Factory. "Andy totally flipped out. He said, 'Paige, don't ever bring those guys into the office, because they'll just like spray-paint all over my paintings.' That's how paranoid he was about it," she says.

So Powell took the artist's career into her own hands, and arranged a small show of his work at her apartment on West Eighty-first Street. "Jean-Michel had sent a video crew to tape it. He had invited people like Julian to come and Francesco Clemente, and all these other artists. I had the invitations printed at Tiffany's. I thought this would be a really great thing to do, make it really formal. Actually A-1 wanted to show his work, and Jean-Michel insisted that I have Rammellzee in the show. And Morton Neumann and all these big collec-

tors were there, people who were interested in A-1's art, but wouldn't go to the South Bronx to look at it. It was really fun." Powell sold a painting to Neumann. Warhol even bought a painting called "Famous." "And then I started selling all of his artwork, so he kept giving me more. He was doing these big triptych panels."

Basquiat camped out at Powell's posh pad for a couple of months. "He turned it into a studio. He painted all the time. There were drawings and paint on the floor and the walls. He was always working." One night, Basquiat gave Powell a tour of his childhood haunts. "He took me around to all the schools he went to. One was St. Ann's. It was like five in the morning or something, we parked the car and then went to his house and then went to White Castle. We went to where his father used to have his hardware [sic] store. And we went to the homes of some of his friends that he knew as a child, sort of a nutty thing."

Stephen Torton, temporarily reinstated after his recent dismissal, built the stretchers for the show. "I was making fifteen to twenty stretchers a day, every one of them handmade. "I kind of liked the idea of being a white slave to a black artist. The hinge paintings were my idea. It was the only way we could get them into the elevator. He liked big canvases, so I started putting them together with hinges. I could open like five paintings that were twenty feet long, one inside the other."

Powell priced the paintings at $2,000 to $3,000 for the small ones and $6,000 to $8,000 for the large triptychs. "For a while I was handling everything. Dealers and collectors were calling all the time. They were after him. Art critics, people who wanted to speak to him. It was overwhelming. He was always trying to hide from it so he could maintain his own privacy."

According to Powell, who was still going out with Shriver at the time, Warhol did his best to sabotage that relationship and promote one with Jean-Michel.

"Jean-Michel really wanted to have a relationship with me, and I just would not have anything to do with him because of the drugs. But Andy, in his very sick way, was trying to aggravate Jay, because he couldn't stand that his main assistant was going out with me," she says.

"Oh and Paige is upset," wrote Warhol in his *Diaries* on May 18,

1983. "Jean Michel is really on heroin—and she was crying, telling me to do something, but what can you do? He got a hole in his nose and he couldn't do coke anymore, and he wanted to still be on something, I guess. I guess he wants to be the youngest artist to go. Paige gave him a big art show uptown last month and she's the reason he's been around the office—they're 'involved.' "

Powell may have been oddly naive, but she wasn't completely oblivious: she quickly realized that, among other things, Basquiat saw her as a convenient conduit to her boss. "He did a show with me because he thought Andy would see it," she says. "I think he started using me in a way to get closer to Andy. When Andy knew I was going to be doing this show, I became the kind of spark plug between them. I would convey messages. Jean-Michel would give me little presents to Andy, and Andy would return this or that. So I was sort of like the liaison that made them friends."

Basquiat began accompanying the duo on their long nights out on the town. Powell was so pleased to see Warhol warming up to her lover that she remained completely unaware of the obvious subtext. "All of a sudden, it was like Andy kind of took him away," she recalled soon after Basquiat's death, in an interview in her Manhattan apartment, where portraits of both dead artists hung above her bed.

"Andy seduced him, but not in a sexual way. Andy really thrived on other people's energy, especially if they were spontaneous and original. Jean-Michel loved stardom, and I think that is one reason why he attached himself to Andy. The first thing he did was set up a dinner with Bianca Jagger and Calvin Klein, and Jean-Michel came running to my office the next day to tell me. That was an important thing to him. And that's how Andy really sort of got Jean-Michel." Powell watched as Basquiat finally realized his dream—bonding with Andy Warhol.

Warhol, Powell, and Basquiat had an uncomfortable triangle for months, with Warhol happily playing the desperately-in-love Powell against the drugged and withholding Basquiat and gleefully repeating the frustrating details of each melodrama to his Boswell, Pat Hackett. Basquiat gets a whopping 115 mentions in Warhol's diaries.

ANDY'S CHILDREN

"I'll give you an interesting analogy here. Have you ever read Carson McCullers' *The Heart Is a Lonely Hunter*? All right. Now, in that book, you'll remember that this deaf mute, Mr. Singer, this person who doesn't communicate at all, is finally revealed in a subtle way to be a completely empty, heartless person. And yet because he's a deaf-mute, he symbolizes things to desperate people. They come to him and tell him all their troubles. They cling to him as a source of strength, as a kind of semi-religious figure in their lives. Andy is kind of like Mr. Singer. Desperate, lost people find their way to him, looking for some sort of salvation, and Andy sort of sits back like a deaf-mute with very little to offer."

—Truman Capote, *Edie*

"I always thought that I'd like my own tombstone to be blank. No epitaph and no name. Well actually, I'd like it to say 'Figment.' "

—Andy Warhol, *In His Own Words*

For three decades, Henry Geldzahler had been an art-world bellwether. The former curator of contemporary art at the Metropolitan Museum, Geldzahler helped put Pop on the map in 1962 during the Museum of Modern Art's symposium on Pop art (he was the only panelist to applaud the new movement); in 1969, he curated *New York Painting and Sculpture, 1940–1970*, the Met's famous centennial exhibition, of work by the New York School—otherwise known as "Henry's show."

Geldzahler was also a longtime Factory intimate. "Henry gave me all of my ideas," Warhol once said. In 1965, Frances Fitzgerald wrote of the cigar-smoking star of Warhol's film *Henry Geldzahler*, "Though he has been described as 'the Metropolitan's ambassador to the Scene,' he serves no such archaic function. Rather he is the Telstar of the art world and all its subsidiary planets—a man so tuned in to all its wave lengths that he registers events almost before they happen."

From 1977 to 1982, Geldzahler served as Mayor Koch's cultural commissioner. When the 1980s rolled round, Geldzahler was, once again, in sync with the zeitgeist, and he became one of the first to support graffiti and Neo-Expressionism. "I felt the juices flowing again and I asked Diego [Cortez] to take me to see Julian, and Francesco and Jean. And I looked at each of them, and I just flipped out. You know the story, I left Julian's studio, and I fell down the stairs."

Geldzahler's much-documented face (it was impossible to look at him without seeing him morph into that David Hockney portrait— $1.1 million at auction in 1992) registered an amused look as he remembered his first brush with Basquiat. Although Geldzahler was one of the key figures in launching his career, he initially played a role in postponing Basquiat's inevitable apprenticeship with Warhol.

In the spring of 1978, Geldzahler was having lunch with Andy Warhol at WPA on Prince Street, a popular SoHo fern bar. It was one of those quintessential New York moments; the world's most famous artist in tête-à-tête with the art-world capital's unofficial mayor.

"We could be seen through the window," Geldzahler recalls. "Jean is walking by with postcard-size things—like an intermediate step from graffiti into the world of galleries. Very sweet. And he notices Andy, so he comes in and he shows Andy the work. And Andy says, 'Show it to the Commissioner.' And Andy and I are busy talking, so I give them back to him, and I said, 'Too young.' And that was it. I didn't mean it to be bitchy or dismissive in any way. It's just Andy and I were talking about something, and some kid came by the table, and that's how it felt." Warhol bought a postcard for $1.

It would take another three years before Geldzahler's celebrated antenna would pick up Basquiat's shock waves, and he became an

ardent champion of the artist and his work. As one of the commis-
sioner's protégés, Basquiat managed to resist his amorous advances
while allowing Geldzahler to buy him art supplies. Says Geldzahler,
"The second time I saw Jean's work, I just flipped out. I took the
painting back to my office, and I called a meeting of the entire staff,
and I said, 'He's twenty-two years old, he's black and he's part of
history.' "

Basquiat's abortive meeting with the Pope of Pop was a momentous
occasion for the young artist. He had been trying to connect with his
idol for years; attempting to hawk him T-shirts, sweatshirts, and post-
cards, much as Warhol himself once stalked Truman Capote, pester-
ing him with notes and drawings.

Basquiat had worshiped Warhol from the time he was old enough
to seriously consider becoming an artist. "Andy Warhol was the ap-
ple of his eye since he was fifteen or sixteen," recalls Monforton. "He
wanted Warhol's fame. Jean-Michel had a mission to accomplish; he
really wanted to be somebody, and he was hell-bent on getting there."
Recalls Zoe Leonard, "He always said he was going to be the next
Warhol."

Basquiat was hardly alone in his obsession with Andy Warhol.
Virtually everyone of his generation had been influenced, in one way
or another, by the artist who more than any other seemed to embody
contemporary culture. "I feel very much a part of my times, of my
culture, as much a part of it as rocket ships and television," said
Warhol about himself.

"Above all," wrote Robert Hughes, "the working-class kid who
had spent so many thousands of hours gazing into the blue, anes-
thetizing glare of the TV screen, like Narcissus into his pool, realized
that the cultural moment of the mid-sixties favored a walking void.
Television was producing an affectless culture. Warhol set out to be-
come its affectless culture hero." If that was indeed his mission,
there is no question that Warhol succeeded—to an extent unrivaled
by any other cultural icon.

Says Kenny Scharf, whose TV-inspired work of Day-Glo cartoon
characters filled an entire room at the Palladium, "He was my hero,
the reason I came to New York in the first place. He just turned art

around and made it fun. I used to call him Papa Pop. He was the father and we were the children."

Whether by utter guile or guilelessness, Warhol became the white-wigged Wizard of Oz to legions of art students; his famous career a grail to every MFA and struggling downtown artist-in-residence; his subject matter a cinéma vérité of modern culture. Thinking about celebrity pre-Warhol is a little bit like thinking about the id pre-Freud. He both identified and personified the defining force of the late twentieth century, starting with his most famous statement, "In the future everyone will be world-famous for fifteen minutes." It was a transmogrifying moment; it contained not only his own fame but all the Oprahs—and John Bobbitts—of the future. Warhol: the Zelig of the zeitgeist.

"Andy made fame okay. He made it part of the aesthetic," says Colacello. "Andy realized very early on that in a totally secular society that no longer believed in God, we needed new saints. And the saints were Marilyn, Elvis, Jackie, and Campbell's soup. The whole approach to being an artist of the eighties came directly from Andy. Salle, Haring, Schnabel—they were like Andy's children. Andy attracted narcissists who were into fame and their own stardom. The Factory was the headquarters of the glamour that Hollywood had thrown away. And I think that kids in art school in the seventies, when *Interview* was flourishing, got Andy's message."

Wrote David Bourdon in *Warhol*, "Success in the post-Warhol art world meant not just feverish acclaim and high prices, but also a fame so pervasive that one's name appears in the gossip columns, fashion magazines and game shows. These were hardly lofty standards of achievement, but they affected the aspirations of subsequent generations of art students who were less interested in creating serious art than in getting their faces published in the fashion press and living it up in style."

But it wasn't just the fame and glamour that attracted the younger generation; it was the Attitude, the deadpan, jaded, cryptic silence onto which so much could be projected. "Andy knew how to put on a good show for the art world," says artist Ronnie Cutrone, an early Factory member. "He was reacting against the Abstract Expressionists. They were all punching each other out in bars and vomiting on

each other's shoes. Andy was trying to be cool and detached and it worked."

Warhol also raised mass production to an art form. "He came up with a really great, fast technique. He came up with *speed*," says Cutrone. "My theory, and Andy would agree, is that a really great artist reflects his or her times. Andy was a really wonderful mirror. He was just a big shining reflector."

In his Brooklyn brownstone, dreaming of a future as a famous artist, Basquiat devoured material about Warhol in consumer magazines like *Time* and *Life*. "He was very curious about Edie and read everything about Andy and drew little pictures of him," says Paige Powell. Says Jane Diaz, "Jean-Michel loved Andy because he was not a *tortured* artist."

Even before he met Warhol, Basquiat had perfected Warhol's catatonic demeanor. He stared through people, and mumbled in ironic monosyllables, a zombie-like effect no doubt enhanced by his profligate use of drugs. "Jean-Michel adopted a Warholian manner," says Victor Bockris, author of *The Life and Death of Andy Warhol*. "You looked at him, and he looked through you, and it was so stupid because it is a very difficult thing to do, and Andy did it based on studying media for fifteen years and being like Greta Garbo. When Warhol did it, it was a new, original thing to reject people. Jean-Michel didn't know how to do it, and when he did it, it splatted back in his face."

Says Benjamin Liu, a special assistant at the Factory in the eighties, who disconcertingly speaks of both artists in the present tense, "One thing I would say about Andy, and I think I would make the same remark about Jean-Michel, is that they are very aware of the part they play in public. I think Jean-Michel likes to pull people's legs. Kidding around, but literally like kind of dangling you a little bit. He can get really cold and it gets a bit scary. It's not a pretty sight. It's almost like a killer effect."

Scharf describes Basquiat's demeanor in a similar way: "His stare would just kill you. He'd draw you in, because he was a really attractive person, and then turn around and slaughter you. It was like he was going to eat your face with his face."

Warhol's statement about Popism, that it "took the inside and put

it outside, took the outside and put it inside," could just as easily be applied to Basquiat's canvases, where free-associations straight from the artist's id collided with images hijacked from a barrage of popular culture.

The artists had more in common than met the eye. Both Warhol and Basquiat had had medical emergencies in childhood with long, bedridden convalescences. Basquiat was hit by a car when he was six, and was hospitalized for several months. It was during this time that his mother gave him *Gray's Anatomy*, which was to be a lifelong influence. At age eight, Warhol suffered a "nervous breakdown," diagnosed as Saint Vitus' dance, and acquired his famous ghostly pallor. He spent the summer in bed with comics and coloring books. His mother rewarded his colorings with candy bars. Basquiat's accident resulted in a ruptured spleen, which was removed, giving him a dramatic abdominal scar. After Valerie Solanas's failed assassination attempt on Warhol in 1968, he underwent surgery, including the removal of his ruptured spleen. The odd coincidence provides a nice metaphor; both Basquiat and Warhol were unable to filter out toxins. Both of them would become insider/outsiders—they existed at the epicenter of the culture while always remaining strangely detached from it.

The arc of their well-chronicled relationship would follow a predictable curve. By the time he was twenty-three, Basquiat had realized his fantasy; he was not only Warhol's protégé but his collaborator and partner; they hung out together, worked out together, painted and partied together. It was in every sense of the word a symbiotic relationship. Basquiat found a father figure in Warhol; Warhol, who had always depended on the energy of a young and outrageous entourage, found inspiration in Basquiat. The pale ghost of Edie and the other dead Superstars still hung over the Factory, like a faint cloud of incense, as Warhol and Basquiat painted enormous canvases that they squirreled away from Bruno Bischofberger, or worked out with Warhol's personal trainer, Lidija.

From the start, their dynamic was complicated. Says Walter Steding, a musician and artist who worked at the Factory in the early 1980s, "It was as though they had always known each other. Jean-Michel wanted to get into the Factory. It was a mystery that he had to

solve. Jean-Michel wanted to get to know things, wanted to work with Andy, yet he didn't want to be used.

"And Andy wanted Jean-Michel there for a lot of reasons. The timing was right for him to say that he was going back to an old style of painting. Andy admired the way Jean-Michel worked and he admired that free spirit. But that same kind of free spirit got him into a lot of trouble throughout his career, so he had to keep his distance. It was really like two tigers walking in the same cage. And all of that tension is in the paintings they did together. It's a real dance."

"I just wanted to meet him, he was an art hero of mine," Basquiat told journalist Cathleen McGuigan in 1985. McGuigan asked how Warhol had influenced the young artist. "I wear clean pants all the time now," he said, with typical insouciance. And he readily took credit for persuading Warhol to paint again. "Andy hadn't painted for years when we met. He was very disillusioned, and I understand that. You break your ass, and people just say bad things about you. He was very sensitive. He used to complain and say, 'Oh, I'm just a commercial artist.' I don't know whether he really meant that, but I don't think he enjoyed doing all these prints and things that his stooges set up for him. I think I helped Andy more than he helped me, to tell the truth."

Jean-Michel also bragged about his influence on Warhol to his father. Recalls Gerard Basquiat, "He called me up at two a.m. and said, 'I'm going to work with Andy. He has not touched a brush in twenty-four years, and I'm going to make him do it.' "

Although the relationship between the two difficult artists would prove to be pivotal for both of them, it did not begin auspiciously. Ever since his nearly fatal encounter with Valerie Solanas, Warhol had become even more paranoid. Although he occasionally bought Basquiat's T-shirts and postcards, the ambitious young artist, with his wild dreadlocks and unruly demeanor, was not somebody that he was eager to cultivate. Moreover, Warhol, according to those who knew him, had ambivalent feelings toward blacks.

Recalls Steding, "Jean-Michel was sort of crashing across the street from the Great Jones Street space. One day he came over and

tagged the door. He wrote, 'Famous Negro Athletes,' or something, and Andy saw it and said, 'Don't let that colored boy inside.' He was afraid of him, but he saw the meteoric rise of Jean-Michel and he wanted to participate in it. I don't think Andy ever got over his fear of Jean-Michel. But Andy thrived on that fear."

Colacello also remembers Andy's initial reaction to Basquiat. "Andy was kind of afraid of Jean-Michel, because he was a young black kid," he says. "His brother Paul told me that when he was a young child, he had been beaten up by a young black girl. He used to cross the street if we saw a scraggly-looking black guy walking in our direction. Jean-Michel was the only black who ever had a significant role in Andy's life."

In 1981, Glenn O'Brien brought Basquiat up to the Factory. But Warhol was still nervous about the raunchy-looking artist, with his messy hair and even messier joints. Says O'Brien, "Jean-Michel was young and wild-looking, with dyed blond hair. I thought Andy would like him. Andy acted shy and nice. He bought a 'Manmade' sweatshirt."

But despite repeated attempts, Basquiat was unable to gain access to the inner sanctum. "Andy never wanted Jean-Michel at the Factory," says Cutrone. "It was my job to keep undesirables out, and Jean-Michel would knock on the door and be a pest, and Andy asked me to get rid of him."

Warhol's interest in the young artist was whetted a year later, when Bruno Bischofberger brought him to lunch and Basquiat dashed off the wacky, wet self-portrait with Warhol ("Dos Cabezas"). And Basquiat's involvement with Paige Powell the following spring brought him into Warhol's immediate orbit.

But it was Bischofberger who finally created a situation that Warhol found irresistible: he made their bond a bottom line. Says Cutrone, "People would always try to use Andy, and Andy had a wonderful way of using them right back. Andy didn't really get closer to Jean-Michel until Bruno Bischofberger coughed up a bunch of money and suggested they collaborate."

According to Cutrone, Warhol's interest in Basquiat followed his typical pattern. "Andy is a big Al-Anon case. Look at his track record with drug addicts, including me. Andy was a total enabler. It gave

him a sense of control. Another aspect was that he needed a shot in the arm himself. He was surrounded with a lot of suits and ties and he wanted a rebel image. He needed to be taken out of the White House and turned back into the kind of artist that would have a crush on a young black boy. He longed for that craziness on some level. Last but not least, there was Bruno's money. With those three things going for him, Jean-Michel was welcomed into the fold. Andy was a gay dandy who really did enjoy collecting people, and they liked being collected."

Basquiat was one of Warhol's final, plum conquests. If Warhol was attracted to his creative energy, he was also drawn by Basquiat's trendiness, his place in the red-hot center of the current cultural scene. Basquiat wanted entree into the Factory; Warhol wanted to inject himself directly into the heart of downtown. They were attracted not only to each other, but to what each had come to represent.

Says Bockris, "Warhol at the time had gotten to the bottom of the sea of his own career. Before he met Jean-Michel Basquiat, he actually had a show of dollar-bill-signs—which didn't sell. He was at a real low point before he started to collaborate with Jean-Michel, and he was sort of in love with him. The association with a new young hip artist was very valuable to Warhol. But you have to understand Andy to understand that Jean-Michel represented to him the fabulous, miraculous beast of the subversive artist. Andy saw in Jean-Michel exactly what Jean-Michel could be, which was a Warhol Superstar burning brightly in the night, before it disintegrates with delight. Jean-Michel's career paralleled many Superstars'—two years of extreme fame, and then disintegration, even death."

In June 1983 Basquiat was out in Los Angeles again. Fred Hoffman introduced him to Lee Jaffe, a former musician in Bob Marley's band. Basquiat was scheduled to leave for Tokyo the next day to model in an Issey Miyake show. With his usual impetuous generosity, he invited Jaffe along. Jaffe recalls Basquiat's shenanigans at the photo shoot in Japan. "He was wearing a shirt worth a few thousand dollars, and he was throwing paint all over the place. The Japanese were totally freaked out."

They decided to continue their trip around the world, with Bas-

quiat, typically, buying first-class tickets for them both. But after an unpleasant, tourist-filled interlude in Thailand, they flew to Zurich, and then on to Bruno Bischofberger's vacation house in Saint Moritz.

Bischofberger was happy to see them; in fact, he had ten blank canvases lined up in his garage for Basquiat to complete. Basquiat was incensed. It didn't take much persuasion from Jaffe to convince him to wreak his revenge by painting on several extremely expensive custom-made mattresses instead.

Recalls Bischofberger, "Whenever he was here, Jean-Michel asked if there was somewhere he could paint. He never painted anything specifically for a show in Zurich. But at Saint Moritz we didn't have a studio yet. So in one of our garages was the storage room where the canvases were, where Jean-Michel, when he wanted to paint, was supposed to paint. There was also a new handmade, super-expensive mattress lying there that Jean-Michel knew was made of hand-cast foam rubber that has to be ordered almost a year in advance. Yo Yo [Bischofberger's wife] was so angry that Jean-Michel would dare just to take this thing."

But Bischofberger was not about to let a Basquiat painting go to waste; he not only got an apology from the artist; he got permission to salvage the painting. "Jean-Michel apologized five times, as well, and I bought this painting anyhow. Later on he allowed me to remove the canvas from the mattress and stretch it."

Says Powell, "Jean-Michel was really upset that Bruno had these canvases waiting for him in the garage. That kind of stuff drove him nuts."

Even then, Jean-Michel enjoyed tormenting the rich collectors who courted him. "I remember one time there were these two collectors, and it was a hot, humid, dog-day night," recalls Powell. "They wanted to take him out to dinner. So Jean-Michel picked out the hottest restaurant outdoors on Columbus Avenue that served Mexican food, and the collectors were just wilting.

"The other thing he did was dropping these German stink bombs. I think I still have a set. He dropped them all at a gallery where Milo Reese [one of the artists who inspired the character Stash in Tama Janowitz's short-story collection *Slaves of New York*] was having a show. They're really vile little things, they come in a vial. They are

just so disgusting. He threw them out the window a lot, if a collector was coming over."

He was not much more civil to dealers; according to one infamous anecdote that quickly circulated SoHo, he had dumped a jar of fruit and nuts on the head of Michelle Rosenfeld, an art dealer who had gone to Crosby Street to buy some of Basquiat's work, bringing with her an offering of health food.

Recalls Powell, "One time I was over at his house, and then all of the sudden Larry Gagosian was downstairs, and he said he was coming up. And Jean-Michel said, 'Don't leave me, don't leave me!' So Larry came up and they had this terrible confrontation, and I was so embarrassed because I had been at Larry's house not that long ago in L.A. and he was so hospitable. Jean-Michel made it look like I was his protector. He'd run over to me and grab me and go, 'I'm not going to do that. I'm not going to make a painting for this person.' I was like mortified. And I just remember going into the bathroom and locking the door. At that point in time I was terrified of Larry, with Andy telling me all of these stories about how he was making obscene phone calls. And then Andy did a show with him, and when I asked why he was doing it after terrifying me for years about this guy, he said, 'Oh well, it's cash and carry.' "

By August, Warhol had successfully insinuated himself into Powell's romance with Basquiat. Powell pins the moment when Warhol made his decisive move to an evening that began in an Upper West Side ice cream parlor: "We had ice cream sundaes and then we went out to dinner. And Jean-Michel is such a passionate person, and we had just started going out, and he was like always kissing me and stuff. And Andy couldn't stand it. After this build-up of exchanging notes and letters and this evening, Andy all of a sudden invited Jean-Michel to come exercise with him."

Wrote Warhol in his *Diaries* on August 17, 1983, "Went down to meet Jean Michel and did a workout with him and Lidija (cab $5). And he has b.o. It's like Chris [Makos] who also thinks it's sexy when you exercise to have b.o., but I want to say, it sure isn't. And all this b.o. has made me think about my life and how I'm not really missing anything great. I mean, I think of Paige having sex with Jean Michel,

and I think, how could she do it. I mean, what do you do, say some hint like, 'Uh, gee, why don't we do something wild like take a shower together?' " A week later, Warhol was taking pictures of Jean Michel in a jockstrap.

The relationship, though never overtly physical, had a certain sexual frisson. August 29: "Jean Michel and I went over to Yanna's, and we had our nails done . . . The two of us would make a good story for Vogue (pedicures $30). "Cab to meet Lidija ($5) Worked out with Jean Michel who brought me some of his hair, cut off and put on a helmet. It looked great . . . He and Paige had a big fight because they had a date for 9:00 and he didn't show up until 1:00."

The situation quickly became intolerable even for someone as masochistically accommodating as Powell. "I started getting pushed out, because Jean-Michel would keep going back to doing stuff with Andy," she says. "Andy would say he was going down to Jean-Michel's studio when he knew I couldn't go, because I had something to do in the office. And Jean-Michel would break dates with me because Andy was coming over.

"It was awful, pure hell. We'd be going somewhere and he'd disappear, and then he would show up, really kind of sheepish, at the office and Andy would come in and apologize for him and say, 'Oh you know, Jean-Michel's here and he's really embarrassed and he wants to have dinner with you tonight, but he's afraid to come into the room.' So, in other words, Andy started acting as his liaison with me." Warhol had won the tug-of-war; his role and Powell's had been completely reversed.

"Jean-Michel was so infatuated with Andy that he'd go through all the books about Andy," Powell says. "He read kind of slowly but everything was kind of like real important to him, and so he'd ask him like six or seven questions on every single line in any book, like *Andy from A to B*."

The infatuation was mutual. Says Colacello, "I think with Basquiat, Andy was fascinated and had a big crush on him. But part of Andy saw you as another theme for his diary, another tape. Andy was trying to be responsible and Andy really did care about Basquiat, but then you wonder, did Andy care about Paige, or was he just using her

as a surrogate lover with Basquiat? He probably even got her to describe sex with Basquiat. That was Andy's kind of dream, to be in the middle of a couple like that. She was going to have Basquiat's child, because of Andy.

"One of Andy's great lines to me was 'I'm living my life through you.' He said the same thing to Candy Darling. He was the Great Recorder, not the Great Pretender. He was a walking tape and video recorder, to the point of wanting to watch someone die. Andy was the sponge of sponges, the Caribbean sea of sponges."

Basquiat and Warhol were never lovers, but Warhol's prurient interest in Basquiat was obvious. Says Liu, "Andy's relationship with Jean-Michel was like a wet dream that didn't go through. Andy would says to me, 'Jean-Michel has a big schlong. Can you imagine? That's why all those girls liked him.' Andy likes to know what makes people tick and what makes people have that incredible sex drive. Jean-Michel had that animal magnetism and Andy keeps probing him at dinners and stuff, jokingly, like, 'So how many times did you come last night?' It's actually a standard thing with Andy, actually with gay boys too. But in this case it's interesting, and also Andy found out that he had actually tricked before and he had tricked with guys too, and that really fascinated Andy. It never developed into a sexual relationship. Andy is the ultimate voyeur."

Basquiat's arrival in Warhol's inner circle coincided with the demise of Warhol's romantic relationship with designer Jon Gould. Says Liu, "Jon was becoming more spoiled, more obnoxious, and had moved out to Los Angeles, and all that pampering that Andy did for him I think in a way he carried over onto Jean-Michel. There was a point when Jean-Michel was more on his mind than Jon. Jean-Michel did revitalize Andy, there's no question about that, just energywise."

To others, the fit was obvious. "Jean-Michel was interesting and facile and cute and sexy and savvy and popular all rolled into one," says art dealer Howard Read. "He was kind of the ultimate exotic because he was black, and young and a drug addict, and probably very in love with Paige at that point."

According to Peter Brant, Warhol viewed him primarily as a daz-

zling new protégé. "When I would talk to Andy, his position was that he thought a lot of Basquiat's work was great. It was like an athlete talking about a younger athlete."

At the end of August, Basquiat took up Warhol's offer to move into the two-story brick building at 57 Great Jones Street that Warhol had occasionally threatened to turn into a laundromat. The rent was high—$4,000 a month. Recalls Powell, "I remember a lot of conversations with Jean-Michel, and we sat with paper and pencil and tried to figure out what he would have to do to make this money. He wanted it more because Andy owned it than because of the space itself."

Warhol, ever the businessman, was apprehensive. "So Benjamin went over to get a lease and I hope it works out. Jean Michel is trying to get on a regular daily painting schedule. If he doesn't and he can't pay his rent, it'll be hard to evict him. It's always hard to get people out," reads the *Diaries* entry for August 26.

Warhol would give Basquiat lukewarm pep-up talks, his version of tough love. "Labor Day. Jean Michel called, he wanted some philosophy, he came over and we talked, and he's afraid he's just going to be a flash in the pan. And I told him not to worry, that he wouldn't be. But then I got scared because he's rented our building on Great Jones and what if he is a flash in the pan and doesn't have the money to pay his rent (supplies $35.06, $6)?" (September 5, 1983).

When Michael Stewart, a middle-class graffiti writer, who happened to be going out at the time with Basquiat's former girlfriend Suzanne Mallouk, was beaten to death by the transit police on September 15, 1983, it had a profound effect on Basquiat. If the dreadlocked Stewart was a logical alter ego, it followed that he had died for his/Basquiat's sins. After all, Basquiat had used his own idiosyncratic graffiti as a launching pad for his supersonic career.

When Basquiat heard the news that Stewart, a twenty-five-year-old aspiring artist and model, had been bludgeoned and strangled into a coma by subterranean white cops, he spent the night at Paige Powell's apartment, drawing black skulls. Stewart died on September 28. Not long afterwards, Basquiat depicted the tragic event on a wall in Keith Haring's building, in a piece called Untitled (Defacement).

Michael Stewart's brutal death was even more of a personal blow

to Basquiat because Suzanne Mallouk was dating Stewart at the time. Horrified by the killing, she began a campaign to investigate the incident and bring the police officers involved to trial. She raised money from a number of artists, including Keith Haring. But Jean-Michel refused to donate a penny. When Mallouk asked him for a contribution, he kept repeating, "It could have been me! It could have been me!"

About a week later, Basquiat left the country. With typical impulsiveness, he decided at the last minute to accompany Warhol to Milan. "I hadn't thought Jean Michel would come, but while I was waiting in line at the airport he appeared, he was just so nutty but cute and adorable," reads the diary entry for October 5, 1983. "He hadn't slept in four days, he said he was going to watch me sleep. He had snot all over the place. He was blowing his nose in paper bags . . . Paige has turned him into sort of a gentleman, though, because now he's taking baths."

Perhaps haunted by Stewart's death, Basquiat was in a funk. He told Warhol he felt suicidal. Warhol ignored him. October 6: "Jean-Michel came by and said he was depressed and was going to kill himself and I laughed and said it was just because he hadn't slept for four days and then after a while of that he went back to his room."

At a time when Basquiat felt particularly vulnerable, Warhol's response was typically flip. The message was clear; even though he actually had some understanding of Basquiat's needs, he was unwilling or incapable of providing empathy on demand.

The next day, Warhol returned to New York, but Basquiat traveled on with Haring to Madrid. He was becoming even more of a jet-setter than his mentor, which Warhol resented, or perhaps he simply felt guilty. The following week he took his pique out on his protégé. October 18: "Jean Michel came by and I slapped him in the face." (laughs) "I'm not kidding. Kind of hard. It shook him up a little. I told him, 'How dare you dump us in Milan!' " One can only imagine how Basquiat reacted to such unexpected physical violence from Warhol, the man he had chosen as his surrogate father.

Meanwhile, Powell continued her upscale campaign for the artist. In late October, she arranged for Basquiat to give a lecture at Vassar.

But this time, her efforts to promote Basquiat did not go according to plan. "He loved the idea. He thought it was just great. He was like really bragging about it," she says. "But when it came time to do it, he was petrified. Everything had been set up, and all of a sudden, like he's like flipping out. He was really nervous, and he didn't want me to go up there at all."

Basquiat went alone: by all accounts his lecture was a success. He told Warhol that he had left Paige in New York because he "would be wanting to fuck the girls up there." Warhol took Paige, whom he described in his *Diaries* as "hysterical," to the Mayfair for drinks. "And Paige was so upset—here she'd just handed Jean Michel a $20,000 check for selling some of his paintings. She said she'd never show or sell his stuff again."

She was as good as her word. "I remember when I told him I was going to quit selling his artwork, he was like crying, he was just so upset. And he just went completely, really hysterical," Powell recalls. "And then Andy was trying to get me to continue doing it because I was selling a lot. But I couldn't be his girlfriend and sell his paintings. It just couldn't work like that, you know? And everybody's leaning on me when he'd disappear. I had everyone down my throat. I had so many phone calls at work, I couldn't even handle it. I mean everyone from his friends trying to find him to the dealers, magazines, collectors, drug people. It was way too much."

Nor could Powell handle the sordid conditions at the loft. "He'd be passed out on the bed covered with dry spaghetti like Rumpelstiltskin," says Powell. "One time I called the Neumanns up and asked them to send some food for him. He never lived that down."

By now, Basquiat's drug habit was completely out of control. "He would always succumb to these drug binges," says Powell. "We'd be walking down the street to go have breakfast or lunch, and he would say, 'Well, I've got to run back to the studio really fast and just get something,' and then I'd hear from him three days later. If an article came out about him, he was so proud to show it to his father, but he'd pour coffee over the spot that said he did drugs. When Andy and I would go down to his studio, Andy would buy some of his drawings and they'd always get in a fight over the price. Andy hated to pay him because he knew where the money was going to. I had offered to take

him to a dry-out place, and he just ridiculed me for it. He did go to a clinic once, but he left early. In his heart, he wanted to clean up. He was ashamed of it."

In February 1984, Basquiat, Powell, and Basquiat's family traveled to Hana, Hawaii. Powell recalls her reaction to the marijuana-laced cookies they baked. "I came into the kitchen and the checkerboard floor was shrinking and going into like Alice in Wonderland proportions. And I said to Jean-Michel, 'There's a circus in my lap.' And he stopped cold and he said 'Magic. that's what it's all about. It's finding the magic. That's all I try to do is find the magic.' And after we broke up and he said 'Oh you're going to tell everybody my secret to painting, and I said I wouldn't, even though he did a lot of mean things to me. But I always kept his secret, and his secret is that he would draw from cartoons on TV. That was like his main thing. That was sort of the inspiration for a lot of his stuff."

Finally, Powell decided to tell Gerard Basquiat about his son's addiction. "We met at One Fifth Avenue and I said, 'You should know Jean-Michel is a drug addict.' For about two weeks we had conversations on the phone. His father couldn't work. He couldn't sleep and he was trying to figure out how to tell Jean-Michel that he knew he had a heroin problem, and he couldn't do it and he asked me if I would do it, which I did. I said, 'Jean-Michel, look at you. Your face is all scratched up. Your teeth are falling out. What are you trying to do? Your family knows you're a heroin addict."

The news came as a shock to Gerard Basquiat, who said he thought his son did nothing much more serious than smoking pot. "I was very upset and very worried," he said. "And I spoke to him a little bit about it, just a little bit. And he brushed it off . . . Jean-Michel always liked to be on the edge. He likes to flirt with danger. And I guess it's a form of self-destruction in a way. . . . He was very upset that I found out."

In a rage, Basquiat threw a glass vase at Powell's head. "I even sacrificed the relationship, to the point of almost getting killed by him when he threw that glass vase," she says. But her courage was not rewarded. Instead Basquiat boasted about the incident. "Jean-Michel was really bragging that he had thrown it at me," she recalls.

Powell's on-again, off-again relationship with Basquiat would last

for two years. Says Cutrone, "Paige was a guilt-ridden Catholic girl who needed abuse, and Jean-Michel was perfectly willing to give it to her."

But even when they were no longer really involved, there was no way she could avoid Basquiat. Warhol made sure of that. "Andy would create these awkward situations. He'd say, 'Would you be my date tonight for the Dia Art Center?' And then we'd be on our way there in the cab and he'd go, 'Oh, Paige, I'm so embarrassed. I forgot to tell you. I just absentmindedly told Jean-Michel he could be my date too.' And then Andy would always say to me, 'Jean-Michel really loves you, but you have to deal with this drug situation and you also have to deal with the fact that he's going to be screwing around with all these other girls, and I said, 'I can't deal with either one of them. It can't be in my life,' and yet, I didn't have a separation from him because Andy would throw us together."

It was Bruno Bischofberger who originally dreamed up the collaborations. He got the idea in the winter of 1983, when Basquiat was visiting him in Saint Moritz, just several months after the dealer had given him a solo show in Zurich. Basquiat and Bischofberger's four-year-old daughter, Cora, had already made a painting together. Now they did a drawing together in the family's guest book, which also included a picture by Francesco Clemente and Cora.

Bischofberger had a brainstorm; he would ask Warhol to collaborate with several of the young artists he represented. Bischofberger considered much of eighties art, with its characteristic style of appropriation, to be a form of collaboration. But adding Warhol to the formula created a whole new dimension. He discussed his idea with Basquiat. After rejecting the idea of Julian Schnabel as the third painter, they decided to approach Clemente, a good friend of the artist who had a studio not far from Basquiat's in New York. On his very next visit to the Factory, Bischofberger proposed the project to Warhol.

Explains Bischofberger, "The collaborations worked in the following way. I asked all three artists if they would agree to make paintings together. Each one agreed and I said, 'My terms are that you each do like twelve paintings, plus three drawings together, and

each of you start four paintings without speaking to the other first. Do any kind of format, any kind of subject matter that leaves some room for the other to add something. And it switches around until everything is finished.' "

Bischofberger showed fifteen of the series of three-way paintings in his gallery in Zurich in the fall of 1984. Noted Warhol, "These combined paintings of Jean Michel and me and Clemente that he [Bruno] said were 'just a curiosity that nobody would want to buy' that he paid $20,000 for like fifteen pictures for, he's now selling for $40,000 or $60,000 a piece . . . oh but well, Jean Michel got me into painting differently, so that's a good thing." (September 17, 1984)

But unbeknownst to Bischofberger, Warhol and Basquiat had embarked on a collaborative project of their own. When the three-way work was completed, they began working together on a new series of canvases.

These large paintings combined Warhol's love of logos with Basquiat's facile catalogue of images—skulls, jazzmen, lists of words. In "Arm and Hammer II," Warhol painted two circular frames with the famous flexed bicep and hammer. Basquiat responded by turning one of the circles into a jazz record—complete with a portrait of a saxophone player. In "Pontiac," Basquiat adds some penguins to the automotive logo of an American Indian, and a snake with the Revolutionary words "Don't Tread on Me." Warhol, imitating himself in his shoe phase, paints a large sneaker; Basquiat adds the words "(endorsement)" and "Don't tread." In "Stoves," Basquiat scribbles all over several kitchen appliances. Their two styles coexist on canvas, but they never manage to merge into a coherent image. Although Warhol is "painting again," to quote a Talking Heads song, Basquiat is merely repeating himself.

Cleverly, the artists had hidden their new work from Bischofberger. "When I met Warhol again, about half a year later in the spring of 1985, on one of my almost monthly visits to New York, he revealed to me that he and Jean-Michel Basquiat had for several months now been working together in the Factory on a large number of further collaborations," says Bischofberger. "He seemed a bit embarrassed, presumably because he and Basquiat had not mentioned it to me earlier." Before long, however, Bischofberger had convinced

the painters that he should represent their collaborative work. According to the records kept by his assistant, Beth Phillips, he initially planned to use the warehouse in Long Island City as a kind of showroom in which to display the work to big clients.

He dictated a note to Phillips confirming to Hahn Brothers Warehouse that Warhol and Basquiat were going to sign fifty collaborative paintings. "Please assemble the paintings so that the artists may sign them. The third room is to act as a showroom for these paintings. Beth Phillips is to be allowed to present them to a small group of clients." He told Phillips that the signing was "very important," and that she was to accompany the artists to the warehouse. He also told her which clients to contact, and what to tell them.

"Tell Asher Edelman that Andy painted them by hand. And that there is a thick, black-felt signature. Call Mr. and Mrs. Schorr and tell them they will have first choice of these paintings. They will be the very first ones to see them. Andy painted them by hand, and they are nowhere else available.

"Call Margulis, Siegal. Call Mr. and Mrs. Dannheisser. She's a crazy old lady, a tough cookie. Call Robert Mnuchin. No one else can see them. Put all the others away. Call Jean-Michel and remind him we need titles for the catalogue."

Bischofberger insists he has no recollection of the note, which Phillips still has in her records. And, in fact, according to both Phillips and Bischofberger, the only people ever taken to the warehouse to see the work were Tony Shafrazi, who later showed the Collaborations in his gallery, and his cousin, a fledgling art dealer named Vrej Baghoomian. Usually, Bischofberger, like most dealers, showed his clients transparencies. But the note reveals his urgency at the time.

Both Basquiat and Warhol were driven out to the warehouse to sign the paintings, but Basquiat refused to let Phillips photograph his current work. Not long afterwards, he went to Hawaii, where, per his request, Phillips wired him $40,000.

The painting duet continued from 1984 through 1985. But Basquiat's heroin habit often interfered; either he nodded out or he had volatile

mood swings. October 2, 1984: "Jean Michel came over to the office to paint but he fell asleep on the floor. He looked like a bum lying there. But I woke him up and he did two masterpieces that were great." October 7, 1984: "I let Jean Michel in downstairs. He did a painting in the dark, which was great . . . Jean Michel is so difficult, you never know what kind of mood he'll be in, what he'll be on. He gets really paranoid and says, 'You're just using me, you're just using me,' and then he'll get guilty for getting paranoid and he'll do everything so nice to try to make up for it." November 29, 1984: "Jean Michel came in and painted right on top of the beautiful painting that Clemente did. There was lots of blank space on it that he could've painted on, he was just being mean. And he was in slow motion so I guess he was on heroin. He'd bend over to fix his shoelace and he'd be in that position for five minutes."

The difference between Basquiat's attitude toward his artwork and that of his mentor couldn't have been more pronounced. Warhol maintained a famously strict work ethic; Basquiat established no boundary between his art and his life.

Jean-Michel would show up in the Factory late in the afternoon, smoking an enormous joint, and work on canvases on the floor. "His daily routine is really funny because it is a nonroutine," says Liu. "Andy is like a regular guy. He comes to work. Jean-Michel on the other hand is like on a drug binge until whatever hour he finally got up, and usually it's like Andy calling and asking 'Aren't you up yet? Don't you want to come over and work and work out a little bit?' Andy is always working out every day. But Jean-Michel works out just when he feels like it. And then Andy makes me buy him food because he didn't eat breakfast, and he didn't eat lunch and he's a mess so we'd have to go to the local deli and get him that horrible junk food so that he could wake up and start doodling. Andy would do his stuff and then Jean-Michel would come in and fill in the spaces."

Then Liu would use a blow-dryer to dry the speedily executed canvases. "The room would be filled with pot smoke, because Jean needed to be high to paint," says Cutrone. "They never quite painted together. Andy was a really busy man, and Jean-Michel would come in because he had nothing else to do and hang out and paint and usu-

ally after he left, Andy would go over what he did or add to it. It was
not a collaboration where they were swinging paintbrushes together.
It was more like hanging out and having Jean-Michel around."

But Jean-Michel clearly reveled in working with his idol. "We
worked for a year on about a million paintings," he told film director
Tamra Davis and writer Becky Johnston in their taped interview. "He
would start most of the paintings. He would put something concrete
down, a newspaper headline or a product, and then I would sort of
deface it and then would try to get him to work some more on it. And
then I would work more on it. I would try to get him to do at least two
things, you know. He would like to do one hit and then have me do all
the work after that. I could paint over his stuff all the time . . . Listen-
ing to what he had to say was fun. Seeing how he dealt with things
was fun . . . that sort of thing. And he's really funny. He tells lots of
funny jokes . . ."

"I think Basquiat really idolized Warhol, you know?" says Larry
Gagosian. "Warhol really lit him up. It was like the *Good House-
keeping Seal of Approval* or something. It wasn't just a father, it was
also the professional approval of a white artist who was one of the
masters. I think that was very, very important to him, professionally. I
think it gave him a lot of confidence. On the other hand, it also gave
him a lot of arrogance. I think it was kind of a mixed blessing, their
association."

But at its core, Basquiat's attachment to Warhol was much more
basic; he desperately wanted Warhol to be the Good Father. "They
were together every night. Andy was a dad to him for sure," says Fab 5
Freddy. "Andy and Jean-Michel loved each other," says Jay Shriver.
"They were very close and good friends. Andy was the only person
that Jean-Michel could look to for affirmation."

Warhol was there for Basquiat to the extent that he was capable
of being there for anyone. But Warhol would have been the first to ad-
mit that he was not equipped to save Basquiat from himself.

BOONE MEANS BUSINESS

I
f Warhol represented the father figure Basquiat perpetually sought, and then rejected, his next dealer, Mary Boone, was the antithesis of a parental surrogate. From the outset, she had doubts about taking on the wild young artist.

Indeed, Basquiat's relationship with Boone would probably never have taken place without the strenuous matchmaking manipulations of Bruno Bischofberger, who had a business deal with Boone. Says Boone, "Bruno was a very clever businessman. He already intuited that Jean-Michel was a very volatile artist and it would be good to have another dealer involved. It took me a while to be convinced."

As his international dealer, Bischofberger was completely involved in every aspect of Basquiat's career. About a year after he first began to represent Basquiat in Europe, he took Beth Phillips to Great Jones Street, to photograph Basquiat's latest output. Explains Bischofberger, "He was desperate that I would find a good gallery for him, and of course I was aiming for Leo Castelli. But Leo wasn't ready at the time for him. So I asked Mary, with whom I was working on other projects. We were representing Schnabel together and Salle together. There was this great group of works and we took Polaroids to Mary. It was very hard to convince her. She was very reluctant. She was up and down and she wasn't sure whether Basquiat was a great artist. And I was pressuring her."

At the time, Bischofberger wasn't the only dealer trying to find a new gallery for Basquiat. Annina Nosei had tried to get Basquiat into the Blum/Helman Gallery. But although Blum was interested in

taking Basquiat on, Basquiat's characteristically out-of-control be-
havior quickly destroyed the deal.

Recalls Irving Blum, "Annina was a very good friend of mine. At
her suggestion, we called Basquiat and we were invited to a studio
visit. We came with a certain amount of enthusiasm and as we saw
more work we became more and more enthusiastic. And as we be-
came more enthusiastic, he somehow became more withdrawn, either
through paranoia, drugs, or something. He tried very hard to focus,
but became increasingly more vague." Still, as far as Blum was con-
cerned, it was a done deal.

"At the end of the visit, we shook hands warmly. When we left
the studio we kind of happily assumed that we would be showing
him. We thought the work was exciting and provocative. It had a kind
of street savagery and an immediacy that I thought was really rele-
vant. We selected a body of work. And we agreed to have a group of
paintings sent to the gallery the next day. A couple of days later I
called him, and he said he would get back to me and he never did. So
many people were pulling him in so many directions."

Bischofberger remembers Basquiat cleverly using the Blum/
Helman interest as a bargaining chip. "Basquiat told me that he was
flying to Los Angeles with Irving Blum and Joe Helman, and they
were taking Roy Lichtenstein to his opening, and that he had to de-
cide by the next day if he was going with them. He told me, 'If Mary
doesn't make up her mind, I will.' " The ploy worked. "I called Mary
and told her she had to decide and she said, 'Okay, I'll do it.' It was
on the verge of not happening."

Beth Phillips began working for Bischofberger in November of 1983.
"Bruno always reminded us of Goldfinger. Only he wanted all the art
instead of all the gold," she says.

Her first encounter with Basquiat took place when she accompa-
nied Bischofberger on one of his search-and-destroy missions. "He
picked me up in a car. I met Andy and Julian. Then we went to see
Jean-Michel Basquiat. I had heard of Julian and Andy, but Basquiat
was just becoming big in the East Village. The first time, we went to
his studio, in a really spooky area on Great Jones Street.

"Bruno started knocking on the door, but nobody answered. So we

came back an hour or two later. We could see through the window that there was some man lying on the floor. Bruno said, 'It's Jean-Michel. He must have passed out.' We knocked a third time and this time Jean-Michel came to the door. He was very disheveled. He smelled bad. He was covered in paint. The whole place was in disarray. I was dressed in a suit, and so was Bruno. Jean-Michel was really angry, he said, 'Get out! What are you, my pimp?' But Bruno laughed and said, 'We'll come around later.' Then he said to me, 'Get a truck, we've bought thirty paintings. Don't tell Mary Boone.' Bruno always paid cash for paintings.

"We took the thirty paintings up to the studio. They looked like the work of a disturbed child. There were figures and writings and layers of images and collage. They were huge paintings, six or seven feet tall. Bruno wanted me to photograph them. He said they were top secret, and I shouldn't tell anyone about them. Within an hour or two, Mary Boone called and said, 'I hear you have a few paintings.' I told her that they had already been shipped.

Bischofberger says that all of his business dealings with Boone were totally on the up and up. Told that Boone sometimes managed to get paintings from Basquiat unbeknownst to Bischofberger, he insists that he himself never engaged in such tactics. But Basquiat was happy to sell paintings to almost anyone for cash.

"I started to realize that Bruno was pulling a quick one on people who trusted him," says Phillips. "Mary trusted Bruno, but he was paying cash for paintings, and moving them over to Switzerland. On the shipping slip, we'd write that each painting was one thousand dollars instead of ten thousand dollars. He would buy in cash so he wouldn't have to pay taxes."

But Bischofberger says that Phillips's recollection about changing the shipping bills is wrong. As a Swiss citizen importing work intended for sale outside Switzerland, he was only required to pay a temporary importation tax.

According to Phillips, Bischofberger had an account with a Swiss bank in New York. "We would take out a maximum of ten thousand dollars a day for whoever was supposed to get money," she says. Bischofberger also provided Basquiat and his other artists with art supplies. "I would take a bag full of cash to get art supplies for Jean-Michel," says Phillips. "We opened accounts at Pearl Paint and New

York Central. Bruno would say, 'What kind of paint does he want? What kind of canvas does he like?' and we would immediately get him twenty or thirty of those."

Bischofberger was responsible for paying the $4,000 a month rent on the Great Jones Street loft, a small duplex with a bright yellow kitchen and large studio downstairs, and bedroom and bathroom upstairs. Phillips was constantly getting messages from the Factory that Basquiat was three or four months behind in the rent.

By now Basquiat was a constant part of Warhol's inner circle, but Warhol never completely trusted him. Wrote Warhol on December 14, 1983: "Bruno came by and drove us crazy. He didn't bring Jean-Michel's rent payment, so later I called Jean-Michel about his rent being due, and then I had a fight with Jay because he gave Jean-Michel my home phone number . . . I yelled at him, 'Are your brains still with you?' I mean, he knew I wouldn't have Jean Michel coming up to my house. I mean he's a drug addict, so he's not dependable."

Basquiat never concealed his profligate use of drugs. Phillips recalls that when they went to collect the thirty paintings, she saw "the biggest bag of coke I ever saw in person. Jean-Michel would throw it down on a dinner plate and snort it. He would snort it with the front page of the *New York Times*. He was always rolling these giant joints."

When Barbra Jakobson wanted to buy a Basquiat from Bischofberger, he took her to the artist's studio. "It was like a scene out of *Scarface*," she says. "There was this mountain of coke on the coffee table and next to it was this gorgeous kid."

Basquiat's relationship with Bischofberger, like those with all his dealers, had its precipitous ups and downs. He would fly to Zurich and hang out with Bischofberger and his wife YoYo and his three children, acting like a member of the family. But he could also act out. YoYo Bischofberger remembers Basquiat refusing to come down from his room on Christmas Eve:

"Jean-Michel insisted he wanted to come for Christmas, but then he wouldn't even get out of bed. Bruno said he was conked out on drugs. I got so furious that I smashed a whole pile of plates and screamed at him and he snuck downstairs and ordered a taxi and went to Zurich. I remember looking in the mirror—I was so beautiful,

my eyes and makeup—and half an hour later I was so angry it was all smeared. But later I understood that Jean-Michel didn't realize how we celebrated. Also, he was embarrassed, because the paintings he wanted to give everyone as presents hadn't arrived from Sweden. They came a few days later. I was just treating him like he was a normal person, like I would treat a white, but the blacks aren't used to be treated like that. In America they get special treatment, people are always kind of extra nice."

Bischofberger's New York–based art business was fairly simple. He bought works straight out of the artists' studios, making sure that he got first pick. Phillips says she often paid the artists in cash, but Bischofberger says the money was usually wired directly into their accounts. The art was trucked to a warehouse in Long Island City, before being shipped to the gallery in Zurich for various clients in Europe.

Bischofberger and Phillips also became familiar faces in the auction houses. "In the early eighties, we'd go to the auctions and buy the artists' work to keep the prices from falling. We'd bid up the price until it was double the high estimate usually, even if we didn't get it. That kept the price up," says Phillips, who says they routinely bid on Schnabel, Basquiat, McDermott & McGough, and Salle. "I was supposed to be an anonymous bidder, but after a while the people that worked at the auction houses began to recognize me."

Although it is not uncommon for art dealers to try to inflate the price of work by artists they represent, Bischofberger says that he never engaged in such practices, and that he bid only on work he intended to buy.

Bischofberger says his deal with Boone was straightforward. "I would go to New York about once a month for three or four days, and each time I went to Basquiat, and most times I sorted out a few paintings which would go either to Mary or to me or to both of us together." Boone and Bischofberger each got a commission of twenty-five percent; Basquiat got the remaining fifty percent, according to Boone.

Basquiat, says Bischofberger, was thrilled to be in the same gallery with Schnabel and Salle. "It brought a lot of publicity as a new coming gallery with new artists. More than Blum/Helman, who was

showing more classical things. And I liked it as well, because I was more closer to Mary as a working relationship."

As usual, Bischofberger had his eye fixed on the bottom line. "I proposed to Mary, 'Could we please be partners on every single thing, so we don't have competition who gets the greater paintings? Let's own the works together. Every single painting and every single drawing we take out, whether you sell it or I sell it, we always split our profit among us.' It went well for about two and a half years with Mary. She always had a very hard time with Jean-Michel, because he was always very irresponsible."

Although Basquiat urgently wanted to show with his peers, and Boone just as urgently wanted to snare the best of the latest new artists, they were never a compatible coupling. Boone was able to deliver both collectors and publicity, but unable to make Basquiat feel as if he were really a peer with her other artists; indeed, after he joined her gallery, she actually lowered his prices, from $10,000 to $15,000 a work to $5,000 to $10,000. Nor did she get him the museum attention he craved.

His carefully orchestrated appearance on the cover of *The New York Times Magazine*, a typical Boone coup, which appeared not long before his relationship with the dealer disintegrated, seemed to signal the artist at his peak. But it was during the next few years that Basquiat—and his career—would begin its nosedive.

If a single art dealer epitomized the driven, celebrity-conscious hustling of the eighties, it was the diminutive Mary Boone. In many ways, her landmark show of twenty-eight-year-old Julian Schnabel in 1979 helped launch the next decade. From the crown of her jet-black head, to the tip of her Maud Frizon shoes, the twenty-seven-year-old Boone was the art-world's first yuppie dealer. She quickly understood the infrastructure of the inflated market, and how to manipulate it.

Like most of the eighties dealers, Boone used as her model the man with the gallery above the tiny space she first rented in 1977 at 420 West Broadway: Leo Castelli, the most famous art dealer in the world.

The paradigmatic modern art dealer, Castelli began his career in 1957, with the discovery of a nascent art movement, Pop, and two of

its premier avatars, Robert Rauschenberg and Jasper Johns. "I was puzzled and delighted to have seen something that was so unexpected," he said of his first sight of a work by Johns. "It was like seeing the treasures of Tutankhamen." The work of Frank Stella gave him "another great epiphany." "In the beginning there were Bob and Jasper . . . ," Castelli told Calvin Tomkins. "Then Frank Stella . . . a whole group that emerges suddenly, all influenced by Jasper's first show . . . You spot movements emerging and you try to pick the best practitioners."

Castelli soon assembled the most successful group of American artists since the Abstract Expressionists: in addition to Rauschenberg and Johns, and Stella, he showed Roy Lichtenstein, John Chamberlain, Cy Twombly, and Andy Warhol. Each was given a stipend. While money never appeared to be Castelli's primary interest, he was nonetheless a master at promoting his artists.

Castelli became an art dealer late in life. He started out in the insurance business and later went into clothing manufacturing. His interest in art was personal before it was professional; he was in love with art for art's sake. When he first arrived in New York, he quickly immersed himself in the library of the Museum of Modern Art, learning everything he could about modern European art. Before he ever opened his first gallery, he became closely involved with the Abstract Expressionists, sharing a summer house in East Hampton with Willem and Elaine de Kooning.

His artist friends continually encouraged him to open a gallery. When he finally did, in 1957, showing works he and his wife, Ileana Sonnabend, had collected over the years, it was in his daughter Nina's bedroom. There was no street sign; only art-world insiders knew of its existence. It would be a year before Castelli's show of work by Jasper Johns, in January 1958, made them both household names: Abstract Expressionism had finally given way to a new movement, and its premier art dealer was Leo Castelli.

Castelli built a stable of stars, but that was not his original intention. Rather, it was a natural outgrowth of his passionate interest in art and artists, a continuation in the tradition of Peggy Guggenheim. The new dealers, some of whom were M.B.A.'s just out of college, jumped into the market with a brashness and an interest in the

bottom line that had nothing in common with Castelli's old-fashioned *modus operandi*. They may have tried to emulate Castelli, but they were fundamentally different.

Mary Boone was born in Erie, Pennsylvania. Her father died when she was four, and she was brought up by a strong-willed mother. She studied at Hunter College and the Rhode Island School of Design, originally intending to be an artist herself. But at sixteen, she decided that "What I loved most was talking about art; I loved putting ideas together and seeing where the new tendencies in art were going." She moved to New York when she was nineteen, getting her start as secretary at Klaus Kertess's Bykert Gallery, on Madison Avenue, which specialized in Minimalist art.

Boone didn't let her subsidiary position limit her ambitions. She clearly had an agenda. She often acted as if she ran the place, and when she left, she plundered her Rolodex of Bykert artists and collectors. She quickly found some backers to put up $50,000, including her attorney, Hugh Freund, a friend, Sheila Meyer-Zaslower, a private-school administrator, Maryann Schwalbe, the Boston collectors Steven and Dotty Webber, and Robert Feldman, owner of Parasol Press.

Boone broadcast her desire to become an instant part of art history when she established her first gallery at 420 West Broadway in 1977. "It made a neat package when I moved into a building where Castelli represented the sixties . . . Emmerich the Greenberg group of the early sixties and John Weber the Minimalism of the seventies," she said in an early interview.

Says Feldman, who still has a ten percent stake in the Mary Boone Gallery, now located just off Fifty-seventh Street, "I thought she would be a good thing in the art business, and I was correct. Whether you like or dislike Mary, she brought a lot of visibility to contemporary art and that was good for the whole art market. Mary would like to be known as the [Joseph] Duveen of this generation. She has a greater sense of history than most people. She really wants to be more than a footnote."

Given the level of her ambitions, Boone's timing could not have been better. At twenty-five, she was easily the youngest dealer in the business, and she almost instantly became a star. Says Kertess,

"The dealer-as-personality came to the fore in a way that it never had before. There was a new celebrity spin to it that was part of the eighties."

From the start, Boone was intent on creating an image, beginning with her own: she got her nose fixed and her hair straightened. (*The Village Voice* printed a revealing pre-surgery photograph taken by Robert Mapplethorpe.) Tiny, exotic, and fabulously chic, the photogenic dealer was soon as famous for discovering new talent as for her extraordinary shoe collection, which quickly became an Achilles' heel.

Observes collector Barbra Jakobson, "You just knew Mary was a contender from the beginning. She was feisty, smart, and had focus. She was like a female Sammy Glick. Mary's gallery came into being at a moment when there was a kind of cohesion in the art world, even though we know it wasn't a movement, in which artists sat down together and made a manifesto, a strategy of how to work your way out of Minimalism and the beast of Abstract Expressionism. It was a lucky moment."

As much as anything else, the "lucky moment" was a generational shift, from the postwar artists who came directly out of the Modernist movement, and those who reacted to them—the Minimalists—to baby-boomer artists, born out of America's burgeoning popular culture. Among the more ambitious of this hungry young brood was a brash young man from Texas who was making his living cooking at the Locale, an artist's hangout in the Village run by Mickey Ruskin. Although Julian Schnabel was soon to become famous for his "plate paintings," bristling with shards of dishes, the collision of these two high-velocity go-getters at an art-world restaurant did not immediately result in any broken crockery. Boone agreed to visit Schnabel's studio, where she immediately had a Castelli-like epiphany.

"The first visit to Schnabel's studio had a staggering effect on my perceptions of art. What I saw was totally opposite from the anti-emotional work of the most applauded artists of the time . . . ," she said in *The Art Dealers*.

Seated behind an elegant Louis XIV desk, her trademark spike heels digging a track into the polished tile floor, Boone recalls the moment. "There I am standing in a room that couldn't be more than

three-hundred-square feet. It was literally floor-to-ceiling covered with paintings. And I have to tell you I was pretty taken with them. I think I said something to Julian like 'It usually takes me a while to get into things, but I think these are pretty good.' Rather than being flattered, he was insulted, and he said, 'Pretty good? What are you talking about? I'm the greatest artist of my generation and in five years I'm going to be on the cover of *Artforum*.' " The ambitious artist had met his match: when Schnabel told her he was also being courted by another dealer (Holly Solomon), Boone instantly signed him up.

Said Jakobson at the time, "In the business, it's called a hard eye. Every movement has a dealer associated with it who is able to 'see' the work before anyone else. In the sixties, Ivan Karp had the hard eye. Later on, during the Minimalist period, Dick Bellamy had the hard eye. Today, Mary has it."

Schnabel spent the summer tooling around Europe with Ross Bleckner. The inspiration for the plate paintings came, Bleckner told one journalist, from an episode of food poisoning. "He said he felt like throwing up the whole meal and making a painting of it—the food, the plates, the forks, and knives, everything," Bleckner recalled. But Schnabel now says he got the idea of the paintings from seeing Gaudi's work and a bad, irregular mosaic wall in a restaurant in Spain. "I went back to my room, which was the shape of a closet, and covered it with plates."

But Boone felt the plate paintings were too "gimmicky" to exhibit in the young artist's first show, in February 1979. It wasn't until November that a show of Schnabel's plate paintings officially ushered in the burgeoning new movement, Neo-Expressionism. Kay Larson, writing in *The Village Voice*, called the work a "wild, wonderful tantrum of painting." Eugene and Barbara Schwartz, art collectors who had not bought anything since the late sixties, were instant converts. "It took us twenty seconds to jump from the sixties to the eighties," said Schwartz after seeing—and buying—his first Schnabel from Boone.

Two major eighties careers had been launched. If anyone had any doubt that Boone meant business, in 1981 she convinced Castelli to become her partner in representing Schnabel. Said Castelli at the time, "I went in [to his studio], and it was like when I went to see

Jasper in '57, or Stella in '59. It was a *coup de foudre*." Even Hilton
Kramer was impressed, and Peter Schjeldahl of *The Village Voice*
wrote, "Schnabel would be the Francis Ford Coppola of art if one
could picture Coppola with all the studio heads, distributors and
other moguls on his side. He is in a state of total success."

It was a state many other artists wanted to emulate. "Julian has
reinvented the art world," wrote critic Rene Ricard. Admits Boone,
"I was made by Julian."

But it wasn't just Julian. It was a potent convergence of artists,
aggressive young dealers, and nouveau riche collectors that had
heated the market up to the flash point. "Mary really started on a very
modest scale," says Stephen Frailey, one of her early assistants. "It
was just the two of us, working at a tiny little gallery in early 1980.
There was very little money around. Things just happened overnight."

Says Boone of the art rush, "I was used to having fifty collectors,
and suddenly it was five hundred. We would have a multitude
of people coming in here whose names I had never heard of, who
from reading the *Times* or the art magazines knew the artists' names,
even if they didn't know how to pronounce them, and went systemati-
cally through them, almost like a shopping list, trying to fill in all the
blanks. Second- and third-rate artists would sell. *Anything* would
sell."

Boone measures the inflated 80's market in terms of material
goods. "In 1970, when I came to New York," she says, the cost of a
painting was comparable to that of a car. In the beginning of the
eighties, the cost of a Rothko was comparable to the cost of a high-
end house. And by the end of the eighties, the cost of a painting was
comparable to the cost of a country. Paintings cost the same as what
islands cost."

Boone herself was the undisputed queen bee of the burgeoning
scene. "This wee, raccoon-eyed woman is the new priestess of the
New York art world," proclaimed *Life* magazine in 1982. Boone's se-
cret? "I had reservations about making art a business," she told the
magazine. "But I got over it."

Boone quickly adapted to the inflated rules of supply and de-
mand. She proved herself to be as ambitious, aggressive, and quick
to pounce on a commodity as any Wall Street trader. "I remember

Mary coming up to me wild-eyed," says writer Jeffrey Hogrefe. "She was really excited—like a gambler on the make, like a grifter. She was spewing numbers on Julian. How wonderful an artist he was and how high the numbers were going. At that time it was strange to find dealers talking about money at all."

"Mary was the master of the waiting list," says another art dealer. "She would bring people to their knees." Says collector Eli Broad, "The dealers were the gatekeepers, and they could be overt or very subtle. If you told Mary you wanted to buy an Eric Fischl, she would say 'That's very nice. You are number ninety-seven on the list.' "

Part of Boone's power was her canniness in manipulating the press. Her openings were art-world events, and she made sure they were instant fodder for the gossip columns. "Not enough can be said of the importance of developing an entire image for the artists I represent," she told *Life*. "Placing the painter in certain shows, getting the right attention from the right art magazines, throwing the right parties at the right clubs. It's all so very important."

"I think Mary helped reinvent the idea of what an art dealer is," says the director of a competitive gallery. "She took advantage of the growth in interest of the media in the art world. She became a media celebrity as much as the artists did."

Boone had her own rationale. "I thought it was embarrassing doing what I had to do," she says now. "Ed Kosner [the former *Esquire* and *New York* magazine editor] told a writer who was doing a piece on me that the story was that I was 'a pretty girl selling pretty paintings.' But if that's what I needed to do to get next to Leo in a major image, I did it. I knew I had to be the girl in the bathing suit standing in front of the car to sell the car. The fact is that it did bring in a large public, which is why I conceded to do articles in major magazines. Three million people read these magazines, and how many people read art magazines? I didn't open a gallery just to be famous and get good seats in some restaurant and buy fancy shoes. I wanted to reach a certain broad public and I had to do what I did to get there."

It worked. Boone was soon considered the "It" girl of the art world. "Mary was as suprised as anyone that it happened in such an emphatic way," says Frailey. "She was perceived as ushering in a

whole different sensibility that was parallel to the times, a way of do-
ing business that was very high-profile."

Frailey describes the painstaking detail of a Boone opening.
"She built a pyramid of four hundred champagne glasses on this five-
foot-square desk. She was teetering over the glasses on her little high
heels, and it was really scary. What if it all fell? There was that sort
of lavish attention and extravagance. She was intent on the result."

Her compulsive behavior on all fronts sometimes resulted in tell-
tale physical symptoms. "When Mary would get mad at me, her nose
would start to bleed," recalls one assistant.

A workaholic, Boone usually put in fourteen-hour days. But she
was almost as much of a party animal as Basquiat. Says Frailey, "Her
stamina is amazing. Even if she were at Area the night before having
a wild evening, she would be up the next morning at six a.m., com-
pletely articulate, focused, and professional."

If Boone herself was a walking advertisement for the eighties art
world, her gallery, by now relocated to a larger space, at 417 West
Broadway, was a blueprint of the Minimalist SoHo aesthetic of the
time. From its distinctive facade of frosted-glass panes to its skylight
and plain plaster walls, the gallery was an essay in elegance and rig-
orously maintained control. Boone's fanatical sense of order was evi-
dent in every detail; from the library of artist archives to a neat
flotilla of oak card-catalogues with shiny brass plaques, entitled
"statements."

Her meticulous work rituals—using green, red, and black pens
to encode her business records, for instance—are legendary. Feld-
man recalls an instance where he and Boone were traveling together
on a business trip, and spent hours searching for a green pen—not
just any green pen, but one made by a certain manufacturer.

In addition to Schnabel, Boone's artists included David Salle,
Gary Stephan, Ross Bleckner, and Eric Fischl. She once told a Ger-
man writer she hoped that "In the next twenty-five years, I will have
shown as many great painters as Leo. Pivotal figures! The best. I like
heroic art."

But by the time Basquiat joined Boone's stable, her first "hero,"
Schnabel, had abandoned her for the blue-chip Pace Gallery, run by

art-dealer-cum-movie producer Arne Glimcher. "I left for Pace because I wanted to separate a couple of things. People said I succeeded because of Mary's marketing strategy and accused us of being co-conspirators in hype . . . ," Schnabel told *The New York Times* in 1984. "This way, she can't be accused of manipulating my career, and people can't say it's my work that makes her gallery, which is all pretty stupid, anyway." "When Julian left, the gallery was in a state of mourning," says Frailey.

Basquiat must have seemed like an expedient antidote. According to Boone, the artist had been lobbying to join her gallery ever since his angry exit from Annina Nosei. "As much as Jean-Michel seemed very scattered, he was extremely calculated [sic], and his idea was that he wanted to be with artists who were serious painters, like Julian and David and Eric," she says. "After he was in the Whitney's 1983 Biennial, he started having people like Henry Geldzahler approach me to see if I would take him on. He really courted me. And other people, like Robert Miller, were making a very big play for him."

According to Don and Mera Rubell, the dealer and artist finally connected at their Whitney Biennial party. "Everyone could see the sexual spark between them," recalls Mera Rubell. "She was the dealer of the moment. But Jean-Michel bit every hand that fed him. He hated authority. He could not be handled. He was a free spirit."

Says Gagosian, "After that party, Jean-Michel told me, 'Mary is taking a look.' She policed his studio, and occasionally squirreled a painting. I advised him against Boone, but it was self-serving, like a waitress advising someone where not to eat."

"Mary Boone is smart, debonair, and sophisticated, just like me," Basquiat told Torton. But the artist and the dealer were at loggerheads almost from the outset. It's hard to imagine Boone tolerating Basquiat showing up in his pajamas in midafternoon, as he had during his infamous days at the Nosei gallery. "His situation was completely chaotic, and hers was meticulous, one of complete control," says Frailey. "I remember she almost came to blows with him over the hanging of one show."

Unlike Boone, whom one associate calls a "phoneaholic," Bas-

quiat didn't have a telephone, and insisted that Boone send him telegrams when she wanted to contact him. And Basquiat delighted in playing cruel tricks on her.

According to Brett De Palma, he once invited Boone and Bischofberger for lunch at his Crosby Street loft. Before they arrived, Basquiat showed De Palma a bag that contained a couple of unskinned eels he had sent Steve Torton to buy at Dean and DeLuca. "It was his way of saying, 'Snakes for the snakes,' " says De Palma. "In most of his relationships he was always testing and toying with people."

Recalls Torton, "I got this fucking amazing eel, and he decorated the platter as if it were a painting, with all these garnishes. We had so much fun. We were freebasing as they were coming up in the elevator." Basquiat served the two eels to the astonished art dealers, urging them to eat.

"It was obvious that they wouldn't eat it, even though it was smoked eel that cost one hundred twenty dollars. It was kind of like, 'Oh Jean, you are such a jokester.' 'Surrounded by Snakes' was one of the pictures he painted at the time," says Torton.

Once, when Boone was out in Los Angeles for a Gagosian show, she admired a gold painting Basquiat had made. Recalls Matt Dike, "I had made this huge slatted structure, and Jean painted it gold and put a big head on it. Mary saw it and said, 'I love this! It's fabulous! I want it!' And after she left, Jean said, 'Fuck her, she's not getting this.' He took out a giant, long canvas and used one of those oil crayons to draw a big line going down it, with an arrow. Then he wrote "Gold Copyright" and said, 'I think this is the best work I've ever done. Have this delivered to Mary Boone!' "

According to Lenore Schorr, an early Basquiat collector, Basquiat once clearly illustrated his attitude toward Boone; he made a large painting of a dollar bill, replacing Washington's head with the dealer's. Basquiat did a painting entitled "Mary's Fucking Shoes," and another of Boone as the Mona Lisa, with blacked-out eyes.

Boone tried to take his bad-boy behavior in stride. "Jean-Michel was a time bomb, and he was going to explode. I knew this when I first took him on," she admits. "Unlike most of my artists, whether they are still with me or not, like Julian Schnabel, or Eric Fischl, or Ross Bleckner, these are artists I took my time getting to know, and

that I felt I would represent for a long time. From the onset with Jean-Michel, it was never like that. I knew this man was like a butterfly. I knew that I would keep my hand open, and he would light on it when he wanted to, and fly away when he wanted to.

"He was too concerned with what the public, collectors, and critics thought. He was too concerned about prices and money. He was too conscious of his place in the world, and who he had dinner with, and everything that implies. He was too externalized; he didn't have a strong enough internal life," says Boone.

In her opinion, Basquiat was still working out his childhood conflicts. "Probably Jean-Michel was an unruly child. But when you look at his personality, at the extreme mood swings, he was always paranoid, and it wasn't just because of drugs. He was obsessed with his father."

Basquiat's first show at Mary Boone, which opened on May 5, 1984, was a huge success, despite the fact that Boone herself felt that it had been rushed. "It was supposed to be in the fall of 1985, but then Julian left, and I thought I needed something really energetic at that point," she says. "Usually I don't do a show with an artist immediately, not until I've already created a market for the work. So it was a very last-minute decision."

Everyone showed up at the opening, including the artist's father, who seemed to appreciate his son's work only in public, and Andy Warhol. Recalls Jeff Bretschneider, "Jean had moved into blue-chip status. Andy was standing in the entrance of the gallery, and he stood there the entire length of the show. It was a barometer to where Jean was in the art world. But the paintings were more like a wallpaper version of his work. The opening was like a circus. It was like the Day of the Locusts, with people pushing up against this velvet rope that separated Jean-Michel from the thronging mass, and Jean-Michel was letting in whoever he thought was appropriate. Some woman offered Jean her baby, and he lifted it up with his arms above him, and looked at us with a big smile. I'll never forget that."

Basquiat had painted an homage to his mentor for the show; "Brown Spots," a portrait of Warhol as a brown-specked banana—

shades of Warhol's famous Velvet Underground album cover. In return, Warhol painted Basquiat, wearing a jockstrap, as Michelangelo's "David"; art-world mutual masturbation.

The handsome catalogue began with a "Poem to Basquiat," by fellow artist A. R. Penck, that ended with a strange, cautionary note: "Be careful baby . . . the big splash the hard crash . . ."

There were thirteen large paintings in the show, including "Pakiderm," "Bird as Buddha," "Speaking Voice," and "Hallop." "Bird as Buddha" is brightly colored, almost impressionistic. Another painting, "Grazing, Soup to Nuts," depicts a skeletal dinosaur dining. One of the few paintings in the exhibition to include words, "Deaf" is a ruby-red portrait of a "Blind Harp Player ©." The work was priced at $10,000 to $15,000.

Wrote Vivien Raynor in *The New York Times*, "The young artist uses color well . . . But more remarkable is the educated quality of Basquiat's line and the stateliness of his compositions, both of which bespeak a formal training that, in fact, he never had . . . Right now, Basquiat is a promising painter, who has a chance of becoming a very good one, as long as he can withstand the forces that would make of him an art-world mascot."

But Basquiat was having an increasingly difficult time resisting those forces. If he intended to burn out like his idols, he was well on his way. "Jean Michel called me at 8:00 this morning and we philosophized," according to the Warhol *Diaries* entry for July 2, 1984. He got scared reading the Belushi book. I told him that if he wanted to become a legend too, he should just keep going on like he was."

Keith Haring understood only too well the dilemma of overnight fame. "He had to live up to being a young prodigy, which is kind of a false sainthood," said Haring. "At the same time, he had to live up to his own rebelliouness and, naturally, the temptations of tons of money. The problem of dealing with success shouldn't be underestimated."

Basquiat also had to deal with something else; a pervasive, if subtle, sense of racism. "Being black, he was always an outsider," says Fab 5 Freddy. "Even after he was flying on the Concorde, he wouldn't be able to get a cab."

THEME GIRL

Basquiat met Jennifer Goode, with whom he had his last serious romantic relationship, at the end of 1984, at Area, the trendiest club of the moment. The sister of two of its owners, Eric Goode and Christopher Goode, she worked as the "theme girl," orchestrating the exhibits for which the club was famous.

Area, which opened in the fall of 1983, was located at 157 Hudson Street in TriBeCa, in what, over a century ago, used to be the stables for the Pony Express. The club was started by Jennifer's younger brothers, Eric and Christopher, and two high school friends, Darius Azari and Shawn Hausman. It was modeled after an earlier scene they had masterminded on Twenty-fifth Street, which was considerably lower-rent: their very first party, for which they charged a $5 admission fee, featured a display case with two live rabbits nested in fake fur, bones fresh from the butcher that they hung from the ceiling, and a cow's head encased in plastic. The invitations were equally original: black-and-yellow pills which when immersed in hot water released the announcement of the new club. Opening night drew a thousand people.

A year later, the foursome decided to find a larger space and some investors. Despite their innovative eighties-style business proposal— a small black box containing a tape recording of their financial plan— it took them some time to raise the money. A fifteen-man crew, including another Goode brother, Greg, worked steadily through the winter, renovating the 13,000-square-foot space. When construction was complete, they sent out another round of capsulized invites: five thousand pills. Once again, the formula worked. On its opening night,

Area became an instant success. Its first theme, "Things That Go On at Night," included props like a dead bat preserved in a jar of liquid.

What went on at night at Area took place on the dance floor; in the immense and decadent ladies' room, where at least as many men as women could be found actively indulging in forbidden pleasures—from drugs to sex, and at the silver bar, with its long, glass-topped pin sculpture (the brainchild of a young man named Ward Fleming). If you brushed your hand along its prickly underside, it conformed to create an instant metal-clad hand. An aquarium held sharks, a visual pun on some of the typical clientele.

On any given night you could find Andy and Jean-Michel and Keith and other art, fashion, and movie stars hanging out at the bar, or on the dance floor with its throbbing disco music, or in the bathrooms, where most of the real action of the club took place. Or, then again, they might appear in the display cases: Matt Dillon watching television; Liza Minnelli as a car mechanic, Robert Downey Jr. cavorting as a robot.

As Warhol put it in his *Diaries*, "Jean Michel . . . made me go to the bathroom there, the men's room, and it's so funny there, there are girls putting on makeup in the mirrors and the men are pissing in the urinals and it'd be great if it weren't that it smelled like shit. It's just my kind of movie."

The club was also famous for its one-of-a-kind invitations: champagne-bottle crackers for New Year's Eve, hollowed-out eggs for "Natural History," black hankies for Halloween.

Area's eight display windows, which lined its hundred-foot-long entrance, transformed the club into a subversive urban theme park. The exhibits usually included some performance art. In a "Science Fiction" display, for instance, an astronaut approached a big spaceship. For "Night," a seductive young female slumbered. "War" was a papier-mâché Reagan with a cabinet of Nazi costumes.

Although the whole staff usually dismantled and assembled the themes, Jennifer was officially designated the Theme Girl. "I was in charge of the themes. Once we'd figure out what it was going to be, I'd go get all the stuff for it, and the performers. It was a lot of work," she said.

With her long, wavy blond hair, face without a trace of makeup,

and almost disarming naïveté, Jennifer was an eighties throwback to a flower child. Her father, Frederick Goode, had started his own School of Arts and Sciences in California. Its experimental format allowed students to study in the morning and play at being artists all afternoon.

"My father was a painter and a teacher, pretty liberal, but there were certain basic rules," she says. The family lived on a ranch in Sonoma that Jennifer's mother had inherited with her sisters; according to a *New York* magazine cover story on the club, it soon became a sort of commune populated by visiting gurus and nudists. Frederick Goode preferred a different lifestyle, and in 1975 he separated from his wife and moved to Seattle. The Goode brothers moved to New York in the late seventies. Jennifer Goode arrived in 1982.

Goode was working the door at Area one night when she first saw Basquiat. "He was like with six people and I didn't comp him, and I saw him go to the ticket booth and buy like eight tickets and I thought, 'Oh God, this is terrible,' " she says. "So I ran up and said, 'Let me buy you some drinks,' and I bought him a bottle of champagne. I didn't know who he was. I did it because he was so weird-looking, and usually people bother you to get in for free, and he just walked in, and didn't say a word."

Shortly afterwards, Jean-Michel called her at the club. "The first date we went on he invited me to the movies, and my mother happened to be in town, and so my mother, my sister, Melissa, Jean-Michel, and I saw *Witness*," recalls Goode. "And even then—I didn't know anything about drugs—even then he had just done something, and he was kind of like nodding out a little bit and my mother was there, so it was kind of uncomfortable."

Typically, Basquiat wooed her with expensive gifts. "He showered me with stuff. I'd be working at Area, and these huge packages from Comme des Garçons would come. No one had ever done that to me before, so it was fun. But the thing was that he could buy you things, and he could take you on trips, but as far as I could tell, he didn't really know how to love."

Goode was soon spending most of her free time at the Great Jones Street loft. "Downstairs was where he painted," recalls Goode. "He'd put canvases on the floor and be crawling all over them. All his furni-

ture was Mission, really nice. He had a huge, long dining table that could seat twenty people. There was a picture Warhol had done of Jean-Michel on one wall, and a picture of Dizzy Gillespie. He had one of those things William Burroughs did, where he took out a pellet gun and shot all these holes in this piece of wood. And upstairs was his bedroom. You didn't go upstairs unless you were invited."

Basquiat's current assistant, Shenge Ka Pharoah, one of Torton's few long-term successors, lived in the basement, a cramped space which nonetheless had its own Jacuzzi. Shenge was a gentle dread-locked painter who partied almost as hard as Basquiat, and spoke in cryptic, philosophical soundbites. His Rasta mannerisms were amusing, given that his real name was Selwyn O'Brien.

Goode would go off to work at Area during the day, while Basquiat slept. At night they would hang out. Like the other women in Basquiat's life, she was completely charmed by this artistic man-child. Of all his girlfriends, Goode seemed to be the only one Basquiat viewed as a possible long-term partner, someone he could marry. But although Goode got pregnant by Basquiat, she had an abortion.

"I had great times with him," she says. "We would listen to records: Gregory Isaacs, Lester Young, Miles Davis, El Grand Combo, and Charlie Parker. He taught me a lot about music. He had a huge collection of films. We both had the same kind of taste and we could laugh at the same things. We had a lot of fun.

"He had all these plans to redo the Hitchcock film *Stage Fright*. He loved food. He was a crazy chef, he loved to cook and he would make a huge mess," Goode continues. "He liked objects. I would buy things at Grass Roots, Haitian, Mexican, and Brazilian folk art. And he would put them in a painting or drawing. I loved his childishness, his boyishness. I loved the way his mind worked. I loved the way he looked at things. But I went through a lot of pain with him, too. A lot of personal pain, about addiction. You know, he has women in his life who take care of him, and I was one of those women."

During the relationship, Goode, who had never really been involved with drugs before, became addicted to heroin. "He didn't push it on me, or anything," she says, "but it was just there, and I was stupid and naive about that drug. It was really strong heroin we

were using. We weren't shooting it, we were snorting it. I would do it twice a day or so. I was a functioning addict."

According to Goode, she was not his first girlfriend who developed a drug habit. "This is a story repeated through other women in Jean-Michel's life. He had no respect for the people that got into it, and would get really distraught about it. It was okay if you did it, as long as you weren't addicted to it."

The drug enabled Goode to get on Basquiat's nocturnal wavelength. "Time goes by, hours go by, and you are doing nothing. It's just real escapism. But he drew on it and he painted on it. He would get into this space where it would allow him to sit there for hours and do these little meticulous, detailed drawings."

Upstairs, where nobody else was allowed, Jean-Michel and Jennifer would lie on his huge bed, watching vintage films (his favorite film was *Taxi Driver*), or she would watch him draw. Time passed in slow motion. When it was time for dinner, Basquiat might go on a shopping spree at Dean and DeLuca, bringing home ten times the ingredients needed for one of his favorite dishes, chicken gobo, made in a clay pot. Temporary nirvana; two affluent children playing hooky from the world.

Esconced in the Great Jones Street loft, Basquiat was living in a style that, at least from the outside, conformed to everyone's fantasy of the life of an art star. He prided himself on acquiring the best of everything, whether it was furniture or wine. Says art dealer John Good, who hung out with Basquiat at the time, "I was teaching him about Bordeaux. He had these bourgeois pretensions. He was very competitive. We would go up to Sherry Lehman and he would ask the pretentious wine clerk, 'How many bottles of 1945 Mouton can you buy for one thousand dollars?' He was hanging out at the Ritz and getting regularly fucked up on heroin."

Robert Farris Thompson, an African art expert at Yale and the author of the book *The Flash of the Spirit* (which Basquiat cites in several paintings) met Basquiat around this time. The two were first introduced by Fab 5 Freddy. Thompson was reporting a story on hip-hop, and accompanied Fab 5 to Basquiat's loft. He was totally un-

prepared for the scene at Great Jones Street, which made an indelible impression.

"I was flabbergasted. Jean-Michel had about four or five workers, and they were all busy nailing boards together that became the stretchers for a painting. He sat me down, and he opened a bottle of the most exquisite Cabernet Sauvignon I've ever had in my life, and then he gave me a Star apple from Jamaica. I realized the guy was copping from the best of several worlds."

Thompson began to question the artist about his work. "He was like a ventriloquist, because he answered questions impishly, five comments later. It was a very typically mercurial way of speaking," he recalls.

Soon afterwards, Basquiat asked Thompson to write a catalogue essay for his upcoming show at Boone. On his second visit, Thompson, still awestruck, watched Basquiat at work. "The room was flooded with superb jazz. Then just boom, he put down this canvas while we were talking, and I realized how intricate the combination of his conversational style and his painting style was. They were the same thing. What struck me is that it was so spontaneous. And if something fell on the painting, what fell was critical, because it left these organic traces. The spillage was part of it. Metaphorically, it was like a black altar. You can tell how rich and reverent it is by how much spillage there is."

Thompson asked Basquiat about his fondness for erasing words and images in his work. "The thing he told me that I will never forget is 'It makes you pay more attention to what I'm saying. You want to see beyond the erasures.' As Western children we were taught by our parents not to interrupt. But in the black world, you are taught to interrupt, because it shows a certain level of attention."

To Thompson, Basquiat's paintings are clearly incantations. "Incantations of his blackness, incantations of what he was afraid of. Most of all, incantations of keeping his body whole. He's like a classical African drummer, just translating nervousness into art. It was as if he was trying to turn his fears into creative energy."

Basquiat was quite cognizant of the impression he was creating; at times it seemed as if he were playing himself. He thoroughly

enjoyed entertaining his erudite audience. On a later visit, opera filled the loft as Basquiat prepared breakfast—omelettes with caviar— for Thompson and "a beautiful blond girl wrapped in the bed sheets." "It was just perfect," recalls Thompson. "I knew that the rascal was fully aware of the fact that this could have been a moment in a movie, 'The Painter.' "

PEAKING

Mary Boone's diligent efforts at promoting Basquiat paid off on February 10, 1985, when *The New York Times Magazine* devoted a cover story to him, complete with a striking photograph. Wearing a paint-splattered Armani suit, the dreadlocked artist was enthroned on a large chair, a paintbrush cocked in one hand like a small scepter. With one bare foot jauntily propped on an overturned chair, his face fixed in an arrogant stare, Basquiat looked like a crown prince disdaining his brave new world.

In a BBC documentary on the artist, *Shooting Star*, Kinshasha Conwill, director of the Studio Museum of Harlem, observed, "The photograph in *The New York Times* is very poignant because it says to me that somehow . . . he was wearing a mask . . . one felt that in an uneasy way he bought into his iconic personality. If he was to be the privileged exotic, he would dress like that. So he had dreadlocks, and no shoes, but expensive clothes worn very casually in a very self-conscious way."

As telling as the photograph was the story's headline: "New Art, New Money; The Marketing of an American Artist." The Saturday night before the article came out, Basquiat took Warhol and Paige Powell to Brooklyn for dinner with Gerard and Nora. Gerard Basquiat recalls the visit with obvious pride. Jean-Michel and Warhol had gone out to the corner newsstand to buy a stack of copies. "We had friends at the house and he was standing there autographing the magazines. It was very nice, a lovely moment. Andy ate!" he boasted.

The article captures Basquiat's precarious state at the peak of his art-world success, painting a cynical picture of an artist who was

clearly suffering from a toxic case of too much, too soon. The ele-
gant dinners at Mr. Chow's, where Basquiat was a regular, the
paparazzi-chronicled nights on the town with Andy, even the pres-
ence of a *New York Times* journalist in his studio, watching him paint
for posterity, created the sense of a life under a media magnifying
glass, which was being hyped almost before it happened.

Basquiat talked frankly about the problems he had with dealers.
"It's no honor [to be courted by them]," he told Tamra Davis. "There're
more dealers than artists these days." And about the vicissitudes of
his career: "People think I'm burning out, but I'm not," he insisted.
"Some days I can't get an idea, and I think 'Man, I'm all washed up,'
but it's just a mood."

Bischofberger asked Beth Phillips to buy him a hundred copies
of the magazine, which, she wryly noted at the time, was "not very
much about art." At first, Basquiat was thrilled with the publicity the
piece generated—and with his image on the cover, his bare feet
sending a not-too-subtle "fuck you" to the establishment. But before
long the euphoria had faded. Basquiat complained bitterly about the
spin of the piece, that it implied that he had been created by his
dealers. "As if I didn't do it myself," he told one friend.

Basquiat's growing disenchantment with the gallery system was evi-
dent in everything he did. For his second Mary Boone show, in March
1985, the artist deliberately painted "boring, bite-sized canvases,
about four by four feet, that would be perfect for collectors. He redid
his entire show as kind of an insidious joke," says Diego Cortez. "It
was his way of expressing contempt for the art scene."

The disappointment was mutual. Boone claims to have had no il-
lusions at this point about her relationship with Basquiat, whom she
describes as emotionally disturbed and—at the ripe age of twenty-
five—past his artistic prime.

"I didn't show him at his creative peak, more at his peak of popu-
larity," she says. "He did his best paintings when he was showing
with Annina. His work was getting too facile, and by the time he did
the second show, he was really crazy, and he tried to beat me up at
the opening. Tina Chow had to pull him off me. He thought I was try-
ing to undermine his exhibition, because I didn't want to hang as

many paintings as he did. We did it his way, and it was terrible. I always defer to the artist, but this was also dealing with someone who was really mentally sick. People don't realize that drug addiction in the long term can make someone mentally ill."

Says Bischofberger, "Mary would have liked to show twelve paintings, and he had prepared thirty, and he insisted absolutely, until she cried that every single thing was shown in double rows. It was a big mistake. She always said, 'I would like to edit his work.' And he said, 'How dare she edit me.' "

The paintings were certainly not among Basquiat's best; they had neither the energy nor the detail of earlier work. The twelve pieces in the catalogue, priced at about $20,000, included "Flexible," a portrait of a black man painted on white slats, with hoselike continuous arms; "Wicker," in which a skeletal figure sprouts, along with a plant, from a basket; and "His Glue-Sniffing Valet," a crazed-looking character in a wheelchair.

But the catalogue essay, by Robert Farris Thompson, was virtually ecstatic. "Afro-Atlanticist extraordinaire, he colors the energy of modern art (itself in debt to Africa) with his own transmutations of sub-Saharan plus creole black impress and figuration. He chants print. He chants body. He chants them in splendid repetitions. . . ."

Repetitions was the operative word. By now Basquiat's life seemed to have become a recursive loop of negative reinforcement, and the more successful he became, the less he seemed able to cope with it. And his work was becoming as automatic a reflex as his heroin habit. Still, the opening was a typically crowded affair. Basquiat wore an odd Comme des Garçons hat that looked like a bird's nest; his version, perhaps, of a crown of thorns.

Robert Pincus-Witten wrote about the evening's festivities in *Arts* magazine, capturing the feverish feeling of a bubble about to burst. "Drugged by his own myth, Basquiat's dreadlocks for the occasion were bound in a nest of straw, doubtless meaningful to the Haitian mysteries now pressed into service by way of catalogue justification: All is shot through by the anguished inexpressivity of the he-who-would-be-found-out, and the child sacred monster glares about the room in inverse timidity. The delirium was toasted with champagne at Odeon, drinks at Area and a privately catered dinner by Mr. Chow at

the Great Jones St. loft sublet from Andy . . . The kids get all the glamour and Andy gets the juice . . . As Aesop might admonish at the end of a cautionary fable, an artist is judged by the company he keeps."

The party was extravagant by anyone's standards. "Everyone from David Byrne to Julian Schnabel was there," said Keith Haring. Even Steve Rubell was impressed by the bowls of beluga caviar and the bottles of Cristal champagne. "I never saw anything like it," he said. "But I thought, 'Who are all these people?' There seemed to be a lot of freeloaders."

"It was a great party," says Brett De Palma. "It was like it was Jean's club. But what was strange was that there were all these undercurrents going on. There was another side to Jean's success, this ugliness of parasites just taking advantage of him."

"The last time I saw Jean-Michel was at that party," says Suzanne Mallouk. "I remember right after the show, Mary Boone put her arm around us and said, 'My two favorite Arabs.' "

If the lavish display of caviar, champagne, and groupies was meant to celebrate his success, the scene itself was a sort of parody of the destructive forces at work in the young artist's life. Hordes of people, including Steve Kaplan, whom Basquiat had abhorred since he dubbed him the pickaninny of SoHo, were turned away at the door.

Upstairs, in his inner sanctum, his mother, looking sedated according to at least one guest, sat on his bed. His father, ever the dapper man-about-town, flirted with one of Basquiat's art groupies and his son threatened to eject him from the party.

Said Victor Bockris, "I was lining up for food, standing behind Richard Gere and Julian Schnabel and David Byrne. Two things stood out. I remember dancing madly with some wonderful gay Swedish guy, within inches of Jean-Michel's paintings, which were leaned against the wall. There was no concern that they were unprotected. I was impressed by the confidence of this guy. He was just invincible. You could smash into a painting, and he would just redo it. Then, in the middle of the party, he stalked out and slammed the door. When he came back he had obviously gotten some junk. He was high, sitting on a stool in front of the stairway. I went over to him and told him what a great party it was.

"I was surprised by his demeanor and told him, 'You look like

somebody betrayed you.' And he said, 'You said it. You said it.' How much higher could you go? But Jean was miserable."

By now, Basquiat's relationship with Boone had almost completely unraveled. Bischofberger, who at a safe distance in Zurich managed to avoid many of the artist's wilder exploits, recounts some of the typical problems. The ever-widening gulf between Basquiat's agenda and that of his dealers could not have been clearer. "Mary would send over a truck and Jean-Michel would not be there. He would show up in the gallery all the time, asking questions and needing help. Or she would sell a painting to Eli Broad, and he would demand it back so he could repaint it."

Between Bischofberger's avarice and Boone's compulsiveness, Basquiat was often the subject of a tug-of-war. Phillips was constantly having to fend off Boone, who was understandably anxious to see the work of the artist she had taken on at Bischofberger's prodding. She also had to smooth the waters when things got out of hand with Basquiat, as a frantic phone message from Boone attests. "JMB cannot treat people. Cannot do business. Compromise position. Mary furious. Very upset about this."

At one point, according to an April 30, 1985, note to collector Heiner Bastion that Bischofberger dictated to Beth Phillips, Basquiat managed to climb into a truck and purloin one of his own paintings, something he apparently did whenever he got the chance.

"Dear Mr. Bastion, Please let me apologize again for the great inconvenience. I believe the fault lies with the artist, Jean-Michel Basquiat, and the confusing 'trick' of taking the painting off the truck and keeping it at his studio. This type of problem has always existed with Jean-Michel Basquiat. . . ."

Meanwhile, Basquiat was having large sums of money wired to him, wherever he happened to be. In February, he was sent $25,000; soon afterwards $40,000 was wired to Maui, Hawaii. On April 15, 1985, Phillips wired Basquiat $5,000 at the Royal Regent Hotel in Hong Kong, where he had gone on a trip with restaurateur Michael Chow. A second $10,000 was wired shortly afterwards to the Ambas-

sador Hotel. Basquiat's assistant, Shenge, called on April 21 to request that yet more funds be wired to the itinerant artist. According to Phillips, when Basquiat was in New York he could get as much as $50,000 a week.

Finally, Basquiat begged Bischofberger to tell Boone he no longer wanted to be in her gallery. "He said, 'I can't be with Mary anymore, I mean she just drives me nuts.' So I had the honor to call Mary and tell her that Jean-Michel wants to be only with me. It wasn't such a big tragedy for her. In some ways she was glad to get rid of him."

Although Phillips described the painter-dealer relationship as "fireworks over lower Manhattan," their relationship ended with a bitter whimper rather than a bang.

Says Jennifer Goode, "They stopped communicating. He wouldn't answer her calls and she wouldn't answer his calls. And then he just left."

"One time I went to his place, and there was a telegram from Mary," recalls Tony Shafrazi. "I asked him why he didn't respond to her. He said he wasn't going to. He really felt set upon by all his dealers."

The artist himself made some scathing remarks about the dealer in an interview shortly before his death. Although he had once considered her "less greedy than the other dealers," he now said, "Mary had no enthusiasm for my career at all. She didn't interest a museum in my work. She did nothing for me at all. I couldn't even talk to her without it ending up in a screaming match. Because I find her really phony. From the word go. Not sincere . . . I think she's clever, I wouldn't go so far as intelligent. She ruined her gallery. She diluted it by going into cooperation with another guy [Boone's ex-husband, German art dealer Michael Werner]. It used to be a good American gallery. Now it's not."

According to Boone, Basquiat was given a stipend of about a million a year, against sales. "He made about one point four million in a peak period. He was extremely prolific, and you remember this was the time when any little scrap of paper from almost any artist would sell," she says. (But Bischofberger recalls the amount as closer to half that.)

There were also a number of luxurious perks; the dealers paid

Basquiat's hotel bills, which were off the books. "We paid for his suite at the Ritz-Carlton for three months—that was a thousand dollars a day," says Boone.

Although she played a significant part in it, Boone makes no bones about the Basquiat phenomenon. "Everything that happened in the eighties had to do with greed and speed. And the fact is that art also epitomized what the eighties were about—you know, luxury, glamour, disposable income, excess. And so, in fact, Basquiat was an artist who epitomized the eighties even more than Schnabel."

In May 1985, a new club, the Palladium, opened with great fanfare on Fourteenth Street. The comeback coup of Studio 54 founders Steve Rubell and Ian Schrager, who had just finished doing time for tax evasion at a minimum-security facility in Montgomery, Alabama, it was a temple to eighties hubris. Designed by Japanese architect Arata Isozaki, the spectacular, multilayered space combined glitzy spectacle with hip, downtown style; an ostentatiously high-tech amalgam of Studio 54 and Area. A mezzanine atop a glass-paneled wall that lit up in time to the music overlooked the enormous dance floor. You could get lost in a honeycomb of various bars, lounges, and dens. Then there was the elitist Michael Todd Room, where anyone from Boy George to Laurie Anderson could be found holding court.

Schrager and Rubell had made sure to include the ultimate eighties accoutrement, art. Their curator was, predictably, Henry Geldzahler. Kenny Scharf had been let loose in a downstairs playpen, where everything from the bathrooms to the phone booths was transformed into fluorescent 3-D cartoons. Keith Haring, Francesco Clemente, and Julian Schnabel were asked to paint murals in the Michael Todd Room. So was Basquiat. "The more artists you get, the more credibility you get, and you can run with it," Schrager told *New York* magazine.

Basquiat had hired his old friend Nancy Brody to work for him at $50 a day. She helped Basquiat paint the mural behind the bar. "He was so late to the Palladium, and Ian Schrager was so nice. When Jean showed up hours and hours after he was supposed to, he told me what to do and I painted by the numbers. He would say, 'Paint that red, blue, or white.' He worked with a really long brush, and he painted from Xeroxes he had made at Todd's Copy Shop. He made it

huge. He did it with so much spirit." The mural incorporated a huge, brightly colored image of a Mexican dragon mask that Basquiat had used frequently before, against a background layered with multiple tiny images.

The club opened on May 14, a mad scene of every self-respecting downtown denizen and trendy journalist. "The Palladium is uptown-meets-downtown. The artists are the rock stars of the eighties," Rubell told a TV reporter. Andy Warhol stayed in relative safety on the mezzanine, taking snapshots of the birth of the latest scene.

"The truth is that in this environment, the art looks sensationally good," wrote Calvin Tomkins in *The New Yorker*. He called Basquiat "the Wunderkind of Neo-expressionism," and added, " . . . Basquiat's two murals are not only larger than anything he has done before but significantly better—stronger in the handling of color, more cleverly structured, more honest in acknowledging their debt to Cy Twombly and a few other artists of the older generation. Like Haring's big backdrop, the Basquiats are a match for their surroundings. They hold their own with the hard-rock music, the lighting, the banks of video screens, the architecture, and the gorgeously caparisoned throngs of people who have managed to get in. They also set a standard for disco art, a new form whose time has clearly come."

But despite the external glitz, Brody, who along with Shenge's brother, Shagzy, worked at Great Jones Street as Basquiat's assistant, recalls the artist's lifestyle at the time as drugged out, zombie-like. "Jean-Michel would sleep all day and Shagzy would be over there smoking a big joint. Shagzy built the stretchers and primed the canvases. He was like a kid with his mom sleeping and waiting for him to wake up so he could play. Jean-Michel would wake up late and come down and make waffles. He would go to Dean and DeLuca and shop, nod out, watch a movie. The TV was always on. He would play records all the time, jazz but also Maria Callas. I still have a bucket of paint he gave me. The pressure of success is so sad."

Basquiat's behavior, always excessive, was spinning further and further out of control. There was nobody to rein him in. Everybody, from his assistants to his collectors to his lovers, was, at least temporarily, along for the ride.

SIDEKICKS

Marcia May, who was part of a high-society circle of uptown ladies who collect between lunches at Coco Pazzo and Mortimer's, met Basquiat the night of his big Mary Boone party. Like many new collectors, May enjoyed not only collecting the artwork, but collecting the artists. She was on a first-name basis with all the major eighties stars, and her trips to New York were always filled with openings, parties, and of course, auctions.

Sitting in the living room of her Park Avenue apartment, its white furniture still covered in plastic from a recent paint job, May talked about her relationship with Basquiat. On the floor, propped up against the wall, were two large paintings, a Schnabel and a Basquiat. The Basquiat featured the repeatedly scrawled word "Shame," which in this setting seemed oddly appropriate.

After being introduced to Basquiat by collector Maggie Bult, May quickly struck up an odd sycophantic friendship with Jean-Michel and Jennifer, going out for dinner with them, getting rides in the Area truck. One day after she had taken the two out to lunch, she invited them back to Dallas to the opening of the Primitive Art show that was on loan from the Museum of Modern Art. Basquiat immediately took her up on the offer.

His escapades in Dallas still amuse May, who speaks about the artist with the affection of a doting, daft godmother. "Jean-Michel actually had a big package of pot Federal-Expressed to Dallas," she says. "I couldn't imagine what it was! I said, 'Oh, you have this sweet bag of potpourri!' He said he just couldn't get any good stuff in Dallas."

Basquiat painted all over May's terrace—and that of her next-door

neighbor, covering the Astroturf. "He made the biggest mess. There was paint everywhere. I had to have the whole thing repainted."

May held a party for Basquiat, introducing him to polite Dallas society, which he had already scandalized by showing up at the museum opening with his Walkman on. "Everyone still talks about how he wore this little plaid knapsack and earphones at this black-tie event. And I think people were kind of terrified that I was having a party for him," she says. "A lot of people brought their copies of the *New York Times Magazine* to get them autographed. He wouldn't come to the party. He kept going back next door to paint. We could barely lure him in, he was so shy. Maybe he just wasn't comfortable with those people." Every night, like clockwork, Basquiat would call Andy Warhol. "He said he had to find Andy a date."

Through May, Basquiat met Texas businessman Sam Feldman; Basquiat did Feldman's portrait, and Feldman got Basquiat an American Express Gold Card, which he used to lavish gifts on Goode. "Jean-Michel was always getting Jennifer clothes," says May. "I don't think he liked the way she dressed. In fact, he traded a painting for clothes for her. Nice clothes, from one of the best shops in Dallas. I tried to buy that painting from the person he traded it to, and he said it wasn't available."

"In Dallas, he was really extravagant with me, especially in the beginning," says Goode. "He would buy me a Chanel suit. He'd want me to try things on and I'd say no. It was his way of showing his love." Basquiat gave Goode a belt with a buckle that had his initials and trademark crown symbol. The two took an impromptu side trip to Mexico, where, typically, Basquiat was detained at the border because he looked suspicious.

But despite his obvious love for Goode, Basquiat was also carrying on an affair with Liz Williams, a stunning young woman he had met through Marcia May, even briefly overlapping the two in Dallas and Florence.

Williams had originally met Basquiat in 1983, when she bought one of his paintings ("Cowboys and Indians") for $8,000. Shortly afterwards, she asked him to do her portrait. Williams, a classically beautiful blonde, was married at the time. According to Williams, her romantic relationship with Basquiat began the night she discovered

that her husband, a British businessman, was unfaithful. Williams gives a deadpan, pulp-fiction account of the beginning of their affair.

"I was upset and stunned. I went down to Jean-Michel's studio. He was wearing boxer shorts. There was something about the way he took charge that was appealing to a person like me. He pulled out a huge canvas as big as half the wall. I was only about twenty-three or twenty-four and I was very nervous. I sensed this animal-like sensuality. He drew my portrait topless. He was a genius. It took twenty minutes. Every flaw was there; one nipple was bigger than the other. Even the flaws in my face were bared. He was funny, he knew what he was doing. The Japanese bought it for five hundred thousand dollars." (The lopsided portrait sold for $40,000 at Christie's 1997 spring contemporary art auction.)

Basquiat invited Williams to a party for Boy George at the Palladium. "I never drank, but I found myself drinking and ended up in a hotel room with Boy George. Jean-Michel was brushing up against me in this very sexy way. He said, 'Let's go upstairs.' He pushed me up against the door, and reached up under my skirt and said, 'I am going to make you come.' He had a beautiful Calvin Klein body with no body hair. He was a really good lover, but he wasn't into foreplay. He was quite rough. I realized that night that there was something about his personality I might truly care about. He was quite a detached person. That suited me." Their relationship would last until shortly before Basquiat's death.

When Williams moved back to Dallas, the two carried on a "torrid long-distance affair." Basquiat would call Marcia May daily to talk about Williams. At the time, May had no idea the two were sexually involved. "It was sort of a victim-victimizer situation," says Liz Williams of Basquiat's relationship with May. "It was fair play. He did make fun of art collectors. He said Marcia made him laugh."

During his stay in Dallas, he and Williams drove around town together in a pickup truck, scavenging for furniture for him to paint on. "I had a beautiful Rolls-Royce, but we rented this truck," says Williams. "We went to a Salvation Army place and got a big crib. He was embarrassed to be buying a baby bed with me. He was dressed like a bum, and acting like a bum. The truck swerved and the crib splattered all over the highway. We were retrieving the pieces. He

made it into two paintings." The two exchanged painted shirts and painted jeans as presents.

"We were an odd couple," she acknowledges. In New York, Williams lived in a luxurious building on Park Avenue. "Once Jean-Michel came over quite late with some hamburgers," she recalls. "The doorman called up and said, 'Has that delivery boy left yet?' "

Like several of his other lovers, Williams got pregnant by Basquiat and had an abortion. She never informed him of the pregnancy. "Jean-Michel was against abortion. He wanted a child. The women in his life always denied him that."

They were the same age, but to Williams, Basquiat was a child. "He had the same sort of impatience as a three-year-old," she says. "He believed he was the center of the world. He was a big spoiled baby. The one word that applies to Jean-Michel is 'excess.' The one word is 'more.' If you asked Jean-Michel what he wanted, the answer would be 'more.' He was never happy. He was obsessive about everything. He wanted *more*, whether it was people, or food, or drugs."

In July, photographer Michael Halsband met Basquiat at a dinner party arranged by Marcia May for Jean-Michel and Warhol. "We ended up going to the bathroom together, and he said to me, 'Hey, you want to get high?' Then he asked me to do a picture of him and Andy Warhol for the show they were going to have."

Shortly after the photo shoot, Halsband went over to Basquiat's loft to show him the contact sheets; the small repetitive squares of Basquiat and his mentor posed as classic contenders looked almost like a Warhol series. Nancy Brody was busy packing, and she told Halsband they were leaving for Paris. Jean invited Halsband along for the ride.

Halsband found the offer of free airfare hard to refuse. He, Basquiat, and Eric Goode flew that afternoon to London and then on to Paris. "I didn't even know him," marvels Halsband. Halsband recorded their takeoff with his video camera; a messy-looking Basquiat, wearing a wrinkled linen suit, continually wipes his runny nose on his sleeves; the junkie's gesture is affectingly childlike.

Soon after they arrived, Eric took off with his girlfriend, leaving Basquiat with Halsband. Jennifer Goode was scheduled to arrive

within a few days, but in the meantime, the two were at loose ends. "Basically I felt kind of responsible to Jean, because he had invited me to come, but also because he had no driver's license, he had no credit cards, he just had a big stack of cash. I think he had about twenty thousand in hundred-dollar bills," says Halsband. "So I rented a car and we drove around a lot. And I felt a little funny about all that money, because he was always very generous."

Halsband offered to pay for the car. "I told him, 'Let me do something because I know it's expensive to keep up with you.' He would go to Agnes B. and buy whatever he wanted. If he saw five shirts and he liked them all, he bought all of them. And if I saw two shirts that I wanted to buy, he would pay for them. And he would pay for dinner. Wherever we would go, he would pay the admission, buy the drinks, buy the food. So it was very uncomfortable for me, because I felt enslaved all of the sudden. And I think it was a test."

They went to a few parties, one where Halsband said everyone was shooting heroin in the bathroom, and another at the apartment of artist George Condo (also represented by Bruno Bischofberger), who had just moved to Paris. There Basquiat indulged in the elite privileges of eighties success: he communed with Picasso by snorting coke off glass-framed drawings by the genius of another era, and later made a special pilgrimage to Picasso's printer with some etchings of his own.

"Jean-Michel came over and we put on videotape of Jimi Hendrix," recalls Condo. "It was an all-out drug scene. We were watching Hendrix and this Miles Davis video and we were really getting into the music. In the other room, all these people were taking down Picasso drawings and using the glass to snort lines of coke. Using an art collection as coke tables is very bourgeois. Jean-Michel made a beautiful drawing in a bound notebook and told me to frame it. He wanted to be sure they would use his drawing as a coke table too. He got completely high and went to the Bandouche. He had bought a stink bomb at the Bastille and he made it go off. Everyone in the place came running out. He wanted to wait and see the expression on their faces. He loved playing pranks."

Next, Basquiat and Halsband flew to Lisbon, where Basquiat hired a limo. Recalls Halsband, "It was a white Mercedes stretch limo, but funky, wrecked. So we got in it and drove to where we

thought we were going, but it was in the middle of nowhere, really scary." The two checked into a hotel and went out to explore the city. "It was kind of one of those very old towns, with those little windy streets, and we started walking around."

After dinner, they decided to look for some nightlife. It was the prelude to a typical Basquiat misadventure. "Jean loved to dance. So we took a taxi to a club about fourteen miles away, and we picked up a couple of girls, and we started dancing."

By two or three in the morning, Basquiat and Halsband were ready to return to the hotel. But there were no taxis to be found. They managed to convince one off-duty driver to take them back to town, but before they could make it back to the hotel, they got into an argument with the driver, and found themselves stranded.

"We were just walking into darkness. We didn't know where we were going. Cars would drive by and not stop for us. There were all these dogs barking, and it was pitch black. And we were at least twelve miles from where we were staying," says Halsband.

"It got so scary at one point that we started to hold hands. Jean was smoking a joint, and I said 'Man, do you have to do that now? Do you really think pot is going to help you on this road?' " Basquiat's only response was "Man, I always knew we would be friends." Halsband could hardly believe his ears. The two walked until dawn. When we got into the hotel, and he collapsed on the bed, I said, 'Jean, I'm out of here.' "

Halsband said he couldn't take the tension of traveling with Basquiat, who was getting high all the time. But it wasn't just the drugs that made the hip young photographer, who had toured with the Rolling Stones, uncomfortable. It was witnessing the response Basquiat seemed to evoke from people.

Watching Basquiat in Europe, Halsband began to understand what it was like to be constantly seen as an outsider. "He was treated weirdly, strangely, like he was an oddity. People were entertained by him, fascinated for the moment, but would sooner or later throw him away. Or he was feared, you know? Just genuinely feared. They didn't know that he was a soft, mild guy who really wouldn't hurt anybody. In situations where I felt really confident, he felt really, really vulnerable. Really scared.

"Were they looking at his skin color, his hairstyle, his dress, the amount of money he was flashing around? I mean there are different things people could have resented. But the energy always got the same. As soon as I separated myself from him, I realized that I was anonymous, just another person, another white person."

Halsband flew back to New York on the Concorde. But several weeks later he had second thoughts and returned to Paris. "I don't know why I went back. I felt really bad about leaving him in Portugal," he says.

By this time, Goode had joined Basquiat. The three embarked on a decadent Continental spree. "We went to Portugal, France, Italy, England, and Amsterdam," she says. "We had a crazy time in Amsterdam. We went to every hash house."

"He taught every bartender in Europe how to make a margarita," says Halsband. "It would be an immediate way to make a friend."

He, Basquiat, and Goode spent their time partying. A significant amount of time was also spent in search of drugs. "He would spend half the day scoring," says Halsband. "He would know every place you could score, but it was never a clean setup. You would have to go and wait and finally someone would come, and he'd make the deal. It just ate up a tremendous amount of time."

The three stayed in a friend's apartment on the edge of the 16th Arrondissement. Every night they went out to bars and clubs. According to Halsband, Goode often drank until she was nearly unconscious. One night they were speeding home so that Basquiat could do some drugs he had just scored.

"We came out of a tunnel, and we were cruising really fast, right past the Louvre along the Seine. We were flying, it's three in the morning, and we were screaming!" recalls Halsband. As they reached the Trocadéro, they were stopped by the French police. "They had their guns drawn, and they were asking us all these questions. Jean was absolutely straight, lucid. Then they shone a flashlight in the back seat, where Jennifer was passed out. They said, *'Elle morte?'* And Jean told me they are asking if she's dead. So we told them, 'Just tired.' "

Back at the apartment, they put Jennifer to bed. Jean-Michel began to smoke some heroin, and Halsband decided to join him. "But,"

he says, "he only let me have two or three hits and then he said, 'That's it, you've had enough.' And the next time I wanted to try it, he ignored me. He had this amazing way of not paying attention to you. He could just shut you out."

Halsband says that Basquiat was extremely attached to Goode. "I think he saw something in Jennifer that he had never seen before in anybody else, which went beyond just superficial beauty." Halsband took a picture of them cuddling in the Tuileries.

They traveled to Rome, and stayed with Halsband's parents, before continuing to Florence, to visit May. After a few days, Jennifer flew back to the United States, leaving Basquiat to his own devices. He painted several big canvases, which he had May ship back to America.

Says Halsband, "Being around Marcia and Jean always made me feel like I was in that Robert Downey movie *Greaser's Palace*. Because she would always say to him, 'You're like a son to me.' It was this absurd statement being repeated, but Jean-Michel didn't respond to it in any way. He would just let it fly."

Liz Williams took advantage of Goode's departure to join Basquiat in Florence. When she got lost driving to May's house, Basquiat spent all day in the middle of the road, waiting for her. They were soon happily reunited. "It was a big house," says Williams. "Nobody could figure out where I was staying. But we were making a lot of noise in the bedroom."

Basquiat's summer vacation had just begun. His next stop was Saint Moritz. The artist was painting in Bischofberger's studio/chalet, when he got a call from Leonart DeKnegt, a self-described "gallery brat" and former assistant, who had worked with him in both New York and Los Angeles. (His father, Fritz DeKnegt, owns several galleries in SoHo, including 417 Broadway, the former Boone gallery.) Now he decided to join Basquiat in Switzerland.

When DeKnegt arrived at the Palace Hotel, where Basquiat was staying, the two immediately went off on a shopping spree. "We bought like thousands upon thousands of dollars of clothes and shoes," recalls DeKnegt. "I remember we were getting dressed, and had just ordered this super expensive breakfast, when we got a call

from Bruno that he was downstairs with a couple of clients. So we went and started talking with them about Italian painters, and all of the sudden, we decided to go to Florence."

Basquiat's Portuguese taxi adventure had not dampened his enthusiasm for running the meter into four digits. The two friends left that morning—by cab.

"We walked out of the restaurant and into the courtyard of this magnificent hotel," says DeKnegt. "And it was funny, because Jean-Michel had like ten thousand dollars in fifties and twenties. Bruno wanted to pay him in Swiss money, and he said, 'No, I want American money.' There was this Rolls, and a stretch Mercedes parked in the courtyard. But he drifted away from me, because he saw the tall end of this Oldsmobile. And he announced, 'That's the car we're taking.'

We called the driver Lefty, because he was missing a thumb on his left hand. Jean asked him to drive us to Florence, and the guy looked at us like we were crazy, but Jean pulled out a wad of money. We paid half up front."

Basquiat and DeKnegt picked up a tour guide in the courtyard, who had been hounding them to be their translator. Then they all piled into the leopard-lined Oldsmobile, just like in a scene from a Jim Jarmusch film.

Their first stop was Portofino. "Maybe he'd seen it on *Lifestyles of the Rich and Famous*," says DeKnegt. "He was drawing the whole way. He had brought *Gray's Anatomy*, and tons of anatomy books. He could throw something up in ten minutes, and it would really be like a masterpiece." But Basquiat wouldn't let DeKnegt see any of his work, even when he drew his friend's hand from life. "At that time he was real cautious about people and his art, because he always thought that they were trying to get over on him."

They spent eight days driving from Portofino to Carrara to Florence, drinking Stolichnaya vodka and listening to a giant boom box on the way. "In the mountains of Carrara, we were blasting Steel Pulse, and some hip-hop," says DeKnegt. They tried to buy pot in Milan, but it turned out to be parsley. They arrived at their destination in the middle of the night, without a place to stay. But then Basquiat flashed some of his American money.

"The cab ride cost eleven hundred dollars," says DeKnegt. "We had gotten a quote of six hundred dollars, which was for the gas and the car. But that wasn't including food for the driver, or a place for him to stay." At the last minute, Basquiat decided the driver was cheating him, and "he freaked out and started yelling and screaming, and threw five hundred at him, and that was that."

In Florence, they visited museums, and shopped. "He was really into the street people of Florence," says DeKnegt. Apparently, Basquiat was acting like a bit of a street person himself. "I had to buy him soap, so I could breathe, you know?" says DeKnegt.

Basquiat, anonymous in the tourist crowds, seemed to relax for the first time in months. "I kind of got to like see his inner child, and I dug that," says DeKnegt. "Because when we were hanging out, there was no real outside world. There was no commercialism, there were no gallery hounds, there were no groupies, you know? Nobody knew who he was."

Basquiat bought a stack of Leonardo da Vinci postcards which he painted over, and at every stop, he mailed them home to friends, including Paige Powell, who saved bundles of the artifacts.

They traveled from Florence to Amsterdam by train. DeKnegt recalls Basquiat's flagrant disdain for money, which he constantly turned into a kind of sight gag. "We had a bag of tons of lire, and I remember at each train station, he would throw handfuls of coins out the window. And we had bought these really great boots, and when he couldn't find one, he threw like this three-hundred-dollar shoe out the window. And ten minutes later he found the other one, and threw that out too. It was like hanging out with Andy had tipped his scale, and instead of bumming money from people, he was throwing it out."

The trip ended abruptly in Amsterdam, where "we stocked up. I remember him twisting this huge joint, like eight papers, and he seemed really happy." But the next morning, when DeKnegt called and asked for Basquiat, he was told he had checked out early that morning. "I called him in New York, and he told me, 'I just had to get out of there.' "

NOTHING IS FOR EVERLAST

The show of the Warhol-Basquiat collaborations at the Tony Shafrazi Gallery in September 1985 marked a major turning point in the artist's increasingly attenuated life. It brought to a head all the specters that were haunting Basquiat, like so many painted images of tormented skulls—from his inability to maintain relationships of any kind to his problems dealing with celebrity.

They were the hot couple of the moment: Warhol and Basquiat, the most famous white and most famous black artist. They made good copy and even better photo ops, and their glitzy socializing, from Mr. Chow's to Area, was obsessively chronicled in the media, from the *Post*'s Page Six to the *New York Times* Sunday magazine. Said Geldzahler of the relationship, "I think it was wonderful. Andy got a real charge out of having a protégé who was a genius. And Jean, maybe he had a bit of his father in him, because he was running with a world-class star, and thereby he was the other world-class star. It was great. It was mutually beneficial."

The two artists famously posed together for the poster for the show, photographed by Halsband, who shot them in matching Everlast—irony not intended—boxer trunks and gloves. Warhol wore a black turtleneck; Basquiat was bare-chested, revealing the jagged scar where his spleen had been removed. "He was about as white as you could get and Jean-Michel was about as black as you could get. It was a boxing match—a *match*, but they were both at odds together," says Factory photographer Christopher Makos. "There is something really important about that picture."

The invitation for the September 14 Palladium party for the show

depicted the contenders in an even more telling pose: Warhol languidly delivering a left uppercut to Basquiat's jaw, the younger artist's face set in a moue of pain.

Even before the opening, Warhol realized that Jean-Michel would have a negative reaction. September 12: "Jean Michel called and I'm just holding my breath for the big fight he'll pick with me right before the show of our collaboration paintings at the Shafrazi Gallery. . . ."

Perhaps it was a preemptive strike, but Warhol was also distancing himself. At the opening, he observed in his *Diaries*, "It was wall to wall . . . I was wearing the Stefano jacket with Jean Michel's picture painted on the back, but I've decided I can't wear odd things, I look like a weirdo. I'm going to stay in basic black." Clearly Warhol had come to the conclusion that promoting his protégé was no longer good for his image.

The poster accurately documented the demise of the relationship, although it was Basquiat who severed the connection. By the time the collaborations were shown, the two were barely speaking.

Shafrazi, Warhol, and Basquiat appeared in a video for the show; "I think you should rub us down," Basquiat says to Shafrazi. But neither he nor Warhol seem to be aware that they are in the same shot.

Keith Haring later wrote a hagiographic catalogue essay. "Jean-Michel and Andy were from different generations and different sociological backgrounds. They had radically different painting styles and equally different aesthetics. They were at different stages of their lives and different levels of their own development. Physically, the only trait they had in common was their hair. Somewhere though, they found a common ground and established a healthy relationship. Their personalities complemented each other. Jean was aggressive and 'point blank,' while Andy was shy and polite. Jean had the nerve to do anything he felt like, anywhere he felt like it, and Andy loved to watch. It was a wonderful kind of give and take which enabled each of them to fulfill their own secret desires . . . The paintings are the physical proof of the harmony that existed beyond the canvas."

But Basquiat's loosely rendered doodles on Warhol's predictable icons drew almost universal pans. One piece, a still life of Hellmann's

mayonnaise, Planters peanuts, and Mott's apple sauce, with Basquiat's ghostly mimicking sketches of orange marmalade, Jell-O, and sliced peas, perfectly illustrated the triumph of packaging over substance.

Wrote Eleanor Heartney in *Flash Art*, ". . . the show offers the spectacle of America's best-known cynic working alongside the 'wild child' of contemporary art, who, we are told, embodies the raw primal energy of the urban jungle. And a curious spectacle it is. Once again, Warhol reveals his version of the Midas touch, whereby everything he handles is infused with banality. Basquiat's 'authentic' images—those gritty figures and that hastily scrawled lettering—as well as the Big Issues of life, death, greed, and lust that the show purportedly tackles, are all revealed to be as canned as Warhol's celebrated soup . . . this collaboration brings together two masters of the carefully constructed persona. The real question is, who is using whom here?"

Perhaps most damaging was Vivien Raynor's review in *The New York Times*. "Last year, I wrote of Jean-Michel Basquiat that he had a chance of becoming a very good painter providing he didn't succumb to the forces that would make him an art-world mascot. This year, it appears that those forces have prevailed, for Basquiat is now onstage at the Tony Shafrazi Gallery . . . doing a pas de deux with Andy Warhol, a mentor who assisted in his rise to fame. Actually, it's a version of the Oedipus story: Warhol, one of Pop's pops, paints, say General Electric's logo, a *New York Post* headline or his own image of dentures; his 25-year-old protégé adds to or subtracts from it with his more or less expressionistic imagery . . . the collaboration looks like one of Warhol's manipulations, which increasingly seem based on the Mencken theory about nobody going broke underestimating the public's intelligence. Basquiat, meanwhile, comes across as the all too willing accessory. Offered in the same spirit as the show's poster . . . the verdict is: 'Warhol TKO in 16 rounds.' "

Warhol instantly understood that the reviews had permanently KO'd his relationship with his young protégé. September 19, 1985: "When we were at Odeon I asked for the paper, and there in Friday's Times I saw a big headline: 'Basquiat and Warhol in Pas de Deux.' And I just read one line—that Jean Michel was my 'mascot.' Oh

God." September 20: "I asked him if he was mad at me for that review where he got called my mascot, and he said no."

But he admitted otherwise to Halsband. "Jean was very quiet at the opening of the Tony Shafrazi show. The next day, Jean and I went to the Odeon and had brunch. He was blown away by the article where they attacked him for being completely manipulated by Andy. Jean was . . . so far way. He was so angry at Andy."

Basquiat, forever fickle to those he loved, and fatally thin-skinned when it came to criticism, immediately reacted by dropping Warhol. In a diary entry nearly a month later, Warhol lamented his absence. October 14, 1985: "And oh I really missed Jean-Michel so much yesterday. I called him up and either he was being distant or he was high. I told him I missed him a lot."

By late November, Warhol's "pas de deux" with Basquiat appeared to have completely ended. November 24: "Jean Michel hasn't called me in a month, so I guess it's really over. He went to Hawaii and Japan, but now he's just in Los Angeles, so you think he'd call . . . Can you imagine being married to Jean Michel? You'd be on pins and needles your whole life."

The collaborations also caused a major rift with Bischofberger. Basquiat had thought he would be paid a lump sum of $500,000. But instead, Bischofberger was doling out the money in monthly stipends. Basquiat complained bitterly about the arrangement in an interview with Anthony Haden-Guest. "Bischofberger. Oh God! He owes me half a million dollars . . . and he's trying to pay me ten thousand dollars a month for the next twenty years. . . . He must think I'm a jerk or something."

Shortly afterwards, according to the *Diaries*, Basquiat's relationship with Powell also officially ended. December 8: "Paige called and she's thinking of going to a place uptown to get treatment for being a chocolate addict, some treatment they give heroin addicts. And she said she finally is completely over Jean Michel. It happened to her at the Comme des Garçons fashion show. She said he looked like a fool out there on the runway modeling the clothes and that's when she finally was over him."

Powell recalls the last time she saw Basquiat. "I was with Chris Stein and Debbie Harry and Tama Janowitz and Steven Sprouse.

Jean-Michel grabs Tama, and says, 'You bigot,' because he was upset about his father posing for the picture in her book *Cannibal in Manhattan*. And Steven grabbed her and said, 'Let's get out of here.' So we went to the Nirvana Club. But Jean-Michel rode in the cab with Debbie. And he goes out and gets this box of Jack-in-the-Box chicken, and this is a typical thing that Jean-Michel would do, the cute-black-boy routine. He was so childish. There were about ten of us, Iggy Pop and David Bowie at this table, and Jean-Michel pulled out all these coins and was trying to do this magic trick. He kept looking over at me, and just glaring."

The three-way honeymoon was over, but Basquiat and Warhol still saw each other occasionally. For Basquiat's birthday on December 22 of that year, Warhol surprised him with a framed wig.

"In the last year and a half before Andy died, they both really kind of pulled away from each other," says Powell. "I can pinpoint it to the bad review of the collaboration show in *The New York Times*. He literally cut Andy off in a way from that point." Not surprisingly, Powell's relationship with Warhol immediately improved.

Warhol's influence on Basquiat was multifaceted. It was Warhol's approval that stamped Basquiat with instant celebrity. But although he had coveted such fame his whole life, Basquiat had neither the maturity nor the inner resources to withstand it. Basquiat had sought a good father in Warhol, but Warhol, despite his affection for the artist, was unable to comply.

Still, the very fact of Warhol's acceptance provided Basquiat with the approval he desperately craved. And it was Basquiat, not Warhol, who ultimately betrayed the friendship by turing on Warhol as soon as their association no longer provided good press. Basquiat's rejection of Warhol is a tragic example of his inability to sustain relationships—particularly with those to whom he felt closest. If he didn't drive people away by his impossible behavior, he cut them off cold.

And, despite his love for Warhol, Basquiat failed to learn Warhol's primary lesson. Basquiat bought into the romance of being an artist, but Warhol was a *businessman*. Although Basquiat idolized Warhol for redefining what it meant to be a successful artist, he never adopted Warhol's basic credo.

Warhol approached art first and foremost as commerce. "Being good in business is the most fascinating kind of art," he wrote in *The Philosophy of Andy Warhol*. His values had more in common with those of Gerard Basquiat than Jean-Michel was willing or able to perceive. It was only after he became successful that Basquiat began to see, much to his despair, that for the dealers, collectors, and even his friends, money was the first priority; that the art world was primarily a marketplace that functioned according to the laws of supply and demand.

Having escaped virtually every other system in the establishment—from getting a school diploma to getting a driver's license, to paying his taxes—he found himself inextricably trapped in an industry that rivaled Wall Street for insider trading, power plays, and corruption.

Warhol's inner circle debated the merits of the relationship. Says Victor Bockris, "In my opinion Andy did Jean-Michel Basquiat a great deal of good. He gave him an enormous shot in the arm for a while. He lent himself as a publicist, literally standing in the window of Mary Boone's, I remember. Under his auspices, Jean-Michel was the toast of the town. Everywhere you went, there was Jean-Michel with Andy. They were a fabulous couple, a great couple. This idea that Andy destroyed Jean-Michel is just nuts."

But art-world documentarian Emile de Antonio told Bockris that "Andy was acting like an old man in love with a tough young woman. Andy was obviously going to be thrown away at some point, if he didn't destroy Jean-Michel first . . . To most people Jean-Michel dominated Andy—Andy had been victimized. But I saw it quite the other way. I came to the conclusion that Andy was the prime mover of a fairly evil thing in relationship to Jean-Michel."

Christopher Makos sees the relationship as yet another example of "vampire lesbianism." Says Makos, "It was a hustle for both of them. I don't care how cool you try to say that Jean-Michel was. He was smart enough to know he's got a big famous Pop artist on the line here, and Andy was smart enough to know that he had the new hot, happening idea possibly. It was like when Elizabeth Taylor and Malcolm Forbes were hanging out together. I mean she had a big capitalist guy and he had a big famous actress. These kinds of relationships are like PR heaven. It was that kind of dynamic—it was user-

friendly. All of this group had perfected the fine art of using each other well. And Andy was the instigator of that. He taught us all how to do that better than anybody. He would just twist things around and make them fabulous."

Basquiat fit right into the well-established Warhol youth-culture mythos. Dotson Rader had written about his warped Pied Piper role years earlier in a 1974 *Esquire* article entitled "Andy's Children: They Die Young." Wrote Rader, "He is like an overindulgent scoutmaster who slips the kids grass and ignores the sounds coming from the pup tents at night.

"Warhol is a father figure to the kids around him, but he is an insufficient one. He listens and watches, but can never come up with more than an 'Oh, really?' to their need. So this generation of children who have been abandoned by their parents, psychologically if not physically, run to him because he pays attention . . . and they are anxious and sexually confused and bored and lonely and they desire not to be."

But while Warhol fatally attracted those with a death wish, he clung tenaciously to life in all its materialistic glory. "Andy was addicted to money, fame, and success," says Bockris. "But Jean-Michel was addicted to something more immediate. The end of their relationship came about largely because Jean-Michel was taking so much heroin. Andy didn't want to be involved with a junkie, because they die. The same thing happened to Edie Sedgwick."

Warhol, hyperconscious of his own image, knew exactly what was going on. "Now and then someone would accuse me of being evil—of letting people destroy themselves while I watched, just so I could film them and tape record them," he wrote in *POPism*. "But I don't think of myself as evil—just realistic. I learned when I was little that whenever I got aggressive and tried to tell someone what to do, nothing happened—I just couldn't carry it off. I learned that you actually have more power when you shut up, because at least that way people will start maybe to doubt themselves. When people are ready to, they change. They never do it before then, and sometimes they die before they get around to it. . . ."

PERISHABLE

"Most addicts look younger than they are. Scientists recently experimented with a worm that they were able to shrink by withholding food. By periodically shrinking the worm so that it was in continual growth, the worm's life was prolonged indefinitely. Perhaps if a junky could keep himself in a perpetual state of kicking, he would live to a phenomenal age."

—William S. Burroughs, from the Introduction to *Junky*

Basquiat's work was still selling, but by late 1985, the painter had faded from the scene. Once his ties with Warhol had been severed, he disappeared from the gossip columns. He secluded himself in his Great Jones Street loft, retreating with Jennifer Goode into a heroin cocoon that was occasionally interrupted by trips abroad; one to Tokyo, one to Los Angeles, and one to the Ivory Coast.

The artist realized his moment had ended. "People have a very short attention span," he would later tell Anthony Haden-Guest. "They're looking for another artist every six months or year, and it's really impossible. There's only twenty good artists in a century."

In an interview with filmmaker Geoff Dunlop, the director of a BBC documentary about the artist called *Shooting Star*, Basquiat talked about his fleeting fame. "You go to restaurants and they write about it in the *Post* on Page Six. I mean I'm sure in some ways it's fun. In some ways it's fucked up. I like to try to remain a little reclusive, and not just be brought up and brought down like they do to most of them."

A haunting exchange follows. Says Dunlop, "Sometimes they can turn on you, can't they?" Basquiat's chin trembles as he responds. "Oh they always do. I can't think of one big celebrity-type person they haven't done that to." "Have they turned on you?" asks Dunlop. "Here and there," Basquiat says, as the camera lingers on his look of exquisite pain. "Here and there," he whispers to himself.

In October, DeKneght was hired to move a shipment of Basquiat's work, including a portrait of Larry Gagosian, to Gagosian's new gallery on Twenty-third Street. The job resulted in a major falling out. According to DeKnegt, who was also doing heroin at the time, he'd regularly see Basquiat taking a cab to score dope in the East Village. "He would have the cab wait for him while he went to cop. Since I was real angry with him, I would always shout, 'Motherfucker, you're going to die!'"

In December, Marcia May threw a twenty-fifth-birthday party for Basquiat at Mortimer's, a place he must have detested. It was a gloomy, alienated affair. "He was late, and I think he felt funny about coming into Mortimer's," says May. "He was very shy about those things, when he wasn't in his own milieu."

Among the quests were Andy Warhol, Malcolm Morley (with whom Liz Williams was also having an affair, and whose presence was especially requested by Jean-Michel), collector Maggie Bult, Baby Jane Holzer, and Tina Chow, whose gift was a jar of caviar. Warhol gave Basquiat a set of rhythm and blues records. May and her husband, Alan, gave Basquiat a custom-made Stetson (he would leave it in a friend's Jeep a week before he died.) Jennifer Goode and her brother Eric were invited, but didn't attend.

After lunch, Basquiat and Warhol went to Bloomingdale's, where Basquiat intended to purchase a $3,000 gift certificate for his mother. But when he took out his gold American Express card, he was asked for further identification. Even when he was with one of the world's most famous artists, Basquiat was still treated with a mixture of racism and suspicion.

If Basquiat was grateful for May's attention, he had a perverse way of showing it. May had commissioned a portrait of her daughter, Alexandra. "He wanted her to pose topless. She didn't pose topless, of course, but he painted her topless," says May, who was horrified, and

asked Basquiat to "fix it up a little." Basquiat offered to return her money, or give her a different painting. Then May heard the painting had been sold in Japan.

Michael Halsband remembers the incident differently. "I happened to be visiting Jean-Michel when Marcia showed up and asked to see the painting. He told her it wasn't quite finished, and he pulled out a picture that's a one-eyed Cyclops with tits. It was an amusing image, but it was not a portrait by any means of a young girl. She kept turning to me, and saying, 'Do you think it looks like Alex?' She had given him twelve thousand dollars as a down payment, and she wanted her money back." Half an hour later, Halsband ran into Basquiat at Indochine. "He shows up with a drawing and asks me to give it to Marcia."

Basquiat had drawn a broken flower, with Alex May's name on it, which he had crossed out. According to Halsband, he had embellished the drawing with a litany of words that more or less summed up his feelings toward his Texan patron: "foamy spit, feces, piss." Says Halsband, " 'Nothing to be gained here, nothing to be gained,' you know, just a continuation of all that. So I called Jean up and told him Marcia didn't want it."

After Basquiat's death, the two squabbled over the scrawl, with May insisting it was an important piece for her daughter, and offering to trade an unsigned color drawing for it. Halsband refused. Basquiat would have approved, since he always complained bitterly that his friends sold the work he gave them.

The portrait of Alex turned up at Christie's 1997 spring auction, entitled "Jewess"; in response to May, Basquiat had angrily written the word on the back of the canvas as Liz Williams watched. Even though her daughter, Alex, insisted she buy it at any price, May contested the ownership, and had the auction house remove the work from the sale.

Basquiat also wreaked revenge on his rival Malcolm Morley. He knew about the relationship with Williams through Brian Williams, aka B. Dub, an assistant they both shared. Besides stretching canvases and painting in the background colors on Morley's canvases, B. Dub was his video delivery boy. According to him, Basquiat made an insulting comment regarding Morley's vulgar taste in videos. Williams repeated the remark to Morley, and "Jean-Michel went berserk," says Williams.

The two artists engaged in a drawing duel. Recalls Morley, "He came around to see me, and it was a very strange meeting, because I asked him if I might draw him. I wanted to show him that I could really draw in a Degas-like fashion. I started making this most beautiful drawing, and he started making a drawing with a felt marker, looking at me. Halfway through he came over, and he looked at my drawing, which was a beautiful, beautiful drawing and he suddenly scribbled graffiti eyes right smack in the center of it! It's really something to put a mark on another artist's drawing. So I gave it to him, and he gave me one he had made of me where I looked like Mr. Monster Man."

At the time, Basquiat had several assistants. Besides Brody and B. Dub, there was Shenge, a dreadlocked character he had met several years earlier at a club called Zippers. Shenge also worked as a deejay at the Reggae Lounge and at Berlin, where he would see Basquiat mooning over Suzanne Mallouk. Like Stephen Torton during the Crosby Street days, Shenge became Basquiat's not-so-secret sharer at Great Jones Street. And like Torton, his ambitions conflated with Basquiat's, ultimately creating an untenably competitive situation.

"I lived there from when he moved in," says Shenge, who looks like a Rasta teddy bear. A soft-spoken man, he speaks in a deliberately enigmatic style, like a guru minus the followers. "I built the whole place. It was a really wild, blending-of-souls type thing."

Shenge lived in the basement from 1983 through 1986, working as a sort of Man Friday, and haphazardly keeping Basquiat's books. He also guarded him from the outside world, censoring his calls, dealing with his dealers. Recalls B. Dub, "Jean-Michel would reward him with presents from Agnes B."

Warhol was never very impressed with Shenge's services. ". . . Jean Michel wanted me to see his paintings down on Great Jones St., so we went there and it's a pigsty," reads the diary entry for August 5, 1984. "His friend Shenge—this black guy—lives with him and he's supposed to be taking care of the place, but it's a sty. And the whole place just smells so much of pot."

According to Warhol, Basquiat complained about his difficulties with Shenge almost from the start. September 16, 1984: "Jean Michel called and he told me about the problems he's having with

Shenge . . . Shenge has his own place downstairs, but then he goes up and uses Jean Michel's bath and bed, and now after staying at the Ritz Carlton, Jean Michel is used to having his bed tucked in."

But whatever Basquiat's qualms might have been, Shenge remained completely oblivious. As far as he was concerned, he was the majordomo at Great Jones Street. With his beard, abundant head of waist-length dreadlocks, and African-inspired wardrobe, he certainly looked the part.

"When I was there, people are treating Jean-Michel the way they should have," he says. "Before, if they wanted two paintings for the price of one, or if they really want four paintings instead of two, they could get that because they had cash. Once I was there, it was different."

But Shenge was scarcely an accountant. (Basquiat's books, if they even existed, were a mess, and the artist never paid his taxes.) He served as a companion and protector; a combination baby-sitter, bodyguard, and big brother.

Shenge recalls their relationship as that of soul mates. "We were kind of living inside each other. I wasn't myself, and he wasn't either. If I wasn't there, he couldn't function. For three years, I never lived my life, never. I used to be studying and I had to give it all up. Because if Jean was awake, I would have to work with him six hours a night. There were people in the house, people stretching canvas, people making frames. He never wrote a check. He didn't know what it was. This is the guy who just got some cash, and that was it, that was the situation. And who had the wrong way of thinking that most things should be cash, and there would be investments down the line. And Andy and I used to talk about it, but you couldn't push Jean to that. Live for today, for right now, was his attitude."

Shenge tried to play shrink with Basquiat. Because of his problems with his own father, he was particularly sympathetic to Basquiat's conflict with Gerard. "What he internally wanted was the attention of his father, and to reconcile with him. Everything was set up for that love he didn't get. Everything. It was expected by him, a reconciliation in the end. But it never happened. And I think his father was death-scared of it."

Shenge encouraged Basquiat to come to terms with his parents. "I told him he has to at least find out what's happening, because I could see that he gets into it whenever he's trying to work, or whenever he's not doing anything, that it's on his mentality constantly." Shenge asked to meet his parents, and was rebuffed. Eventually he convinced Basquiat to go to Brooklyn for Thanksgiving dinner.

"I was like a pallbearer. I knew from way, way back that Jean was going to die. Because you could see it. You could see that he didn't have the love he needed from his father. All of the sudden, the world is telling you you're a genius, and he was thinking, 'If I'm a genius, what's wrong with this man [Gerard] accepting this?' "

But Shenge had his own ambitions. He "silently" painted down in the basement, and eventually he had a show at the John Good Gallery. "Shenge never painted a day in his life before he moved in with Jean," says B. Dub. Basquiat saw Shenge's art career as the ultimate betrayal. His tour of duty ended in 1986, when Basquiat peremptorily kicked him out.

"He didn't want me to show. Because he wasn't painting. The drugs took him over and made him stop. At times he used to come downstairs really pleading with me to stop painting, because he can't take it. And I would say, 'This is where you have reached, man, to be jealous of me,' " says Shenge.

"From 1986 I don't believe he knew what Shenge was. Something had happened in his mind. What I see in my soul in those moments, it was like a shadow of before. It was like a specter of what he had been. Maybe it was a combination of the drugs and Jennifer. It's hard to pinpoint, because I saw a myriad of different things from what I know him to be."

Basquiat's dismay at Shenge's success was a source of amusement to Warhol. Wrote Warhol on January 20, 1986, "Jean Michel woke me up at 6:00 this morning . . . He's got problems because he's trying to get Shenge out of the house, he says he's been supporting him for three years, but the main reason is that (laughs) Shenge is now painting like he is. They're copies of his paintings. Jennifer's away. And oh, Jean Michel must be so hard to live with. . . ."

Continued Warhol a few weeks later, "Jean Michel is really

unhappy—Shenge is having his one-man show. And I mean, he's (laughs) just as good as Jean Michel. And Jean Michel kicked him out and changed the locks, but then finally he let him in to get his paintings."

"I thought he might like it if I showed his friend," said Good, who had befriended Basquiat and claimed to be surprised by his reaction. "But I really walked into a buzz saw."

It's hardly surprising that Basquiat, who wanted to be understood as a major artist on his own terms, and had so vehemently tried to distance himself from the graffiti artists, was incensed by the fact that his only black factotum was now painting—and that people were taking his work seriously.

"People come here for two months and have a show. I've seen it happen," he told Anthony Haden-Guest in that last interview. "I had a roommate that used to live here to do some bookkeeping and stuff for me . . . he never had any desire to be a painter, and he began painting strictly for the idea of making some money. He had a show, which was *terrible.* He was copying maybe a small part of what I do."

Says Barbara Braathen, who had continued her ongoing affair with Basquiat and became friendly with Shenge, "Jean-Michel had a pattern of rejecting those who got too close to him. And he complained that the books weren't kept properly. Things were overlooked, receipts were missing, not out of malice, just a sloppy job. When they did break up, Jean wouldn't even let Shenge in to get his albums. And Shenge made his living as a deejay before that."

Shenge sought refuge with Lee Jaffe, who put him up in a room in his studio. "I never talked to Jean-Michel again after taking Shenge in," says Jaffe. "I called him, but he didn't return my calls. I had the feeling he was getting more and more withdrawn. I'd stop by his house every once in a while and ring the bell, and no one would answer it. His phone numbers were always changing, and then there was no phone."

In February 1986, Basquiat went to Atlanta for a show at the Fay Gold Gallery. Typically, he invited Nancy Brody, whom he had run into on the street, along for the ride. Brody remembers Basquiat's discomfort as Gold began talking about her maid, Bessie. "It must have been awkward for Jean. The only other black person Fay knew

was a maid," says Brody, who recalls Basquiat holing up in the Ritz Carlton once they arrived.

Gold had discovered Basquiat several years earlier, on her birthday, when her husband had given her $5,000 to buy a diamond bracelet. Instead she spent $5,200 on a Basquiat diptych at the Annina Nosei Gallery. She met the artist again, later that year, at the Basel Art Fair. "He seemed disoriented and wild-eyed, and Annina whispered that he was taking drugs. But I've always had an affinity for eccentric people, maybe because of my mild Jewish-mother instincts. I was a close friend of Mapplethorpe's," says Gold.

In 1985, she decided she wanted to do a show of Basquiat's drawings, and went down to Great Jones Street to see him. He sold her eleven drawings for $16,500, but said he was afraid he would be lynched if he came down to the South. He also bought ten drawings by folk artist Sam Doyle from Gold.

Nearly a year later, Gold mounted the Basquiat show, and invited the artist down for the occasion. She had arranged for Basquiat to appear on a talk show, but when they reached the station, he had second thoughts. She threw a party for him, but he nodded out. Two months later, he sent his Maine coon cat, Rasputin, which Gold had admired, to Atlanta. He said he was traveling a lot, and couldn't take care of it. She renamed the cat Basquiat.

By early 1986, Basquiat's drug habit was so extreme that rumors began to circulate that he had AIDS. He had lost a front tooth, and his face was covered with blotchy sores. Basquiat traveled several times to Hana, in Maui, Hawaii, with Goode in an effort to clean up. "We would rent a house there," she says. "It's the only place I was with him where he didn't do any drugs. We would drive around in this Jeep, and he would be blaring the radio, and it was just great. I remember him dancing."

But back in New York, Basquiat instantly went back to his old habits. At the time, he was buying heroin from Linda Yablonsky, who lived with Pat Place, a musician with the punk-rock group The Bush Tetras, and sold dope to a clientele that included a number of well-known artists and musicians. Yablonsky's 1997 novel, *The Story of Junk*, a semi-fictionalized account of her dealing days, includes a composite character called Claude Ballard, in part based on

Basquiat. Yablonsky creates a harrowing scene where she saves him from nearly OD'ing by injecting him with water and salt. (In real life, this incident did not involve Basquiat.)

"I dealt out of my apartment. We were all friends. It wasn't like a shooting gallery," she says. "Everyone in the world was using, all kinds of artists. He bought fairly large quantities and gave a lot of it away to girlfriends like a party drug. He often came over during the middle of one of his parties to get more." Yablonsky says she bought work from Basquiat, but always paid him in cash, not in drugs. "But I'm sure people did trade art for drugs. I was just uncomfortable with it."

A few years later, when Yablonsky was busted by the Drug Enforcement Agency, Basquiat helped pay her rent by giving her some of his work. "I'll never forget it," she says. "It got me through two months of my life."

Although she herself was a junkie at the time, Yablonsky could see how heroin was affecting Basquiat. "As his drug use intensified, he stopped working, which was the greatest tragedy of all," she says.

When he wasn't holed up at Great Jones Street, Basquiat traveled with Goode. In August 1986, Basquiat finally satisfied his fantasy of going to Africa. He and Goode flew to the Ivory Coast for a show that Bruno Bischofberger had organized in Abidjan, at the French Cultural Institute.

It was Basquiat's first and last trip to Africa. Says Bischofberger, "He wanted a show in Africa, and we arranged one. Bischofberger warned Basquiat not to be disappointed that there were paved streets and skyscrapers in Abidjan, not just people living in primitive huts. "He was hoping that very unsophisticated African people would see his show," says Bischofberger. "But everyone was invited there by the government, and there were three or four of the most famous artists in the country, and people who had been trained in Paris. It was not the man in the street who got to see Jean-Michel's work."

Still, Basquiat enjoyed meeting the indigenous artists, although they turned out to be more influenced by Western art than he had anticipated. After the show, the group took a car trip through the country-side, to a tribe in Korhogo. "Jean-Michel was smoking so much pot, I

wasn't sure the chauffeur would be able to stay on the road," says Bischofberger. His wife, YoYo, took a lot of pictures. "The only thing you saw of black people was their eyes in the evening," she recalls.

Although by now he was almost a recluse, Basquiat, dressed in pajamas, could often be seen pedalling his small red bike to the East Village for drugs. He was quickly eroding into a mere caricature; a cartoon junkie with predictably mercurial ups and downs. The childlike idiosyncrasies that contributed not only to his charisma but to his talent had degenerated into a perverse series of behavioral tics. His bad-boy routine was getting boring, as was his formulaic painting.

At one point, a large group of the artists of the moment were scheduled to pose for a photograph at Mr. Chow's. When the artists were assembled at the restaurant, Basquiat started a food fight, then ducked to make it seem as if Keith Haring were the culprit.

During the opening of Julian Schnabel's first one-man show at the Whitney, in the fall of 1987, Basquiat managed to sneak past the guards and scribble graffiti near Schnabel's paintings. Scott Borofsky, an artist who had just gotten to know Basquiat, witnessed this act of hubris—and Basquiat's parting gesture. "I remember seeing him glance back over his shoulder with this big smile on his face," recalls Borofsky.

His drug-induced cravings led to some humorous incidents. B. Dub recalls Basquiat's obsession with White Castle cuisine. "He would get cravings for things he hadn't had since he was ten years old. We would get a car service and drive over the Fifty-ninth Street Bridge to Queens and buy like thirty dollars' worth of White Castle burgers." Once they were back home, Basquiat froze the burgers, only to nearly incinerate his place the next day by putting them in the microwave oven, even though he had sent B. Dub out to get Puerto Rican food. When B. Dub returned to the smoke-filled loft, Basquiat gave him $100 to go back to White Castle.

Basquiat even convinced German art dealer Michael Werner, who at the time was Mary Boone's husband and her partner in the gallery, to dine at White Castle. Werner had come by Great Jones Street with a collector to look at some work. "Jean-Michel liked to kind of play and fuck with people. He was a terrorist in that way,"

says B. Dub. "So he asked them out to lunch. I could just picture him sitting in a car with those two guys and saying to the driver, 'Take us over the Fifty-ninth Street Bridge, to Queens'!"

Basquiat kept his assistant busy with various errands, like going to Whole Foods to buy $40 worth of Italian, natural-bristle toothbrushes. (B. Dub was used to Basquiat's unusual requests. Once, at the artist's behest, he had shipped a book packed full of pot from the Larry Gagosian gallery to the Fruitmarket Gallery in Scotland, where Basquiat had a show in 1984. The package was intercepted, and the Gagosian gallery was nearly busted.) B. Dub would prepare canvases for Basquiat during the day, while the painter slept. "He'd work mostly late at night. Most of the time I would come the next day and see that a whole huge drawing or painting had totally changed," he says.

Once, B. Dub witnessed an encounter between two of the most famous artists of their generation. Mark Kostabi had stopped by Jean-Michel's studio. "He had brought a catalogue of his work to show Jean. I was working in the back, and I heard Kostabi asking genius questions, like 'When do you decide to cross out a word?' "

As Basquiat chatted with Kostabi, he was turning the first drawing in the catalogue into a caricature. Basquiat added dreadlocks and clothes to one of Kostabi's standard cookie-cutter figures, and the punch line "You always draw bald guys?"

"Jean-Michel was so moody. A lot of people had just gotten sick of his attitude. To me it was kind of like, well, he's a genius and that's the way it is. I've never seen somebody so smart about so many different things. And he had so much energy. The funny thing was as much weed as he smoked, he never seemed stoned or tired," says B. Dub, who had a high tolerance for Basquiat's behavior.

But Goode saw the downside of the drugs firsthand. "They made him much less creative, because he wasn't seeing things. He wasn't going out, he wasn't reading. He was locking himself in that house."

In late 1986, Jennifer Goode finally accomplished the near impossible; she got herself and Jean-Michel into a methadone program in Manhattan. But Basquiat quit after only a few weeks; he found talking about his childhood to the staff psychiatrists too uncomfortable. Then again, Basquiat had never related well to authority figures—

from his father, to the principal he threw a pie at, to his numerous art dealers. "He just went back to his old ways," says Goode, who remained in the program for a year and finally kicked the habit on her own after Basquiat's death.

For months, Basquiat had been shooting speedballs—the lethal mixture of heroin and cocaine that killed John Belushi. "It was just really scary," says Goode. "I saw a big change in him. You know, you become paranoid. He became really intense and not happy, just really angry. When I first met him, his face had one little scar, and by the end his face was completely covered. It was all sores, and he would pick at it, a nervous thing brought on by coke. He was missing his front tooth. He lost it while I was with him. And then he wore a temporary fake tooth. He was supposed to get a permanent tooth. He wanted a gold one, but he never got it."

According to Goode, Basquiat was spending upwards of $300 a day on heroin at this point. "And then it escalated, and his sources dried up, and so he had to start going to the street. And he'd have to do more of the street stuff because it wasn't as strong," she says. "It made him function less and less, and he painted less and less. His paintings were getting muddier. They weren't as clear. But he still idolized people who took heroin. He *loved* William Burroughs."

Basquiat had actually recently met his idol through Victor Bockris. Says Bockris, "I took him over to the bunker at 222 Bowery, where Burroughs was staying, for cocktails. For Jean-Michel, meeting Burroughs was like Andy meeting Muhammad Ali. It was a very interesting scene. Keith Haring and John Giorno were there. And I remember a very vivid image. At one point Bill whipped out an enormous knife that had been given to him by Chris Stein of Blondie. It was maybe ten inches long, and he was flashing it and acting out some role and being very funny. And Jean-Michel was laughing, doubled up like a child with sheer delight and pleasure."

Not long afterwards, according to Bockris, Giorno and Burroughs went over to Basquiat's loft. "There were little bags of heroin stacked on the table in an enormous mountain. At least five hundred dollars' worth on the table. Most people hide that. John Giorno told me that Jean-Michel was obviously trying to kill himself." But Basquiat had always prided himself on his tolerance for huge amounts of drugs.

Goode was constantly afraid that she would return home to find him dead from an overdose. "I would go over to his house, and he would say, 'Jennifer, don't worry. I'm not going to die.' He would reassure me, even though he really didn't like to talk about it, because then he'd have to face it."

Goode was so worried about Basquiat that she tried to get him to write a will. "We talked about leaving a will," she says. "It felt like a macabre thing to talk about, but I never could get him to go to a lawyer. He told me that he didn't want his father involved. And he just left it right there. We talked about the paintings going toward taking care of his sisters and mother, and putting the rest in a show that traveled to different parts of the world, and was not all auctioned off and everything. But he was so disorganized, and he didn't think he was going to die."

By November of 1986, Goode had reached her limit. "I loved him dearly, but I ultimately came to the realization that I wasn't going to change him, and there wasn't going to be a future for us except as friends. I talked to people that really knew him, like Tina Chow, and we would commiserate. People said, 'You have to take care of yourself. You've done what you can for Jean-Michel.' "

Goode broke up with Basquiat, but although they were no longer a couple, she continued to see him. "For nine months after I left, I would drop by. He was always kind of in this drug fog," she says. It wasn't until she became involved with another man, who also happened to be black, that Basquiat seemed to realize it was over.

"I gave him back the keys to his house, and he destroyed everything in sight. He broke every piece of glass, everything," says Goode. "And he wrote on the walls. He cooled down, but he never really faced it. I kept thinking it was going to get better. I hoped that he would fall in love with someone and be happy. But it didn't work out that way."

Basquiat punched a hole through his bathroom window. Near it, he wrote, "Broken Heart."

RIDING WITH DEATH

On February 22, 1987, Andy Warhol, who had reluctantly checked into New York Hospital for what should have been a routine emergency gallbladder operation, died. In a sense, so did Basquiat. According to those who knew him best, he never recovered from Warhol's death.

"I saw Jean cry about Andy," says Nancy Brody. "I never saw him cry before." Recalls Fab 5 Freddy, "Andy's death put Jean-Michel into a total crisis. He cried a lot and wore a black armband. I ran into him at a club a few days after Andy died, and it was really sad. Typical Jean-Michel. He's at Madam Rosa's being a total asshole. He's standing in the middle of the dance floor, crying in agony, and leaning his head on the wall. He couldn't even talk. I put my arm around him and bought him a drink."

Barbara Braathen tells a harrowing tale of visiting Jean-Michel soon after Warhol's death. She had gone over to Great Jones Street at four in the morning, in part because there were several collectors in town who were interested in Basquiat's work. "He was so happy to see me. I told him what I wanted and he said, 'We can talk about it, but you have to stay.'"

Basquiat kicked everyone else in the loft out. The next day, Braathen left briefly for a change of clothes, and returned with the collectors. Basquiat had left a note saying he'd be back in fifteen minutes. The paintings had been chosen, and the collectors were leaving for the airport when Basquiat returned. "He came running in the door. I asked if he wanted to meet them, but he kept his head down. And he

ran into the kitchen and he grabbed a big knife and tried to stab himself."

Braathen tried to calm Basquiat down. Once she got the knife away, he crumpled into a fetal position on the bed. Braathen and Basquiat's housekeeper, Blanca, tried to console him. "It was the saddest thing. He was just crying and crying and crying and saying, 'I'm always alone. I'm always alone.' And he said that since Andy had died, he could only think of killing himself." Braathen stayed with Basquiat for several days. "The telephone had been disconnected, and it was like being a prisoner. I remember at one point we were all crying. The third morning I woke up and some people had come over and they had brought him some heroin.

"I asked him what the appeal of heroin was, and he pulls out this book by Burroughs and said, 'Here, read this book.' " Once Braathen told him, "We've got this one layer of atoms around ourselves, and drugs put holes in that layer, and you have to be very careful or your soul will escape." "My layer is *this* thick," Basquiat responded. Says Braathen, "His entire life, I'm sure from the time he was a little kid, he was developing that layer, those layers, that thickness, to be able to cope with what he saw."

Once he was high, Basquiat came out of his "nervous breakdown." Indeed, he reneged on his most recent art deal, telling her that he wouldn't sell the paintings to the collectors, who turned out to be dealers. "He said, 'Why should I sell anything to them?' and I said, 'Because of me.' And he said, 'Who are you?' That was one of the last times we saw each other."

Perhaps it was a measure of Basquiat's diminished status in the art world that he was not invited to Warhol's funeral in Pittsburgh, which he took as a personal insult, although, like thousands of others, he attended the absurdly overcrowded memorial at Saint Patrick's Cathedral on April 1, 1987. "I know he was really upset that he wasn't invited to the funeral," says Jennifer Goode. "I think he was hurt that the people at *Interview* didn't call him and include him. But more than that, he once told me that every great artist was dead. I stood with Gerard and Nora at the memorial because I couldn't find Jean-Michel. We were supposed to meet."

Typically, Basquiat arrived late. Gerard and Nora had saved a

place for him, but Basquiat, distraught, stayed off to one side. "I saw him at the memorial. He was totally unapproachable," says Michael Halsband.

Soon afterwards, Jean-Michel created his own memorial to Warhol in Marcia May's Park Avenue building. It would remain there until shortly after Basquiat's own death. "After Andy died Jean-Michel drew on the elevator," May says. "He wrote, 'A.W. lives—SAMO lives.'

"When Andy died it was like his life was over," says May. "He told me he had never lost anybody before. That's when he came over to visit us and the doorman thought he was the delivery boy. We saw him a lot then. He was totally grief-stricken, totally. He was knocked for a loop. It was almost like a warning that it was the end for him."

Warhol's death also threw the artist into an unnecessary panic about his status at Great Jones Street. He was convinced that the Warhol Foundation was planning to evict him. "He got more paranoid after Andy died, and he was afraid he was going to be thrown out of Great Jones Street," says Vincent Fremont of the foundation. "I tried to persuade him that that was not the case."

Although none of Warhol's efforts to keep Basquiat off drugs had succeeded, he acted as a moderating influence. Now, with no one to protect him, Basquiat was in free fall. He plunged into a permanent drug binge. Nick Taylor spent a lot of time doing drugs with Basquiat in 1987. He used to go over to Great Jones Street to "chase the dragon"—use a straw to smoke a smear of heroin directly off tinfoil. He recalls one particularly intense incident.

"He had this really exotic dope that he got from this dealer who had been busted in Italy for bringing the stuff back to New York with condoms up her body," says Taylor (an incident alluded to in Yablonsky's book). "It was Tibetan heroin, brownish beige stuff. I just sniffed it and I was stoned for three days. There was a mound of it, three or four balls, and it was all gone in one sitting. He was ruthless, relentless. He had no fear of OD'ing. He was really a genuine madman and I realized there was no holding him back, he was doing as much as he could. I was afraid of him. I knew that something really tragic was going to happen, and that's the last time I hung out with him."

Arto Lindsay, an early friend of the artist, went over to his loft in late 1987. "I remember before Jean-Michel died I heard some tapes he made. They were the weirdest thing, very lonely-sounding, a lot of echo and space. Abstract, almost like the sound of wind with chunks of noise floating through."

Basquiat was cutting all his ties. By now he had severed his relationship with Bischofberger, in part over a fight about their deal concerning the Warhol-Basquiat collaborations. "When I was with Jean-Michel, Bruno and he were close," says Goode. "Bruno gave Jean-Michel money every month, twenty, thirty, or forty thousand dollars—he lived off what Bruno gave him. And we traveled with him, and stayed at his house in Switzerland. It happened after Andy died and someone called from the Factory saying that Bruno was up there picking out paintings from the work Jean-Michel and Andy did together. And Jean-Michel got really angry, because he wasn't participating in that, and that's when he broke off with Bruno."

Basquiat thought that Bischofberger was going to give him the money for the collaborations in one lump sum, but the Swiss dealer was paying him in monthly installments instead. Basquiat told Anthony Haden-Guest that he had no written contract with Bischofberger. But he complained bitterly that he had been ripped off. He also regretted ever having agreed to the deal with Bischofberger.

"I had about forty paintings that I had done with Andy, that were stuck there when Andy died, and Bischofberger was so intent on getting them that he pressured me into selling them to him. When I thought about it later, I realized I didn't have to sell them to him," said Basquiat. "I kept two [paintings]. But I could have kept twenty. But he kept calling me, and calling me. Like there was a big rush for it, you know. He was just dead too."

Says Vincent Fremont, "I just wanted to make sure that Jean-Michel got the paintings because that was always the arrangement. Well, Bruno got them. He said he paid Jean-Michel for them. All I know is that when Jean-Michel came up to the office, he ran into Ed Hayes [the lawyer for the Warhol estate], which was really scary because Ed is Mr. Brusque. So I took Jean-Michel upstairs and told him to start picking his half of the collaborations. But he had a big problem

with his tooth, and he said he just couldn't deal with it. Then Bruno took over Jean-Michel's fifty percent share. The problem with Jean-Michel is that you could take advantage of him if you had money in either cash or check form that you were willing to put down right then and there."

Says Jay Shriver, "He needed money. Anyone walking in with cash walked out with a painting. You could empty his whole studio of everything by dangling a three-hundred-thousand-dollar check in front of him. But Jean-Michel set himself up as a scapegoat. He knew how to avoid being exploited. He used it as an excuse for things to go bad. He always liked to be the victim of a foul plot."

Bischofberger has his own explanation of the contract he had with Basquiat to purchase the Collaborations. According to Bischofberger, Fred Hughes called him and asked him to arrange for Basquiat to pick up his share of the paintings. But Basquiat, he recalls, "was pretty disturbed and crazy from drugs. He said, 'I don't want to show up there. Please do it for me.' "

Bischofberger says he first got written permission from the artist to select Basquiat's fifty percent of the work. When Bischofberger got up to the Factory, he and Hughes flipped a coin, and "Fred won and got the first choice of the paintings." But Bischofberger felt he knew the Collaborations better than Hughes: "I think I got the more interesting work."

Bischofberger returned to Great Jones Street with a list and Polaroids of the paintings he had selected, and asked Basquiat to sell him the work. The artist, says Bischofberger, agreed. But Basquiat doubled the price Bischofberger offered, because he said that the value of Warhol's work had appreciated since the artist's death. (Warhol would have approved.)

"He gave it to me all in writing on a big piece of paper, the kind he did drawings on," says Bischofberger, who made a down payment of about $40,000 dollars, and agreed to pay the balance in $10,000-a-month increments. "The way I did it was absolutely correct," he says, adding that, after Basquiat's death, he paid the estate the remaining sum owed—several hundred thousand dollars.

Although Basquiat told his friends that he was no longer working with Bischofberger, Bischofberger says that he had arranged with

Galerie Maeght de Long to co-represent Basquiat. Indeed, he says that they gave Basquiat a stipend of between $10,000 and $15,000 a month, for seven or eight months, even though they received no work for their payments.

"He was irrational. He was only interested in drugs," Bischofberger says. "We still had our contract. Of course, he broke it off completely. But for me he was still my artist."

Basquiat's last art dealer was Vrej Baghoomian, an Iranian expatriate, who first met the artist through his cousin, Tony Shafrazi. Baghoomian was born in Teheran. His father worked in Kuwait as a civil engineer, until the oil fields were nationalized. When he was nine, Baghoomian's family sent him to an Armenian boarding school in Lebanon. When he was fifteen, he and his older brother were enrolled in a British boarding school.

The two boys soon became accustomed to being beaten up by various gangs. "We became really rough characters," says Baghoomian. "The whole school was one big party and that's where everyone learned to play poker and lost their virginity. Eventually the school was shut down."

Baghoomian moved to South Wales, and graduated from the University of Cardiff in 1966, with a degree in business administration. But his business career was temporarily sidetracked, he says, by an obsession with chess. He soon realized he didn't have the stuff to make it in the major tournaments, and began working with computers.

In the early seventies, he moved back to Iran, taught English, worked for Northrop's computer department, and eventually started his own software business, called DEC Punch. According to Baghoomian, his clients included Bell Helicopter, Lockheed, Drummond, and the U.S. Embassy.

Throughout this period, Baghoomian had stayed in touch with Tony Shafrazi, who had recently graduated from the Royal College of Art. "I was always interested in the arts, and because we were really good friends, his interest really rubbed off on me. And later on when I did become successful, I started buying a little bit." One of his first acquisitions was a Warhol.

When the Iranian revolution took place in 1978, Baghoomian's

U.S. military connections got him in trouble, he says, and he fled the country after the government confiscated his passport. "I think they were trying to label me as a CIA operative. The last month was hell. I went underground."

Baghoomian forged a new passport by changing the *B* in his last name to a *P.* He resurfaced in Paris, where the *B* was reinstated. From there he traveled to Berlin, and finally resurfaced in Los Angeles in 1979.

Initially, he tried to start up a diversified corporation that included an art gallery, a computer firm, an import-export business, and an insurance company. But his backers were stuck in jail in Iran. "Then Tony opened a gallery and it was expanding and he needed someone to help him, someone with a business mind," he says. Shafrazi had recently moved into a space on Mercer Street.

Baghoomian's survival technique at boarding school and later during the Iranian revolution would stand him in good stead in the ruthless art world, where he operated like an outlaw from the start. In 1983, Baghoomian moved to Astoria, Queens, and began to work as his cousin's bookkeeper. But he was also selling art on the side, and eventually had a falling out with his cousin over a financial matter.

Whether or not he had at this point done anything illegal, Baghoomian always had a checkered reputation. With his ingratiating manner and dark, exotic looks, he soon developed a reputation for being the "carpet salesman" of the art world. He appeared to be from a completely different world than his elegant cousin, Shafrazi, who became a media darling after vandalizing "Guernica," and whose gallery represented Keith Haring and Kenny Scharf, among other early eighties art stars. Baghoomian never seemed quite respectable, and was always perceived as a potentially suspicious interloper. (His frequent trips to Atlantic City to gamble did not help his image.)

"I helped Tony in every way, whether it was computerizing the gallery or helping build the downstairs space," he says. "Initially, my function was to be the business administrator. His gallery was becoming a big deal and it was getting out of hand, because Tony at that time had no clue about administration or business."

Baghoomian's introduction to the art world coincided with the ex-

plosion of the East Village art scene. "I saw this incredible energy. Everything was happening. I loved the excitement. I met absolutely everybody," he says.

After he left Shafrazi, Baghoomian says he took advantage of his new connections, and by 1984 he had set himself up in his own office at 594 Broadway near Houston Street, in a handsome space with his own staff. "It was right next door to Mark Kostabi's studio," he says. "I had already had my own operation outside the gallery, buying and selling and managing James Brown, the artist. I found a lot of other artists not getting along with their galleries, who saw need for a manager, or agent, or middleman. Jean-Michel was not happy with Mary Boone."

From the start, Baghoomian positioned himself as a bottom feeder. He had originally met Jean-Michel in 1983, when he was still operating out of Shafrazi's basement and Jean-Michel had sold him the occasional painting. "He made a tremendous impression on me," says Baghoomian of his first contact with the artist. "He liked me because I wasn't pushy and I didn't try to cheat him. I was always fair with him. And my complexion was a little darker," he emphasizes. "There was a nice flow between us." But it wasn't until 1987 that Baghoomian seriously approached Basquiat to represent him.

By this time, Basquiat was in desperate straits. It was not long after Warhol's death. The painter's drug habit had escalated and he had not produced any work in months. "I think the significant change I saw in him when I took him on was that he was really depressed. He was down. Everything about him and his studio was gloomy. He had a lot of personal demons," says Baghoomian, a master of understatement. Besides everything else, Basquiat's personal finances were in total disarray. "He hadn't paid his taxes in three years," says Baghoomian.

Whatever his initial hesitancy, Baghoomian quickly overcame it. Basquiat may have been a hopeless junkie, but he was still an art star, and as such represented a significant opportunity for Baghoomian, who had still not really broken into the art world.

"Jean-Michel became an obsession with me," says Baghoomian. "I wouldn't call him another child of mine—I considered myself a fan, but it was like a twenty-four hour job."

There are others who would use different terms to describe Bag-
hoomian's relationship with the artist, who by this time was barely
functioning. "His deterioration was shocking," say Don and Mera
Rubell. "His drug problem became so severe that the work suffered.
As the drugs took over, so did his underlying hostility. You had to be
willing to deal with the drugs. You had to be willing to have an un-
pleasant transaction. No dealer really wanted him at that point. Vrej
fed Jean-Michel's habit."

There were tales of Baghoomian driving Basquiat to his drug
sources, cleaning up his vomit, hanging around to make sure he didn't
overdose. Says Baghoomian, "He needed people to care for him. All
these people, Annina, Bruno, told him, 'You have to go to a clinic,
you have to clean up,' but they didn't stick to it. I tried to be there,
and I wouldn't give up."

Baghoomian claims he didn't originally know the extent of Bas-
quiat's problem. "I had known Jean-Michel for five years and the
whole world was telling me he has this drug problem and I was say-
ing, 'What are you talking about?' Because I used to ask him if he
was doing a lot of drugs, and he would tell me he was only doing
grass. He was obviously lying to me. I didn't find out until we went
out to dinner at the Odeon a year before he died. By this time he's
more or less accepted me as his agent. He's dealing with me, so I'm
giving him lots of money. Every day he's asking for it. So I said, 'Lis-
ten, I'm giving you X number of dollars a day, and even if you are a
drug addict, this doesn't make sense.' "

Basquiat took Baghoomian's hand and led him outside into the
street. "He was embarrassed. He said, 'Look, Vrej, for six years,
seven years, I've been an addict. The amount of drugs that I do would
have killed anyone else. But I want to clean up.' "

Baghoomian claims he was in a quandary. "What do I do now?"
he asked the artist. "I'm supposed to be your friend. If I don't give
you money, you're going to leave me. If I give you money, you're going
to do drugs. So I have this dilemma." Basquiat, says Baghoomian,
promised he would go to Hawaii to clean up as soon as he came back
from two shows that had already been arranged in Europe. Baghoo-
mian decided it was a dilemma he could live with.

———

Even in his moribund state, Basquiat had no trouble attracting women. His companion for the last year of his life was a young woman named Kelle Inman, a fragile beauty with a pierced nose. He had met her one night when she was waitressing at Nell's and she offered him a free dessert. Although it may have started out as a romantic fling, Basquiat was by this time in no condition to have sex. But his charisma was intact, and by August, the naive, waiflike Inman was living in Shenge's old space. She and Baghoomian and Basquiat, all in their way outsiders, formed an odd, dysfunctional family.

Inman, who was in her early twenties, clearly had no idea what she was getting involved with when she moved into Great Jones Street. "The very first day I asked him if he was into drugs, and he said, 'Isn't it obvious?' I said, 'You either want to live or you want to die. There's no in-between. You're alive, but you're dead.' How many times did we say can we actually physically take this guy and put him in a clinic?" she recalls tearfully during an interview conducted a week after Basquiat's death.

"It was very hard to get close to him," she says. "He didn't trust anybody. People wanted things from him, did drugs with him, asked him for money. He walked on the edge all the time, but I thought he wouldn't go over it. A long time ago, he told me he was going to live until he was eighty and then be poor again. The only time I was really scared was when I went into the studio one day when he was very upset about Andy."

Inman even consulted with a dermatologist who had at one point treated Basquiat for his chronic skin problem. "He said, 'Get him in here on the excuse that I want to look at his skin, and then we can slowly get him into a clinic,' " says Inman. "But he would never even go for his skin."

Basquiat retreated to his airless bedroom. "He wasn't doing art. He was doing drawings on paper upstairs, just lying down. He didn't want to go out, and he didn't want to see anybody. Every day I wondered if that would be the day he would die." He told Inman he had no friends, that those artists who really have something to say never live very long. "He got really emotional and started to cry."

The situation rapidly became intolerable, and Inman tried to leave a number of times. But Baghoomian convinced her to stay. "I

tried to stop her. I told her he needs somebody there, and I could only be there twenty hours a day. She wasn't even on salary. She was just a great little kid who has a big heart. Eventually, it became like a family."

Cultivating Basquiat as his surrogate son was not Baghoomian's only interest. He considered himself Basquiat's exclusive dealer at this point, and that meant business. He scheduled a solo show for the artist in the Cable Building in April 1988, as well as two shows in Europe, one at Yvon Lambert in Paris and one at Hans Mayer in Düsseldorf. He also called Gerard Basquiat and told him about his son's drug problem. "He pushed it away. He ignored it. He said, 'Don't even tell him that you called me.' He couldn't face it, I guess."

So Baghoomian went back to his role as father/dealer. "I guess what I'm trying to say is that in a lot of cases, I was acting as his father." That meant continuing to give him money, about $400,000 a year, much of which was going for drugs. It also meant trying to revive his dwindling career.

One has to give Baghoomian credit for his tenacity. In order to get his ailing painter working again, he hired a former East Village art star, Rick Prol, to assist Basquiat in the studio. "I was at one of Vrej's first openings at the Cable Building, and I was talking to Jean-Michel about having to start to look for work to support myself. And he was saying very similar things, and I was shocked. He was supposed to have this show at Maeght de Long, and he said he hadn't painted all summer. His show at the Cable Building had a certain finality, but a certain grandeur too," says Prol.

Not long afterwards, Prol got an urgent call from Baghoomian. "He told me that Jean-Michel had a show coming up, and asked me if I would work with him. He said, 'It would be good for both of you.' He was insinuating that Jean-Michel really needed the help, but that working for him would also help me. He was laying it on really thick. He was telling me what a great time I would have, and he was talking to me as if I weren't even a painter, but would be like so amazed and inspired by being around Jean-Michel. He's a salesman and these guys don't give a shit about Kenny Scharf or me or anybody. They care about who is hot and who they can make some money off of. Vrej is a sleazeball."

Prol had been warned about Jean-Michel by a mutual friend, graffiti artist Daze. "He said, 'Don't get close to Jean-Michel. He'll just shit on you.' " But despite second thoughts about the job, Prol needed the work and agreed to the arrangement.

Every night, he says, Baghoomian appeared at Great Jones Street to oversee things. After he left, Basquiat would make fun of him.

"He paid me fifteen dollars an hour. I used to arrive at seven p.m. and I would get him up. Basically I'd sit around and do nothing— ninety-nine percent of the time, it was like waiting for Jean-Michel to get up. And the whole time, Vrej kept encouraging me to get him to work. When I told Jean-Michel that, he got pissed off, and Vrej told me I wasn't supposed to have told him."

Prol worked with Basquiat for nearly half a year, helping paint the work for what would be his last show. "He wouldn't communicate very much. He seemed isolated. I never saw him totally strung out or nodding out. This was the weird thing. They are very, very simple paintings, but he allocated exactly what I would do. He would allow me to paint sections the way he wanted them, and he was still very much in control. The idea was that he would hand-paint the whole thing. But there were certain flat areas that needed to be filled in. It's like de Kooning saying, 'Gimme a big brushstroke here.' "

Basquiat, says Prol, never lost control of his painting. He was quite insistent about what Prol was permitted to do on each canvas. According to Prol, the other part of his job as Jean-Michel's assistant was to provide psychological support. "He needed the emotional backing, like I could spur him on to spark that competitiveness or show off in front of me, or do his best."

Prol would set up about half a dozen canvases. "They were all going to be a certain size. I would paint the background, and the next day I would walk in and he would have drawn on them and he would ask me to fill in this color, and it was very sparse. I had the feeling that in relation to his earlier paintings they were really like knocked off and not really worked on that much. But even with that, they had a kind of simplicity and directness that I liked."

Prol did the background for "Riding with Death," then watched the artist paint the skeletal figure on an equally spectral horse. "He had a da Vinci book open. He changed the drawing a lot from da

Vinci. And then I painted in the red, and he said, 'No, no, no, paint in with this color.' Then he made me stop and he drew on it a bit."

Prol was impressed by the remnants of Basquiat's remarkable energy, despite his obvious decline. "He would be getting into a painting, and then he would see a door or something, and then he would draw a rat on it, and walk off, and it would just have this great quality of being very spontaneous. And I started realizing all the source material he had around him. He had *Krazy Kat* and all these other books. And he also used his earlier work as source material. Images would keep recurring or popping up again and again."

Basquiat questioned Prol about his opinion of the Neo-Geo painters, who were getting a lot of attention at the time. When Prol said he liked some of the work, Basquiat called him a traitor. Basquiat was particularly enraged by the success of Peter Halley, Jeff Koons, and Meyer Vaisman, who had been anointed the latest art stars by the media. Prol watched as the artist constantly anesthetized himself.

"Characters would come by. There was a kind of Guido-ish looking guy who was giving him drugs, and they would go upstairs. Vrej must have known how much money he was spending on it. Jean-Michel was always inebriating himself somehow or somewhere," says Prol.

The opening at the Cable Building in April 1988 was the last show in New York Jean-Michel would have during his lifetime. Those who knew the artist well were shocked by his condition. His face was completely covered with sores. "Half of his teeth were missing at Vrej's opening," says Don Rubell. Diego Cortez remembers that Basquiat suddenly took him aside and tried to mend fences. "Jean-Michel kind of beelined toward me and he said, 'Let's go down for a drink.' So we left the opening. He drank margaritas and he looked really awful. He was talking about how everything was just fucked up and he hated his life, he hated everything, and that I was really nice, and had helped him and he really appreciated it. It was really sad and tender. That was the last time I saw him."

Cortez was not the only person with whom Jean-Michel tried to reconcile. During the opening, Basquiat made one last desperate attempt to win back Jennifer Goode. "He somehow took it that because

I was at the show I was back together with him. And I remember he grabbed my hand and wouldn't let go. He was just like a child, jumping up and down, and it would have been great if that's what I was there for. But I just had this dreaded feeling that I was going to have to tell him. He took me down the hall, and I told him he should really be at his own opening, but he said, 'Fuck that.' He said, 'Will you be my girlfriend?' And I finally said, 'No, I can't be your girlfriend,' and I ran out. That was the last show I went to."

Afterwards, there was a celebratory dinner at Mr. Chow's, just like the old days. But that time was clearly over.

MOST ~~YOUNG~~ KINGS GET THIER [sic] HEAD CUT OFF

—text from Basquiat's painting "Charles the First," 1982

What happens to a dream deferred?

Does it dry up
like a raisin in the sun?
or fester like a sore—
And then run?
Does it stink like rotten meat?
Or crust and sugar over—
like a syrupy sweet?

Maybe it just sags
like a heavy load.

Or does it explode?

—Langston Hughes, "Harlem [2]"

In early 1988, Basquiat had a show at the Galerie Yvon Lambert in Paris. During the opening, he met a black artist named Outarra, who was to greatly influence the last days of his life. A broad-faced, sweet-natured man, Outarra was living in Paris with his girlfriend. Basquiat was instantly taken with the French-speaking African, who was from a small village on the Ivory Coast, and whose quiet demeanor was markedly different than the graffiti artists that Basquiat knew in New York. Typically, Basquiat decided to take off then and there to see Outarra's work, and together they left Basquiat's show and took a limo to Outarra's studio.

When they got back to the gallery, it was closed; everyone had gone

to a post-opening party. The next day, Basquiat, who could not remember where Outarra lived, tried to track him down. When he finally found him, he settled into his studio as if he had found a long-lost friend. "We talked until the wee hours," says Outarra. "We spoke in French. He told me he wanted to buy everything in my studio." They discovered a coincidence that apparently made a deep impression on Basquiat, that Outarra came from Korhogo, the small village that he, Jennifer, and the Bischofbergers had visited during their trip to Africa two years earlier.

Basquiat was leaving for Düsseldorf the next day for his show at the Hans Mayer Gallery, then traveling on to Amsterdam. "He kept calling me and asking me to join him," says Outarra. Basquiat clearly wanted company in Amsterdam. When Outarra couldn't make it, he tried to organize a two-day party, and according to George Condo, "invited everyone in Europe, three hundred people. He called everyone personally himself. A few people actually showed up, and he was asleep in his pajamas."

Back in Paris, Basquiat and Outarra went to a few art shows together, one by Julian Schnabel and one by Cy Twombly. Basquiat left a small artwork for Schnabel, whose show, "Tomb for Josef Beuys," followed his at the Lambert gallery: a painted cigar box with the suggestion "Let's Squash It." Schnabel says it was Basquiat's effort to reconcile their relationship.

Basquiat spent the next several months in Paris, staying at a hotel in the Marais section, and traveling everywhere by limo. "He drew the whole time," says Outarra. "And we had a lot of existential discussions." Basquiat also sent slides of Outarra's work to Baghoomian back in New York.

But Brian Kelly, a musician, had a different perspective on Basquiat's last sojourn in Paris. Kelly was helping Schnabel install the "Tomb" show, and was staying at the same hotel as Basquiat. Jean-Michel knocked on Kelly's door the day he got back from Amsterdam. Basquiat told Kelly that he was nervous about the hotel staff. The chambermaids, perhaps scared by his obvious drug supply, no longer wanted to clean up his room. The bellboys seemed to be eyeing his new bags nervously.

Basquiat wanted to escape from his own room, which he was sharing with Kelle Inman. He deserted Inman, despite her many

pleas, and brought a bag of drugs, some compact discs, a boom box, some drawing pads, some colored pencils, and his big overcoat down to Brian Kelly's room, where he virtually moved in.

His habits were not to everyone's liking. Several friends stopped by, and were taken aback by Basquiat's frequent drug-related trips to the bathroom, but even more by the incredible pharmacy lined up on the satin bedspread. "There were glassine and tinfoil packages of grass, hash, heroin, and cocaine," says Kelly. "It wasn't a lot of stuff, but it really caught your eye." Basquiat seemed oblivious to the others' discomfort.

Basquiat told Kelly about his drug sources in Amsterdam, that he'd found all the "right places." He went through his stash quickly. "Over the next three days, he took all of the drugs in combinations. It was amazing to see how particular he seemed at any moment about whatever he was using, and yet how soon after one he'd be taking another. Actually he did smoke grass and hash together and mix cocaine and heroin together." Basquiat cooked the heroin in a spoon of lemon juice, tied off his arm with a necktie, and told Kelly about the subtleties involved in mixing various drugs.

Kelly was impressed by Basquiat's resistance; the massive amount of drugs seemed to have little or no effect on him. Kelly asked whether Basquiat had any control over his habit. Basquiat got defensive. Kelly suggested Basquiat try to kick, and Basquiat got angry. "What makes people feel they can say that? What do they know about it? I think you're saying it because you care, but most people don't know shit about it."

Kelly persisted. "What happens if you take too much one time?" Basquiat told Kelly he had OD'd once, and just revived in time. "I know what I'm doing," he said. "I've been there." Says Kelly, "He talked about death and heroin as one thing. Like he'd had a relationship with them."

He also told Kelly he planned to quit painting, that he wanted to become a writer, a musician, or a singer. "He made it sound like the art world had poisoned art for him. He said it didn't take artistic ability to make it in the art world, and that he found making paintings very boring. It didn't interest him anymore.

"Watching him work, very distractedly, on some drawings on the

pads in the hotel room and later on paintings in the back room of Yvon's gallery, I had to agree with him. It was a formula, listing words and parts of words, picking colors, but really, he just didn't care, and it wasn't just about art. He just didn't care about most things."

Basquiat rambled on about his various future plans, going to Africa, Hawaii, moving to upstate New York. He seemed to be desperately trying to find a way to reinvent himself, to break free not only of his drug habit but of his entire tormented lifestyle. But most of all, he seemed to feel totally alone. The year since Andy died, he told Kelly, had been awful. He missed Andy unbearably, and said that his "best times" had been with Andy. He continued his litany of sorrow between hits of heroin, aiming the needle into his neck or his hand.

"It really felt like complicity being there while he drugged himself again and again, but he could become so lucid so suddenly. I can remember him drying dots of fresh blood off his skin with a towel. He was silent a long time. Then he started to talk very clearly, very calmly about different things."

Basquiat told Kelly that Bischofberger still owed him a large amount of money for the Collaborations and was only paying him a bit at a time. "What's he think? That I don't know what money's about?" He talked about the Warhol estate, and its attitude toward him since Andy's death; that Andy had promised to sell him the Great Jones Street loft, but that now Fred Hughes was trying to evict him.

He complained about the way people used him, girls who were interested in him only because of his money. "Girls can't really see me for who I am," he told Kelly. Kelly was mesmerized by the famous artist who seemed to have everything, but felt as if he had nothing.

"I don't have a big thing about needles, but I couldn't believe it when he'd knead his skin with his fingers trying to get a vein up, and then push that pin in. I kept thinking he was going to fuck up with that needle. I'd see a guy who had good arms and legs and a good face and hair. He had everything, and he was sitting on the edge of the bed in the middle of the night, totally involved in the needle he was pushing into his arm." When the sun came up, Kelly watched as Basquiat, who had just done some coke, stared at himself in the mirror, compulsively picking at the sores on his face.

They decided to go over to the gallery. They walked through the

beautiful meandering streets of the Marais, down the rue de Vieille Temple, and Basquiat dashed into a patisserie, where he ordered bags of éclairs, napoleons, and almond croissants. Basquiat was enjoying himself. He walked down the middle of the street, voraciously consuming the sweets, as cars honked and people stared. "Here was this black guy with his dreadlocks sticking out, well dressed, stuffing his face with pastry, getting it all over his clothes and dropping it on the street." When they finally got to the gallery, he did more coke. "Yvon wasn't even fazed," says Kelly.

Shortly before he returned to New York, Kelly stopped by Basquiat's hotel room. "I guess the spells between his binges were getting pretty short. The TV was on and he was asleep. The room was a mess and I saw ashtrays full of half-smoked joints, cocaine dust, all that stuff. There were really nice clothes and things he had bought just kind of trashed. I wanted to air the place out, it was so hot and closed." A few days later, when Kelly went to say goodbye, Basquiat was gone. He had flown back to Amsterdam to stock up on more drugs.

Almost ten years earlier, Basquiat had invented SAMO, a religion in which wool was placed on the faithful's eyes, and, in a sense, ignorance was bliss. ". . . Once a week we attend service where the Samoid priest places a piece of yarn on our eyes . . ."

Basquiat's drug addiction—the wool over his eyes—insulated him from the increasingly painful truth; that success had an untenable price. But even drugs could not blind him to the fact that in the harsh reality of the marketplace, all that mattered was profit. And that the more successful he became, the less the quality of his art actually mattered. Nor could success buy him the love he craved. He had lost Warhol and Jennifer. And in the last year, he had barely communicated with his father. Basquiat tried to anesthetize himself with drugs, but he couldn't escape the fact that the very success he had always sought was destroying him.

In April 1988, Basquiat, Outarra, and Kevin Bray, a young video director who had recently become friendly with Jean-Michel, went to New Orleans for the jazz festival. They went to a voodoo shop and bought some gris-gris. The three young black men also made a ritual visit to the Mississippi. Says Outarra, "On the last day, Jean-Michel

said he had a surprise for me. And he took me to see the Mississippi. It symbolized the bond between us, because of the slaves who traveled on it when coming through the Delta."

In June 1988, Basquiat made one last trip to Hawaii, in an effort to clean up. Before he left, he called Jennifer Goode and asked her to go with him. Goode refused, but Basquiat wouldn't take no for an answer. "So he came up here, and we had dinner. He didn't look good, he was kind of fucked up, and I told him again I couldn't go to Hawaii with him. I felt really bad about it. I wanted to go, but I had a boyfriend. If Jean had accepted my boyfriend, you know, we could have all gone together. But he didn't," says Goode.

After dinner, Goode gave Basquiat a ride home in her pickup truck. "He started to come on to me. He started to kiss me. I said, 'Jean-Michel, I can't do this,' so he got out of the truck and slammed the door. That was the last time I ever saw him. The night he died he was looking for me. He did that when he got angry or hurt. I said all the things I wanted to say to Jean-Michel, you know. We said them to each other, and I don't have any regrets."

Basquiat flew to Hawaii by himself in late June. His calls to Kelle Inman were enthusiastic; he was really planning to quit painting and become a writer. Inman joined him several weeks later. She was dismayed to find that although Basquiat did not appear to be doing heroin, he was drinking heavily. She had sent him art supplies, but he was not painting. Instead, he drank all day and played his favorite jazz tapes incessantly.

On the way back from Hawaii, Basquiat stopped off in Los Angeles. He planned to stay only a day, but he stayed nearly a week. His strung-out behavior terrified his friends.

Basquiat arrived unannounced at Matt Dike's place. Dike, who by this time had his own record label and was in the middle of producing a disc, took one look at the painter and realized he couldn't handle him. "He came stumbling in with this big duffel bag full of tapes and all kinds of garbage, and this big ghetto blaster, and just dumps the whole thing out in the middle of the floor. There was shit everywhere, dirt, weed, rolling papers." Basquiat made one of his famous pots of chili; much of it ended up on the ceiling.

Dike was spooked by Basquiat's missing tooth, and the eerie re-

semblance he now bore to a painting he had done three years earlier that was still hanging in Dike's kitchen. "It has dreads and a missing tooth and bones, and then this syringe down in the corner, and Jean was sitting there looking at it, like, 'Yeah.' It was this weird sort of prophetic thing. He had death written all over him when he was here. I told Kelle that he was going to die, that somebody should help do something. But I wanted him out of my house. He was driving me crazy. I was really compassionate for about a week, and then I just flipped out. I kind of feel bad about it, but what can you do?"

Dike lent Basquiat some money, then called Tamra Davis, a mutual friend, to bail him out. "That's one of the few times Jean-Michel got really emotional," says Dike. "He said, 'You're the only guy that ever came through for me.' " He had burned his bridges and nobody wanted to help him. And then he wanted me to get him heroin. I certainly didn't want him OD'ing in my house. He said he was kicking, and he was sweating profusely and drinking bottles of rum, trying to kill the pain of withdrawal."

Tamra Davis, a young director, had met Basquiat several years earlier at Ulrike Kantor's gallery, where her then husband was having a show. They had become fast friends. She had seen him frequently over the past few years and shot one of the few videotaped interviews with him, but now she was shocked by his desperate condition.

She had already gotten a hint of it when Basquiat called her right after he arrived in L.A. "When he got in from Hawaii, it was like, 'Hey, guess who this is?' There was something about the way he said it that was so chilling, because it was like he was already gone," she says. "It was very painful for me, because all the time I was with him, it was almost as if I were a nurse. He was just so needy, all you could do was just baby him and be with him. It was like one of those things where he really needed to just go to a hospital. It was really difficult, just a nightmare.

"His tooth was gone. His hair was all matty. He looked like a Jamaican bum. He was guzzling alcohol. And he was smoking so much pot. He was totally out of control."

Davis hung out with him and tried to entertain him, taking him to various parties and clubs. "The guy was just a basket case. He threw a bottle through a Cadillac window. He was kicking these hard-core

gangster-looking guys in this club. Then we went up to a parking lot at the Country Store in Laurel Canyon, and he's rolling joints, and he's got like tons of Buds all over the dashboard of my car, and food all over the place. It was the Fourth of July, and he's yelling out the window to people walking by, 'Yo! Happy Fourth of Julyyyyy!'

"He was like this Tasmanian devil [sic]," says Davis. "He was acting just the way a friend of mine who knew Jim Morrison said *he* acted, spinning so fast, and so out of control."

Basquiat begged her not to drive him to Oki-Dogs, a well-known place for scoring drugs. Davis tried to check him into a hotel, but he looked so bad she was afraid he would be turned away, so she checked herself in, and snuck him up in the elevator. "It was a really bad hotel, but he didn't want to go to a nice hotel, like L'Hermitage, because he was feeling awful about himself. So he stayed at Hotel Hollywood, this really corny hotel on Sunset."

Basquiat's bag had two nearly empty drawing pads in it, some crayons, and a dog-eared copy of one of his favorite books, Kerouac's *The Subterraneans*. He was still insisting that he was going to become a writer—or maybe open a tequila factory. Davis drove Basquiat around, trying to cheer him up. They sat up on Mulholland Drive, listening to the radio. Recalls Davis, "The local station was playing the Elton John song 'Candle in the Wind,' and we had a long talk about it. I was sure he wasn't going to make it through the night." Basquiat told her how much he identified with the song. "That's me. I'm not a real person. I'm a legend."

Basquiat returned to New York in mid-July. It was a full-blown summer in the city, hot, muggy, and oppressive. He ran into Keith Haring, who was on assignment for *Vogue* magazine and walking up Broadway with a camera. "The last time I saw him was the only time he ever discussed his drug problem with me," said Haring shortly after Basquiat's death. Haring took pictures of his friend stretched out like a homeless person, or a corpse, on a subway grate.

Basquiat also ran into his old friend Vincent Gallo. "I thought he had AIDS when I saw him. I was shocked at how he looked. He had open sores all over his face. He looked terrible, terrible. I didn't go over to his house, because I didn't want to get involved with this

junkie guy. I saw him three days later, and he looked better. He was sitting outside Dean and DeLuca. He had money falling out of his pockets, and he went to buy pot. He didn't buy a dime bag, he had to buy a big pouch, a hundred dollars' worth. The same Jean I knew for years. He used to brag about how much he could take," says Gallo. "He told me, 'Man, I take a hundred bags a day. That's more than Keith Richards, man, I'm strong.'

"I spent some time with him," Gallo recalls. "It was like he died years ago. It's hard to explain. It made me cry later when I thought about it. There are not that many people anymore that live that vulnerably. He left his favorite hat in my car, a gray felt hat, made in Texas. Inside it, it said, 'Jean-Michel Basquiat.'

"He said he was going to get a clarinet. He told me we were gonna do a new kind of music together, 'jazzrap.' He said, 'You'll hear it for the first time when we do it.' He gets that sparkle in his eye, like he had ten years ago. He was doing this Caesar thing, where he was giving a thumbs-up or thumbs-down when I'd ask him about Africa, or Hawaii, or other places he'd been. He told me Africa was beautiful. He said, 'When I go to Hawaii, I don't think about drugs. I gotta get out of New York.' But the thing that made me cry the most is that Jean was such a New York kid. We used to go to Wall Street every Friday, Saturday, and Sunday night, till like five in the morning, because it was deserted then. We'd do graffiti, make some tapes. We used to cry thinking about how beautiful New York was. We always used to say, 'I want to die right here. I want all the buildings to crumble on me right here.'

"Now he was telling me, 'Man, I hate New York. It sucks. I gotta get out of the city. New York's changed. I hate it here.' " But Gallo says that Basquiat hadn't lost his interest in women; he told him he was madly in love with Lauren Hutton, that he was having an affair with her. And every time they passed a pretty girl, he'd say, just as he always had, 'Break my heart, man.'

"A lot of people were always just waiting for him to fall on his face, and I think he felt that," says Gallo. "He never grew up. He never had a chance to."

One of the last people besides Kelle Inman to spend time with the painter was Paul Martini. Jean-Michel had originally met Martini

through Steve Torton, in 1981. Martini had baby-sat for Torton when he was growing up. At the time he met Basquiat, he was teaching psychology at the Institute of Cognitive Studies at Rutgers. They would run into each other at various clubs.

Martini, meanwhile, who had always made money selling pot, had become a major drug dealer. He was supplying heroin, through a Pakistani connection, to Linda Yablonsky, where, he says, "[William] Burroughs was not unknown." According to Martini, the drugs were smuggled into the country in small clay statues.

"When Linda's scene ended," says Martini, "I began to see Jean-Michel on an everyday basis. I became his dealer for about a week. I would sit with him. He would shoot up for an hour at a time. His arms were a disaster. We talked about his dying of an overdose. He would shoot up seven hundred dollars' worth of street dope. He'd get on his little bicycle and go over to Fourth Street and Avenue D. He bought so much they thought he was a dealer. There were usually fifty bags on the table. He would be in the toilet for four hours retching and shooting up and shooting and bleeding. It was incredible—I never saw anybody with such a tolerance. He must have had the constitution of a horse."

According to Martini, Basquiat used to have drugs sent to him between canvases of his paintings: opium from Iran, coke from Bolivia. "I remember on New Year's Eve, 1987, I was going to Belize with an Italian friend of mine to kick. Jean gave me two long cigar containers of Iranian opium. He was certainly into excess. For a long period of time he managed to work under the influence in very positive ways. For a long period of time he used the drugs, and then the drugs used him."

But now Martini noticed a change in the artist. "When he came back from Hawaii, he was quiet. Attentive. He didn't always have to be the center of attention. We talked about how if he had been born ten years earlier, he would have been a guitarist, not an artist. One of the things he really missed was how political the sixties had been."

According to Martini, Basquiat didn't want to work alone anymore. "He didn't want everything to come from him, for there to be this gigantic weight to paint and to produce for these shows. He was

optimistic. He had plans for the future. He was beginning to see that there were positive reasons for living."

Indeed, the week before he died, Basquiat, Baghoomian, and Inman had gone to look at a house Basquiat was interested in buying in Liberty, New York. Basquiat also told a number of people, including Valda Grinfelds, Steve Rubell, Paul Martini, and Rick Temerien that he thought he had fathered a child in New Orleans named Noah. In fact, he even showed Temerien, who owned Madame Rosa's, the club where Basquiat deejayed during the last year of his life, a photograph. The child has never been traced, and in the years since Basquiat's death, nobody has ever filed a paternity claim.

But Basquiat's drug habit finally proved to be stronger than he was. Says Martini, "When you do that much it's not possible to stop without a paramilitary course. When he came back, he didn't want to use needles anymore. But he wasn't ready. As soon as he got back to the city, he wanted to snort something. He held out for a few hours, and then he was right back in his context."

It's possible to piece together Basquiat's final days from the accounts of the few people who still wove in and out of his life on a regular basis. Basquiat originally had airplane tickets for himself, Outarra, and Kevin Bray booked for Abidjan, Ivory Coast, on Sunday, August 7. But he had rescheduled his trip for August 18. The plan was to go to Outarra's village for a ritual cleansing. Outarra had arranged with the local shamans to perform a ceremony that would cure him of his addiction. "Everything was prepared," he says.

But on August 11, just a week before the trip he hoped would save him, Basquiat was in bad shape. He was churlish in a phone conversation with his sister Lisane that morning. During the day, he made several trips to the East Village to buy a few grams of heroin. For a few friends, the last image of the painter is that of Basquiat pedaling over to Alphabet City on his small red folding bike. Jay Shriver stopped over at Great Jones Street that afternoon, and found Basquiat nodding out. "He was painting, but he fell out of his chair twice," says Shriver.

Still, Basquiat managed to put in an appearance at M.K. that night, where there was a party for Bryan Ferry. Kelle and another

friend, Kirsten Vigard, went with him. "He was not in great shape," says Inman. "But it was good to see him get out. He patted my shoulder and he squeezed my hand and said, 'I'm so sick of this.' And I said, 'I am too.' And he said, 'I love you,' and I said, 'I love you too.' "

Then Basquiat wandered off on his own. He was looking for Jennifer Goode. He never found her. Kevin Bray ran into Basquiat at the club, and was upset to see his friend completely high. Later that night Basquiat returned to the Great Jones Street loft with a few friends.

"I rode my bike home after him, because he was really fucked up," Bray recalls. "Usually when you talked to Jean-Michel when he was high, there was some of him there. But there was none of him there that night." Unable to talk to him, Bray wrote Basquiat a note: "I don't want to sit around here and watch you die. . . . Yes, you do owe me something." Bray even read the note aloud, but Basquiat was too far gone to hear it. According to Martini, he had drunk a lot of vodka before doing more heroin.

Basquiat's bedroom was hot as a furnace. Both Tamra Davis and Matt Dike, who had stayed there the month before, remember it as being intolerable. "I'll never forget that night and how hot it was. It was the hottest place in the universe," says Davis. "The air-conditioning was broken and it was during a fucking heat wave," agrees Dike. "I've never been so hot in my life. I felt like committing suicide in that room."

The next day, Blanca heard Basquiat coughing several times, but thought nothing of it. It wasn't until late that day that Inman discovered his unconscious body. Blanca touched his hand. It was still warm. She says she had a vision that "his spirit was already far away." When the paramedics arrived, around 7 p.m., they attempted to resuscitate him. Basquiat was rushed to Cabrini Medical Center on East Nineteenth Street. At 7:23 p.m., he was pronounced dead on arrival.

Outarra, already in Africa, at first thought the news of Jean-Michel Basquiat's death was a hoax, that Basquiat had staged a cynical "publicity stunt." When the truth registered, he informed the shamans who were waiting to cure Basquiat. "They did the ceremony for the dead," says Outarra. "It takes place at night, and involves an ani-

mal sacrifice. It's related to voodoo. They wore masks, and prayed and did mystic dances around the fire all night long."

As Gerard Basquiat was claiming his son's body in the city morgue, the African magic men were releasing his spirit in an ancient rite.

Vrej Baghoomian, who was on vacation in San Francisco, learned the news of Basquiat's death from his terrified assistants, who had been called by Kelle. "My brother called me and told me to call the gallery. It was about six p.m. New York time. There was a message that something terrible had happened and that they were all going over to Jean-Michel's studio. So I called the studio and I stayed on the phone talking to Kelle and Helen and Vera. And that was exactly the time the paramedics and the police and everybody was there trying to revive him."

Baghoomian called Gerard Basquiat. "I went to his house," Gerard said a week after his son's death. "When I arrived there, there were a couple of people at the door, saying they had taken him to Cabrini. I rushed there, and there were a couple of his so-called buddies by the reception desk. I knew, I just knew. I was always worried about Jean-Michel. I guess I always had the fear of losing him."

Suzanne Mallouk recalls Gerard Basquiat expressing guilt about his relationship with his son a few years before his death. "He and Nora came into Madame Rosa's several times when I was bartending," she says. "He said, 'Please tell me, was I a good father to Jean-Michel? I have to know.'"

Gerard Basquiat said that he had planned to speak to his son about his heroin addiction several months earlier, when "somebody" had called him to warn him about it. "I saw him after that in the Odeon. I didn't mention drugs. Jean-Michel would probably have run the other way. I told him we should sit down and discuss a lot of things, and he said, 'Right now I am busy with a show.'"

But in the end, they never had that conversation. Gerard acknowledged his regret at not having intervened. "I think probably I'm the only person who could have done something, and I'm sorry that I didn't. But I know Jean-Michel very well. If you tell him not to go to the door, he'll crash right through it.

"I have a lot of guilt in me right now, because there are things

that perhaps I should have done, that I didn't do. As his father, I could have gone to his house any time, and rang the bell, and said, 'Hey, your father is here. How are you doing?' I've never done that. I've always respected his privacy. I never got involved. A lot of people don't even know me as Jean-Michel's father. I was not John McEnroe Sr., where I was always in the stand, watching my son play tennis. I've always been the guy in the background."

But in the wake of his famous son's tragic death, Gerard took center-stage. "I had to identify the body three times. First time at the hospital, the second time at the morgue, and the third time at Campbell's funeral home. I picked out the casket. Picking out the casket was terrible, mind-blowing. We went to the morgue, and the smell . . . Jean-Michel died on Friday, and we went to the morgue on Sunday. I never want to do that again. Then we had to go to the cemetery. It was the first time I was in a cemetery as an adult. It's a beautiful cemetery, with nice trees. It's a very nice setting. I arranged the funeral. We went down the list. We had to say no to many people."

Basquiat's body was laid out at Frank E. Campbell's. "His dreadlocks had blond tips," said his father. "He was wearing his favorite suit. Everything was perfect. He looked at peace, for which I'm glad.

"I have buried Jean-Michel," his father continues. "I had to bury my son. I saw the best and worst of him and I'm still strong. Some people can take it and some people can't. Jean-Michel's mother is finished. She's aged twenty years. She's a wreck. She must be very weak. For all Jean-Michel being so famous, we had to do it all, and I'm still standing."

Jeffrey Deitch got a call from the artist's father just before the funeral, asking him to deliver the eulogy. He stayed up all night jotting down his thoughts. Although he had been one of Basquiat's earliest supporters, the choice of Citibank's art adviser to speak to the small circle of family and friends at the funeral on August 17 seemed a cynical coda to the Basquiat myth. It rained nonstop on those gathered to mourn, as Deitch memorialized the artist as a young man.

Jean-Michel already had such a distinctive vision, such a sure hand, even as a teenager, that he could just draw a few lines or make a few marks on the wall with a Magic Marker, and these im-

ages, however spare, were unforgettable, and they were uniquely his . . . when you met Jean-Michel you understood why that line and that signature were so powerful. He was a personality unlike any other—a remarkably breadth, intelligence, passion, sympathy, generosity. A person with such charisma and strength of character that just his look, a few terse comments, a few lines drawn on paper, could communicate so much . . . Jean-Michel has left behind not just memories but a legend. . . .

Born in Brooklyn, Basquiat is now buried there. The modest headstone is inscribed, simply, "Jean-Michel Basquiat, Artist, Dec 1960–Aug 1988."

A few days after Basquiat's death, the Vrej Baghoomian Gallery was empty. The walls were being painted and the floors polyurethaned. Baghoomian sat in his office at a desk covered with transparencies of Basquiat's work. The phone kept ringing—with eager reporters and even movie producers. Baghoomian was prepared: on August 15 he had sent out a double-sided press release announcing that "Jean-Michel Basquiat has passed away in his sleep," and summarizing the artist's short, intense career.

Suddenly, Rene Ricard burst into the room. He appeared to be high and was hysterical with grief. He said the bottle of champagne he planned to pour on Basquiat's grave exploded. "Jean-Michel was touched by God," he raved. "He was a black saint. There was Martin Luther King, Hagar, Muhammad Ali, and Jean-Michel." A bizarre combination of commerce, pathos, and hyperbole, the surreal scene seemed a fitting epilogue to the death of the eighties art star.

Not long after Jean-Michel Basquiat died, Nancy Brody went over to Great Jones Street with Jennifer Goode. The loft where Goode had spent so many hours watching Basquiat paint and draw was strangely empty. Says Brody, "Jennifer took some clothes and a scrap of paper." Written in Basquiat's unmistakable scrawl, it said, simply, "Sweet Bird of Youth."

BASQUIAT RECYCLED:
FROM FAKES TO FILMS

"Death means a lot of money, honey. Death can really make you look like a star."

—Andy Warhol, "Andy Warhol," The South Bank Show, London Weekend Television

The afterlife of Jean-Michel Basquiat has been nearly as full of chaos and conflict as his life. The various legal battles began before he was even buried—and have yet to be fully resolved.

Some called the artist's death the ultimate career move: the value of his paintings instantly appreciated. People who said Basquiat had given them work immediately began asserting their claims and badgering the Baghoomian gallery. "Before he was even buried, there were vultures wanting entry to his place," says Vera Calloway. And anybody who had anything created by the artist seemed to come out of the woodwork to sell it. Says Gagosian, "Ex-girlfriends came to me with icebox doors and toilet covers. If he had done tattoos, they would have been amputating themselves."

Just a few days after Jean-Michel died, Gerard Basquiat engaged a lawyer, Michael Stout, who was intimately familiar with the art world and its convoluted legacies. Stout represented the estate of Salvador Dalí for fifteen years, and currently represents the Robert Mapplethorpe, Donald Judd, and Keith Haring estates. "I have had famous clients with complicated and famous problems," he once said.

And he still does. Stout is suing Christie's, Christie's Appraisals, Inc., and Christie's former general counsel and current president, Patricia Hambrecht, as well as its Deputy Chairman, Stephen Lash, over

a disagreement regarding Christie's 1990 appraisal of Mapplethorpe's photographs, which was cited in 1993, during the lawsuit about the valuation of the Andy Warhol estate. Although Stout and the Attorney General's office subsequently settled on a reduced executor's commission, Stout is seeking $200 million in compensatory and punitive damages for breach of contract, fiduciary duty, defamation and intentional infliction of emotional distress. (Both parties strongly defend their positions in the ongoing lawsuit.)

If Basquiat's life were a film noir, Stout would be played by Sydney Greenstreet. He is a fifty-something gentleman of the world, with a distinctly cosmopolitan air and oddly graceful posture, despite a body matching his name. Says Stout, "The Basquiat estate was like a law school textbook of problems."

Stout's first step was to secure the goods: he arranged to get the keys to the Great Jones Street loft from Baghoomian, who had had access to the premises since Basquiat's death, and to seal it. Baghoomian acted almost as quickly.

According to the deposition later given by Stout to Baghoomian's attorney Morell Berkowitz, in March 1990, after turning over the keys to the loft, Baghoomian attempted to gain access to the several warehouses where Basquiat's work was stored. He gave Stout the name of a nonexistent facility, then tried to present himself as the estate's executor to one of the warehouses where the work was actually stored. But he was not admitted because he didn't have the proper documentation.

By August 20, a week after Basquiat's death, both his loft and the warehouse holdings at Olendorff in Long Island City and Hahn & Dards in Washington Heights were safely under lock and key. Shortly afterwards, Christie's—along with Stout and several of his assistants—began its meticulous process of cataloguing the Basquiat estate.

Explained Stout to Berkowitz, "Mr. Basquiat wanted very much to have everything removed from that space as rapidly as possible. It was emotionally disturbing for him to be there. He had various animosities that he felt towards the Warhol people, and that building was owned by the estate of Andy Warhol, and he felt they were rude to him about the rent or whatever, and he wanted to be out by the end of September or the middle of October, and I advised him that it was

crazy to move anything until everything was counted, photographed, insured, protected. . . ."

Basquiat had kept virtually no written records of payment for his work, nor had he filed regular income tax returns. So Stout attempted to get written documentation of their transactions from each of Basquiat's former art dealers. According to his deposition, he was able to get professional records from Annina Nosei, Bruno Bischofberger, and Mary Boone. The transactions with Larry Gagosian were "very unbusinesslike." And the materials given to him by Baghoomian were shocking, even to someone as steeped in art-world affairs as Stout.

"We really couldn't deal with someone—I don't mean as an art dealer. I mean on any level whatsoever—who could have had the courage to present that set of books to me and my tax counsel," he testified. "I believe the words of the tax lawyer were, 'Mr. Baghoomian, we can't do business together on any level. Goodbye.' We asked him how he could possibly have paid all that cash for those paintings, and Mr. Baghoomian said, 'I launder a lot of money for people.' "

Sally Heller was hired to help with the appraisal. Recalls Heller, "When I got to the loft there were huge garbage bags of his things waiting to be picked up. The place was a wreck. It was really disorganized, and basically we had to go through his belongings and put aside a lot of paints and things that were being donated to Odyssey House. There was a kind of gloominess about the loft—the skylights had been sealed off. People were lining up at the Dumpsters outside, going through the garbage, looking for stuff they could sell. Every day there would be like four or five people, waiting to see what would be thrown out, like vultures. There were a lot of people who claimed they had left paintings. There were just stacks of drawings, they were all on twenty-by-twenty-four-inch paper with tiny little pencil marks in the center of doodlings. And there was this goofy hat made out of straw that looked like a bird's nest or a piece of folk art. We catalogued and took Polaroids of everything."

They didn't take Polaroids of the drug detritus. "There were bloody sheets and used syringes everywhere. It was pretty spooky," says Tina Summerlin, who worked for Stout.

"Vrej asked me to go to the second-floor bedroom and go to a spe-

cific dresser drawer and remove a large quantity of heroin," Stout said in the deposition. "So I thought, gee, I better discuss this with the father, but Vrej had warned that it might upset the father or something like that. I think he was trying to be caring, you know, to protect the parents from having to see this drug-abuse scene where there were clearly hypodermic needles on the floor and blood on the bed."

It took several months to catalogue Basquiat's various belongings. The Christie's inventory is 157 pages long. In addition to 917 drawings, 25 sketchbooks, 85 prints, and 171 paintings and "other works of art by Jean-Michel Basquiat," there were 16 boxes of the rap record produced with Rammellzee, dozens of Warhols, including a diamond-dusted "Shoes," "Diana Vreeland," and Warhol's portraits of the Basquiat family: Jean-Michel, Gerard, his sister Jeanine, and his mother, Matilde.

There were also photographs by Vanderzee, works by Haring, Kosuth, Lichtenstein, Sam Doyle, and Alison Saar, and an odd piece by William Burroughs, made of wood. And then there were all his antique toys: a Buddy "L" wrecking truck, a cast-metal dog nutcracker, an Erector set, and enough Stickley furniture—from a Mission bookcase to ten side chairs and a dining-room table—to furnish the living room of a mansion.

Christie's estimated the worth of the Basquiat estate to exceed the sum of $3,800,000. On August 24, 1988, twelve days after her son's death, Matilde Basquiat signed a document agreeing to Gerard's appointment as administrator, thereby renouncing all rights to matters— letters of administration and other legal processes—regarding the estate. (Her name was signed in its English form, "Matilda.") As the administrator of the Basquiat estate, Gerard received principal assets with a value of $2,195,545. According to the estate tax statement he filed in May 1989, Gerard and Matilde each received $489,778.

From the time of his son's death, Gerard seemed apprehensive about everything regarding his son's affairs. Certainly the haphazard business dealings during Jean-Michel's life justified his paranoia. Gerard was particularly wary of Vrej Baghoomian. On October 28, Matilde wrote to Baghoomian, apologizing for a little scene that had taken place at the funeral and the misunderstanding that Gerard had about

"your pulling me aside in order to speculate." She thanked Baghoo-
mian for her son's obituary in *The New York Times*. "Only God knows
what drove him to drugs," she wrote. "May God bless your endeavors."

But Baghoomian's endeavors, which would soon include suing
the Basquiat estate, were not to be blessed.

Kelle Inman was the first to sue. In February 1989, she filed a suit
claiming that the estate owed her more than $800,000 in interest in
works that Jean-Michel gave her, including ten by Andy Warhol that
were sold at Christie's shortly after Basquiat's death. The suit was
never settled, and Inman says she has no plans to pursue it.

In March, Baghoomian filed a notice of claim against the estate
seeking the return of an "orange painting" Basquiat had given him, as
well as reimbursement of some $27,000 worth of loans to the artist.

In May, the Robert Miller Gallery, located at 41 East Fifty-
seventh Street, sent out thousands of announcements that it would be
representing the estate of Jean-Michel Basquiat. Says former Miller
gallery director John Cheim, "Gerard wanted his son to be in an up-
town rather than a downtown gallery. They liked the fact that we were
committed to painting and that there was a certain established feel-
ing about the gallery. And they did not want to be associated with any
previous dealer or any of that scene. We met with Gerard and Nora at
the gallery and showed them our catalogues and made general nice
noises, and everything happened fairly quickly after that, to the gen-
eral astonishment of the SoHo crowd."

According to Cheim, that crowd included Tony Shafrazi and Mary
Boone, who apparently thought that Basquiat might now be somewhat
easier to handle. "Gerard was very, very wary about anyone that had
represented Jean-Michel in the past," says Cheim. Adds former co-
director Howard Read, "It worked in our favor that we had a totally
clean slate."

No sooner had the Miller gallery been chosen to represent the
estate, now valued at between $5 and $20 million, than Baghoomian
filed suit against the Robert Miller Gallery, the Basquiat estate, and
Gerard Basquiat, alleging breach of an oral agreement to handle the
estate, asking for fifty percent of all sales of the artist's works, and re-
questing $30 million in damages.

According to Baghoomian's affidavit, filed in the New York City Surrogates Court, Baghoomian's exclusive right to represent the work was based on "a long-term successful relationship" with Jean-Michel Basquiat, in which he raised his prices to record levels, a June 1988 "express understanding with the artist," and "a new arrangement" recently made with Gerard Basquiat. "Robert Miller," claimed Baghoomian, "appeared out of the blue as dealer for the estate and has appropriated my rights." Baghoomian asked for—and got—an injunction preventing the Miller gallery from selling any of the work. The injunction was later vacated.

In June, the contents of the estate were once again inventoried, this time for archival purposes. The Miller gallery's longtime registrar, Wendy Williams, spent weeks painstakingly going through every last item. According to Cheim, there were several dozen really important paintings among the works, which later sold for between $75,000 and $500,000.

Recalls Williams, "We were given a copy of the Christie's inventory. Jeanine, Gerard, and I watched them pack up all the stuff and take it to the Miller warehouse at 430 West Fifty-fifth Street. We sat on the floor and tagged and photographed and catalogued everything. We set aside his record collection, toys and African art collection for Gerard. We also gave him Jean-Michel's composition notebooks, which contained page after page of writings, and sometimes little drawings that were very dense on the page."

On August 9, Matilde Basquiat wrote to Baghoomian again, despite the fact that she had been told not to contact him, as she put it, because of legal reasons, "but, as everyone else, I have a mind of my own." She added that she knew her husband could be "intimidating," and apologized for any "ill-feeling" that may have been caused.

In October 1989, while the injunction against the Miller gallery was still in place, Vrej Baghoomian mounted a large show of Basquiat's work to inaugurate his new gallery at 555 Broadway. The opening, on October 21, was celebrated by an invitation-only dinner with "dancing with live music."

The event made Page Six of the *New York Post*. "Today's grand opening of art dealer Vrej Baghoomian's new gallery on Broadway is

fraught with drama. The works of Jean-Michel Basquiat were slated for the premiere show and the invitations had Basquiat's 1982 'Red Warrior' on the cover. But yesterday, Michael Stout, lawyer for the late artist's estate, obtained a restraining order from Manhattan Surrogate Rene Roth enjoining Baghoomian from offering to sell any of the more than 30 Basquiat paintings that were in his possession when the artist died. . . ."

The opening was jammed with the late artist's friends and fans, including Diego Cortez, Jeffrey Deitch, Keith Haring, David Bowes, Maripol, Glenn O'Brien, and Leisa Stroud. Then there were Annina Nosei, Tony Shafrazi, and collector Lenore Schorr. People were pointing out the works they had loaned. Inman, her head shaved like Sinead O'Connor's, said only, "I have a scar, but I feel cleansed."

Vrej and Shenge stood behind the gallery desk, gossiping about Gerard and Michael Stout. "Gerard was thrown out of a bar saying, 'But I'm Jean-Michel Basquiat's father.' " "The collectors are prostitutes, they'll go wherever the wind blows." "Nobody could get behind Jean-Michel's curtain. Nobody had a dynamite moment with the guy."

The dinner was a glitzy affair; people were formally dressed for the occasion in velvet, gold lamé, and diamond jewelry. There they dined, this predominantly white crowd, surrounded by Basquiat's fierce, angry-looking paintings, "Famous Negro Athletes," "Live from the 5-spot, Charlie Parker," "Eroica," "Joe."

Eventually the band began to play. The drums were set up directly beneath the word "Famous" on one of the paintings. But nobody danced. At some expense, Baghoomian had produced a thick, handsome catalogue, as well as a facsimile of one of the artist's composition notebooks.

Before long, there were several new lawsuits in the works. In November 1989, art dealer Michelle Rosenfeld sued for $900,000 in damages for Basquiat's failure to deliver three paintings she had bought for $12,000 in 1982.

In the meantime, the estate had filed a counterclaim against Baghoomian, claiming that he had not paid for twenty or more paintings that he had in inventory. Baghoomian, in return, filed a $50 million

defamation of character suit against Gerard Basquiat. Finally, the estate turned around and sued Baghoomian in Federal District Court for copyright infringement for the catalogue he had published to accompany his posthumous Basquiat show. Eventually, the court ruled that Baghoomian owed the estate $209,000 for the unauthorized use of images in the catalogue.

In 1991, Baghoomian lost his primary suit, claiming he had been granted exclusive representation of Jean-Michel Basquiat. Baghoomian and the corporation representing his gallery went into involuntary bankruptcy in 1992, and all unsettled claims against him and his gallery have been stayed. According to his attorney, Dennis Trott, "Vrej is currently living in California, but has withdrawn from public view." None of the legal actions brought by Baghoomian are being pursued.

Meanwhile, Basquiat's prices at auction were dramatically on the rise. In the May 3, 1989, evening sale at Christie's, the first after the artist's death, Annina Nosei and Vrej Baghoomian, seated side by side, were among the many bidders. A Basquiat entitled "Thin Foil," estimated at $100,000 to $150,000 went for $260,000. Nosei whispered to Baghoomian, "I'll go with you if you try again. I'll stay here just to support you. You have to sell it for five hundred thousand eventually."

When lot 62, Basquiat's 1981 painting "Jesus," went up, Baghoomian leaned over to Nosei and whispered, "Here we go again." "It's a beautiful painting," she replied. The bidding on the painting, which was estimated at $100,000 to $150,000, was brisk. Baghoomian bought it for $280,000 ($296,000 with commission). "All right," he said. "Congratulations," Nosei told him. "Finally. That's great." "Instead of buying a lot of junk," added Baghoomian. "There's nothing else left for me."

Basquiat's prices continued to rise for the next several years. During the artist's life, according to Bischofberger, the highest price for a Basquiat painting was about $30,000. In 1984, Basquiat's first work at auction went for $20,900. In November 1989, "Arroz con Pollo" sold for $440,000 at Christie's, while Sotheby's sold "In the Field Next to the Road" for $407,000. In May 1990, Christie's sold "Sienna" for $330,000.

In February 1992, Baghoomian, whose financial affairs had been in
serious arrears since he first arrived in this country, fled the United
States for Armenia, and then went underground. He would later claim
to have spent the next two years at his brother's in San Jose, Califor-
nia. He left over $1 million in debts, several unsettled lawsuits, and a
variety of claims a by number of angry creditors, as well as artists,
whose artwork, still on consignment, was locked up in his huge
Broadway space.

The gallery officially closed on March 24, 1992, when it was
forced into involuntary bankruptcy by one of his creditors, Anthony
McCall, a printer who said Baghoomian owed him $105, 878.

Baghoomian still owed Rosenthal & Rosenthal, his primary lender,
over $1 million in loans. Rosenthal & Rosenthal, which had already
filed suit against him, seized his assets on March 27, pursuant to a
court order. Among the twenty-three-page inventory of artists' work
still in Baghoomian's possession were thirty-two George Condos, nine
James Browns, four Malcolm Morleys, and fifty-eight Basquiats. By
the end of March, all of SoHo was gossiping about Baghoomian's dis-
appearance and the way he had stranded various artists.

Said sculptor Bernard Venet, "When he left, he owed me two
hundred thousand dollars for artwork. I was fortunate, because I took
as security a Basquiat painting that I was told belonged to Vrej. But I
received notification from a lawyer that in fact this painting was
owned by someone else."

Baghoomian left behind a number of claims by artists, collectors,
and other dealers asserting that they were owed money, artwork, or
both. The case of "Undiscovered Genius of the Mississippi Delta" is
a typical example of Baghoomian's twisted business dealings. He
borrowed $400,000 from Rosenthal & Rosenthal to purchase the
painting, which went into the firm's possession as collateral. But at
the same time, he pledged it as security to Mercer Air, one of his
creditors, while actually placing another, different painting in the
vault. He also allegedly sold shares in the painting to several collec-
tors, including Marcia Fogel and Ari Arslanian. (All of these claims
have since been settled.)

Says Douglas Kramer, the attorney for the trustee of Baghoo-

mian's failed corporation, which at the time was battling with the Basquiat estate over the title to thirty-seven paintings the Baghoomian gallery claimed it owned, "He is clearly not above suspicion. He has been sued for fraud by any number of people."

According to Kramer, Baghoomian was also alleged to have borrowed money to buy paintings that in some cases he already owned and to have claimed he purchased paintings that he never purchased. At one point, in an impressive display of hubris, he paid one of his attorneys with a Basquiat drawing, then paid himself a commission. Even the judge in bankruptcy court referred to transactions that "perhaps could be described as fast and loose," and "Phoenix-like" revivals.

Finally, Rosenthal & Rosenthal sued the gallery's insurer, Lloyd's of London, over twenty paintings the gallery's trustee said were missing from Baghoomian's inventory. Lloyd's settled the claim.

Four years after his death, Basquiat finally got the museum recognition he had so desperately desired during his lifetime. The Whitney retrospective, curated by Richard Marshall, opened on October 23, 1992, and ran through February 14, 1993. Basquiat's mass appeal was evident at the crowded opening, which overflowed with more than two thousand people—a record for a museum used to mob scenes and blockbuster shows, including its Biennial.

There stood Gerard Basquiat, flanked by Stout and a number of other serious-looking men in business suits, while at the other end of the gallery, Suzanne Mallouk hugged several friends and fought back tears.

The retrospective opened to glowing reviews. In a *New York Times* piece entitled "Basquiat, Man for His Decade," Roberta Smith wrote, "Basquiat's rich tapestry of subject matter ranges through the history and culture of the world, of America and of black America, tying things together in fresh ways . . . taken as a whole, this exhibition argues convincingly that whatever the dramatic trajectory of Basquiat's career may symbolize, he is still talked about because there is something gripping, real and original about his art . . . His work is one of the singular achievements of the 80's and through its insistence that the political is strongest when it is the most personal,

it also has great relevance for the 90's . . . His art was essentially an anatomy of himself, one that charted his passion for language and knowledge, his love of popular culture and music, his ambition and his blackness and even the possibility of his own death."

Robert Hughes and Hilton Kramer, however, were not among the fans. Hughes called the show a "parody of a funeral rite, performed over a slender talent encased in a sarcophagus grossly too large for it. . . . The life was so sad and truncated, and the art that came out of it so limited, that it seems unfair to dwell on either. Who breaks a butterfly upon a wheel?"

Kramer, writing in *The New York Observer*, judged the show "a disaster." "Basquiat's sensibility, insofar as he can be said to have had any, was that of an untrained and unruly adolescent wise only in his instinct for self-display as a means of self-advancement . . . I've seen subway-car graffiti that was a lot more interesting than this stuff."

There were some hundred artworks on display, including a number of his best paintings: "Hollywood Africans," "Leonardo da Vinci's Greatest Hits," "Undiscovered Genius of the Mississippi Delta," "Eyes and Eggs," "Arroz con Pollo," "Obnoxious Liberals," "CPKR," "Charles the First," "Horn Players," "Portrait of the Artist as a Young Derelict," and "Eroica," with its sad little scrawl, "Man Dies." The insistent, raw energy of the paintings, chronologically arranged in room after room, created a powerful, unsettling impact.

But one thing was immediately obvious: Basquiat's early work was by far his best. His talent had not kept pace with his fame. The haunting 1988 painting "Riding with Death" is a stark and final exception.

In November 1994, Michelle Rosenfeld won her case against the Basquiat estate and was awarded $395,000. Rosenfeld claimed to have given Basquiat $1,000 in cash as a down payment for three paintings she had never received. She had no documentation of the transaction other than a contract that Basquiat had written in crayon and then torn in half. "He laughed. He said someday this contract will be worth money. You'll see, I will be like Julian Schnabel," Rosenfeld testified, giving a vivid description of her visit to the

artist's loft. "It was early evening. The television was blaring, which was typical . . . and cartoons were on. He was walking around eating out of a can of Spam with the lid still attached. He was wearing, like baggie pull-on exercise pants . . . He had a couple assistants roaming around . . . There were many paintings all over. Some were unfinished, some were just canvases, but if you came in and saw all the paintings, it was overwhelming."

Rosenfeld made a second visit to the artist's loft, this time proffering the gift of a jar of dried fruits and nuts. When she left, Basquiat tossed the contents out the window. An amplified version of the incident was soon circulating SoHo—that Basquiat had dumped the health food on her head.

"He repeated the story many times to me," said Mary Boone, who testified that Basquiat had always had an attitude problem. "I didn't like the way he treated people and I often got involved with the messes he started . . . I made his paintings worth from five hundred to three hundred fifty-thousand dollars. He was an international star. He was on the cover of *The New York Times Magazine* section. Which, incidentally, he stood up the photographer three times and refused to wear his shoes. You know, he was just rude to people."

The judgment in favor of Rosenfeld was reversed by the court of appeals in 1996. In January 1997, the case was retried. A number of art dealers testified, including Boone, Annina Nosei, and Barbara Gladstone, who provided an interesting anecdote about smoking a "water pipe" Basquiat had offered her when she had gone to Crosby Street in 1982 to buy work. This time, the jury found that Rosenfeld's contract with Basquiat had been breached, but in July 1997, the court dismissed Rosenfeld's action upon the grounds of expiration of the statute of limitations. Rosenfeld's appeal of the dismissal is now pending.

In October 1994, Baghoomian suddenly resurfaced. He moved into a loft on Bleecker Street, rented to him by Basquiat's former lover, the gallery owner Barbara Braathen, and immediately began to peddle artwork. Within weeks, Baghoomian was again at the center of a major scandal, this time involving alleged Basquiat forgeries.

Sitting in his new downtown loft, Baghoomian attempted to ex-

plain himself. "I intended to leave for only three weeks, but things got so out of hand after they padlocked the gallery and took everything away, I really saw no point in coming back. I guess it was a combination of shame and pride. I was very uncomfortable about what had happened."

Baghoomian had actually returned to New York in August 1993. But it took him a while to find his feet. Meanwhile, he says, he "just brokered around, a little commission from here, another there."

On October 12, 1994, however, several Basquiat fakes were unearthed at FIAC, the annual international art fair held in Paris. They were discovered by a self-proclaimed Basquiat expert, an impassioned collector named Richard Rodriguez, who worked as a counsel for the French bank BPP.

"The dates didn't correspond to the style," he observed. "The paintings that were dated 1986 and 1987 were done in the style of earlier works, 1982 and 1983. I looked at the catalogue to the Whitney exhibition and realized that the paintings were fabricated from different images from other paintings. Some of the images were reversed, like you do with photography. Basquiat never put reverse images of the same figure in different paintings. I realized these three paintings were fabrications. All these paintings came from Baghoomian. Afterwards I found many paintings with the same system of fabrication."

The dubious paintings were displayed at the booth of Parisian gallery owner Daniel Templon. Rodriguez informed Templon, the Basquiat estate, and the Robert Miller Gallery of his discovery. The immediate result was that both Baghoomian and Templon sued Rodriguez for slander.

With typical bravado, Baghoomian responded by sending Rodriguez a letter calling him an impulsive liar and suggesting, "You better shut your mouth and throw yourself in the Seine before you do yourself more damage." Templon called him "imbecile, stupid man," to his face, and in an interview characterized Rodriguez as "like an Elvis Presley fan. He's fanatic. He's a bit paranoiac."

However, several art-world figures in Paris attested that Mr. Rodriguez is an art lover and collector who is considered an authority on Basquiat's work. (At this point, Templon is grateful for Rodriguez's

revelation: according to him, Interpol is now investigating the case. The FBI confirmed that they are investigating the matter, which, because of its international scope, also involves Interpol.)

Back in New York, Baghoomian discovered that Cinque & Cinque, the litigating firm for the Basquiat estate, had frozen his personal and corporate bank accounts, as well as the proceeds from Sotheby's for "Undiscovered Genius of the Mississippi Delta," which Rosenthal had had consigned to the auction house, and which had just been sold for $294,000. (The court reprimanded the lawyers and ordered Sotheby's to release the money, some of which went to settle the three claims over its ownership, and Baghoomian was barred from bidding at Sotheby's.)

By November 22, the Authentication Committee of the Basquiat estate, which was chaired by Gerard Basquiat and included John Cheim, Diego Cortez, Jeffrey Deitch, Larry Warsh, and Richard Marshall, met to examine the works in question. After analyzing transparencies and canvases, they ruled that five of the paintings—"Smoke Bomb," "Mass Slums," "Tax-Free," "Balloon," and "Ascecticism" [sic] were fakes. They sent out certificates bearing Basquiat's trademark crown, stating that the works in question were *"not"* by Jean-Michel Basquiat. (The certificates included a long disclaimer that the decision was "merely the opinion based upon the inspection of the work and the circumstances known to the committee at this time. It is not a warranty of any kind. . . .")

Templon, who had bought half a dozen paintings from Baghoomian, some of which had already been sold, contacted the dealer, requesting documents proving the works' provenance. He received no answer. He also demanded reimbursement for two paintings, "Balloon" and "Smoke Bomb," valued together at $143,000. Art dealers Michelle and Herbert Rosenfeld, who had bought paintings from Baghoomian that they had subsequently sold to Templon and Perry Rubenstein, also demanded their money back.

Says Templon, "Normally a fake is a bad painting, but these are so beautiful, so perfect." (Indeed, they were so convincing that *Le Figaro* printed one on the cover to its Arts and Leisure section during FIAC.) "Baghoomian's reputation is not perfect," Templon says, "but there is a difference between not being totally honest and making

and organizing the sale of fake paintings. He is a bad businessman, but now we doubt he is an honest person. He has to prove where the paintings came from."

The provenance of the paintings remains in question. Although some of them were done as early as 1982, they bear no stamp but that of the Baghoomian gallery. When the Rosenfelds' attorney asked for documentation of "Ascecticism," Baghoomian provided the name of a Paris dealer, who denied ownership of the painting. "That was the only thing I did wrong," said Baghoomian. "I sold the painting to my brother. The worst thing is that the story went wrong and the dealer said he never owned the painting. But I have nothing to hide."

Baghoomian seemed cheerful and at ease in his art-filled loft. A sepia-toned Warhol self-portrait looked over his shoulder. An enormous white Basquiat triptych, scrawled repeatedly with the word "alchemy," hung on the back wall. Baghoomian sifted through a batch of transparencies and said he had the largest archives of Basquiat material in the world, "twelve hundred paintings and over twenty-five hundred drawings."

Baghoomian produced invoices that he said documented the transactions between himself and the most recent owners of three of the paintings. The previous owners of two—"Mass Slums" and "Tax Free"—were, oddly, located in a remote area in Cardiff, Wales. One of the Cardiff contacts, reached by phone, turned out to be Baghoomian's brother and his family. The owner of "Smoke Bomb" was, Baghoomian acknowledged, his brother Paul in California. None of the paintings in dispute have ever been shown or catalogued.

"I think it's a smear campaign," said Baghoomian, about the allegation that the paintings were fakes. "I can only talk about the paintings I handled. If I got them direct from Jean-Michel, how could they be fakes?"

A number of Basquiat experts, including Bruno Bischofberger and Annina Nosei, were shown a transparency of one of the paintings and initially thought it was authentic. But there is now a widespread consensus that the paintings are indeed fakes. Rubenstein demonstrated how words and images from two adjacent paintings in the Whitney catalogue had been cleverly recombined to create several new Basquiat look-alikes. "These are very skillfully painted by some-

body who understood how he applies paints and puts the pictures
and texts and images together," he says. "It's a precise replication of
the image probably traced from an opaque projection." According to
Rubenstein, the canvases and staples of the alleged fakes also ap-
pear to be brand-new.

There are several New York–based artists who are rumored to
have been possible accomplices to the crime of forging the Bas-
quiats, including one who borrowed a slide projector and returned it
with a Basquiat transparency still inside.

But Baghoomian was not deterred by his most recent brush with
scandal. Within a year, he had opened a new gallery in Tony Shaf-
razi's old space at 163 Mercer Street. By the summer of 1996, he had
once disappeared from the art world.

Julian Schnabel had always wanted to make a movie. So when Lech
Majewski, a Polish filmmaker, interviewed the artist for a film he was
planning to make about Jean-Michel Basquiat, Schnabel couldn't
resist appropriating the project. He paid Majewski $50,000 for his
research (another $50,000 was paid by Peter Brant) and began to
make a film of his own. Says Schnabel, "Originally I had no intention
of directing this movie. I really got forced into it to make sure the
story was told the right way."

Schnabel spent the summer of 1995 shooting the film. The cast
included David Bowie as Warhol, Dennis Hopper as Bruno Bischof-
beger, Parker Posey as Mary Boone, Paul Bartel as Henry Geld-
zahler, Michael Wincott as Rene Ricard, and Courtney Love as Tina
Lhotsky. Claire Forlani plays a composite girlfriend primarily based
on Suzanne Mallouk, and Benicio del Toro plays a composite friend,
part Al Diaz, part Vincent Gallo. Basquiat himself was portrayed by a
relative newcomer, Jeffrey Wright, who had previously played Nurse
Belize in *Angels in America*.

Schnabel shot the movie with his usual fervor—despite a heat
wave and even a flash-flood on the final night of filming. He even per-
sonally re-created several examples of Basquiat's trademark SAMO
graffiti.

At one point, he and his crew spent a grueling night in an alley
near the former Mudd Club. Joey Arias played himself, the original

Mudd Club doorman. Between midnight and 4:30 A.M., when the sun rose, Schnabel, dressed in a damp sarong and looking like Marlon Brando playing Mr. Kurtz in *Apocalypse Now*, obsessively shot and reshot a single scene; Jeffrey Wright getting beaten up by two punks who are trying to steal a bit of SAMO graffiti that he's obligingly signed.

They'd done a dozen takes of the fight in the alley. Each time, Wright fell in a choreographed collapse, a ribbon of fake blood spilling from his mouth. But Schnabel was still unhappy with the shot. He wanted the Steadicam to pan directly from Wright's bloody face to the fake poster of Basquiat (Wright) and Warhol (Bowie) in their boxing gear. "I should learn how to operate the Steadicam myself," he said, staring at the snow on the monitor. "It looks like a bunch of nuns that got chopped up in a Vegematic."

For Wright, much of the film was a case of art imitating life. "There are a lot of double parallels working in this," he says. "There's the double iconography of Bowie and Warhol, and the double thing of me not being known to the greater film audience and Basquiat not being known to the greater film audience. And the relationship between Basquiat and Warhol being informed by that, just as the relationship between me and Bowie in the film is informed by that. I really got some insight into Basquiat, because I really had to travel through the same doorways and rooms and hallways that he did. And I think my performance was appropriated, literally, and the way I was edited was appropriated in the same way his story has been appropriated and that he was appropriated when he was alive.

"There's another parallel, that the mystery you are left with at the end of the film about who Basquiat was is the stuff that Julian didn't know, so he assumed it didn't exist. The sense I got about him from his work and what I found out about his life was a profound sense of aloneness, not loneliness, because he had friends, but a real sense of isolation."

Ultimately, says Wright, "Julian made him out to be too docile and too much a victim and too passive and not as dangerous as he really was. It's about containing Basquiat. It's about aggrandizing himself through Basquiat's memory. It's really fucking barbaric. But maybe our culture can't take the real danger of Basquiat right now."

Says Schnabel, "I think Jean was like the character in the novel *Perfume*. Grenouille is this guy who has this extrasensory capacity. He'd smell something and he'd see a whole landscape. So he creates this perfume that's so delicious that people devour him. Basically that's what happened to Jean."

The film received respectable reviews. But many in the art world were amused by the fact that Schnabel, who had never been particularly close to the artist in real life, and whom Basquiat had frequently ridiculed, had cast himself as a Basquiat expert—even an alter ego. Especially humorous was the artistic coup de grâce; refused permission from the estate to reproduce Basquiat's paintings, Schnabel and his assistants created their own.

In April 1996, Gerard Basquiat decided to sever ties with the Robert Miller Gallery. According to several sources familiar with the situation, there had been tension building between Rorbert Miller and Basquiat Senior. Basquiat was embittered by losing the first round of the Michelle Rosenfeld case.

After nearly ten years on the periphery of the art world, trying to unravel the apparently ceaseless chaos of his son's estate, he had come to believe that he could manage it as well as any dealer, and had quit his full-time job. In addition, he believed that by temporarily taking Jean-Michel Basquiat's work off the market, he could bring the prices back up to their peak point of the 1980s.

The ploy may be working. In May 1996, at Sotheby's evening sale, a 1984 painting, "Desmond," sold for $233,000, nearly $70,000 above the high estimate. At Christie's Henry Geldzahler estate sale, a pencil drawing of Geldzahler on graph paper sold for $11,213, almost six times its high estimate. An untitled piece consisting of three cryptic lines, "thier dogs, thier harpoons, thier wives"(sic), estimated at $500 to $700, sold for $5,175.

In November 1997, a world record was set for a Basquiat work on paper when an untitled 1982 drawing sold for $255,500 at Christie's; that same week a Basquiat painting, "Saxaphone" (sic), sold at Sotheby's for $244,500.

"There's a new group of collectors who've developed a case of Jeanophilia. They are looking under rocks to find the pieces," says

private dealer Andrew Terner. "I get calls from all over the world every day."

Covert Street is in the Bushwick section of Brooklyn, a slum near Williamsburg. The house where Matilde Basquiat lives, with its unpainted door and filthy drawn blinds, is the most dilapidated building on the residential street where girls are playing jump rope and the occasional blast of a boom box jolts the sleepy Sunday summer afternoon.

Joseph Andrades, Jean-Michel's maternal uncle, a tall, thin graying man in a worn T-shirt, answers the door. He goes upstairs to get Matilde.

The inside of this house looks as if it hasn't been painted, or perhaps even cleaned, in decades. Cobwebs hang from the cracked ceiling. The paint on the walls is peeling. Basquiat's mother is living in conditions of extreme apparent poverty. "If I had known what you wanted, I wouldn't have let you in," says Joseph, disappearing into the kitchen.

A woman in a flowered housedress descends the rickety staircase, pausing on the last step. Matilde Basquiat is wearing worn-out bedroom slippers. Her hair is combed back, but her nails and teeth need attention.

She stares straight ahead. When asked about her son, she rolls her eyes and seems disinclined to speak. When it is explained that her son is now considered an important painter and that this information is for a book about him, she slowly responds.

"Not important," she says, conclusively. "Accomplished . . . somewhat." She continues only after another long pause. "Not everyone can handle . . . some people's curiosity. My husband wanted to limit people's curiosity."

Basquiat's mother doesn't waver from her determination not to talk about her son. "He's not a public figure," she says firmly. "Politeness," she adds, as she closes the door.

It's Puerto Rico Day, and at a table set up on one street corner, a couple is hawking flags and strings of beads. Matilde Basquiat is Puerto Rican, and taught her son fluent Spanish. But nobody is celebrating on Covert Street.

When Jean-Michel Basquiat died intestate, both his parents be-

came co-executors of the estate. Although Matilde Basquiat signed over administration to her husband, she is still entitled to her half of the proceeds. "They are legally equal heirs," says Michael Stout.

According to at least one source familiar with the estate, any gallery that represents the estate, and that includes the Robert Miller Gallery during its nine years with Gerard, "is walking on eggshells. One day this woman will bump into a lawyer and be told she's due her fifty percent."

Today, nobody resides at 57 Great Jones Street. There's a crown drawn on the outer door, but it's not one of Basquiat's. The loft is being rented by a Japanese restaurant supply company and used as storage space for raw meat and fish.

Inside, the surprisingly small duplex is as dark as ever. The upstairs floor and the banquette that used to serve as a platform for Basquiat's bed are still covered in gray industrial carpeting. Downstairs, the kitchen walls are still painted a brilliant lemon yellow. There's a "Do Not Enter, Dogs Below" sign on the basement door, which leads to the cramped, claustrophobic space where Shenge and Kelle Inman once lived.

There is no sign that an artist ever lived here. No remnants of graffiti, no residual doodle. But a handwritten list is tacked to one kitchen wall: "Kukibara, Miru Himo, Corn, Hashira, Choice Rib Eye." Seen by the tutored eye, it looks random, poetic, right; it could be the text in a Basquiat painting.

CHANNEL-SURFING
IN PAINT

Basquiat was an omnivorous consumer of source material; he came, he saw, he painted. Whether he was mimicking the drawings of a child, as he did when he copied the drawing of a car done by Theo Sedlmayr, the son of a friend, or taking off on Depression-era hobo symbols, Basquiat had an instinctive talent for incorporating diverse— yet oddly related—material into his art.

Basquiat's work, like that of most of his peers, was based on appropriation rather than draftsmanship. In contrast to most of his peers, the images he appropriated—whether they were from the Bible or a chemistry textbook—became part of his original vocabulary, alphabet letters in an invented language, like notes in a jazz riff, or phonemes in a scat song. Basquiat combined and recombined these idiosyncratic symbols throughout his career: the recursive references to anatomy, black culture, television, and history are his personal hieroglyphics.

First and foremost, Basquiat was a wordsmith; some would say a poet. The SAMO sayings were a distilled version of the themes he would repeatedly return to in his later work: racism, materialism, capitalism, pop culture, mortality. At every period of his life, he kept notebooks filled with free verse; he self-consciously used the standard student's marbleized composition books.

Publisher Larry Warsh printed a collection of four such notebooks in 1993. Left at a friend's house and later sold to Warsh, they are filled with poems, ideas, and occasional sketches. "Holed up in rented bed waiting on new word . . ." begins one entry. Even in those paintings that include no language, Basquiat uses images more as ironic icons

than for pure visual effect; his visual strength is in his compositional style, which often parallels, in pictorial terms, musical syncopation.

A crude video made by Stephen Torton in 1983 clearly illustrates Basquiat's love of wordplay. The photographer Hans Namuth captured Jackson Pollock splashing paint across canvas in heroic, gestural drips, a macho display of the genius at work. Torton's video, in its own limited way, creates a revealing document of Basquiat's individual style.

Wearing the sort of striped sailor shirt favored by Picasso (in 1984, Basquiat did a painting of Picasso in a similar striped shirt), Basquiat jumps up to secure a canvas attached to the wall by strings. Then, standing in front of several large canvases, he begins working, painting without apparent hesitation or doubt—like *Harold and the Purple Crayon*—creating a childlike world of nonsense words that he continually revises with a few simple strokes.

First he paints the word "VERSUS," lingering over the first *S*, almost as if he were going to complete the word with an *E*. Then he slowly paints the word "POP," before turning the final *P* into an *R* to spell "PORK." He stops after each transition, savoring the word before it becomes the next word. When the painting is finished, only he will know that "POP" is embedded in "PORK." Typically, Basquiat has created several double-entendres. At the time, his friend Toxic was encouraging him, Muslim style, to eliminate pork from his diet; pork bellies are also a commodity. The word "VERSUS" also sums up Basquiat's antagonistic attitude toward the world.

He employs the same process in a second canvas; the word "ON" becomes "ONE," completed by the phrase "MILLION YEN." He adds a date in Roman numerals, then a cruciform with a copyright sign, then a crown. The painting is almost a Basquiat schematic.

On the last canvas, he paints his own left hand in one continuous stroke, followed by a basic skull with bared teeth. Now he goes back to the canvas with "ONE MILLION YEN" and underlines the words, adding "2 PER CENT." Then he draws a line around the percentage. He adds the words "LEGAL TNDR.," then "SPARERIBS." He returns to the "VERSUS PORK" painting, adding a thick red line between an *X* and the cruciform, then a pair of eyes.

———

Basquiat frequently spread his canvases on the floor, walking over them as he worked on each. Sometimes he crouched in the middle of a drawing, watching television as he doodled; he rarely if ever painted in silence; there was always either music or the drone of the TV as a sound track that filtered directly into his art.

Basquiat's work falls into several different periods, with a great deal of overlap. One of his strongest suits was his artistic ability to constantly absorb apparently random material—and technique—and to make it unmistakably his own. Critics have compared his aesthetic to sampling, as if this child of the media were a highly tuned antenna who received, and then broadcast, urgent bits of his message, loud, clear, and often angry.

In his essay "The Ecstasy of Communication," Jean Baudrillard, writing about the fragmentation of self in the postmodern world, precisely captures the essence of Basquiat's hyperactive artistic energy— an almost schizophrenic response to his immediate environment:

> . . . this state of terror proper to the schizophrenic: too great a proximity of everything, the unclean proximity of everything which touches, invests and penetrates without resistance, with no halo of private protection, not even his own body, to protect him anymore.
>
> The schizo is bereft of every scene, open to everything in spite of himself, living in the greatest confusion. He is himself obscene, the obscene prey of the world's obscenity. What characterizes him is less the loss of the real, the light-years of estrangement from the real . . . but very much to the contrary, the absolute proximity, the total instantaneity of things, the feeling of no defense, no retreat. It is the end of interiority and intimacy, the overexposure and transparence of the world which traverses him without obstacle. He can no longer produce the limits of his own being, can no longer lay nor stage himself, can no longer produce himself as mirror. He is now only a pure screen, a switching center for all the networks of influence.

Many of Basquiat's paintings powerfully illustrate the point, some quite explicitly. As Steven Henry Madoff noted in an October 1985 article in *Arts* magazine, "In Jean-Michel Basquiat's 'Masonic

Lodge,' an acrylic, oil and crayon on canvas from 1983, a human head is fractured into various elements of its composition, all under the general heading 'Paranoid Schizophrenic,' though several of the letters are rubbed out, making the image of these words resemble their meaning of a mental breakdown in continuity." In another painting, Basquiat has simply written the words "Disease Culture."

"Talk about the problems of being a successful artist in New York."

"The problems? Specifically which ones . . . the ones I bring upon myself, or the ones that are brought upon me?"
—interview with Anthony Haden-Guest

Basquiat's work charts his interior and exterior map of the world, from his days as a street artist to a gallery painter of international renown. After he literally sold out to the media in 1978, in the highly symbolic act of taking $100 from *The Village Voice* to identify himself and Al Diaz as SAMO, Basquiat began his accelerated transformation.

His first works on canvas, done for the New York/New Wave show, were basically SAMO sayings with some added icons. Spare and ex-pressionistic, they are some of his most immediate work. A collision between a car and a milk truck, for instance, bears the partially erased legend "Catalyst." The 1981 metal piece with the spray-painted slogan "Jimmy Best on His Back to the Suckerpunch of His Childhood Files," with an inset of the same automobile accident, stating both "Boom, for Real," and "Plush Safe, He Think," is a co-gent summary of Basquiat's response to his own traumatic childhood.

At the same time, Basquiat was making a variety of artifacts, from Rauschenberg-like collaged baseballs and postcards, to clothing with the slogan "Manmade." Todd's Copy Shop on Mott Street was a major resource. Basquiat xeroxed drawings to collage onto the postcards he sold on the street, and later onto canvases, including his large Palla-dium mural. The crown, first seen in his SAMO days, remains a con-stant trademark.

By the time he was painting in Nosei's basement, he had enough money to buy art materials and reference books, and his repertoire

expanded. The work of this time reflects his interest in artists of every period, from Leonardo to Twombly, as well as a sharp awareness of such peers as Julian Schnabel and David Salle. In addition to anatomical references, particularly skulls and skeletons, skelly courts, frame houses, black athletes, and various commodities (pork, salt) or forms of legal tender became frequently repeated images.

In some cases, Basquiat first made small drawings which he later expanded into paintings; sometimes he pasted the drawings right onto the canvas. His association with Stephen Torton resulted in the variety of cross-hatched and hinged frames, as well as painted found objects, which are a trademark of this period. By 1983, he had added silk-screening to the processes he used in making paintings.

Brian Gormley, a contemporary painter who befriended Basquiat in the mid-eighties, has spent years tracking down much of Basquiat's source material, including individual issues of *Mad* magazine, various comic books, late Picasso, and of special interest, a book of symbols.

Gormley first met Basquiat when he stopped by the loft of Great Jones Street in 1986, and was invited in. About the same age as Basquiat, Gormley was fascinated by Basquiat's work. At the time, Gormley was making ceramic masks. Now that he was in Basquiat's studio, he watched as Basquiat rolled a big joint. The book he was using as a surface to clean pot was an oversized paperback by a famous industrial designer, Henry Dreyfuss: *Symbol Sourcebook, An Authoritative Guide to International Graphic Symbols*, with a foreword by R. Buckminster Fuller.

Paging through the book after Basquiat's death, Gormley recognized many of Basquiat's favorite words and symbols. It is no coincidence that Basquiat chose hobo language to express his ideas; like the hobos he was quoting, Basquiat felt himself to be the eternal outsider. In a published interview, he told Henry Geldzahler that his subject matter was "royalty, the streets, heroism." To him, they were synonymous.

The hobo symbol of a circle, for instance, signifies "Nothing to be gained here"; Basquiat used both the icon and its definition in a number of paintings. An X means "O.K., all right." Two parallel vertical lines mean "The sky is the limit." A grid means "Jail." In one

drawing alone, "Arsenic," Gormley has identified over two dozen hobo symbols, and their carefully spelled-out meanings, from "Men fight" to "Dangerous neighborhood" to "Ill-tempered man lives here" to "Child dies."

Browsing through Basquiat's studio, Gormley also discovered a number of other books that Basquiat frequently turned to for images and inspiration, among them Burchard Brentjes's *African Rock Art* and *Prehistoric Art* by P. M. Grand, which were originally given to him by Lorraine O'Grady, a black curator who had hoped to include him in her 1983 Black and White show at the Kenkeleba Gallery. Basquiat has copied the image of a "moon king" from the book on rock art in several paintings, including two with the legend "The Kangaroo Woman That Makes The Rain To Cleanse Sick Souls."

Wrote O'Grady in *Artforum*, "In anticipation of the pieces he said he would make for me, I visited his loft on Crosby Street several times. We talked about art, performance, and the places he'd been, especially Rome, and about the need to hold on to his best work, and as we talked, he sat in the middle of a canvas, writing with oilstick. 'I'm not making paintings,' he said, 'I'm making tablets.' "

Basquiat's work began as a guerrilla tactic: attacking the art world by satirizing its values—as well as his father's—on public walls in highly visible places. Through 1982, and the Fun Gallery show, he continued to make art that clearly rejected the white, patriarchal establishment. Even after he became an overnight success, Basquiat's work seemed fueled by conflict and anger.

But from the start, Basquiat was overproducing, and there were periods, including a marked dip in 1984, when his work was clearly running on empty. Some of his sloppiest work is that done for his shows at Mary Boone, when Basquiat appeared to be simply catering to the world that anointed him a success; a knowing and fatal symbiosis. His collaborations with Clemente and Warhol, and later with Warhol alone, are also among his weakest paintings.

In the span of five years, Basquiat's work went through phases that ranged from textual to expressionist to a sort of faux Neo-Expressionism—but it always remained distinctly his own. Even at the end, Basquiat was capable of creating surprisingly apt juxtapositions, where each line is exactly right, and every element seems to

fall into its own place in a unique universe. At his best, Basquiat improvised masterful riffs on powerful themes; at his worst he floundered in flaccid name-dropping doodles and fashionably wild-looking pastiches.

Virtually all of Basquiat's work can be deciphered, Rorschach style, in terms of the artist's psychological sense of—and search for—self (in a way, they are all self-portraits), but his actual self-portraits offer another perspective of his evolution. The year 1982 emerges as pivotal, with the artist repeatedly painting and drawing himself, as if newly discovering himself as an artist.

In "Self-Portrait," 1982, Basquiat has painted a black man with dreadlocks and bared teeth holding an arrow. There is also a repeated grid—the hobo sign for jail. This painting was done while he was in Annina Nosei's basement. There are no words on the canvas; the solo black figure is painted against an abstractly textured background.

In "Self-Portrait as a Heel," 1982, Basquiat depicts himself as a wide-eyed black man, with inmate-style numbers across his chest, side by side with a labeled "Ace" comb.

In "Self-Portrait as a Heel—Part Two," also from 1982, Basquiat has given himself a much more detailed face, with Picassoid eyes. Two large, disembodied backwards hands hover above and below the truncated figure, on which, perhaps to orient the viewer, he has written, "back view and composite."

"Portrait of the Artist as a Young Derelict," 1982, combines a number of Basquiat motifs and is a good illustration of his literate irony. A hinged triptych, it includes a masklike self-portrait, a single panel of the Stanhope Hotel, where Charlie Parker died, along with a cross and the word "Morte," a panel with labeled ankle, several crowns, and the word "salt."

In "Self-Portrait with Suzanne," 1982, he has drawn two haloed figures, a man and a woman, on a background filled with words, letters, and doodles.

Painted dead center on a scrap of paper pasted to a large piece of canvas mounted on rough wood supports, Basquiat's "Self-Portrait," 1982, is one of the few to depict him smiling, although he sports a halo barbed like a crown of thorns.

Another 1982 painting, a frightening blur of an Edward Munch–like face frozen in fear under its halo, is untitled but clearly a self-portrait, as are his warriors from this period, one black, one red, brandishing swords.

In the 1983 painting Untitled (1960), a reference to his own birthday, Basquiat has depicted himself as a flat, black silhouette-style shadow, with empty space for his eyes and mouth.

In "Hollywood Africans" 1983, both Basquiat and his birth date appear (labeled "Self-portrait as a Heel #3") along with Rammellzee and Toxic, in a painting about the institutionalized racism in the movie industry; a second version depicts Ramellzee and Basquiat as "Hollywood Africans In Front of the Chinese Theater with Footprints."

A 1984 untitled painting uses the same stylized cookie-cutter form as the 1983 version that mentions his birth date, but this one is painted on a jagged piece of wood, and the broken mouth and crooked eyes of the shadow-self look both angry and sad. Two paintings done at the same time, also on wood—one of two simple, toothy skulls, another of a cartoony figure with a single eye and a cross on its chest—also seem like alter egos.

The innumerable screaming heads—sometimes primitive-looking masks, sometimes intricate skulls—can be construed as self-portraits. Throughout his career, Basquiat painted a number of found objects: doors, a child's easel, boxes, wood panels. He gave the child's easel, painted with a shrieking skull, to Warhol; it is one of his most poignant self-emblems. The 1985 door "Heaven" includes a stylized black silhouette, entitled "Autoportrait ©," as well as a bird's head, with the copyrighted legend "Dead Bird." In it, Basquiat seems to be announcing his own death, while at the same time equating himself with Charlie Parker.

Then there is "Embittered," painted in 1986, in which the emblem for the artist is a simple black-and-white profile; a fringe of hair and a Cyclopean eye painted on a black, ovoid splotch.

In a 1986 "Self-Portrait," Basquiat portrays himself on a bright, wordless background, a primitive black man with wild hair, bearing a sickle in one hand and a sledgehammer in the other. It looks as much menaced as menacing—the image of someone under attack.

A 1987 triptych called "Gravestone" is self-explanatory. One

door is a simple cross and a black rose; the central door has the blurred word "Perishable," written twice; on the last door a skull and a heart are merged into a voodoolike symbol.

Basquiat's last self-portrait, "Riding with Death," is a tragic ode to his own mortality. Stripped of all wordplay, lists, and pop-culture interference, rendered in a spare, lyrical line, it depicts the artist as a skeleton on a skeletal horse, completely alone on the canvas. Its composition is strikingly similar both to a well-known drawing by Leonardo da Vinci and, even more, to Julian Schnabel's 1980 painting entitled "Death," also portrayed as a skeletal rider on a skeletal horse.

Basquiat's painted alter egos were black heroes drawn from the worlds of sports and music: the baseball player Hank Aaron, the Olympic athlete Jesse Owens, the boxers Sugar Ray Robinson, Joe Louis, Jersey Joe Walcott, and Jack Johnson, the jazz geniuses Miles Davis, Dizzy Gillespie, Max Roach, and most of all, Charlie Parker, with whom Basquiat closely identified for obvious reasons.

Bird Lives! the Charlie Parker biography by Ross Russell, was one of his favorite books, bebop his favorite music. Like Parker, Basquiat left home at fifteen; like Parker, he was a terminal junkie and sex addict; like Parker, he quickly became conversant in the latest artistic vernacular, becoming a legend by the time he was twenty-one; like Parker, he was a clever and self-conscious bad boy. Basquiat must have found many passages in the book deeply resonant:

> "Iconoclast, breaker of rules, master of the put-on, Bird was the first jazz musician who carried the battle to the enemy . . . The act of throwing his saxophone out of a hotel window, walking into the sea wearing a new suit, standing up the promoter of a Paris jazz concert, drinking sixteen double whiskies in two hours, eating twenty hamburgers at a sitting . . . the patronizing way he took his pleasure with any white girl who offered herself—every episode in the cumulative legend of the Bird, however ineffectual and childish, was seen as a blow struck against the forces of opression . . .

"Charlie Parker was the first angry black man in music. Because he was ahead of his time, he bore the burdens of loneliness and frustration. The futility of blows he directed at the establishment did much to encourage his dependence upon heroin and alcohol, adding to his loneliness and accelerating an inner drive toward self-destruction . . . In spite of his successes and growing prestige Charlie saw no future of the music he played, or for his race in America. To live once, and to the limit—that was his game plan," writes Russell.

It was a plan that Basquiat brazenly adopted for his own. Parker and Basquiat shared the prodigious anger and appetites of outsiders desperately driven to leave a permanent mark on a predominantly hostile world. After Parker died, the graffiti "Bird Lives!" appeared all over New York City. But, while Basquiat romanticized Parker the way, in the aftermath of his death, some critics romanticized Basquiat, their talent cannot realistically be compared.

Parker was a bona fide genius who also earned his chops. He had dazzling technique, and at least in terms of his music, incredible discipline. While he was still in his teens, long before he became the master of bebop, he painstakingly taught himself all the twelve major scales in all the twelve minor keys of the blues, practicing for hours a day. Parker was more than the precociously brilliant member of a pack; he was a seminal innovator whose work is still a major influence on contemporary jazz musicians.

"If you didn't paint, what do you think you would be doing?"
"Directing movies I guess."
"What kind of movies?"
"Ones in which black people are portrayed as being people, you know, of the human race. You know, not aliens, not all negative, or thieves, drug dealers, the whole bit. Just real, real stories."
 —interview, Tamra Davis and Becky Johnston

The titles of many of Basquiat's paintings—"Irony of Black Policeman," "Jim Crow," "History of Black People," "Nothing to Be Gained Here," "Most Young Kings Get Thier Head Cut off," "Origin

of Cotton," "Famous Negro Athletes," "Slave Auction," "Oreo"—as well as their subject matter, indicate that Basquiat never lost his sense of where he fit into the white art world. Indeed, Basquiat was bitterly aware of his Faustian bargain.

In conversations with his friend Arden Scott, Basquiat made it clear that celebrity was more important to him than the actual quality of his art. He told her he would have time to learn how to draw later— that what mattered most was being rich and famous.

You can see talent in the early work—a natural sense of color, shape, and line, a playful poetic irony, a wealth of loaded images. But the paintings quickly become shamelessly repetitive. Basquiat was incapable of editing himself, and nobody else bothered to do it for him—in the go-go eighties, it wouldn't have been a good business ploy.

Although Basquiat was soon being lauded as everything from a street Rimbaud to an African-American Picasso, his work did not continue to evolve. By the time he was showing at Mary Boone, the painter was consciously parodying himself. Basquiat never completely lost his touch, and in the last few years of his life, some of his work regained its original energy.

Basquiat knew, as he explained to Tamra Davis and Becky Johnston, that people wanted work they could recognize; that artists were like brand names. He understood that the collectors were motivated by almost everything but aesthetics. He colluded in his own marketing, and he paid the ultimate price. One of his early works—two doors done in 1982, with two large black skulls, one grimacing, one grinning, against a background dense with doodles and words—is entitled, simply, "Famous."

"I remember the first time I saw his work," says Robert Hughes, whose relentless Basquiat-bashing was something of a sign of the times in the eighties. (After Basquiat died, he wrote a piece in the *New Republic* entitled "Requiem for a Featherweight.") "Bruce Chatwin and I went to P.S. 1. A couple of little Basquiats really did stand out. He seemed to have some kind of graphic zip. But the stuff became incredibly repetitious, as it does when you are painting too much. He only had very few shots in his locket, poor little bastard.

He never had any training. I think he had talent. But the discrepancy between a kid who had talent and the kind of fetish figure he was built into by the art world is glaring. He was sort of a desire object, an inflatable doll that people projected things onto."

Critic Stanley Crouch also considers Basquiat a symptom of the cultural times, his paintings the visual analogue to rap songs. "His central problem is not the subject matter, but that he is an example of the extension to painting of the standards of rock and roll—intensity, shock, and disregard for technique. I don't know if you can make a sincere statement if you don't really have the tools to give a sense of what you are actually saying. There's no substitute for skill, but you don't face that when you maintain an adolescent posture in the world. What this kind of thing begets is an arrested development."

There is no question that the response to Basquiat and his art has also been influenced by an almost endemic reverse racism, which turned him into a multicultural hero during his lifetime and a sacrificial lamb after his death. Says Marcia Tucker of the New Museum, "His work is very embroiled in the intersection of race and class, and that has very much distorted everything. He was always dealt with as an exoticized other, and it was very rarely about the work itself."

But for many others, Basquiat's work, at its best, makes a unique and enduring contribution to modern art. Says Arthur Danto, "I thought the way he put paint on canvas was a gift. Basquiat had not just an eye, but a touch. If you respond to the physicality of paint, Basquiat is a very rewarding artist. He goes down as a sort of Rimbaud of the era, but he left behind a substantial body of work, and would have been a significant painter in any era."

For Ingrid Sischy, the enduring value of Basquiat's work is self-evident. "Jean-Michel had an instant Duchampian ability to pick up the right found thing, an instant poetic ability to pick up phrases that looked like strong images and also read with incredible resonance. I have this image of Jean-Michel standing outside with his arms up, pulling whatever that thing is straight from the air. On an art level he was a true talent who really understood not only the power of painting, but how words can be images, and how images can have total language. He put the jazz back into abstraction."

While Basquiat's appropriate place in art history—seminal

painter or negligible footnote—continues to generate debate, his career has left another, less tangible legacy; an entire generation of students has turned him into an art hero, someone to be admired, emulated, studied. Dead nearly a decade, Basquiat has become the subject of numerous graduate theses; the kind of idol to a younger set that Charlie Parker was to him. If fame was indeed his primary goal, Basquiat has entered the pantheon.

Notes and Sources

This book is based on hundreds of interviews done between August 1988 and November 1997. All comments from Gerard Basquiat are quoted from two interviews done in August 1988. Because most sources were interviewed on more than one occasion over a period of years, I have not attempted to date their quotations.

CHAPTER ONE

1 Author's interview with Kelle Inman.

1 Author's interview with Brian Gormley.

2 Author's interview with Kevin Bray.

2 Author's interview with Victor Littlejohn.

2 Author's interview with Vera Calloway.

2 Author's interview with Vrej Baghoomian.

2 Author's interview with Helen Traversi.

3 Author's interview with Amos Poe.

3 Death certificate: August 12, 1988, D.O.A., 7:23 P.M. Signed by Pierre-Marie Charles. Date issued: August 16, 1988.

3 Author's interview with Gerard Basquiat.

3 Author's interview with Paul and Melissa Lamarr.

3 Author's interview with Blanca Martinez.

3 Author's interview with Vrej Baghoomian.

3 October 28, 1988, letter from Matilde Basquiat to Vrej Baghoomian.

3 Christie's inventory.

3, 4 Author's interview with Andrew Decker.

4 Ross Russell, *Bird Lives: The High Life and Hard Times of Charlie (Yardbird) Parker* (New York: Charterhouse, 1973).

4 Author's interview with Dan Asher.

4 I took photographs of the shrine to Basquiat outside his Great Jones Street loft.

4 I attended the memorial service at Saint Peter's Church.

5 "Genius Child" by Langston Hughes. Fab 5 Freddy changed several words in the poem; most significantly the last line, which verbatim reads, "Kill him—and let his soul run wild."

5 I attended the memorial party at M.K.

CHAPTER TWO

6 Claes Oldenburg's store: Calvin Tomkins, *Off the Wall* (New York: Penguin, 1981), p. 177.

6 Warhol's Campbell's soup cans: ibid.,
p. 178.

6 Andy Warhol and Pat Hackett,
POPism: The Warhol 60's (New York:
Harper & Row, 1980), p. 3.

6 Pop art symposium: *Off the Wall*,
pp. 178–79.

7 *POPism: The Warhol 60's*, p. 198.

7 Ibid., p. 134.

7 Andy Warhol, *The Philosophy of Andy
Warhol (From A to B and Back Again)*
(New York: Harcourt Brace Jovanovich,
1975), p. 178.

9 Charlie Ahearn, *Wild Style*, 1982,
starring Patti Astor, Fab 5 Freddy, Lee
Quinones, Crash, Futura 2000, Daze, and
Lady Pink.

10 The $2 billion art market: *The New
York Times*, May 15, 1983, Arts and
Leisure section, p. 1.

10 "Irises," sold at Sotheby's,
November 1987, to Alan Bond. "False
Start," sold at Sotheby's, November 1988,
to Larry Gagosian, who was bidding for
S. I. Newhouse.

10 Eugene and Barbara Schwartz:
Dinitia Smith, "Art Fever," *New York*
magazine, April 20, 1987.

10 Anthony Haden-Guest, "Sandro
Chia: Art Breaking," *Vanity Fair*, August
1988, p. 68.

11 *POPism: The Warhol 60's*, pp. 20–21.

11–12 Henry Louis Gates, Jr., *Figures
in Black* (New York: Oxford University
Press, 1987), pp. 237, 239, 243.

12 Tomb for Billie Holiday: Interview
with Jeff Bretschneider.

12 *Black Male*, Whitney Museum of
American Art (New York: Harry N.
Abrams, 1994), p. 117.

13 Hobo signs: Henry Dreyfuss, *Symbol
Sourcebook* (New York: Van Nostrand
Reinhold, 1972), pp. 90–91.

13 Stanley Crouch, *Notes of a Hanging
Judge* (New York: Oxford University
Press, 1990), pp. 187, 196.

13 Author's interview with Arden
Scott.

13 Author's interview with Kinshasha
Conwill.

15 *The Complete Works of Nathanael*

West (New York: Farrar, Straus and
Cudahy, 1957), p. 235.

CHAPTER THREE

16 Author's interview with Gerard
Basquiat.

16 "the Diane von Furstenberg of Haiti,"
author's interview with Stephen Torton.

16 Author's interview with John
Andrades.

16, 17 Author's interview with Gerard
Basquiat.

17 Steve Hager, *Art After Midnight*
(New York: St. Martin's, 1986), p. 39.

17 Author's interview with John
Andrades.

17 Transcripts of two interviews with
Basquiat done by Anthony Haden-Guest,
Spring 1988.

17 Author's interviews with Ken
Cybulska, Al Diaz, David Bowes.

17 Transcripts of Anthony Haden-
Guest/Basquiat interviews.

17 Interview with Basquiat done by
Steve Hager, January 23, 1985. (Basquiat
told Hager that he was seven when he was
hit by a car; when I interviewed Gerard
Basquiat, he told me that Jean-Michel was
six years old. According to the chronology
by M. Franklin Sirmans, published in
Jean-Michel Basquiat, the catalogue for
the Whitney Museum's 1992–93
retrospective (New York: Harry N. Abrams,
1992), he was hospitalized for one month
in May 1968 at Kings County Hospital.)

18 Interview with Basquiat done by
Steve Hager, January 23, 1985.

18 Anthony Haden-Guest, ibid.

18 *The Andy Warhol Diaries*, edited by
Pat Hackett (NewYork: Warner, 1989),
p. 603. (All quotes from the *Diaries* are
used with the permission of Warner Books.)

18 Author's interview with Gerard
Basquiat.

18 Author's interview with Howard
Lewis.

18 Author's interview with Monroe
Denton.

18 Author's interview with Paige Powell.

19 Author's interview with Sylvia Lennard.

19 Author's interview with Gerard Basquiat.

19 Author's interview with Sylvia Lennard.

19 Author's interview with Stephanie Lewis.

19 *Champions* (New York: Tony Shafrazi Gallery, January 1983), p. 16.

19 Author's interview with Estelle Finkel.

20 Author's interview with Cynthia Bogen Shechter.

20 Author's interviews with Ken Cybulska, Al Diaz.

20 Author's interview with Gerard Basquiat.

20 Author's interview with Howard Lewis.

21 Author's interview with Howard Lewis, Sylvia Lennard.

21 Author's interview with Gerard Basquiat.

21 Author's interview with Lisane Basquiat.

21 Author's interview with Al Diaz.

21 Author's interview with Howard Lewis.

21 Author's interview with Al Diaz, Jane Diaz, Mary-Ann Monforton, and Julie Wilson.

21 *Champions* art catalogue, Tony Shafrazi Gallery, January 1983.

21 Henry Geldzahler, "Jean-Michel Basquiat," *Interview* magazine, January 1983.

22 Author's interview with Howard Lewis.

22 Author's interview with John Andrades.

22 Videotaped Basquiat interview with Tamra Davis and Becky Johnston.

22 Henry Geldzahler, ibid.

22 Author's interview with Eric Johnson.

23 Author's interview with Julie Wilson.

23 Suzi Gablik, *Has Modernism Failed?* (New York: Thames and Hudson, 1984), p. 108.

23 Author's interview with Eric Johnson.

23 Author's interview with Gerard Basquiat.

24 Author's interview with Fred Rugger.

24 Author's interview with Mary Ellen Lewis.

24 Author's interview with Lester Denmark.

24 Author's interview with Al Diaz.

24 Author's interview with Ken Cybulska.

24 Author's interview with Sylvia Milgram.

25 Author's interview with Lester Denmark.

25 Author's interview with Ken Cybulska.

25 Author's interview with Lester Denmark.

25 Author's interview with Al Diaz.

25 Author's interview with Mary Ellen Lewis.

25 Philip Faflick, "The SAMO Graffiti: Boosh-Wah or CIA?" *The Village Voice*, December 1, 1978.

26 Jean Basquit [sic], "Samo," *The Basement Blues Press*, City-As-School, Spring 1977.

26 "Experience SAMO," one-page flyer created by Jean-Michel Basquiat, Al Diaz, Shannon Dawson, and Matt Kelly, City-As-School, Spring 1977 ("based on an original concept by Jean Basquiat and Al Diaz").

26 Author's interview with Ted Welch.

26 In the City-As-School graduation program, Ted Welch is referred to as Edward Welch, Department of Family Planning, Metropolitan Hospital.

27 Author's interview with Leslie Stein.

27 *The Village Voice*, ibid.

28 Author's interview with Kate McCamy.

28 Author's interview with Arden Scott.

28 Author's interview with Al Diaz.

29 Author's interview with Arden Scott.

29 Author's interview with Lester Denmark.

29 Author's interview with Ted Welch.

29 Author's interview with Leslie Stein.

29 Author's interview with Lester Denmark.

30 City-As-School graduation program, June 1978.

30 Interview with Basquiat done by Steve Hager.

30 Author's interview with Al Diaz.

30 Author's interview with Ted Welch.

31 Author's interview with Fred Rugger.

31 Author's interview with Fred Koury.

31 Author's interview with Mary Ellen Lewis.

CHAPTER FOUR

32 Author's interview with Keith Haring.

32 Author's interview with Kenny Scharf.

33 *sous rature*: David Lehman, *Signs of the Times* (New York: Poseidon Press, 1991), p. 53.

33 Keith Haring, "Remembering Basquiat," *Vogue*, November 1988, pp. 230, 234.

33 Jeffrey Deitch, review of Jean-Michel Basquiat at Annina Nosei, *Flash Art*, May 1982.

33 Philip Faflick, "The SAMO Graffiti: Boosh-Wah or CIA?" *The Village Voice*, December 1, 1978.

34 Richard Goldstein, "The Fire Down Below: In Praise of Graffiti," *The Village Voice*, December 24–30, 1980, citing *The New York Times*.

34 Author's interview with Mary Ellen Lewis.

34 Author's interview with Patricia Fields.

35 *High & Low*, catalogue essays: "Words" and "Graffiti," by Kirk Varnedoe and Adam Gopnik (New York: The Museum of Modern Art, 1990).

36 Peter Frank and Michael McKenzie, *New, Used & Improved* (New York: Abeville Press, 1987), pp. 26–61.

36 Suzi Gablik, *Has Modernism Failed?* (New York: Thames and Hudson, 1984), pp. 104–5.

36 Lucy R. Lippard, *Mixed Blessings* (New York: Pantheon, 1990), p. 161.

36 *Has Modernism Failed?* p. 104.

36 Author's interview with Lee Quinones.

36 Richard Goldstein, "The Fire Down Below: In Praise of Graffiti," *The Village Voice*, December 24–30, 1980.

37 *New, Used & Improved*, p. 28.

37 Jeffrey Deitch, "Report from Times Square," *Art in America*, August 1980.

37 "Beyond Words" poster, reproduced in Steven Hager, *Art After Midnight* (New York: St. Martin's, 1986), p. 105.

37 Author's interview with Charlie Ahearn.

37 Author's interview with Patti Astor and Bill Stelling.

38 "Graffiti/Post Graffiti," Paul Tschinkel's Art/New York Video Series, Tape No. 21, 1984.

38 Kim Levin, "The 57th Street Stop," *The Village Voice*, December 20, 1983.

38 Arthur C. Danto, "Post-Graffiti Art: Crash, Daze," published in *The State of the Art* (New York: Prentice Hall, 1987), p. 30.

38 Michael T. Kaufman, " 'Guernica' Survives a Spray-Paint Attack by Vandal," *The New York Times*, March 1, 1974.

39 Rap lyrics from "Ganter Chronicles," Rammellzee and Phase 2.

39 Daze comment from Elizabeth Hess, "Graffiti R.I.P.," *The Village Voice*, December 22, 1987.

39 Author's interview with Toxic.

39, 40 Robert Hughes, "The SoHoiad: or, The Masque of Art," in *Nothing If Not Critical* (New York: Penguin, 1990), p. 406.

40 *Champions* (New York: Tony Shafrazi Gallery, January 1983), p. 3.

40 Elizabeth Hess, "Graffiti R.I.P."

40 *Has Modernism Failed?* p. 106.

41 Ibid., p. 113.

41 Ibid., p. 108.

41 "Jean-Michel Basquiat," interviewed by Marc Miller, Paul Tschinkel's Art/New York Video Series, Tape No. 30, 1989.

41, 42 Greg Tate, "Flyboy in the Buttermilk," *The Village Voice*, November 14, 1989.

42 Author's interview with Lee Quinones.

CHAPTER FIVE

43 Author's interview with Steve Mass.

43 Author's interview with Diego Cortez.

44 Steven Hager, *Art After Midnight* (New York: St. Martin's, 1986), pp. 47–55.

44 *People* magazine, July 16, 1979, p. 32.

44 Author's interview with Stanley Moss.

44 Author's interview with Vincent Gallo.

45 Author's interview with Anita Sarko.

45 Author's interview with Nancy Brody.

45 Author's interview with Michael Holman.

45–46 Videotaped Basquiat interview with Tamra Davis and Becky Johnston, 1986.

46 Author's interview with Jeff Bretschneider.

46 Author's interview with Chris Sedlmayr.

46 Author's interview with Theo Sedlmayr.

47 Author's interview with Henry Geldzahler.

47 Author's interview with Diego Cortez.

47 Author's interview with Nick Taylor.

47 Author's interview with Maripol. (The jewelry designer does not use her last name, Foque.)

48 Author's interview with Alexis Adler.

49 Author's interview with Wayne Clifford, aka Justin Thyme.

49 Author's interviews with Al Diaz, Ken Cybulska, Kenny Scharf.

49 Author's interview with Arlene Schloss.

49 Author's interview with Gray band members: Nick Taylor, Michael Holman, Wayne Clifford.

50 Author's interview with Kenny Scharf.

50 Author's interview with Ann Magnuson.

51 Author's interview with Joey Arias.

51 Author's interview with Stan Peskett.

51 Author's interview with Jennifer Stein.

51 Author's interview with Lee Quinones.

52 Author's interview with Julie Wilson.

52 Author's interview with Arden Scott.

53 Peter Frank and Michael McKenzie, *New, Used & Improved* (New York: Abbeville, 1987), p. 31.

53 *TV Party* tape.

53 Author's interview with Glenn O'Brien.

53 Author's interview with Maripol.

CHAPTER SIX

54 Langston Hughes poem printed with permission from the Langston Hughes Estate, *The Collected Poems of Langston Hughes* (New York: First Vintage Classics Edition, 1995), p. 405.

54 *Desperately Seeking Susan*, Susan Seidelman, 1985, starring Rosanna Arquette, Madonna, Aidan Quinn.

54 Transcript of Anthony Haden-Guest interview with Basquiat, Spring 1988.

54 Author's interview with Nancy Brody.

54 Author's interview with Vincent Gallo.

56 Author's interview with Eszter Balint.

57 Cathleen McGuigan, "New Art, New Money: The Marketing of an American Artist," *The New York Times Magazine*, February 10, 1985.

57 Author's interview with Maripol.

57 Author's interview with Lee Quinones.

59–61 Author's interviews with Suzanne Mallouk.

61 Author's interview with Stephen Lack.

61–63 Author's interview with Patti Anne Blau.

CHAPTER SEVEN

64 Author's interview with Diego Cortez.

65 Author's interview with Alanna Heiss.

66 Kay Larson, *New York* magazine, March 16, 1981, p. 69.

66 John Perreault, "Low Tide," *SoHo News*, February 25, 1981, p. 49.

67 Author's interview with Brett De Palma.

67 Author's interview with Lee
Quinones.
67 Author's interview with Nick Taylor.
67 Author's interview with Alanna
Heiss.
68 Peter Schjeldahl, *The Village Voice*,
March 4–10, 1981, p. 69.
68 Author's interview with Henry
Geldzahler.
68 Author's interview with Sandro Chia.
69 Author's interview with Liz Gold.
69 Author's interview with Annina
Nosei.
69 Author's interview with Bruno
Bischofberger.
69 Author's interview with Michael
Holman.
69 Author's interview with Jennifer
Stein.
69 Author's interview with Fab 5
Freddy.
69 Author's interview with Brett De
Palma.
69 Author's interview with Stanley
Moss.
69 Author's interview with Kai Eric.
70 Author's interview with Tina
Lhotsky.
70 Author's interview with Henry
Geldzahler.
71 Author's interview with Diego Cortez.
72, 73 Author's interview with Massimo
Audiello.
73 Author's interview with Brett De
Palma.
73 Author's interview with Patti Astor.
74–76 Author's interview with Tina
Lhotsky.
76 Author's interview with Diego Cortez.
77 Author's interview with Annina
Nosei.
77 Laura de Coppet and Alan Jones,
The Art Dealers (New York: Clarkson N.
Potter, 1984), pp. 287–88.
78 Author's interview with Annina
Nosei.
78 Author's interview with Nick Taylor.
78 Author's interview with Patti Anne
Blau.
79 Author's interview with Suzanne
Mallouk.

80 Tamra Davis and Becky Johnston
video interview, 1983.
80 Heinz Kohut, *The Restoration of the
Self* (New York: International Universities
Press, 1977), p. 286.
80–81 Author's interview with Robert
Farris Thompson.

CHAPTER EIGHT

82 "Jean-Michel Basquiat,"
interviewed by Marc Miller, Paul
Tschinkel's Art/New York Video Series,
Tape No. 30, 1989.
82 Author's interview with Fab 5
Freddy.
83 Author's interview with Don and
Mera Rubell.
83 Author's interview with Douglas
Cramer.
83 Author's interview with Annina
Nosei.
83 Author's interview with Liz Gold.
83 Author's interview with Gene
Sizemore and several off-the-record
sources.
84 Author's interview with Liz Gold.
84 Author's interview with Annina
Nosei.
85 Author's interview with Vincent
Gallo.
86 Author's interview with Gerard
Basquiat.
86 Author's interview with Jeff
Bretschneider.
87 Transcript of Anthony Haden-Guest
interview with Basquiat, Spring 1988.
87 Author's interview with Gene
Sizemore.
89 Rene Ricard, "The Radiant Child,"
Artforum, December 1981, pp. 35–43.
89 Author's interview with Gene
Sizemore.
89 Author's interview with Annina
Nosei.
89 Author's interview with Al Diaz.
89 Author's interview with Joe LaPlaca.
89 Author's interview with Arden Scott.
89 Author's interview with Diego Cortez.
90 Geoff Dunlop, *Jean-Michel*

Basquiat, Shooting Star (documentary), London, Illuminations Production, 1990.

90 Author's interview with Annina Nosei.

91 Author's interview with Jeffrey Bretschneider.

91 Author's interview with Arto Lindsay.

91 Author's interview with Leisa Stroud.

92 Author's interview with Valda Grinfelds.

92 Author's interview with Rene Ricard.

93 Victor Bockris, *The Life and Death of Andy Warhol* (New York: Bantam, 1989), pp. 169, 197.

93 David Bourdon, *Warhol* (New York: Harry N. Abrams, 1989), p. 238, attributed to Gerard Melanga, "The Secret Diaries," Mother, May Days 1967, Number 8, p. 66.

93 Rene Ricard, "Golden Boy," *Vogue*, October 1992, p. 200.

93 *The Andy Warhol Diaries*, edited by Pat Hackett (New York: Warner, 1989), p. 551.

94 Author's interview with Rene Ricard.

94 Author's interview with Leisa Stroud.

95 Author's interview with Valda Grinfelds.

95 Author's interview with Rene Ricard.

96 Author's interview with Leisa Stroud.

96 Author's interview with Valda Grinfelds.

96 Author's interview with Jeff Bretschneider.

CHAPTER NINE

98 John Russell Taylor and Brian Brooke, *The Art Dealers* (New York: Scribner's, 1969), p. 261.

99 Author's interview with Jeffrey Bretschneider.

99 Author's interview with Suzanne Mallouk.

100 Author's interview with Joe LaPlaca.

100 Author's interview with Suzanne Mallouk.

100 Author's interview with Stephen Torton.

101 Jim Jarmusch, *Stranger Than Paradise*, 1984, John Lurie, Eszter Balint.

101 Author's interview with Stephen Torton.

101 Author's interview with Patti Anne Blau.

101 Author's interview with Tina Lhotsky.

101 Torton dealing drugs: Author's interview with Stephen Torton.

102 Rene Ricard, "Pledges of Allegiance," *Artforum*, November 1982, p. 48.

102 Author's interview with Stephen Torton.

102 Author's interview with John Lurie.

102 Author's interview with Suzanne Mallouk.

103 Author's interview with David Bowes.

104 Author's interview with Anna Taylor.

105 Author's interview with Saskia Friedrich.

106 Author's interview with Suzanne Mallouk.

106 Author's interview with Stephen Torton.

109 Author's interview with Gerard Basquiat.

109 Author's interview with John Lurie.

109 Jeanne Silverthorne, *Artforum*, Summer 1982, pp. 82, 83.

109 Lisa Liebmann, *Art in America*, October 1982, p. 130.

110 Jeffrey Deitch, *Flash Art*, May 1982, p. 49.

110 Author's interview with Nick Taylor.

CHAPTER TEN

111 Author's interview with Annina Nosei.

111 Author's interview with Kai Eric.

114 Frederick Ted Castle, "Saint Jean-Michel," *Arts*, February 1989, p. 61.

114 Author's interview with Jeffrey Bretschneider.

115 Author's interview with Kai Eric.

116 Author's interview with Annina Nosei.

116 Author's interview with Brett De Palma.

116 Author's interview with Perry Rubenstein.

116 The words "Mercanti di Proscuitto" appear in the 1982 painting "Man from Naples." According to Stephen Torton, however, Basquiat got the idea for this painting and two others from Torton's description of a Florentine street vendor who sold prosciutto and "pig sandwiches."

116 Cathleen McGuigan, "New Art, New Money: The Marketing of an American Artist," *The New York Times Magazine*, February 10, 1985.

CHAPTER ELEVEN

117 Rene Ricard, "The Radiant Child," *Artforum*, December 1981, p. 38.

117 Author's interview with Larry Gagosian.

118 Grace Glueck, "One Art Dealer Who's Still a High-Roller," *The New York Times*, June 24, 1991.

118 Judd Tully, "A Master of the Mix of Big Art and Big Money," *The Washington Post*, June 6, 1993.

119 Allan Schwartzman, "Go Go Takes Off," *Manhattan, Inc.*, October 1988, pp. 151–55.

119 Andrew Decker, "Art a GoGo," *New York* magazine, September 2, 1991, pp. 37–43.

119 Carol Vogel, "The Art Market," *The New York Times*, June 26, 1992.

119 Carol Vogel, "The Art Market," *The New York Times*, March 5, 1993.

119 Carol Vogel, "The Art Market," *The New York Times*, June 11, 1993.

119 Carol Vogel, "Revolving Door at Gagosian," *The New York Times*, September 23, 1994.

119 Jonathan Napack, "Halley's Comet Fading After Split?" September 26, 1994, *The New York Observer*.

119 Author's interview with Larry Gagosian.

119 Author's interview with Peter Halley.

119 Author's interview with John Seed.

119 Judgement and Lien Filings, New York County Clerk, December 12, 1993, Federal Tax Lien: $6,459,048.

119 New York Department of State, UCC Record, Total Lien amount: $7,220,886, January 4, 1988.

119 Author's interview with Manuel Chodosh at Hecht & Company.

120 Civil Summons, Civil Court of the City of New York, January 1, 1992, re $16, 308 owed to Busters Cleaning Corp.

120 Civil Summons, City Court of New York, June 22, 1992, re $3,000 owed to Rizzoli Journal of Art, Inc.

120 Author's conversation with Heather Bechel for Victor Cohen, counsel for Ralph Lauren.

120 Interview with off-record source familiar with Gagosian's business operations.

120 Andrew Decker, "Art a GoGo."

120 *Progressive Architecture*, December 1983.

120 Author's interview with Bob Colacello.

120 Author's interview with Peggy Siegal.

120 Author's interview with Peter Brant.

120 Author's interview with Larry Gagosian.

120 Barbaralee Diamonstein, *Inside the Art World: Conversations with Barbaralee Diamonstein* (New York: Rizzoli, 1994), p. 73.

120 Author's interview with Larry Gagosian.

120 Bob Colacello, "The Art of the Deal," *Vanity Fair*, April 1995, pp. 315–16.

121 Dana Wechsler Linden, *Forbes*, October 22, 1990, p. 72.

121 Judd Tully, "A Master of the Mix of Big Art and Big Money," *The Washington Post*, June 6, 1993.

121 Deborah Gimelson, "What Makes Larry Go-Go?" *Seven Days*, December 20, 1989.

121 Dana Wechsler Linden, *Forbes*.

121 Barbaralee Diamonstein, *Inside the Art World*, pp. 71–77.

122 Author's interview with Eli Broad.

122 Barbaralee Diamonstein, *Inside the Art World*.

122 Judd Tully, *The Washington Post*.

123 Author's interview with Douglas Cramer.

124 Author's interview with Larry Gagosian.

124 Deborah Gimelson, "What Makes Larry Go-Go?" p. 18.

124 Ibid.

125 Author's interview with Larry Gagosian.

126 Author's interview with Annina Nosei.

126 Author's interview with Claudia James.

126 Author's interview with Ulrike Kantor.

126 Author's interview with Annina Nosei.

126 Author's interview with Matt Dike.

128 Author's interview with Claudia James.

128 Author's interview with Larry Gagosian.

129 Author's interview with Matt Dike.

129 Author's interview with John Seed.

130 Author's interview with Stephen Torton.

CHAPTER TWELVE

131 Author's interview with Lawrence Luhring.

131 Author's interview with Stephen Torton.

132 Author's interview with Fab 5 Freddy.

132 Author's interview with Annina Nosei.

132 Author's interview with Liz Gold.

133 I visited the basement of the Nosei gallery in 1991.

133 Author's interview with Bruno Bischofberger.

133 Videotaped interview with Tamra Davis and Becky Johnston, 1986.

133 Author's interview with Jan Eric von Löwenadler.

134 Author's interview with Stephen Torton.

135 Author's interview with Bruno Bischofberger.

135 *The Andy Warhol Diaries*, edited by Pat Hackett (New York: Warner, 1989), p. 462.

136 Bob Colacello, *Holy Terror* (New York: HarperCollins, 1990), p. 474.

137 Author's interview with Patti Astor.

137 Author's interview with Suzanne Mallouk.

138 Author's interview with Stephen Torton.

138 Author's interview with Bill Stelling.

138 Author's interview with Fab 5 Freddy.

138 Author's interview with Bruno Bischofberger.

138 Author's interview with Patti Astor.

139 Author's interview with Anna Taylor.

139 Author's interview with Patti Astor.

139 Author's interview with Lawrence Luhring.

139 Author's interview with Annina Nosei.

139 Author's interview with Stephen Torton.

139 Transcript of Anthony Haden-Guest interview with Basquiat, Spring 1988.

139 Author's interview with Astor and Stelling.

139 Author's interview with Annina Nosei.

140 Author's interview with Bruno Bischofberger.

140 Author's interview with Stephen Torton.

140 Nicolas A. Moufarrege, "East Village," *Flash Art*, March 1983, p. 38.

140 Susan Hapgood, "Jean-Michel Basquiat: Fun," *Flash Art*, March 1983, p. 58.

140–41 Lisbet Nilson, "Making It Neo," *Art News*, September 1983, p. 70.

141 Author's interview with Perry Rubenstein.

141 Author's interview with Bruno Bischofberger.

CHAPTER THIRTEEN

142 Andy Warhol, *In His Own Words* (London: Omnibus Press, 1991), p. 72.

142 Author's interview with Bruno Bischofberger.

142 William O. Johnson, "Every Man Has a Mad Streak," *Sports Illustrated*, January 20, 1975, p. 67.

143 Author's interview with Beth Phillips.

143 Author's interview with Allan Schwartzman.

143 Author's interview with Barbra Jakobson.

143 Author's interview with Peter Brant.

144 Author's interview with Beth Phillips.

145 Author's interview with Howard Read.

145 Author's interview with Bruno Bischofberger.

146 Author's interview with Bob Colacello.

147 Author's interview with Bruno Bischofberger.

147 Bob Colacello, "The House That Fred Built," *Vanity Fair*, August 1993, p. 159.

147 Author's interview with Bob Colacello.

147 Author's interview with Bruno Bischofberger.

148 *The New York Times*, April 16, 1971.

148 Author's interview with Bruno Bischofberger.

149 Author's interview with Holly Solomon.

150 Author's interview with Allan Schwartzman.

150 *The Andy Warhol Diaries*, edited by Pat Hackett (New York: Warner, 1989), p. 343.

CHAPTER FOURTEEN

151 Geldzahler: Maureen Dowd, "Youth, Art, Hype: A Different Bohemia," *The New York Times Magazine*, November 17, 1985, p. 36.

151 Russell: Ibid., p. 30.

151 Robert Hughes, "Careerism and Hype Amidst the Image Haze," *Time*, June 17, 1985, p. 78.

151 David Bourdon, "Sitting Pretty," *Vogue*, November 1985, p. 116.

152 Calvin Tomkins, *Off the Wall* (New York: Penguin, 1981), p. 61.

152 "The Irascibles" was first published in *Life*, January 15, 1951.

152 Author's interview with Wendy Olsoff.

152 Author's interview with Bill Stelling.

153 Author's interview with Patti Astor.

153 Author's interview with Fred Braithwaite, aka Fab 5 Freddy.

154 Rene Ricard, "The Pledge of Allegiance," *Artforum*, November 1982, p. 42.

154 Kim Levin, "Power: The East Village," *The Village Voice*, October 18, 1983.

154 Author's interview with Gracie Mansion and Sur Rodney Sur.

155 Author's interview with Wendy Olsoff.

155 Author's interview with Freya Hansell.

155 Author's interview with Walter Robinson.

156 Author's interview with Gracie Mansion.

156 Nicolas A. Moufarrege, "The Year After," *Flash Art*, November 1984, p. 51.

157 Author's interview with Pat Hearn.

157 Amy Virshup, "The Fun's Over," *New York*, June 22, 1987, p. 49.

157 Judd Tully, "The East Village: Is the Party Over Now?" March 1986, p. 21.

157 Author's interview with Bill Stelling.

157 Craig Unger, "There Goes the Neighborhood," *New York*, May 28, 1984, p. 35.

157 Craig Owens, "The Problem with Puerilism," *Art in America*, Summer 1984, p. 163.

158 Walter Robinson and Carlo McCormick, "Slouching Toward Avenue D," *Art in America*, Summer 1984, pp. 135, 137.

158 Maureen Dowd, "Youth, Art, Hype: A Different Bohemia," *The New York Times Magazine*, November 17, 1985, p. 87.

158 Craig Unger, "There Goes the Neighborhood," p. 38.

159 Interview with Gracie Mansion.

159 Robert Pincus-Witten, "The New Irascibles," *Arts*, September 1985, pp. 102–10.

159 Nicolas A. Moufarrege, *Flash Art*, November 1984, p. 51.

159 Interview with Patti Astor.

159 *Art Talk: The Early 80's*, edited by Jeanne Siegel (New York: Da Capo, 1988), p. 182.

CHAPTER FIFTEEN

160 Author's interviews with Michael Holman and Nick Taylor.

160 Christopher Andersen, "Madonna Rising," *New York*, October 14, 1991, p. 48.

161 Author's interview with Ed Steinberg.

162 Author's interview with Anna Taylor.

162 Author's interview with Eszter Balint.

162 Jean-Michel Basquiat, *The Notebooks*, compiled and edited by Larry Warsh (New York: Art + Knowledge, 1993).

162 Author's interview with Stephen Torton.

163 Author's interview with Nick Taylor.

163 Author's interview with Suzanne Mallouk.

163 Author's interview with Glenn O'Brien.

163 Author's interview with Matt Dike.

164 Author's interview with Kenny Scharf.

164 Author's interview with Larry Gagosian.

165 Author's interview with Stephen Torton.

165 Author's interview with Brett De Palma.

166 Madonna, "Me, Jean-Michel, Love and Money," *The Guardian*, March 5, 1996.

167 Author's interview with Barbara Braathen.

168 "Jean-Michel Basquiat," interviewed by Marc Miller, Paul Tschinkel's Art/New York Video Series, Tape No. 30, 1989.

170 Author's interview with Tony Shafrazi.

170 Author's interview with Perry Rubenstein.

170 Author's interview with Jennifer Stein.

170 Author's interview with Stephen Torton.

170–71 I have deliberately omitted the girlfriend's name.

CHAPTER SIXTEEN

172 Author's interview with Stephen Torton.

173 Author's interview with Anna Taylor.

174 Author's interview with Matt Dike.

175 Author's interview with Douglas Cramer.

175 Author's interview with Lee Jaffe.

175 Author's interview with Suzanne Mallouk.

176 Author's interview with Matt Dike.

176 Author's interview with Larry Gagosian.

177 Author's interview with Fred Hoffman.

179 Susan Muchnic, *Los Angeles Times*, March 11, 1983.

180 George Christy, "The Great Life," *The Hollywood Reporter*, March 24, 1983.

180 Author's interview with Jeff Bretschneider.

181 The 1983 Whitney Biennial catalogue, preface by John G. Hanhardt, essays by Barbara Haskell, Richard Marshall, Patterson Sims.

181 Jane Bell, "Biennial Directions," *Art News*, Summer 1983, pp. 77, 78.

181 Author's interview with Don and Mera Rubell.

182 Hilton Kramer, "Signs of Passion: The New Expressionism," published in

The Revenge of the Philistines (New York: The Free Press, 1985), pp. 374, 375.

182 Arthur Danto, "Approaching the End of Art," in his *The State of the Art* (New York: Prentice Hall, 1987), pp. 206-7.

CHAPTER SEVENTEEN

183 Robert Hughes, "Sold," *Time*, November 27, 1989, p. 65.

183 Grace Glueck, "When Money Talks, What Does It Say About Art?" *The New York Times*, June 12, 1983.

183 Jeffrey Hogrefe, "Julian Schnabel's Crock of Gold, " *The Washington Post*, May 20, 1983.

183 Barbara Rose, "For Painter Julian Schnabel, There's No Sound Sweeter Than Cracking Pottery," *People*, December 12, 1983, p. 109.

183–84 E. J. Vaughn and John Schott, *America's Pop Collector: Robert C. Scull— Contemporary Art at Auction* (New York: Cinema Five, 1973).

184 Barbara Rose, "Profit Without Honor," *New York*, November 5, 1983, p. 80.

185 Author's interview with Don and Mera Rubell.

185 Alice Goldfarb Marquis, *The Art Biz* (Chicago: Contemporary Books, 1991), p. 191.

185 Anthony Haden-Guest, "Burning Out," *Vanity Fair*, November 1988, p. 190.

185 Tom Wolfe, "Bob & Spike," *The Purple Decades* (New York: Berkley, 1982), pp. 7, 9, 13.

185 Rita Reif, "Week's Art Auctions Rewrite the Record Books," *The New York Times*, May 18, 1980.

185 Michael Brenson, "Artists Grapple with the New Realities," *The New York Times*, May 15, 1983.

186 Tom Wolfe, *The Bonfire of the Vanities* (New York: Farrar, Straus & Giroux, 1987).

187 Debora Silverman, *Selling Culture* (New York: Pantheon, 1986), p. 11.

187 John Taylor, *The Circus of Ambition* (New York: Warner, 1989), p. 15.

187 Oliver Stone, *Wall Street*, 1987.

187 John Taylor, "Party Palace," *New York*, January 9, 1989, pp. 20–30.

187 The Reagan administration's 1986 Tax Act provided that art donors could deduct only the original, not the appreciated, value of art works.

187 James Servin, "SoHo Stares at Hard Times," *The New York Times Magazine*, January 20, 1991, p. 26.

187 Robert Hughes quoted in Dinitia Smith, "Art Fever," *New York*, April 20, 1987, p. 37.

187–88 Tina Brown, "Gayfryd Takes Over," *Vanity Fair*, November 1986, pp. 107–112.

188 Dinitia Smith, "Art Fever," p. 41.

188 :"State of the Art Party," *Vanity Fair*, October 1989, pp. 279–80.

188 Werner Muensterberger, *Collecting: An Unruly Passion* (Princeton: Princeton University Press, 1994), pp. 13, 254.

188 Lucie Young, "The Possessed: When Too Much Is Not Enough," *The New York Times*, February 6, 1997.

188 Ibid.

189 Alice Goldfarb Marquis, *The Art Biz* (Chicago: Contemporary Books, 1991), p. 173.

189 Ibid.

189 35,000 art graduates: Robert Hughes, "Careerism and Hype Amidst the Image Haze," *Time*, June 17, 1985, p. 78.

189 close to a million artists: James Gardner, *Culture or Trash* (New York: Birch Lane, 1993), p. 26.

189 90,000 artists in New York: Ibid.

189 Robert Hughes, "Careerism and Hype," p. 79.

189 Michael Brenson, "Artists Grapple with the New Realities," *The New York Times*, May 15, 1983.

189 Number of galleries in 1970 to mid-80's: Meg Cox, "Dazzling Picture: A Boom in Art Lifts Prices, Stirs Fears of a Bust," *The Wall Street Journal*, November 24, 1986.

189 Stuart Greenspan, "Bright Lights, Big Bucks," *Art & Auction*, May 1989, p. 220.

189 Meg Cox, "Dazzling Picture."

190 Grace Glueck, "The Met Extols Itself," *The New York Times*, December 7, 1975, Hoving quoted from the catalogue of *Patterns of Collecting*.

190 Robert Hughes, *Time*, June 17, 1985, p. 79.

190 Richard H. Rush, *Art as an Investment* (New York: Prentice-Hall, 1961).

190 Meg Cox, "Dazzling Picture."

191 Author's interview with Mary Boone.

191 Author's interview with Andrew Terner.

191 Author's interview with Ivan Karp.

191 Ellen Lubell, "New Kid on the (Auction) Block," *The Village Voice*, May 29, 1984.

191 Peter Watson, *From Manet to Manhattan* (New York: Random House, 1992), p. 394.

191 Author's interview with Klaus Kertess.

192 Peter Watson, *From Manet to Manhattan*, p. 391.

192 Author's interview with Richard Feigen.

192 Alice Goldfarb Marquis, *The Art Biz*, p. 252.

192 Author's interview with Andrew Terner.

192 Robert Hughes, "Sold," *Time*, November 27, 1989, p. 72.

193 Ibid., p. 60.

193 John Russell, "Clapping for Money at Auctions," *The New York Times*, May 21, 1989.

193 Dinitia Smith, "Art Fever," *New York*, April 20, 1987, p. 39.

193 Grace Glueck, "When Money Talks," *The New York Times*, June 12, 1983.

193 Author's interview with Martha Baer.

194 Jane Addams Allen, "Wheelers, Dealers and Supercollectors," *New Art Examiner*, June 1986, p. 27.

194 Author's interview with Richard Feigen.

194 Author's interview with Tina Lhotsky.

195 Author's interview with Paige Powell.

197 Author's interview with Stephen Torton.

197–98 *The Andy Warhol Diaries*, edited by Pat Hackett (New York: Warner, 1989), p. 502.

CHAPTER EIGHTEEN

199 Jean Stein, edited with George Plimpton, *Edie* (New York: Dell, 1982), p. 195.

199 Andy Warhol, *In His Own Words* (London: Omnibus Press, 1991), p. 93.

199 Calvin Tomkins, *Off the Wall* (New York: Penguin, 1981), p. 178.

199 Paul Goldberger, Obituaries, *The New York Times*, August 17, 1994.

200 Frances FitzGerald, "What's New, Henry Geldzahler, What's New?" *New York Herald Tribune*, November 21, 1965.

200 Author's interview with Henry Geldzahler.

200 Hockney portrait: Paul Goldberger, Geldzahler obituary, *The New York Times*, August 17, 1994.

200 Author's interview with Henry Geldzahler.

200 Cathleen McGuigan, "New Art, New Money: The Marketing of an American Artist," *The New York Times Magazine*, February 10, 1985.

201 Author's interview with Henry Geldzahler.

201 Author's interview with Jeff Bretschneider.

201 Author's interview with Mary-Ann Monforton.

201 Author's interview with Zoe Leonard.

201 Andy Warhol, *In His Own Words*, p. 5.

201 Robert Hughes, "Andy Warhol," *Nothing If Not Critical* (New York: Penguin, 1987), p. 248.

201 Author's interview with Kenny Scharf.

202 Famous quote about fame: Bob Colacello, *Holy Terror* (New York: HarperCollins, 1990), p. 31.

202 Author's interview with Bob Colacello.

202 David Bourdon, *Warhol* (New York: Harry N. Abrams, 1989), p. 13.

202–3 Author's interview with Ronnie Cutrone.

203 Author's interview with Paige Powell.

203 Author's interview with Jane Diaz.

203 Author's interview with Victor Bockris.

203 Author's interview with Benjamin Liu.

203 Author's interview with Kenny Scharf.

203 Andy Warhol and Pat Hackett, *POPism: The Warhol 60's* (New York: Harper & Row, 1980), p. 3.

204 David Bourdon, *Warhol*, p. 17.

204 Victor Bockris, *The Life and Death of Andy Warhol* (New York: Bantam, 1989), p. 233.

204 Author's interview with Walter Steding.

205 Cathleen McGuigan, "New Art, New Money: The Marketing of an American Artist," *The New York Times Magazine*, February 10, 1985, pp. 34, 35.

205 Victor Bockris, *The Life and Death of Andy Warhol*, p. 330.

205 Author's interview with Gerard Basquiat.

205 Author's interview with Walter Steding.

206 Author's interview with Bob Colacello.

206 Author's interview with Glenn O'Brien.

206 Author's interview with Ronnie Cutrone.

207 Author's interview with Victor Bockris.

207 Author's interview with Lee Jaffe.

208 Author's interview with Bruno Bischofberger.

209 Author's interview with Paige Powell.

209 *The Andy Warhol Diaries*, edited by Pat Hackett (New York: Warner, 1989), p. 520.

210 Ibid., p. 522.

210 Ibid., pp. 524, 525.

210 Author's interview with Paige Powell.

211 Author's interview with Bob Colacello.

212 Author's interview with Benjamin Liu.

212 Author's interview with Howard Read.

212 Author's interview with Peter Brant.

212 Author's interview with Paige Powell.

212 *The Andy Warhol Diaries*, p. 525.

212 *The New York Times*, September 15, 1983.

212 *The New York Times*, September 29, 1983.

212 Author's interview with Paige Powell.

212, 213 Author's interview with Suzanne Mallouk.

213 *The Andy Warhol Diaries*, pp. 534, 535.

214 Author's interview with Paige Powell.

214 *The Andy Warhol Diaries*, p. 536.

214, 215 Author's interview with Paige Powell.

215 Author's interview with Gerard Basquiat.

216 Author's interview with Ronnie Cutrone.

216 Author's interview with Bruno Bischofberger.

217 *The Andy Warhol Diaries*, p. 600.

217 "Artists Only," The Talking Heads, Sire Records, 1978.

217 Author's interview with Bruno Bischofberger.

218 Beth Phillips notebook, September through April 1984; February 13–April 4, 1985.

218 Author's interview with Beth Phillips.

218 *The Andy Warhol Diaries*, p. 604.

219 Ibid., p. 605.

219 Ibid., p. 618.

219 Author's interview with Benjamin Liu.

219 Author's interview with Ronnie Cutrone.

220 Videotaped interview with Basquiat done by Tamra Davis and Becky Johnston, Los Angeles, June 1986.

220 Author's interview with Larry Gagosian.

220 Author's interview with Fred Braithwaite.

220 Author's interview with Jay Shriver.

CHAPTER NINETEEN

221 Author's interview with Mary Boone.

221 Author's interview with Bruno Bischofberger.

222 Author's interview with Irving Blum.

222 Author's interview with Beth Phillips.

224 *The Andy Warhol Diaries*, edited by Pat Hackett (New York: Warner, 1989), p. 543.

224 Author's interview with Beth Phillips.

224 Author's interview with Barbra Jakobson.

225 Author's interview with Yo Yo Bischofberger.

225 Author's interview with Beth Phillips.

225 Author's interview with Bruno Bischofberger.

226 Grace Glueck, *The New York Times*, June 12, 1983.

226 Cathleen McGuigan, "New Art, New Money: The Marketing of an American Artist," *The New York Times Magazine*, February 10, 1985.

226 Calvin Tomkins, *Post-to-Neo: The Art World of the 1980's* (New York: Henry Holt, 1988), pp. 9–51 (originally published in *The New Yorker*, May 26, 1980).

227 Calvin Tomkins, *Off the Wall* (New York: Penguin, 1981), p. 141.

227 Meryle Secrest, *Art News*, Summer 1982, p. 71.

227 Calvin Tomkins, *Post-to-Neo*, pp. 22, 25.

228 Joan Juliette Buck, "Dealer's Choice," *Vogue*, February 1989, pp. 337–43, 390.

228 Laura de Coppet and Alan Jones, *The Art Dealers* (New York: Clarkson N. Potter, 1984), p. 273.

228 Author's interview with Adam Sheffer.

228 Author's interview with Mary Boone.

228 *The Art Dealers*, p. 274.

228 Author's interview with Robert Feldman.

228 Author's interview with Klaus Kertess.

229 Author's interview with Mary Boone.

229 Author's interview with Barbra Jakobson.

229 *The Art Dealers*, p. 275.

230 Author's interview with Mary Boone.

230 Jakobson quoted on "a hard eye," in Steve Hager, "A Boone for the Art Scene," *The Daily News*, August 21, 1981.

230 Michael Stone, "Off the Canvas," *New York*, May 18, 1992, p. 33.

230 Author's interview with Julian Schnabel.

230 Michael Stone, "Off the Canvas," p. 33.

230 Anthony Haden-Guest, "The New Queen of the Art Scene," *New York*, April 19, 1982, p. 28.

231 Peter Schjeldahl's comment quoted in Michael Stone, "Off the Canvas," p. 34.

231 Anthony Haden-Guest, "The New Queen of the Art Scene," p. 26.

231 Rene Ricard, "Not About Julian Schnabel," *Artforum*, June 1981, p. 78.

231 Author's interview with Mary Boone.

231 Author's interview with Stephen Frailey.

231 Author's interview with Mary Boone.

231 "Boone Means Business: Hot Dealer in Wild Art," *Life*, May 1982, p. 83.

231 Ibid., p. 87.

232 Author's interview with Jeffrey Hogrefe.

232 Author's interview with Eli Broad.

232 "Boone Means Business," p. 86.

232 Author's interview with Mary Boone.

232 Author's interview with Stephen Frailey.

233 Author's interview with Robert Feldman.

233 Boone's quote to German writer quoted in Anthony Haden-Guest, "The New Queen of the Art Scene," p. 30.

234 Grace Glueck, "What One Artist's Career Tells Us of Today's Art World," *The New York Times*, December 2, 1984.

234 Author's interview with Stephen Frailey.

234 Author's interview with Mary Boone.

234 Author's interview with Don and Mera Rubell.

234 Author's interview with Larry Gagosian.

234 Author's interview with Stephen Torton.

234 Author's interview with Stephen Frailey.

235 Author's interview with Brett De Palma.

235 Author's interview with Stephen Torton.

235 Author's interview with Matt Dike.

235 Author's interview with Lenore Schorr.

235 Author's interview with Mary Boone.

235 Author's interview with Jeff Bretschneider.

235 *Jean-Michel Basquiat*, May 5 to May 26, 1984, Mary Boone, Michael Werner gallery, in association with the Bruno Bischofberger gallery, Zurich.

237 Vivien Raynor, "Paintings by Jean-Michel Basquiat at Boone," *The New York Times*, May 11, 1984.

237 *The Andy Warhol Diaries*, edited by Pat Hackett (New York: Warner, 1989), p. 584.

237 Author's interview with Keith Haring.

237 Author's interview with Fred Braithwaite.

CHAPTER TWENTY

238 Author's interview with Jennifer Goode.

238 Jesse Kornbluth, "Inside Area," *New York*, March 11, 1985, pp. 33–41.

238 Author's interview with Eric Goode.

239 *The Andy Warhol Diaries*, edited by Pat Hackett (New York: Warner, 1989), p. 633.

239 Author's interview with Jennifer Goode.

240 Jesse Kornbluth, "Inside Area."

240 Author's interview with Jennifer Goode.

242 Author's interview with John Good.

242 Author's interview with Robert Farris Thompson.

CHAPTER TWENTY-ONE

245 Cathleen McGuigan, "New Art, New Money: The Marketing of an American Artist," *The New York Times Magazine*, February 10, 1985, pp. 20–28, 32–35, 74.

245 Geoff Dunlop, *Jean-Michel Basquiat, Shooting Star*, London, Illuminations Production, 1990.

245 Author's interview with Gerard Basquiat.

246 Videotaped interview with Basquiat done by Tamra Davis and Becky Johnston, Los Angeles, June 1986.

246 Beth Phillips notebooks, February 13–April 1985.

246 Author's interview with Diego Cortez.

246 Author's interview with Mary Boone.

247 Author's interview with Bruno Bischofberger.

247 Robert Farris Thompson, in catalogue: *Jean-Michel Basquiat*, March 2 to March 23, 1985, Mary Boone, Michael Werner gallery, in cooperation with the Bruno Bischofberger gallery, Zurich.

247 Robert Pincus-Witten, "Entries: Becoming American," *Arts*, October 1985, pp. 101–3.

248 Author's interview with Keith Haring.

248 Author's interview with Steve Rubell.

248 Author's interview with Brett De Palma.

248 Author's interview with Suzanne Mallouk.

248 Author's interview with Victor Bockris.

249 Beth Phillips notebook, April 4–May 5, 1985.

249 Ibid.

250 Author's interview with Bruno Bischofberger.

250 Author's interview with Jennifer Goode.

250 Author's interview with Tony Shafrazi.

250 Transcripts of Anthony Haden-Guest interview, Spring 1988.

250 Author's interview with Mary Boone.

251 Michael Daly, "The Comeback Kids," *New York*, July 22, 1985, pp. 29–39.

251 I attended the Palladium's opening night party, May 14, 1985.

251 Michael Daly, "The Comeback Kids," p. 37.

251 Author's interview with Nancy Brody.

252 Calvin Tomkins, *Post-to-Neo: The Art World of the 1980's* (New York: Henry Holt, 1988), "Disco," pp. 190–91 (originally published in *The New Yorker*, July 22, 1985).

252 Author's interview with Nancy Brody.

CHAPTER TWENTY-TWO

253 Author's interview with Marcia May.

254 Author's interview with Jennifer Goode.

254 Author's interview with Liz Williams.

255 Author's interview with Michael Halsband.

257 Author's interview with George Condo.

257 Author's interview with Michael Halsband.

259 Author's interview with Jennifer Goode.

259, 60 Author's interview with Michael Halsband.

260 Author's interview with Liz Williams.

260 Author's interview with Leonart DeKnegt.

CHAPTER TWENTY-THREE

263 Author's interview with Henry Geldzahler.

263 Author's interview with Christopher Makos.

264 *The Andy Warhol Diaries*, edited by Pat Hackett (New York: Warner, 1989), p. 676.

264 Ibid., p. 677.

264 Geoff Dunlop, *Jean-Michel Basquiat, Shooting Star*, London, Illuminations Production, 1990.

264 Keith Haring, "Painting the Third Mind," October 4, 1988. Catalogue essay, Mayor Rowan gallery show, London, November 21, 1988–January 21, 1989.

265 Eleanor Hearney, "Basquiat/Warhol: Tony Shafrazi," *Flash Art*, December 1985–January 1986, p. 43.

265 Vivien Raynor, "Art: Basquiat, Warhol," *The New York Times*, September 20, 1985.

265 *The Andy Warhol Diaries*, pp. 679, 680.

266 Author's interview with Michael Halsband.

266 *The Andy Warhol Diaries*, p. 685.

266 Ibid., p. 695.

266 Transcripts of Anthony Haden-Guest interview, Spring 1988.

266 *The Andy Warhol Diaries*, p. 699.

266 Author's interview with Paige Powell.

268 Andy Warhol, *The Philosophy of Andy Warhol (From A to B and Back Again)* (New York: Harcourt Brace Jovanovich, 1975), p. 92.

268 Author's interview with Victor Bockris.

268 Victor Bockris, *The Life and Death of Andy Warhol* (New York: Bantam Books, 1989), pp. 331, 332.

268 Author's interview with Christopher Makos.

269 Dotson Rader, "Andy's Children: They Die Young," *Esquire*, March 1984, p. 168.

269 Author's interview with Victor Bockris.

269 Andy Warhol and Pat Hackett,

POPism: The Warhol 60s (New York: Harper & Row, 1980), p. 108.

CHAPTER TWENTY-FOUR

270 William S. Burroughs, *Junky* (New York: Penguin, 1977), p. xvi.

270 Transcripts of Anthony Haden-Guest interview, Spring 1988.

270 Geoff Dunlop, *Jean-Michel Basquiat, Shooting Star*, London, Illuminations Production, 1990.

271 Author's interview with Leonart DeKnegt.

271 Author's interview with Marcia May.

271 *The Andy Warhol Diaries*, edited by Pat Hackett (New York: Warner, 1989), p. 702.

271 Author's interview with Marcia May.

272 Author's interview with Michael Halsband.

272 Author's interview with Marcia May.

272 Author's interview with Brian Williams, aka B. Dub.

272 Author's interview with Liz Williams.

273 Author's interview with Malcolm Morley.

273 Author's interview with Shenge Ka Pharoah.

273 *The Andy Warhol Diaries*, p. 592.

273 Ibid., p. 599.

273 Author's interview with Brian Williams.

274 Author's interview with Shenge Ka Pharoah.

275 Author's interview with Brian Williams.

275 *The Andy Warhol Diaries*, p. 709.

276 Ibid., p. 714.

276 Author's interview with John Good.

276 Transcripts of Anthony Haden-Guest interview, Spring 1988.

276 Author's interview with Barbara Braathen.

276 Author's interview with Lee Jaffe.

276 Author's interview with Nancy Brody.

277 Author's interview with Fay Gold.

277 Author's interview with Jennifer Goode.

277 Author's interview with Linda Yablonsky.

277 Linda Yablonsky, *The Story of Junk* (New York: Farrar, Straus & Giroux, 1997).

278 Author's interview with Bruno Bischofberger.

279 Author's interview with Yo Yo Bischofberger.

279 Author's interview with Keith Haring.

279 Author's interview with Scott Borofsky.

279 Author's interview with Brian Williams.

280 Author's interview with Jennifer Goode.

281 Author's interview with Victor Bockris.

282 Author's interview with Jennifer Goode.

282 Author's interview with Paul Martini.

CHAPTER TWENTY-FIVE

283 Author's interview with Nancy Brody.

283 Author's interview with Fred Braithwaite.

283 Author's interview with Barbara Braathen.

284 Author's interview with Jennifer Goode.

285 Author's interview with Michael Halsband.

285 Author's interview with Marcia May.

285 Author's interview with Vincent Fremont.

285 Author's interview with Nick Taylor.

286 Author's interview with Arto Lindsay.

286 Author's interview with Jennifer Goode.

286 Transcripts of Anthony Haden-Guest interview, Spring 1988.

286 Author's interview with Vincent Fremont.

287 Author's interview with Jay Shriver.

288 Author's interview with Bruno Bischofberger.

288 Author's interview with Vrej Baghoomian.

291 Author's interview with Don and Mera Rubell.

292 Author's interview with Kelle Inman.

293 Author's interview with Vrej Baghoomian.

293 Author's interview with Rick Prol.

295 Author's interview with Don Rubell.

295 Author's interview with Diego Cortez.

295 Author's interview with Jennifer Goode.

CHAPTER TWENTY-SIX

297 Langston Hughes, "Harlem [2]," *The Collected Poems of Langston Hughes* (New York: Vintage Classics, 1995), p. 426, reprinted with permission from the Estate of Langston Hughes.

298 Author's interview with Outarra.

298 Author's interview with George Condo.

298 Author's interview with Julian Schnabel.

298 Notes from Brian Kelly, Paris, February 1988.

301 "Samo," by Jean Basquit [sic], *The Basement Blues Press*, City-As-School, Spring 1977.

301 Author's interview with Outarra.

302 Author's interview with Jennifer Goode.

302 Author's interview with Kelle Inman.

302 Author's interview with Matt Dike.

303 Author's interview with Tamra Davis.

304 Author's interview with Keith Haring.

305 Author's interview with Vincent Gallo.

305 Author's interview with Paul Martini.

307 Author's interview with Vrej Baghoomian.

307 Author's interview with Kelle Inman.

307 Author's interviews with Valda Grinfelds, Steve Rubell, Rick Temerien.

307 Author's interview with Jay Shriver.

307 Author's interview with Kevin Bray.

308 Author's interview with Kelle Inman.

308 Author's interview with Tamra Davis.

308 Author's interview with Matt Dike.

308 Author's interview with Blanca Martinez.

308 Death certificate.

309 Author's interview with Vrej Baghoomian.

309, 310 Author's interview with Gerard Basquiat.

311 Author's interview with Jeffrey Deitch; copy of eulogy.

311 Visit to Vrej Baghoomian gallery.

311 Author's interview with Nancy Brody.

CHAPTER TWENTY-SEVEN

312 "Andy Warhol," The South Bank Show, London Weekend Television, 1987.

312 Author's interview with Vera Calloway.

312 Author's interview with Larry Gagosian.

313 Author's interview with Michael Stout.

313 Steven Vincent, "Michael Stout's Sleepless Nights," *Art & Auction*, March 1994, pp. 98–123.

313 Lisa Reed, "Stout-Hearted Defender of Artistic Freedom," *Art & Auction*, January 1990, pp. 89–91.

313 Steven Vincent, "Stout v. Christie's: Heating Up," *Art & Auction*, October 1996, p. 32.

313 Author's interview with Janet Gochman, lawyer representing Christie's.

313 Author's interviews with Larry Goldfein, Michael Spencer, lawyers representing Michael Stout.

313 Michael Stout deposed by Morell
Berkowitz, March 28, 1990, p. 6.
 313 Ibid., p. 17.
 313 Ibid., p. 54.
 313 Ibid., p. 52.
 314 Ibid., pp. 58, 67.
 314 Ibid., pp. 74, 75.
 314 Author's interview with Sally Heller.
 314 Author's interview with Tina
Summerlin.
 314–15 Michael Stout deposition, p. 53.
 315 Christie's Appraisals, Inc.,
Property Belonging to the Estate of Jean-
Michel Basquiat, located at Crozier
Warehouse, 541 West Twenty-first Street,
New York.
 315 Affidavits filed by Andrea C.
Krahmer, Vice President of Christie's
Appraisals, Inc., on November 8, 1988,
and March 22, 1989, that "the fair market
value of the property of the estate
described therein as of August 12, 1988
($2,922,610 and $980,260, respectively),
exceeded the sum of $3,800,000.
 315 Surrogates Court, County of New
York, Renunciation of Letters of
Administration and Waiver of Process,
signed August 24, 1988, stating that
Matilde Basquiat 1) renounces all rights to
Letters of Administration upon the estate
of said decedent; 2) waives the issuance
and service of process in this matter; 3)
consents that such Letters of
Administration may be granted by the
surrogate to any person or persons entitled
thereto without any notice whatsoever to
the undersigned; 4) agrees to the
appointment of Gerard Basquiat as
Administrator.
 316 Letter from Matilde Basquiat to
Vrej Baghoomian on October 28,
1988.
 316 Tony Robinson, "Woman Seeks
Proceeds of Basquiat Estate Sale,"
Manhattan Lawyer, March 7, 1989.
 316 Deborah Gimelson, "Inside Art," *7
Days*, March 8, 1989.
 316 "Court Battle Looming over Rights
to Basquiat Estate," *The Art Newsletter*,
vol. XIV, no. 22, June 27, 1989.
 316 Karin Lipson, "Artist's Legacy:

High-Stakes Legal Battle," *Newsday*, July
13, 1989.
 316 Grace Glueck, "The Basquiat
Touch Survives the Artist in Shows and
Courts," *The New York Times*, July 21,
1991.
 316 Author's interview with Kelle
Inman.
 316 Judd Tully, "Basquiat Mistrial—
The Legend Continues," draft of an
unpublished article written for *Art &
Auction*.
 316 To: Estate of Jean-Michel Basquiat,
Notice of Claim # 2, March 8, 1989,
Surrogates Court of the State of New York,
County of New York.
 316 Memorandum of Law by Vrej
Baghoomian, Inc., in Support of Motion
for a Preliminary Injunction with
Temporary Restraining Order, Surrogates
Court of the State of New York, County of
New York, May 30, 1989.
 316 Vrej Baghoomian affidavit in
support of Order to Show Cause for
Injunction, Surrogates Court of the State
of New York, County of New York,
June 9, 1989.
 316 Author's interview with John
Cheim and Howard Read.
 317 Author's interview with Wendy
Williams.
 317 Letter from Matilde Basquiat to
Vrej Baghoomian, shown to me by Vrej
Baghoomian.
 317 Invitation to the opening.
 317, 318 Richard Johnson, "Not for
Sale," Page Six, *The New York Post*,
October 21, 1989.
 318 I attended the opening and the
dinner on October 21, 1989.
 318 Author's interview with Michael K.
O'Donnell, Blumenthal and Lynne counsel
for Michelle Rosenfeld.
 318 "Artist's Estate Held Liable for
$395,000," *New York Law Journal*,
November 17, 1994.
 319 Grace Glueck, "The Basquiat
Touch," *The New York Times*, July 22, 1991.
 319 David D'Arcy, "Turning Point for
Basquiat: Exposure or Stardom," *The Art
Newspaper*, no. 13, December 1991.

319 Richard W. Walker, "The Basquiat Battle," *Art News*, May 1991, p. 38.

319 Cerisse Anderson, "Surrogate Bars Claims Against Artist's Estate," *New York Law Journal*, August 30, 1991.

319 Cerisse Anderson, "Surrogate Allows Subpoena for SoHo Gallery's Records," *New York Law Journal*, October 12, 1990.

319 David D'Arcy, "Basquiat Case," *Vanity Fair*, November 1992, p. 124.

319 November 8, 1994, Subpoena re $209,400 owed by Vrej Baghoomian to Gerard Basquiat in June 9, 1992, judgment in copyright case. May 26, 1992, judgment in favor of plaintiff, Gerard Basquiat, in the amount of $209,400, as against the defendants, Vrej Baghoomian and Vrej Baghoomian, Inc.

319 Author's interview with Dennis Trott.

319 I was present at the May 3, 1989, evening sale at Christie's and sat behind Vrej Baghoomian and Annina Nosei.

320 Judd Tully, "Where's Baghoomian?" *Art & Auction*, July 6, 1992.

320 Deborah Mitchell, "New York's Most Wanted Gallery Owner," *The New York Observer*, May 18, 1992.

320 Robert Atkins, "Baghoomian: It's Only Money," *The Village Voice*, October 25, 1994.

320 Author's interview with Vrej Baghoomian for article in *The New Observer*, December 12, 1994.

320 Author's interview with Arthur Toback, attorney for Rosenthal & Rosenthal.

320 Author's interview with Bernard Venet for *The New York Observer* article.

320 Author's interview with Arthur Toback.

320–21 Author's interview with Douglas Kramer.

320, 321 Court transcripts: Robert Fisher as Trustee of Vrej Baghoomian, Inc., Plaintiff, vs. Gerard Basquiat, Administrator of the Estate of Jean-Michel Basquiat, U.S. Bankruptcy Court, November 16, 1994, before Honorable Prudence Beatty Abram.

321 I was present at the opening of the Whitney retrospective on October 23, 1992.

321 Roberta Smith, "Basquiat: Man for His Decade," *The New York Times*, October 23, 1992.

322 Robert Hughes, "The Purple Haze of Hype," *Time*, November 16, 1992, p. 88.

322 Hilton Kramer, "Whitney Beatifies Basquiat as Ross Plays Race Card," November 2, 1992, p. 1.

322 Author's interview with Michael K. O'Donnell, Blumenthal and Lynne counsel for Michelle Rosenfeld.

322 "Artist's Estate Held Liable for $395,000," *New York Law Journal*, November 17, 1994.

322, 323 Transcripts of Michelle Rosenfeld vs. Gerard Basquiat, United States District Court, Southern District of New York, November 7, 8, 9, 10, 1994.

323 Transcripts of Barbara Gladstone testimony in January 1997 retrial.

323 Author's interview with Michael K. O'Donnell, Blumenthal and Lynne.

323 Author's interview with Vrej Baghoomian for article in *The New York Observer* ("Citing Forgeries, Basquiat Group Spoils Return of Artful Dodger Vrej Baghoomian," December 12, 1994).

324 Author's interview with Richard Rodriguez.

324 Letter from Vrej Baghoomian to Richard Rodriguez, October 18, 1994.

325 Author's interview with Jim Margolin, New York City Press Department, FBI.

325 November 22, 1994, certification sent by the Authentication Committee of the Estate of Jean-Michel Basquiat to Galerie Templon.

325 Author's interview with Daniel Templon.

325 Author's interview with Michelle and Herbert Rosenfeld.

326 Author's interview with Vrej Baghoomian.

326 Invoice from Vrej Baghoomian, Inc., for "Smoke Bomb" and Untitled to Paul Baghoomian, Sonnyvale [sic], Calif., January 1, 1988.

326 Invoice from Vrej Baghoomian, Inc., for "Tax Free" to Mrs. Emily Ghazikhanian in Cardiff, Great Britain, November 17, 1987.

326 Invoice from Vrej Baghoomian, Inc., for Untitled to J.S.B. Coopey, in Cardiff, Great Britain, October 4, 1984.

326 Author's interview with Bruno Bischofberger.

326 Author's interview with Annina Nosei.

326 Author's interview with Perry Rubenstein.

327 Author's interview with Julian Schnabel.

327, 328 I was on the movie set for a week for an article I wrote for *Vogue*, February 1996, pp. 224–25, 270.

328 Author's interview with Jeffrey Wright.

329 Author's interview with Julian Schnabel.

329–30 Author's interview with Andrew Terner.

330 I spoke to Matilde Basquiat at her house on Covert Street on June 9, 1996.

331 Author's interview with Michael Stout.

331 I visited the Great Jones Street loft in the spring of 1996.

EPILOGUE

332 Author's interview with Theo Sedlmayr.

332 Jean-Michel Basquiat, *The Notebooks*, edited and compiled by Larry Warsh (New York: Art + Knowledge, 1993).

333 Galerie Enrico Navarra in Paris published a two-volume set of Basquiat works in February 1996. The Picasso portrait (it says Pablo Picasso, although the painting itself is untitled) is on page 239 of the second volume.

334 Jean Baudrillard, "The Ecstasy of Communication," in *The Anti-Aesthetic*, edited by Hal Foster (Seattle: Bay Press, 1983), pp. 132–33.

334 Steven Henry Madoff, "What Is Postmodern About Painting: The Scandinavia Lectures, II," *Arts*, November 1985, pp. 59–64.

336 Author's interview with Brian Gormley.

336 Henry Dreyfuss, *Symbol Sourcebook* (New York: Van Nostrand Reinhold, 1984), pp. 90–91.

337 Burchard Brentjes, *African Rock Art* (New York: Clarkson N. Potter, 1970).

337 P. M. Grand, *Prehistoric Art: Paleolithic Painting and Sculpture* (Greenwich, Conn.: New York Graphic Society, 1967).

337 Lorraine O'Grady, "A Day at the Races," *Artforum*, April 1993, pp. 11–12.

340 Ross Russell, *Bird Lives!* (New York: Da Capo, 1996), pp. 257, 258, 261.

341 Videotaped interview of Basquiat by Tamra Davis and Becky Johnston, 1986.

342 Author's interview with Arden Scott.

342 Author's interview with Robert Hughes.

343 Author's interview with Stanley Crouch.

343 Author's interview with Marcia Tucker.

343 Author's interview with Arthur Danto.

343 Author's interview with Ingrid Sischy.

Acknowledgments

Jean-Michel Basquiat's short, intense life made an indelible impression on many of those who knew him, from those who met him briefly to those who were intimately involved with him. I am deeply indebted to the dozens of people who generously shared their memories, observations, and knowledge of the artist's life and his work with me. I am also grateful to those who made notes, articles, materials, books, and catalogues available to me during the seven years it took to complete this book. There are some sources who preferred to remain anonymous, and although I cannot thank them by name, I would like to express my gratitude for their equally valuable input.

My thanks to the following, arranged alphabetically: Alexis Adler, Charlie Ahearn, Kirsten Aldrich, John Andrades, Joey Arias, Patti Astor, Doris Atheneos, Massimo Audiello, Martha Baer, Vrej Baghoomian, Eszter Balint, Doug Baxter, Richard Bellamy, Bruno Bischofberger, Yo Yo Bischofberger, Patti Anne Blau, Irving Blum, Victor Bockris, Mary Boone, Scott Borofsky, David Bowes, Fred Braithwaite, Peter Brant, Barbara Braathen, Kevin Bray, Jeff Bretschneider, Eli Broad, Nancy Brody, Christopher Burge, Vera Calloway, Leo Castelli, May Castleberry, Cynthia Cathcart, John Cheim, Sandro Chia, Bob Colacello, George Condo, Kinshasha Conwill, Andree Corroon, Diego Cortez, Douglas Cramer, Stanley Crouch, Ronnie Cutrone, Ken Cybulska, Arthur Danto, Tamra Davis, Andrew Decker, Jeffrey Deitch, Leonart DeKnegt, Lester Denmark, Mark DeMuro, Monroe Denton, David D'Arcy, Brett De Palma, Al Diaz, Jane Diaz, Matt Dike, Jim Dormant, Kate Drury, Geoff Dunlop, Kai Eric, Richard Feigen, Robert Feldman, Patricia Fields, Estelle Finkel, Stephen Frailey, Vincent Fremont, Saskia Friedrich, Larry Gagosian, Vincent Gallo, Leslie Garfield, Henry Geldzahler, Deborah

Gimelson, Mark Glimcher, Fay Gold, Liz Gold, John Good, Eric Goode, Jennifer Goode, Brian Gormley, Valda Grinfelds, Anthony Haden-Guest, Steve Hager, Michael Halsband, Chris Hanley, Freya Hansell, Keith Haring, Pat Hearn, Alanna Heiss, Sally Heller, Fred Hoffman, Jeffrey Hogrefe, Michael Holman, Fred Hughes, Robert Hughes, Kelle Inman, Lee Jaffe, Barbra Jakobson, Claudia James, Eric Johnson, Becky Johnston, Ulrike Kantor, Ivan Karp, Klaus Kertess, Stephen Lack, Paul LaMarre, Gary Lang, Joe LaPlaca, Sylvia Lennard, Zoe Leonard, Howard Lewis, Mary Ellen Lewis, Stephanie Lewis, Tina Lhotsky, Lisa Liebmann, Arto Lindsay, Victor Littlejohn, Benjamin Liu, Jan Eric von Löwenadler, Lawrence Luhring, John Lurie, Christopher Makos, Suzanne Mallouk, Gracie Mansion, Richard Marshall, Blanca Martinez, Maripol, Paul Martini, Steve Mass, Marcia May, Kate McCamy, Marilyn Minter, Mary-Ann Monforton, Malcolm Morley, Stanley Moss, Enrico Navarra, Nancy Neuhauser, Annina Nosei, Glenn O'Brien, Michael O'Donnell, Wendy Olsoff, Outarra, Francesco Pellizi, Stan Peskett, Beth Phillips, Amos Poe, Paige Powell, Rick Prol, Lee Quinones, Howard Read, Harry Reid, Janelle Reiring, Rene Ricard, Walter Robinson, Richard Rodriguez, Liz Rosenberg, Don and Mera Rubell, Perry Rubenstein, Fred Rugger, David Salle, Anita Sarko, Kenny Scharf, Peter Schjeldahl, Arlene Schloss, Julian Schnabel, Lenore Schorr, Allan Schwartzman, Arden Scott, Chris Sedlmayr, John Seed, John Serdula, Tony Shafrazi, Steve Shane, Cynthia Bogen Shechter, Adam Sheffer, Shenge, Jay Shriver, Franklin Sirmans, Ingrid Sischy, Gene Sizemore, Holly Solomon, Walter Steding, Jennifer Stein, Leslie Stein, Ed Steinberg, Bill Stelling, Michael Stout, Leisa Stroud, Tina Summerlin, Sur Rodney Sur, Anna Taylor, Nick Taylor, Rick Temerien, Daniel Templon, Andrew Terner, Robert Farris Thompson, Justin Thyme, Arthur Toback, Stephen Torton, Toxic, Dennis Trott, Paul Tschinkel, Judd Tully, Larry Warsh, Ted Welch, Liz Williams, Wendy Williams, Julie Wilson, Melissa Wolf, Jeffrey Wright, Linda Yablonsky.

I am also grateful to the photographers who permitted me to publish their work: Edo Bertoglio, William Coupon, Catherine McGann, Mark Sink, Gianfranco Gorgoni, Timothy Greenfield-Sanders, Rose Hartman, Beth Phillips, and Michael Halsband.

In addition, I would like to thank the several researchers who provided invaluable assistance: Merv Keizer, who stuck with this project even when it seemed to be permanently on hold; Jennifer Borum, who

provided much-needed early assistance in culling the first bunch of clips; Pat Neiring, who very generously offered her time and energy to comb the library for me; and Samantha Hoyt, for her help in locating photographs.

Thanks also to my editor, Paul Slovak, for volunteering to oversee a complicated book at the eleventh hour, and for his unflagging enthusiasm and patience.

Finally, I could not possibly have endured the many tribulations of this project were it not for the true grit of my family and friends.

I would like to thank my parents, Lillian and Russell Hoban, who inspired me to become a writer; from my earliest years they taught me that it is possible to turn what you love into your life's work.

I also would like to give special thanks to Joan Westreich, Cynthia Rigg, Celia McGee, Ted Mooney, Steven Levy, Eddie Sutton, Jacob Sturm, Andreas Agas, David Kirkpatrick, Patti Cohen, Susan Ruskin, Dani Shapiro, Gwenda Blair, Jaimie Diamond, Stephen Hall, M.G. Lord, Andrew Terner, and Stephen Westfall, all of whom provided friendship, intelligence, and support, and some of whom gave me the additional help of reading the manuscript.

My heartfelt thanks to Michael Brod, for inspiring and sustaining me through the arduous last lap.

Index